PHOTOS THAT INSPIRE
PHOTO WORKSHOP

Lynne Eodice

BICENTENNIAL
1807
WILEY
2007
BICENTENNIAL

Wiley Publishing, Inc.

Photos That Inspire Photo Workshop

Published by
Wiley Publishing, Inc.
111 River Street
Hoboken, N.J. 07030
www.wiley.com

Copyright © 2008 by Wiley Publishing, Inc., Indianapolis, Indiana

Published simultaneously in Canada

ISBN: 978-0-470-11955-6
Manufactured in the United States of America

10 9 8 7 6 5 4 3 2 1

For general information on our other products and services or to obtain technical support, please contact our Customer Care Department within the U.S. at (800) 762-2974, outside the U.S. at (317) 572-3993 or fax (317) 572-4002.

Wiley also publishes its books in a variety of electronic formats. Some content that appears in print may not be available in electronic books.

Library of Congress Control Number: 2007934456

About the Author

© Photo by Lynne McCready

Lynne Eodice is the Managing Editor of *Double Exposure*, the online publication for Photoworkshop.com. She began her career writing and shooting pictures for weekly newspapers in southern California during the '90s, including *The Walnut Independent*, *Pasadena Weekly*, *Sierra Madre News*, and *The Herald Tribune*. For eight years she was Feature Editor for *Petersen's PHOTOgraphic*, until the magazine's demise in 2005. In addition to having articles and photos published in this magazine, her images have appeared in a popular instructional book called *The Complete Idiot's Guide to Photography*, and she's contributed stories to *Rangefinder*, *California Tour & Travel*, and *Family Photo* magazines, and www.takegreatpictures.com, a photo community Web site. She has marketed her stock photos through Index Stock Imagery in New York. *Photos That Inspire* is her very first book.

A native of southern California, Lynne currently lives in Altadena, California, with her husband, Dennis.

To learn more about *Double Exposure*, visit www.doubleexposure.com.

Credits

Senior Acquisitions Editor
Kim Spilker

Senior Project Editor
Cricket Krengel

Editorial Manager
Robyn Siesky

Vice President & Group Executive Publisher
Richard Swadley

Vice President & Publisher
Barry Pruett

Business Manager
Amy Knies

Senior Marketing Manager
Sandy Smith

Book Designers
Tina Hovanessian
Erin Zeltner

Project Coordinator
Erin Smith

Graphics and Production Specialists
Laura Campbell
Jennifer Mayberry
Erin Zeltner

Quality Control Technician
Jessica Kramer

Cover Design
Daniela Richardson
Larry Vigon

Proofreading
Broccoli Information Management

Wiley Bicentennial Logo
Richard J. Pacifico

Special Help
Alissa Birkel

Cover photo taken by Yolanda Pucinski

I dedicate this book in memory of my father, Edward Nitsch, who also loved photography.

And to my husband Dennis, who gave me my first 35mm SLR, and has always given me so much love and support in my writing and photography.

Acknowledgments

I want to acknowledge Robert Farber for making the photoworkshop.com series of books possible, and for being such a great mentor.

I'd also like to give special thanks to Senior Project Editor Cricket Krengel and to Senior Acquisitions Editor Kim Spilker. Without your help, this book would never have gotten finished!

And to all of the photographers whose images appear in *Photos That Inspire* — this book is all about you. I thank everyone for sharing your time and talent.

Foreword

FROM ROBERT FARBER, CREATOR OF PHOTOWORKSHOP.COM

After 10 years of helping photographers hone their skills on photoworkshop.com, I'm thrilled to present this new line of books in partnership with Wiley Publishing.

I believe that photography is for everyone, and books are a new extension of the site's commitment to providing an education in photography, where the quest for knowledge is fueled by inspiration. To take great images is a matter of learning some basic techniques and "finding your eye." I hope this book teaches you the basic skills you need to explore the kind of photography that excites you.

You may notice another unique approach we've taken with the Photo Workshop series: The learning experience does not stop with the books. I hope you complete the assign-

© Photo by Jay Maisel

ments at the end of each chapter and upload your best photos to photoworkshop.com to share with others and receive feedback. By participating, you can help build a new community of beginning photographers who inspire each other, share techniques, and foster innovation and creativity.

Robert Farber

Contents

Preface

At one time or another, most of us have probably looked at a wonderful photo in a magazine, on the Internet or on a gallery wall and wondered how the photographer came up with such a great idea. So what better way to learn photography than by studying inspiring images?

The photographs in this book represent some of the best work of Photoworkshop.com members in the Portfolios or Bio & Visual Exchange pages, as well as people who have entered contests on *Double Exposure,* the online publication for Photoworkshop.com, and others whose photography has caught our eye. Many of these people are amateurs and students, individuals like you who share a passion for photography. Others are working professionals who have chosen to make photography their life's work. They're from the United States as well as around the globe.

On these pages, you will look at a variety of situations — from landscape to scenic and travel, from flora and fauna to skin, from animals to people. Each photographer shares a story on how he or she arrived at an idea and shot that inspiring image. The photographer's camera gear and technical data are also included to help you understand why the image works.

How do inspiring photo ideas come about? As you'll see, these ideas are as varied as the photographers themselves. Sometimes an opportunity presents itself serendipitously to the photographer: In the dim light of dusk, a boatman turns to gaze at a famous monument, creating a fleeting photo opportunity for a passenger who has his camera handy. Or a dog briefly looks at its owner with love in its eyes, and again, the photographer catches the moment. In more than one case, the photographer was shooting one scene only to turn around and discover another great vista in the opposite direction. In other instances, the photographer planned the photo session in advance. One image from a Photoworkshop.com member is part of a series on people and their dogs that he photographed for an exhibition. Other images were captured at sporting events where the photographers made arrangements for special access, and some were photographed specifically for Photoworkshop.com's weekly assignments. The point is, regardless of where or why you are shooting, inspiring and fantastic photo opportunities are everywhere.

Everyone sees and interprets our world differently. But one thread of commonality between all of these photographers is the love of their chosen subjects. Great landscape photographers rise early to capture early morning light and don't put their

cameras away until after the sun has gone down. Portrait photographers have a knack for establishing a rapport with their subjects and revealing something of their personalities, while still-life photographers prefer to arrange inanimate objects to create artistic photos. Architectural photographers enjoy interpreting the design of a building, or perhaps capturing the essence of a city scene.

As you'll discover in the pages that follow, you don't have to be a professional to create beautiful images, but you do need to spend a lot of time behind the lens. You must learn to perceive a subject in your own way and interpret it successfully on a memory card or film.

So, go out and shoot a successful scenic. Take pictures of your pet, or perhaps a portrait of a loved one or your friends. Find a way to depict motion or to shoot a low-light scene. Go into the city to photograph the hustle and bustle or go out into nature to photograph plants and flowers. Capture the intimate world of macro or close-up photography. Arrange and shoot a still-life composition. Maybe you'll even want to challenge yourself by photographing the beauty of the human form.

We hope that you enjoy this book so much that you want to share some inspiring images of your own in the categories outlined here. You can upload images by going to www.pwsbooks.com, and setting up a free account, which allows you to upload your photos in the various categories and view and critique the assignments submitted by others.

As you begin to apply your own photographic vision to the world around you, we hope you use what you learn from the photographers who have contributed to this book to improve and inspire your own great shots!

PART 1

LANDSCAPE, SCENIC, AND TRAVEL PHOTOGRAPHY

Next to people, landscape and travel rank among the most popular photographic subjects. But as evidenced by many people's vacation pictures, it isn't easy to shoot a great travel image. The human eye tends to view scenes selectively, but the camera simply records the entire picture, often with disappointing results. Being in a great locale also contributes to the experience — you may be enthralled with the sound of a trickling stream or the fragrant aroma of spring flowers in the mountains. The challenge is how to capture the essence of a travel destination and the feeling that goes with it. Scenic photography takes a lot of devotion, patience, and practice (and as some of the following photographers attest, a certain amount of serendipity). The essence of a great scenic image is to zero in on — and convey — what grabbed you about the scene in the first place.

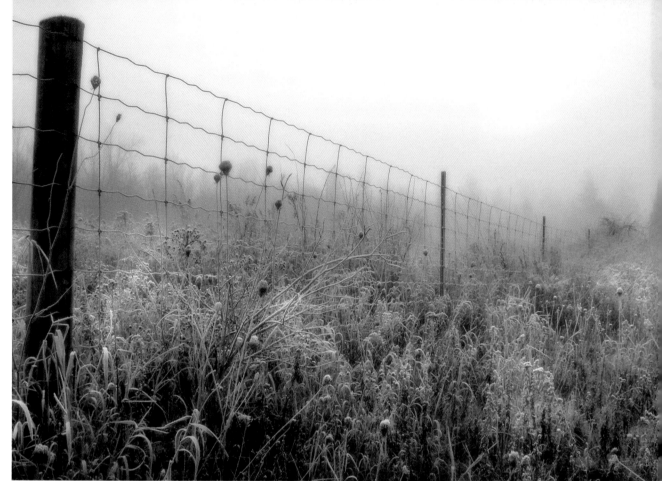

"Foggy, Frosty Morning"
© *Wendy Stevenson*
Oxford Station, Ontario, Canada
www.intoitphotography.com

Bright, sunny days are great for capturing post-card-type landscape shots, but sometimes less than perfect weather can really help you interpret the essence of a place. Fog offers a lot of atmosphere and has a way of obscuring distracting elements in a scene. In this image, the focus is on the frost covering the foliage in the foreground. On a sunnier day, the background may have been more visible, making the scene a little busier. As this image illustrates, the farther an object is from the camera, the more it seems to dissolve into the misty background. When you're shooting on a foggy day, exposure can be a challenge. Because fog is very reflective, it has a tendency to fool your light meter into causing underexposure. You can compensate for this by opening your aperture one stop above the meter's reading.

Photographer's Comments
"On my way to work one morning, I stopped at an intersection and saw this most beautiful scene. What caught my eye was the way the white frost and cloudy sky seemed to make the fall colors of the long grass pop! The fence had a nice rustic look and was leading toward the diffused light of the cloud-covered sun. It was just as though it was all set up for me."

Technical Data
Canon EOS Digital Rebel XT
Canon EF-S 17-55mm f/2.8 zoom lens
set at 21mm
1/20 of a second at f/22
ISO 100
Ambient light on a foggy day

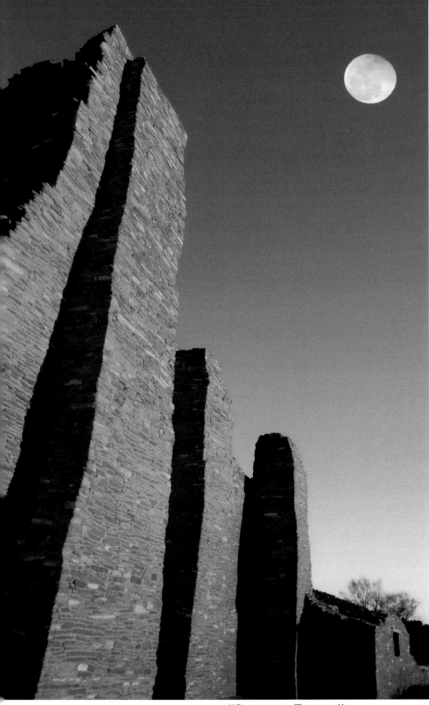

"Salinas Ruins"
© Eric Williams
Albuquerque, New Mexico
http://eric_williams.photoworkshop.com

These ruins — standing tall and glowing in lingering afternoon light — provide a beautiful contrast to the blue sky. And the rising moon makes this image especially intriguing. (To get a successful moonrise, you may find that you want to combine two images in Photoshop to get the best results, particularly if you want a large moon with detail.) Late in the day, the long shadows cast by the sun emphasize the three-dimensionality of a landscape. The light rakes across the land, which enhances texture dramatically. Many photographers, as this one did, plan their landscape shots well in advance to capture events like a lunar eclipse. You may also want to do a little scouting for locations ahead of time. As late afternoon turns into dusk, the sky takes on a colorful, rapidly changing light. You need to work quickly before the sun goes down if you want to capture the beautiful light of the magic hour. Because the light is increasingly becoming dimmer, use a tripod and cable release to avoid camera shake during long exposures.

Photographer's Comments

"On the evening I took this picture, there was going to be a partial lunar eclipse that would occur around sundown. The moon was supposed to rise around dusk, so I thought that this would make a very interesting shot with the moon rising over the ruins in the evening."

Technical Data

Canon EOS Digital Rebel XTi
Canon EF 17-40mm zoom lens
set at 17mm
1/40 of a second at f/7.1
ISO 100

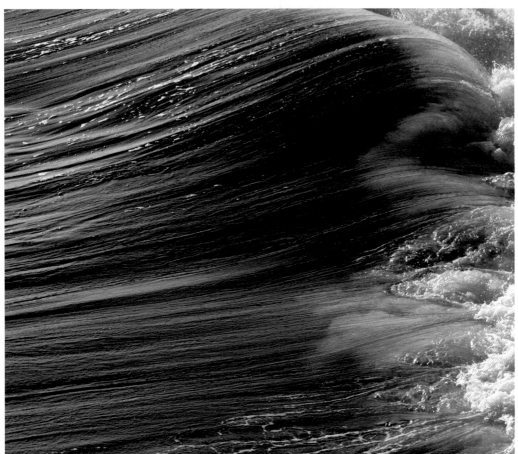

"FOLDOVERBLUES"
© *Robyn Raggio*
Oxnard, California
www.raggiovisio.com

This image makes a statement about the beauty and power of the sea. The smooth blue green of the water is a great contrast to the crisp spray as the wave breaks onshore. The best time to photograph the surf is at high tide, when the sea is most volatile. Using a moderate telephoto lens, as the photographer did here, allows you to isolate a single wave as it crashes onto the shore. A fast shutter speed (1/250 second or greater) freezes the spray, but timing is very important. You need to click the shutter an instant before the wave breaks to catch it at its peak. A motor drive or Sports/Action setting on your camera allows you to fire off several frames in rapid succession, thus increasing your chances for success.

Photographer's Comments

"The waves call to me every morning... 'Come and see! Come and see!' I walk to the pier and up and over the chaotic liquid as the sun rises, the clouds and fog contain the light and throw it onto the sea. Some days red, some days purple, some days pink, but those special days are aquamarines and rich cobalts, boiling under the surface like a frantic painter's palette, the surface remaining as smooth and silken as a maiden's hair. I hover and shoot, spellbound by the show that lasts only a few minutes, then is gone forever. Yet I feel no sorrow for the passing of the moment, for I know I have captured the day's performance — snug and safe in a little black box."

Technical Data

Canon EOS 5D digital SLR
Canon EF100mm f/2.8 macro lens
1/500 of a second at f/22
ISO 1250
Natural light

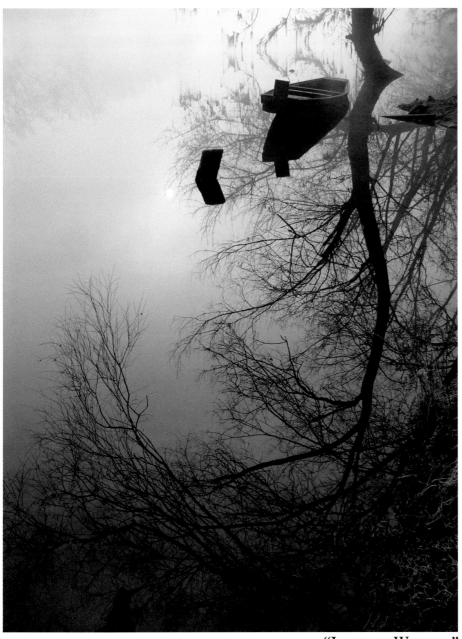

Painters and photographers throughout the years have presented water as a prominent source of reflections, as it offers more possibilities than other reflective surfaces. This image has a very painterly feeling, and evokes a sense of mystery and romance. The smooth surface of this water mirrors the environment perfectly. Perhaps the best time to find glass-smooth water like this is just after dawn, before the sun warms up the air and breezes begin.

Photographer's Comments

"The beauty of the frozen moment is silent and intimate, yet it is a narrative of wild nature with smothered light and color full of narrowness and restless in the early morning."

Technical Data

Olympus C-5050 Z digital SLR
Built-in 3X aspherical zoom lens
1/320 of a second at f/4
ISO 64

"LAND OF WISTFUL"
© *Aleksandra Podrebarac*
Karlovac, Croatia
www.alexartphoto.com

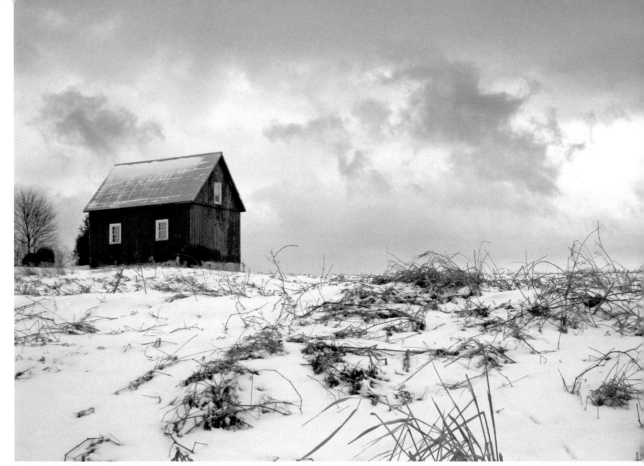

"LITTLE RED BARN"
© *Wendy Stevenson*
Oxford Station, Ontario, Canada
www.intoitphotography.com

This rustic red barn provides subtle color in contrast to the starkness of a snow-covered landscape and a gray, cloudy sky. Simple compositions are always more effective than cluttered ones, and this is very true of winter scenes. Also, be aware that the light snow poses a challenge to exposures. The camera meter is designed to record scenes with an 18-precent gray reflectance, which can underexpose the scene and turn white snow to gray. You'll probably want to give snowy scenes a tad bit more exposure than what the meter indicates. A snow scene on a sunny day may need an extra stop or two, while a dull day may require a half to one stop. Late in the day in very cloudy conditions like this may not require any exposure compensation at all.

Photographer's Comments
"I have passed this little barn many times, but on this winter day, the sun was setting and very low on the horizon. I pulled my car over, climbed down into a ditch and set up my camera gear. I liked the way the red barn stood out against the whiteness of winter, as well as the texture of the snow-covered field and the beautiful diffuse light of the setting sun. I chose to shoot this scene from a low perspective — as I do in many situations — to keep the background clean and simple."

Technical Data
Canon EOS Digital Rebel XT
Canon EF-S 17-55mm f/2.8 zoom lens
set at 22mm
1/2000 of a second at f/20
ISO 100
Late afternoon light on a cloudy day

This scene of volcanoes is awe-inspiring and otherworldly — and well worth getting up before dawn to arrive at such a dramatic vantage point at sunrise. It's also difficult to find a great (and safe) place to photograph volcanoes, particularly active ones. At high elevations like this, sunrise occurs later than if you were taking pictures at the beach. But either way, early morning light is warm and yellow, and the low light casts long shadows on the land, which accentuates texture. The mist at the base of the volcano in the foreground is beautiful as well. When photographing a scene like this where it's important to have all of the elements in sharp focus, use a small aperture for great depth of field.

Photographer's Comments

"The Bromo Tengger National Park in East Java, Indonesia, is one of my favorite photo locations in the world. Starting from the crater rim village of Cemoro Lawang, a one-hour climb in the early morning darkness brings you to an amazing viewpoint. The scene here is always so primal — especially so if you catch it at sunrise. Mt. Semeru, the highest volcano in Java, spews ash about every 30 minutes and forms the backdrop. Sulphurous gases are always emanating from the foreground crater, Mt. Bromo. Early morning light highlights everything beautifully. What more inspiration could you ever want?"

Technical Data

Canon EOS D60 digital SLR
Canon EF 28-135mm IS zoom lens
1/5 of a second at f/11
ISO 100
Sunrise

"VOLCANOES, BROMO TENGGER NATIONAL PARK, INDONESIA"
© Dennis Walton
Bellingham, Washington
www.fdwphotos.com

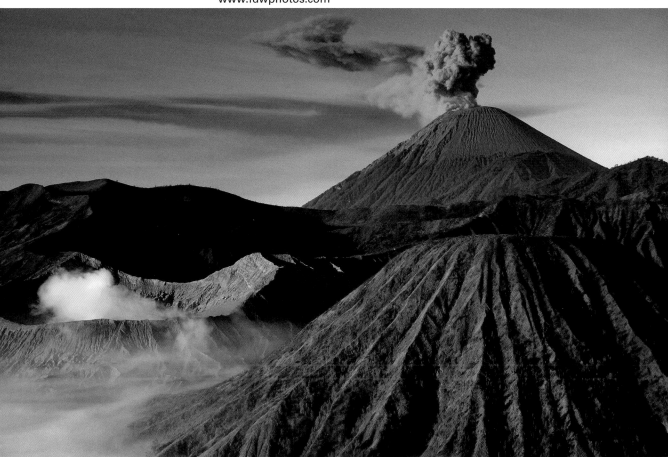

Early and late in the day, the raking light imparts texture, depth, and form to landscapes. This light, combined with the illumination immediately after a storm gives you outstanding photo opportunities, as the photographer demonstrates in this lovely mountain lake scene. The three boats that are docked on the shore also offer a visual clue that indicates scale, as well as providing some bright colors.

Photographer's Comments

"After a full day of hiking under a cool blanket of rain and mist, the cloud cover broke. The early evening light lay across the landscape, showing its brilliant color against the otherwise gray horizon. Combined with the silent shadows of drifting clouds along the mountain range, there was a stillness that could only be captured with my camera and a bit of luck in being in the right place at the right time."

Technical Data

Nikon D70s digital SLR
12-24mm f/4.0 Nikkor
zoom lens set at 12mm
1/60 of a second at f/16
ISO 200

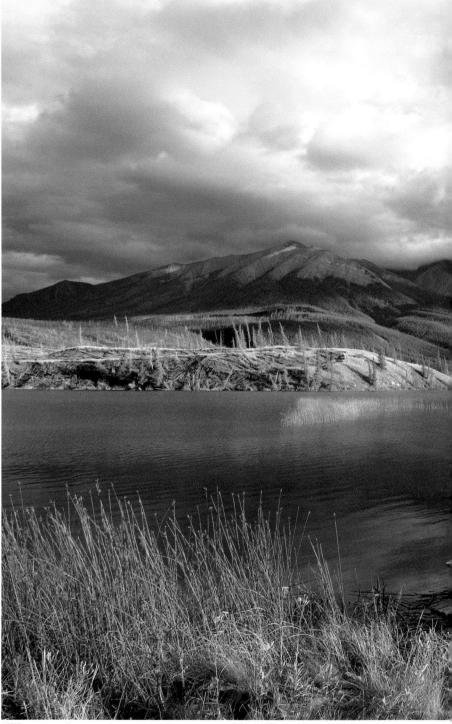

"TALBOT LAKE, JASPER NATIONAL PARK"
© *Michael Bayer*
Nova Scotia, Canada

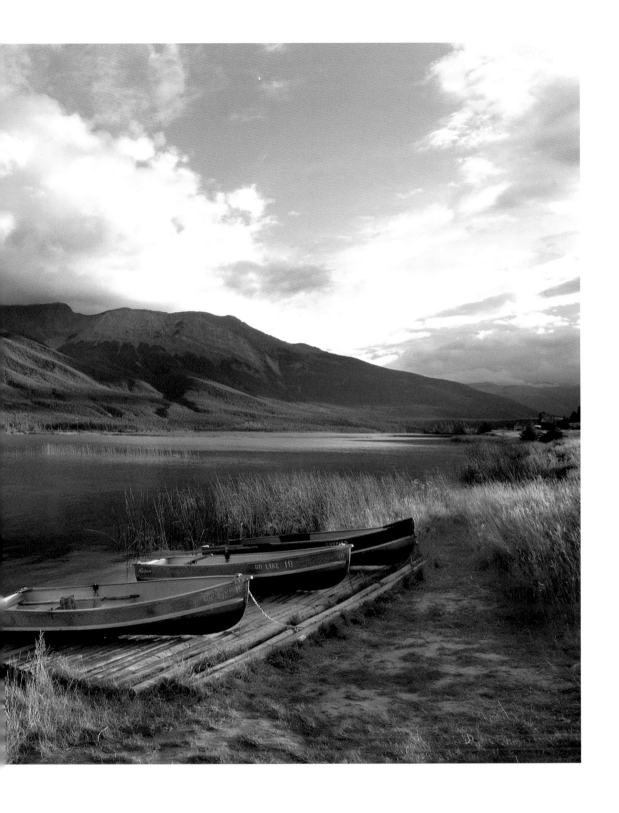

This image definitely gives us the sensation of a plane circling the city below in preparation for landing. Doing aerial photography on commercial airlines is challenging partly because of the thick plastic windows that make sharp focus difficult, but you can minimize this fuzziness by getting your lens as close to the window as possible. Take-offs and landings are the best time to shoot, because the lower altitude makes features on the ground more recognizable and there's less atmospheric haze. This image also works well because the photographer focused on the plane's wing and the result is much like panning in action photography — the moving subject is relatively in focus while the background is a blur.

Photographer's Comments

While traveling for work one summer (as I often do), I decided that in order to spend more time behind the lens, I would have to start requesting window seats on flights and haul the camera out of overhead storage. On a flight coming home to Harrisburg from Chicago, I began shooting long exposures of the city lights below and liked the sense of movement that I achieved. As we neared the airport on our descent, it dawned on me that without much air turbulence, I could probably hold the camera still enough with an IS (Image Stabilizing) lens to keep the wing in focus and allow the lights below to do their merry dance around it. 'Night Approach' is the happy result of that inspired experiment."

Technical Data

Canon EOS 20D digital SLR
Canon EF-S 17-85mm f/4-5.6 IS lens set at 17mm
1.3 seconds at f/4
Pattern metering mode and auto white balance
Minor adjustments to the white balance and levels and curves made in Adobe Photoshop

"NIGHT APPROACH"
© Daniel G. Walczyk
Wrightsville, PA
http://wystudios.photoworkshop.com

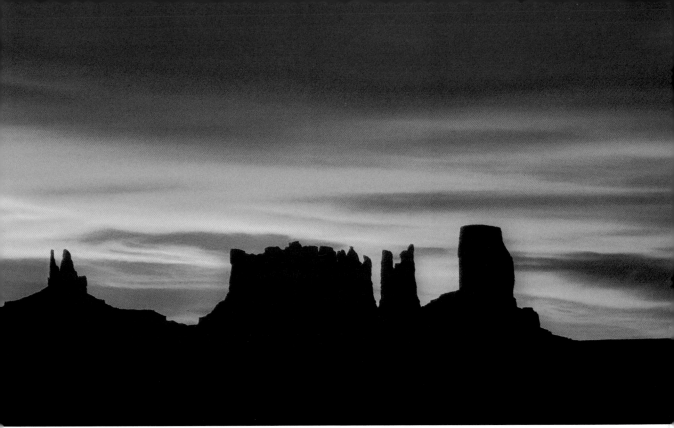

"MONUMENT VALLEY SILHOUETTE"

© *Michael Cetta*
Brooklyn, New York
www.mikecetta.com

For anyone who loves shooting landscapes, Monument Valley's buttes and rock formations easily distinguish this Navajo Tribal Park from other wilderness areas. The silhouetted spires are very striking against the colorful pre-dawn sky. To photograph a silhouette, take a meter reading of a bright background — the sky, colorful wall, or perhaps the glittering ocean at sunset — and use your exposure lock to hold that exposure. This renders foreground shapes in silhouette. When looking for subjects for silhouettes, find ones that have bold and easily recognizable shapes for best results.

Photographer's Comments

"I was staying at a hotel close to the entrance to Monument Valley on the Arizona side. I woke up at 5:30 a.m. and happened to look out the window at this incredible sunrise. The whole area reeks of mystery and haunting beauty, but this topped it all. So I grabbed my camera, went out on the terrace, and started shooting. The colorful sky was changing by the minute, so I just shot away. All I could think about was the conversation I had the day before with the Indian guide who drove me through the valley. He pointed out places and rock formations that Indian tribes experienced as mystical symbols. I was torn between shooting the scene and just taking it all in — it was easy to understand what the guide was talking about."

Technical Data

Canon EOS 1D Mark II N digital SLR
Canon EF 70-200mm f/4.0L IS lens set at 200mm
1/99 of a second at f/9.1
ISO 400
Spot metering
Natural light at sunrise

Mist is very effective in photography because it creates a lot of atmosphere, and as shown here, can render sunlight as dramatic beams when the sun breaks through. The photographer was in the right place at the right time to capture this wonderful light streaming through the trees. As I mentioned earlier, dramatic light can occur early or late in the day, or after a storm. On sunny days, beams of light can come in through high windows in cathedrals or other buildings designed for this phenomenon. Have your camera handy, as you may come across beautiful light when you least expect it. A wide-angle lens helps you encompass a scene with mist and the interesting lighting that it produces.

"MORNING RAYS"
© *Michael Pickelsimer*
British Columbia, Canada
http://mpickelsimer.photoworkshop.com

Photographer's Comments
"Stanley Park, located in Vancouver, British Columbia, is a wonderful place to take pictures. I took this image on a typical late October morning where the cool fall air produces a thick mist over the entire countryside. When the sun rises, an incredible display of natural lighting effects takes place. On this occasion, I wanted to capture the unique way that the trees and mist were bending the sun's rays."

Technical Data
Canon EOS 20D digital SLR
Canon EF 24-70mm lens set at 24mm
1/80 of a second at f/7.1
ISO 200
Morning light

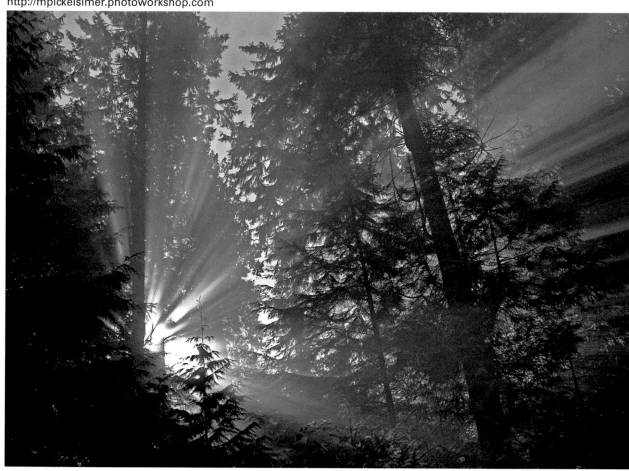

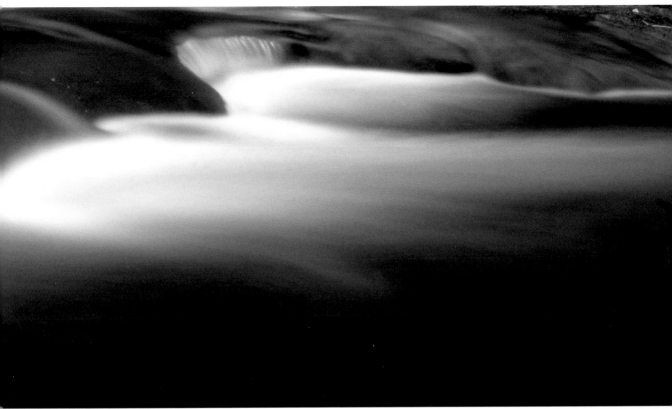

"QUILLION CREEK, BANKHEAD NATIONAL FOREST"

© Cynthia McKinney
Decatur, Alabama
http://cynthiamckinney.photoworkshop.com

Many people choose to freeze the action of rushing water by using a fast shutter speed. But this photographer chose to render the water as soft and dreamy by using a long exposure. She also used a neutral density filter to allow less light into the lens, enabling her to use a slow shutter speed of several seconds. The image makes a statement about the peacefulness of nature. She also chose a low vantage point to emphasize the silky feeling of this small waterfall, and I like the way that the white water fades into the dark shadows. The composition is very simple, and extraneous elements are eliminated.

Photographer's Comments

"This is a small waterfall on Quillion Creek in Bankhead National Forest. This area of the forest is calm and peaceful, where one can find a quiet moment to reflect. I was inspired to shoot this image while sitting along the creek's edge one day. I looked at the waterfall thinking about the black rock and quickly flowing water, and knew that it would make a great black-and-white image. I set up the camera on a tripod and looked through the lens. That's when I noticed that the waterfall looked like a set of angel wings."

Technical Data

Canon EOS Digital Rebel
Tamron 28-300mm zoom lens set at 28mm
15 seconds at f/22
#6 Neutral Density filter
Monfrotto 3001BD tripod with a
3030 Manfrotto head
Changed the color to black-and-white in
Adobe Photoshop CS

A rainbow sighting is awe-inspiring for nearly everyone, even the most jaded among us. It's difficult to predict where a rainbow will appear, but you increase your chances of seeing one by facing in the direction of a dark sky, in the opposite direction of the sun after a storm. This photographer also included an interesting foreground in the scene, giving the image a sense of scale. It's more interesting than simply photographing a rainbow hanging in the open sky. You can also use a polarizing filter to intensify the colors of a rainbow (just be sure you don't rotate the filter in a way that eliminates the rainbow altogether).

Photographer's Comments

"It was 6:16 a.m. on St. Bartholomew in the French West Indies, and I had just awakened at the rental house where I was staying. My Canon 5D was upstairs, and I knew that the rainbow would be gone before I could run and get it. Because I always try to keep my little Canon point-and-shoot with me, I fired off two shots, locking the exposure on the left frame image, with about a 30% overlap. Five minutes later the squall had passed and it was sunny outside. I then manually stitched the image together in a software program called Ptgui and output the maximum size that was possible —3504 × 1676 at 240 dpi."

Technical Data

Canon PowerShot SD800 IS compact digital SLR
1/250 of a second at f/7.1
ISO 100
Natural light

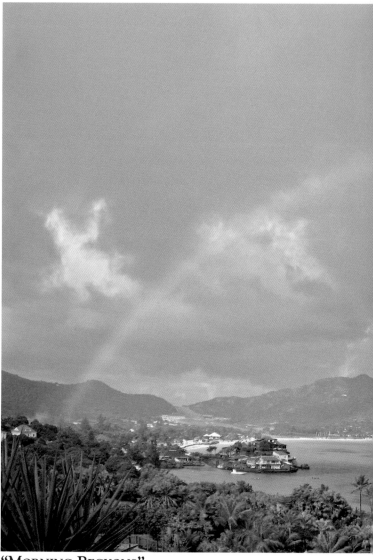

"Morning Beckons"
© Rice Jackson
Austin, Texas
www.terra360.com

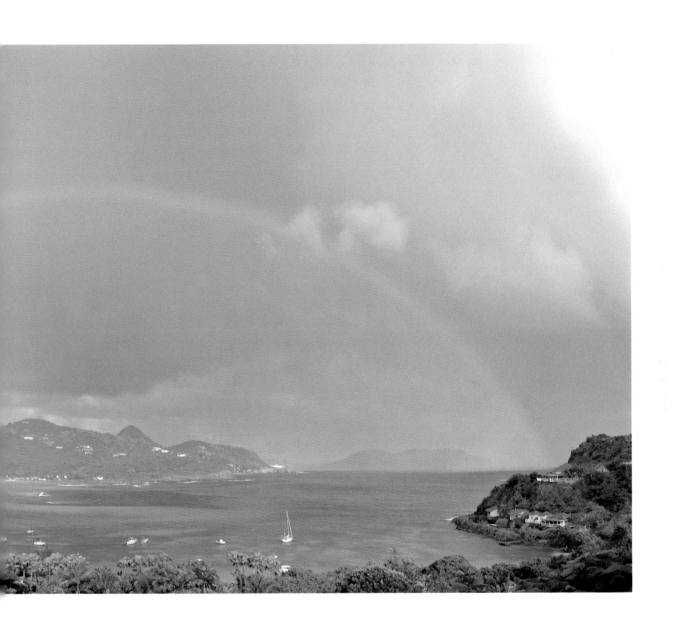

This image is a testament to the fact that simple compositions are best — a good photograph should reveal a simple subject or idea with as little clutter as possible. Paring your compositions down to the most basic elements begins as a mental process. You need to decide what your subject is and figure out the best way to focus attention on it. There is no question in this photo that the tree is the subject, but the photographer has taken it a step further by portraying it as a lonely figure. Its bare branches against a cloudy sky further accentuate this statement. Color may have contributed to the mood of this photo, but the choice to render it in black-and-white adds to the bleakness of the scene.

"SOLITARY TREE"
© Cheri Homaee
Richfield, Ohio
www.trinityconsult.com

Photographer's Comments

"I enjoy taking pictures of trees; I feel that they show human emotions. This particular tree is located in Valley Forge National Park. I was feeling very much alone at the time. My husband had moved to Cleveland, Ohio to open an office and my son was also away. When I saw this tree, it reminded me of how I felt at that moment, and it seemed as though it must also be feeling lonely in that field."

Technical Data

Canon EOS Digital Rebel SLR
Canon EF-S 18-55mm f/3.5-5.6 zoom lens set at 55mm
1/500 of a second at f/16
ISO 400
Natural light on an overcast day

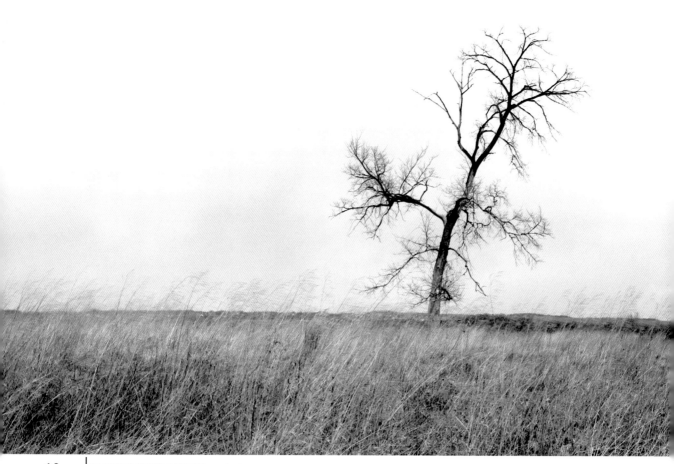

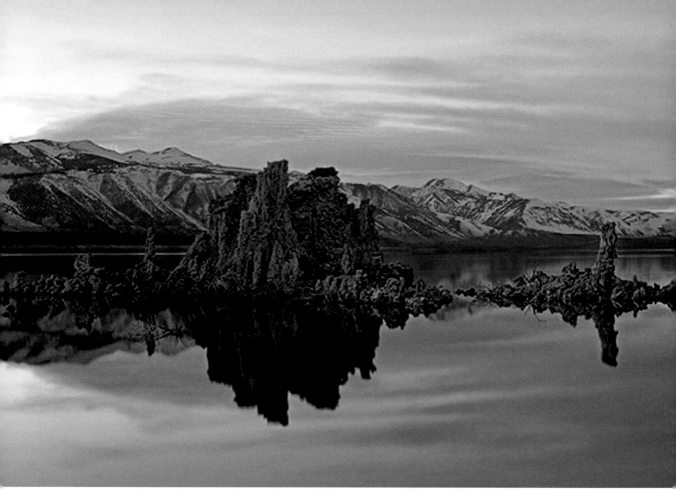

"Lake on Fire"
© Richard Aksland
Manteca, California

This image not only depicts a beautiful sunset, but the dramatic tufas that distinguish northern California's Mono Lake offer a sense of time and place. The fiery sky, as well as the lake's unique calcium-carbonate spires, is reflected in the calm water. The foreground elements would have been depicted beautifully as silhouettes, but this photographer was able to expose both the foreground and colorful sky equally well. This can be done by using a graduated neutral-density filter, which balances the exposure for the land and sky so that you'll get detail in both parts of the image.

Photographer's Comments
"I had been to Death Valley, California, to shoot some photos at the "Racetrack." This was my fourth trip and each time, the weather didn't cooperate. While I was returning home on Highway 395 I noticed the clouds accumulating over the mountains. I was just south of Mammoth Lakes and was heading toward Mono Lake. I thought, 'this sky could really pop when the sun sets.' I picked up my pace and the closer I got to Mono Lake, the better it looked. But I knew there was a chance I may not make it in time. As I pulled into the parking lot, the sky took on an orange glow. I quickly gathered up my gear and ran down to the shore. I set up my camera and tripod, and got three pictures as the sky turned this brilliant shade of red — then it was gone."

Technical Data
Camera 20D digital SLR
Canon EF 24-70mm f/2.8L lens
1.3 seconds at f/22
ISO 100
Tripod
Ambient light at sunset

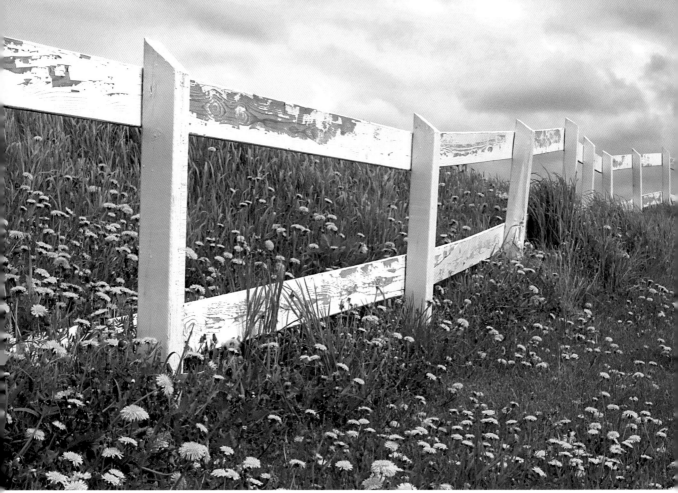

"FENCE LINE"
© *Wendy Stevenson*
Oxford Station, Ontario, Canada
www.intoitphotography.com

When shooting landscapes, look for an element that will lead the viewer's eye into the image. This fence creates a pleasant leading line that meanders across the frame. Lines can be used to create a sense of depth, or to lead a viewer's eye to the main subject. In this case, the fence is the subject, which leads our eye from the left to the right side of the picture. Other subjects for leading lines could be a road curving off into the distance, or the graceful S-curve of a river. When looking for lines to photograph, observe how they work with each other, since this interaction can add to the tension the photo captures. Here, the weathered fence provides contrast between the cloudy sky above and the grass and flowers in the lower portion of the frame.

Photographer's Comments

"I was driving around and almost headed home because of an impending storm rolling in. The skies were filled with heavy clouds when I came upon this rickety fence with a lot of peeling paint at a local golf course. It was on a dandelion-covered hill. The grass hadn't been mowed yet and the sky was very dramatic. I really liked the limited color palette, the different textures, and who doesn't like bright yellow dandelions?"

Technical Data

Canon EOS Digital Rebel XT
Canon EF 50mm lens
1/125 of a second at f/22
ISO 100
Afternoon light on a cloudy day

After a rainstorm, landscapes often look fresher, cleaner, and colors are deeper. If you are in an urban area, the best time to photograph city lights is often after a good downpour clears the air of smog and haze while leaving the city glistening. In rural areas barns often look redder and grass greener. And, on the ocean, colors are darker and richer providing a nice contrast against white caps and blue seas. Remember that because of the Rule of Thirds, objects are more pleasing to the eye when placed off center.

Photographer's Comments

"I was on the coast of Oregon for a week and took photos of this sea stack, affectionately called "the Dragon" by locals, every day. Of all the photos I took — sunsets, midday, and so on — this is my favorite. A downpour had just drenched the area and the skies were a deep blue in the late afternoon when I took this photo. The colors of the sand and rock were richer and more saturated after the rain gave everything a good soaking and I love the moody feeling that was captured."

Technical Data

Canon EOS Digital Rebel XT
Canon EF 28-80mm 1:3.5-5.6 zoom lens
1/2000 of a second at f/7.1
ISO 100
Natural light

"THE DRAGON"
© *Cricket Krengel*
Pendleton, Indiana

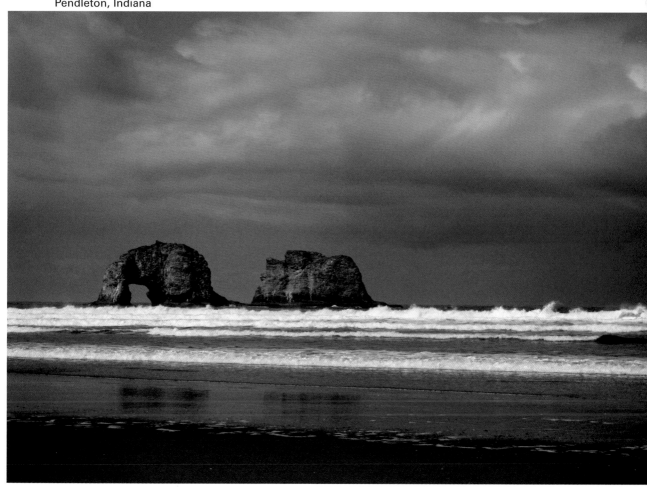

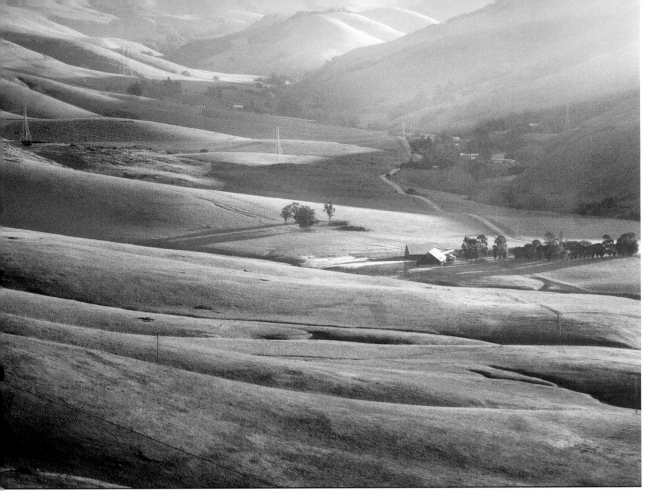

"East of Black Mountain"
© Eugene Langer
Sacramento, California

A successful landscape image should capture the mood and spirit of the place. Before shooting pictures, ask yourself what it is about the scene that appeals to you emotionally. Here, the photographer captured the serenity and cool greens of these rolling hills. A farmhouse in the right third of the photo also offers scale to the image. For me, the overall feeling of this pastoral scene is that of peacefulness and calm.

Photographer's Comments

"While I was in Morro Bay on a crisp March morning, I took a short hike up the hill behind the golf course (Black Mountain), set up my camera and tripod facing west, and like most photographers, began taking pictures of Morro Rock. I took a few shots and decided to add a filter. I turned to get the filter out of my camera bag and shazamm!

There it was — a quiet little farmhouse nestled among rolling hills of green and gold. The peace and tranquility of the scene might lead one to think of Kentucky or perhaps Tennessee. But I double-checked, and Morro Rock was still there. I thought, 'yep, this is California all right.' I think the most important aspect of this shot — as with many of my photos — is serendipity."

Technical Data
Canon EOS 20D digital SLR
Canon EF 28-135mm f/3.5-5.6 IS zoom lens
set at 90mm
Gitzo 2227 Tripod with Really Right Stuff Ball
Head D55
1/200 of a second at f/9.0
ISO 100
Early morning light

This beautifully composed scene makes a strong statement about winter. Color adds much to the mood of a photograph, and the blue tones of this image underscore the stark, dead-of-winter feeling in this scene. It's almost a monochromatic study of white and blue-gray. I also like the texture created by the delicate tree branches in the background, and the way that this texture is echoed in the reflection below. If you often visit an area with some regularity during all times of the year as the photographer does this one, consider photographing the same scene in fall, winter, spring, and summer to create a series of memorable images.

Photographer's Comments

"The place where this image was captured is not far from my home. It is an oasis of nature surrounded by the hustle and bustle of urban/suburban life. Because it is close by, I visit there often during the various seasons, as I find it to be a place of natural beauty and peace. What caught my eye were the tree limbs reaching out of the cold, semi-frozen water, as if frozen in time. I also liked the patterns of the reflections in the water, as well as the contrast of the tiny, fragile branches against the heavier, stark tree trunks. I altered the color to blue in Adobe Photoshop, as I felt that this was appropriate for the mood of the picture."

Technical Data

Sony Cybershot compact digital SLR
Built-in zoom lens set at 30mm
1/125 of a second at f/2.5
ISO 100
Available light

"REFLECTIONS IN BLUE"
© Marian Rubin
Montclair, New Jersey
http://marianrubin.photoworkshop.com

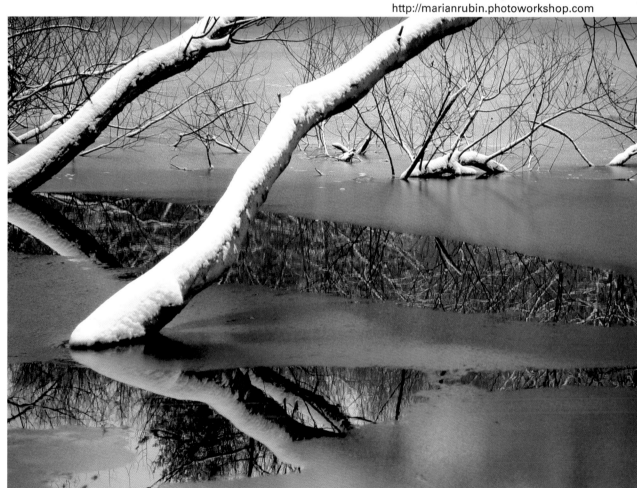

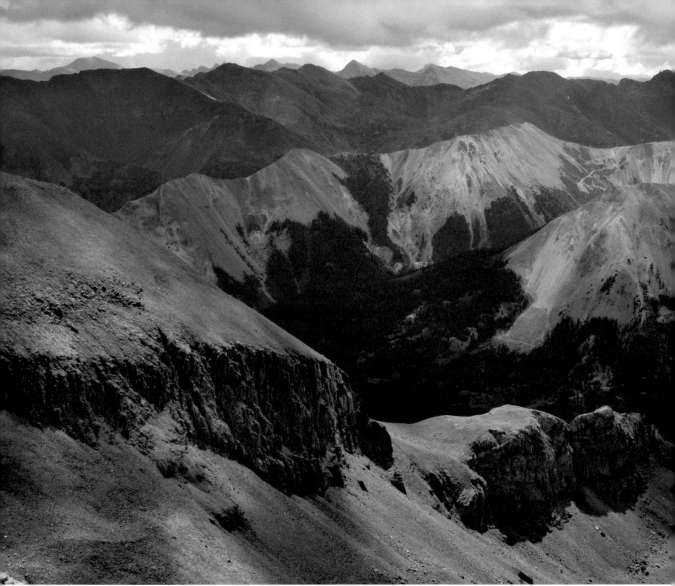

"RED MOUNTAINS, OURAY, COLORADO"
© *Ricardo Reitmeyer*
Wichita, Kansas
www.ricardoreitmeyer.com

This beautiful panoramic view of the Rocky Mountains in Colorado celebrates what's beautiful about mountain scenery — jagged peaks, a variety of terrain, and contrasting colors and layers that result from numerous minerals in the soil. This photographer successfully portrayed the majesty of these mountains, and the sun peeks through cloudy skies and makes for very dramatic light. When you encounter a situation such as this — one can only truly be represented by a panoramic image — keep the camera as level as possible (or use a tripod if you have one handy) and take multiple images, overlapping each slightly, to capture the entire expanse. You can stitch the images together using one of several different software programs.

Photographer's Comments

This scene says it all about mountain views. I took a long jeep tour up a very rough jeep trail with my family, led by a very professional local Ouray tour guide, to the top of Imogene Pass, hoping for this

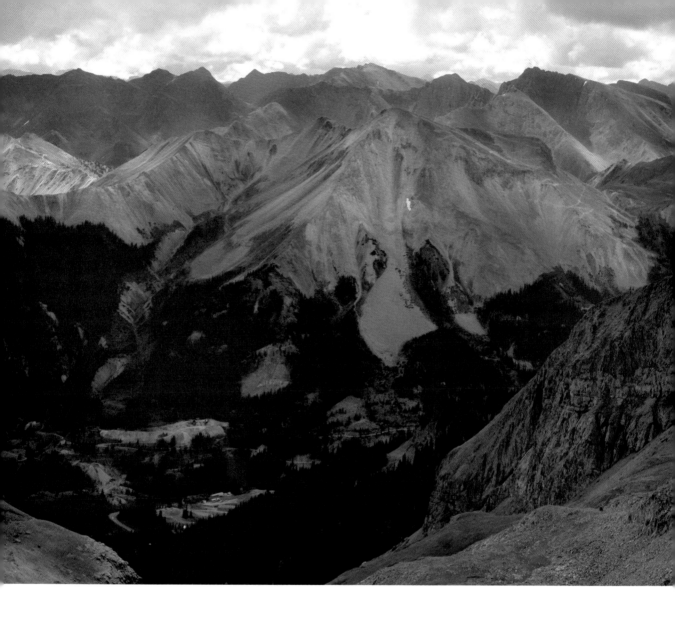

amazing view at the summit. Sometimes the challenge is just being there at the right time with the right conditions. The Red Mountains are rich in iron ore and have 'rusted' over the years, creating this marvelous coloration. It was a normal, hand-held series of two photos stitched together in Adobe Photoshop that created this beautiful panoramic scene of the mountain range from a 'cloud bottom' altitude. The incredible layering of the San Juan mountain peaks in the distance adds to the depth of the view."

Technical Data

Canon 20D digital SLR
Canon EF 28-105mm f/4.0-5.6 zoom lens
set at 38mm
1/125 of a second at f/8
ISO 100
Pattern metering mode
Natural light

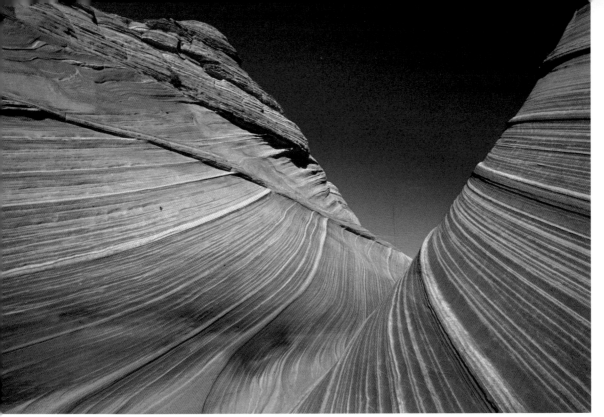

"The Wave"
© *Lynne Eodice*
Altadena, California

When planning to shoot in areas you have not been to or are not familiar with, it's best to do research in advance via travel guides or the Internet, and find out when is the best time of day (and time of year) to photograph your destination — especially in the desert southwest where this photo was taken. You may want to narrow down your shooting to a few specific ideas. For example, there's usually specific geographic features that identify a particular region, such as the rocky arches of Arches National Park, the stone pillars of Monument Valley, and the sweeping lines of 'The Wave' at Coyote Buttes North.

Photographer's Comments

"After seeing photos of 'The Wave' at Coyote Buttes North in the Vermillion Cliffs Wilderness, I was determined to go there one day. As this area is under the auspices of the Bureau of Land Management, visitation is limited and by permit only. My husband and I were finally able to get a permit for January about six months in advance. The weather was cloudy and dull as we drove to

southern Utah the day before our big excursion, and I was very disappointed. Rescheduling our visit wasn't an option. Thankfully, the sky was clearing when we awakened before dawn the next day. The low angle of the winter sun provided great illumination, and hiking to The Wave was an adventure as well. I was fascinated with the wavy texture of the rock, which gives this beautiful natural area its name. I was standing near the center of the relatively small area that comprises The Wave, and enjoyed photographing these lines leading toward the center of the frame, as well as the blue of the sky against red rocks."

Technical Data

Canon EOS-3 35mm SLR
Canon EF 28-105mm f/3.5-4.5 II zoom lens set at 28mm
Kodak Ektachrome E100VS transparency film
1/125 of a second at f/8
Tiffen circular polarizing filter
Bogen 3001 tripod
Canon RS-80N3 cable release

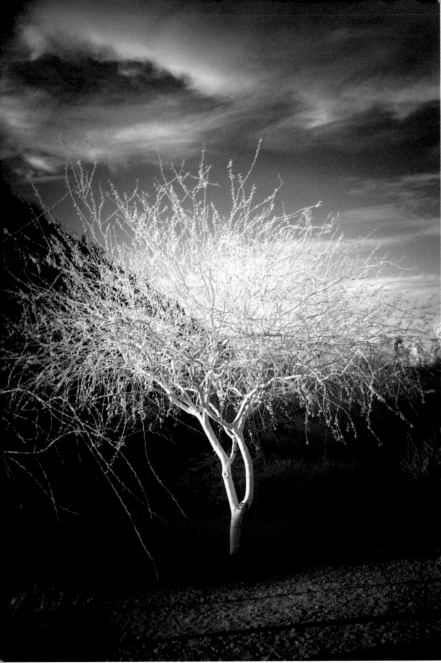

"Palo Verde #1"
© *Carol Watson*
Austin, Texas
http://carol_watson.photoworkshop.com

Black-and-white infrared images look as though they were taken in eerie moonlight, as evidenced by this ethereal scene. The illuminated white tree appears to be full of life, even though its leaves are gone and it looks as if it's in a dormant, wintertime mode. Vegetation becomes white because chlorophyll reflects a lot of infrared, but the sky darkens because it absorbs infrared rays. The late-afternoon light rakes across the land in this image, resulting in haunting feeling. The dark sky with the contrasting pale clouds are very dramatic too.

Photographer's Comments

"During a trip to Phoenix, Arizona, I accidentally happened upon an indigent cemetery gate and it glowed a warm, green color in the golden light of the day. I chose to photograph the tree using digital infrared techniques. The infrared-rendered contrast created by the surrounding dramatic sky symbolized the darkness often associated with death. Still, the bright green branches of the tree reflected a bright white warm glow, which captured a sense of hope and symbolized the fond memories of love that lives on forever after death."

Technical Data

Sony DSC-F828 Cybershot digital SLR
Carl Zeiss built-in zoom lens set at 10mm
1/30 of a second at f/2.2
ISO 160
Hoya R72 infrared filter
Natural late-afternoon light

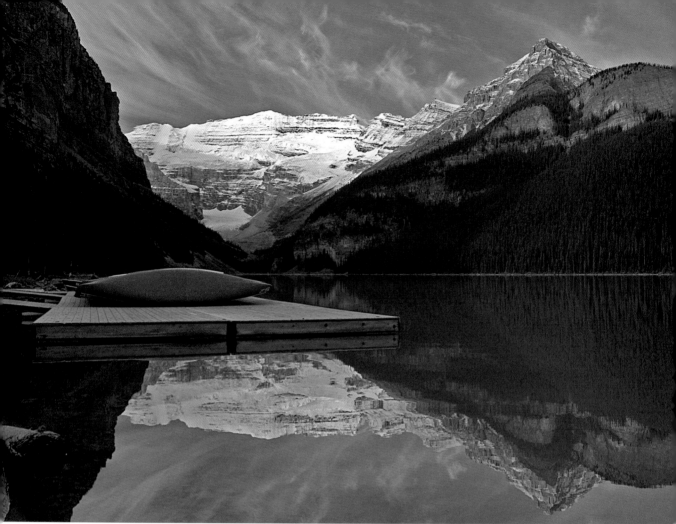

"MORNING LIGHT ON LAKE LOUISE"
© Michael Pickelsimer
Vancouver, BC, Canada
http://mpickelsimer.photoworkshop.com

On a calm day, any sizable body of water can become a large mirror, reflecting perfect images of the surroundings. Water is most reflective when the sun is low in the sky early in the morning (especially just after dawn), or late in the day. I really like the mountain grandeur reflected in this lake, and the peaceful feeling I get by looking at this photograph. The canoe on the left side of the image offers a sense of scale and indicates the magnitude of the majestic Canadian Rockies in the background. It also adds a bit of unexpected bright color to the otherwise muted hues of nature.

Photographer's Comments

"I wanted to capture the splendor of Lake Louise at sunrise. The image was taken early on a clear, cold morning when there wasn't a breath of wind. The entire area was incredibly quiet and still, which allowed the mirrored surface of the lake to frame the composition. The morning sun provided the perfect backdrop for the frosty deck as the warm light began to bathe the glacier."

Technical Data

Canon EOS 20D digital SLR
Canon 18mm wide-angle lens
1/60 of a second at f/5.6
ISO 100
Circular Polarizing Filter
Natural light at sunrise

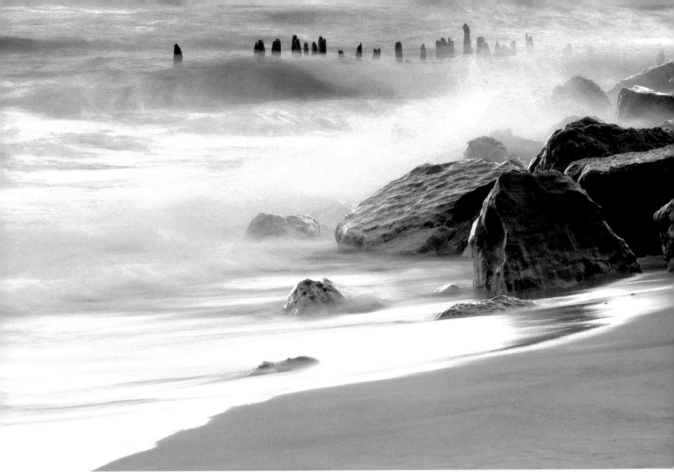

"On the Rocks"
©Tom McCall
Saint Joseph, Michigan
www.phototown.com

Brief time exposures freeze the action of the waves, and can accentuate the power of the sea. On the other hand, long exposures ranging from 1/4 to several seconds impart a smooth, glossy sheen to the shore and rocks. I really like the photographer's choice of shooting this scene with a one-second exposure, which creates a beautiful impressionistic blur. The softness of the water also provides a very effective contrast to the jumbled rocks and the pilings beyond.

Photographer's Comments

"Taken just before sunset, it was seeing the interplay of the quality of light with the natural elements of wind, waves, sand and rocks, the old jagged wooden pilings, and the light and shadows all coming together with a slow shutter speed and small aperture to capture an ethereal effect. I watched the crashing waves wash over the rocks with the wind catching the spray. The water quickly returned to the lake, creating fleeting moments that revealed reflections of color from the rocks and sky. The long exposure of the spray and waves creates a mist that floats like a blanket of fog over the water. I feel fortunate to have been able to photograph it when I did. Soon afterward, storms and strong waves removed all the sand, and this location has a totally different appearance."

Technical Data

Canon EOS 30D digital SLR
Canon EF 75-300mm f/4-5.6 zoom lens
set at approximately 200mm
1.6 seconds at f/36
ISO 100
Natural light late in the day

Images of the open highway always inspire me to take a road trip. The lonely road in this photo leads the eye into the frame, and I want to travel on it to see what's beyond the vanishing point. The storm clouds add a lot of drama — this scene would be somewhat mundane if it were shot in the middle of the day in sunny, calm weather conditions. The grass blowing in the wind warns of a storm that's either approaching or receding.

Photographer's Comments

"This photo was taken in Connemara, Ireland, on the road going to Clifden by the seaside. I was there with my students (I'm a teacher) and asked the bus driver to stop the bus for a while on that deserted road. The sky was heavy from the rain, but it started to clear up and it was very windy. I took this picture because the landscape was amazingly beautiful and wild, and that deserted road gave a feeling of endlessness to the scene. I've always like taking pictures of deserted roads in nature because they represents freedom, adventure, mystery — and somehow — the loneliness of mankind among nature."

Technical Data

Fujifilm FinePix 7000 digital compact camera
Super EBC Fujinon lens with an optical zoom
1/180 of a second at f/2.8
ISO 200
Natural light
Sepia-toned the image in Adobe Photoshop

"Connemara"
© Sandrine Huet
Juvisy, France
http://cendrynneh.photoworkshop.com

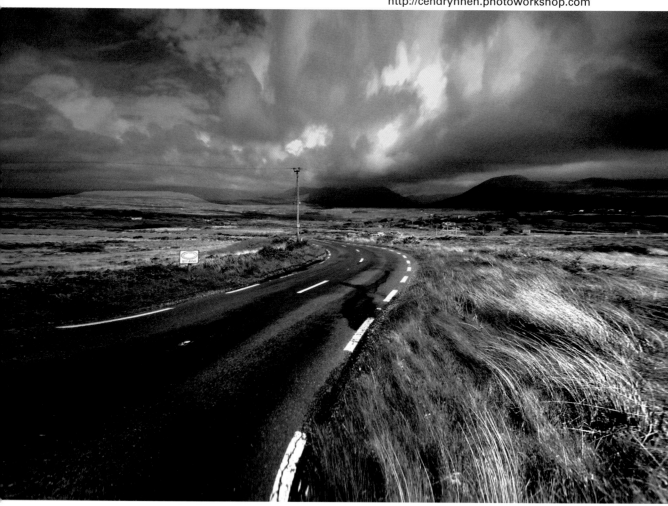

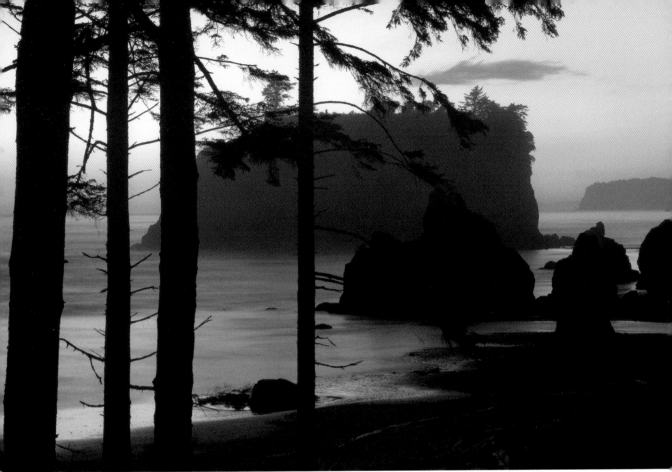

"SUNSET AT RUBY BEACH"
© *Doug Bascom*
Bellingham, Washington
www.dbascomphoto.com

You can create some beautiful images of rocky shorelines, such as those found along the Pacific Northwest. A wide-angle lens allows you to capture a lovely array of dramatic standing rocks as the water gently comes to shore during low tide. This image, photographed very late in the day, features soft, pastel skies as well as silhouetted rocks and trees. A long exposure gives the appearance of water softly enveloping the rocks, rather than a brief exposure of crashing waves.

Photographer's Comments

"It was the end of a full day of taking pictures on the Olympic Peninsula in Washington, and I stopped to look back at the area from which I had come. I was struck by the beauty of the light and the design elements that the trees provided."

Technical Data

Canon EOS 20D digital SLR
Canon EF 24-85mm f/3.5-4.5 zoom lens
10 seconds at f/22
ISO 100
Natural light late in the day

A beautiful waterfall is always a visual treat for nature photographers, and the cool blue color palette in this photo is especially soothing. On a hot day, you'd want to jump right in. As with several other water images in this section that utilize long time exposures, you should select a slow ISO (100) and set your camera up on a sturdy tripod. To render the water with a soft look, you should use a shutter speed of one second or longer. Using a neutral-density filter cuts down on the light entering your lens in bright-lighting conditions, which allows you to use longer exposures.

Photographer's Comments

"This photo was taken at Westfield Falls near our former home in Middletown, Connecticut. We lived there for 18 years and drove by but never had a chance to visit the falls. This is one of those places you take for granted because you live so close and think that you'll get there, but never get the chance to stop. We have since moved away and often speak of having missed the opportunity to visit this landmark. I stopped one day and took this picture so I could show my wife what we had missed for so many years. Now we take the time to stop and visit the falls to watch the water on a regular basis."

Technical Data

Canon EOS 20D digital SLR
Canon EF 28-135mm f/3.5-5.6 IS zoom lens set at 80mm
1 second at f/10
ISO 200
Cokin #80 cooling filter and circular polarizing filter

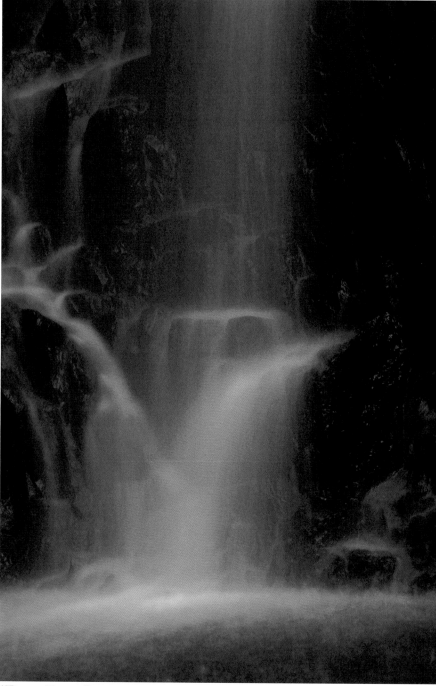

"BLUE FALLS"
© *Steven D. Handley*
Meriden, Connecticut

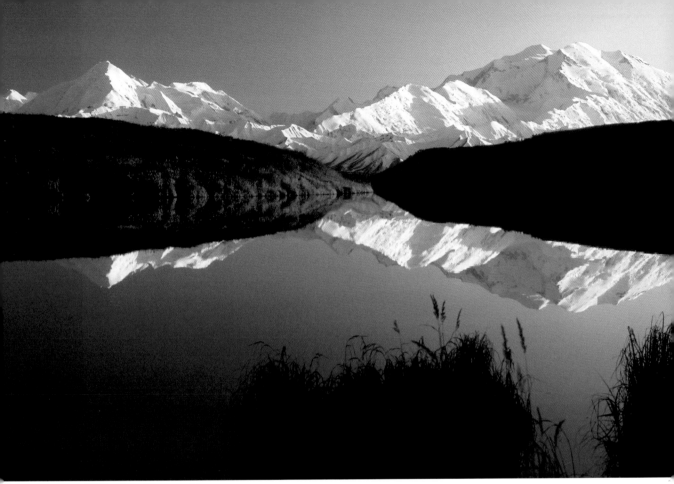

"MT. MCKINLEY"
© *Victor Van Keuren*
Bar Harbor, Maine
http://victorvankeuren.photoworkshop.com

The low light of dusk and dawn give mountain images depth, texture and three-dimensional form. This scene would not have been nearly as dramatic if it had been photographed at midday. A polarizing filter deepens blue skies on a sunny day, and can accentuate reflections in water or other reflective surfaces. The calm conditions rendered this mountain lake as a huge mirror that reflects the mountain majesty surrounding it. And at very high altitudes late in the day, you may experience a special phenomenon known as "alpenglow." This occurs when blue light is scattered by the atmosphere and warm light briefly infuses the peaks with a radiant glow.

Photographer's Comments
"This shot was taken while I was traveling along the Denali Park Road in Alaska. As sunset approached, I found myself in an area dotted with tundra ponds. It was an unusually clear day with no wind, which made for perfect reflections. I shot about 150 exposures in 90 minutes with various degrees of alpenglow on the mountain. After dark, the northern lights came out for an incredible display. It was three hours of visual feasting!"

Technical Data
Nikon F4 35mm SLR
50mm f/1.2 Nikkor lens
Kodak Kodachrome ISO 64 film
1/60 of a second at f/22
Polarizing filter
Tripod

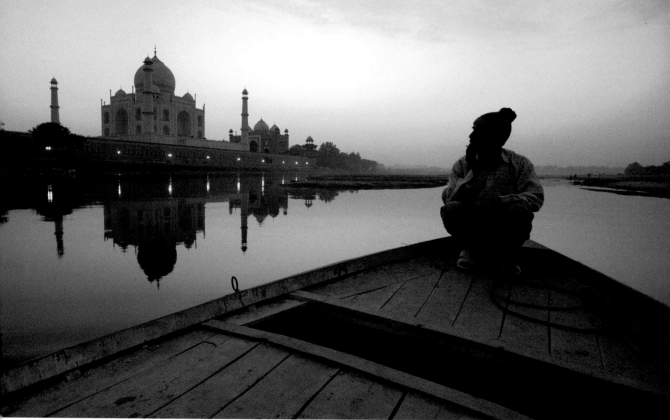

"TAJ MAHAL–RIVER VIEW"
© Marcin Kizior
Dublin, Ohio
www.marcinkizior.com

Photographing people in distant lands adds interest and a human element to often-photographed scenes. The owner of this boat gazed off in the direction of the Taj Mahal, providing the photographer with the opportunity to capture an outstanding travel image. Many people like to take vacation pictures of people smiling stiffly at the camera, but you often get better results if you shoot more candidly. Take pictures of people enjoying the scenery or participating in an activity. Also, unless you really need to use flash in dimly lit scenes, try to shoot with the existing light as the photographer did here. Nothing ruins the spontaneity of a moment like an electronic flash being fired.

Photographer's Comments

"I had seen a lot of photos of the Taj Mahal, and most of them were similar. I wanted to get some unique images, but didn't have anything specific in mind. I knew there was a way to photograph this icon from the outside, and found someone to take me there by boat. It was getting late and the sunset was nearly over, so I wanted to get to the other side of the river ASAP. I inquired about the price, but because it was getting dark and the guy saw all my photo gear, there wasn't any room for negotiation. I adjusted my camera settings before I got aboard, hoping for a shot from the river. I shot one image of the Taj Mahal alone, and turned around to see the owner of the boat looking at the Taj Mahal. There was no time to check the settings on my camera — just focus and shoot — and then the moment was gone."

Technical Data

Canon EOS 5D digital SLR
Canon EF 16-35mm f/2.8L zoom lens
set at 16mm
1/60 of a second at f/4.5
ISO 1000
Ambient light at dusk

"Beach Outlet"
© David Amos
Woodcroft,
Australia
www.davidamos
photography.
com.au

Shooting pictures at the beach is always fun, but presents a special set of challenges. Shot with a wide-angle lens, this scene offers a variety of textures ranging from the rocks along the coast to the reflections in the water, and finally, the dark, brooding sky. This photo also has leading lines that take the viewer's eye to the center of the picture. The colors in the scene are saturated and rich, which is one advantage of shooting on a cloudy day.

Photographer's Comments

On a weekend away with my wife, I had no plans to photograph any particular scene. While walking along the beach, I came across this view of a storm water outlet into the ocean. I liked the way the lines were converging, as well as the color contrast between the land and dark clouds in the distance. Also, the reflection in the water is always an attraction for me when shooting landscapes. I shot two photos with different exposures to keep the clouds in detail and the dark foreground. I combined the two exposures for a wider dynamic range in the scene."

Technical Data

Canon 5D digital SLR
Tokina 19-35mm zoom lens
1/125 of a second at f/5.6
ISO 100
Natural light

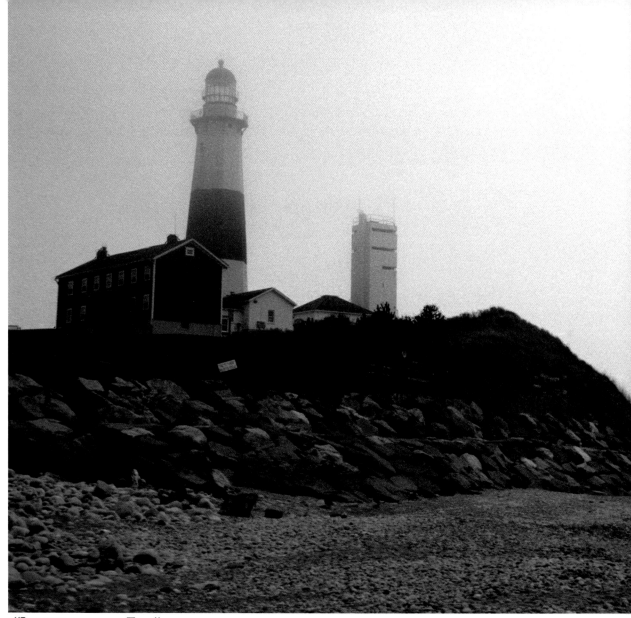

"LIGHTHOUSE IN FOG"
© *Ricardo de Masi*
East Northport, New York
www.rdmphotography.com

Photographic subjects often take on a diffuse, gauzy quality during foggy conditions, and hues are muted. You can simplify your images in fog, as distant objects fade off into the pale background. Depending on how heavy the fog is, you'll get varying results. In this image, the fog appears to be a light morning mist as opposed to a thick cloak of haze. The lighthouse and the dark foreground stand out nicely against the light sky, and the mood is further emphasized by the image's sepia tone.

Photographer's Comments

"On my first wedding anniversary, my wife and I decided to spend a few days out on the east end of Long Island to sightsee and enjoy the island before summer began. One morning, we went to

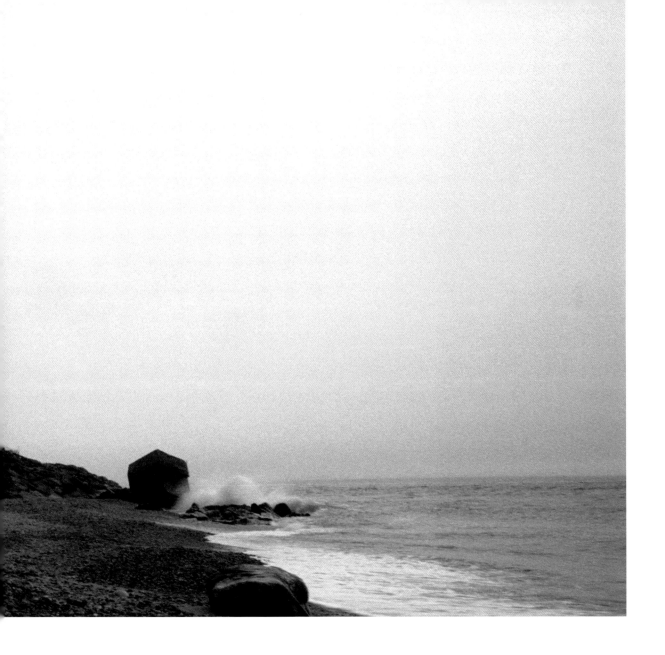

Montauk Lighthouse to get what every Long Island photographer needs in his/her portfolio—pictures of the Montauk Lighthouse. Foggy weather was not what I had hoped for, but once we got to the beach, I saw the lighthouse standing proud in the fog. This was something I hadn't seen before, as this lighthouse is usually photographed on clear, sunny days. So I shot several rolls of film and ended up with this one."

Technical Data

Nikon N70 35mm SLR
Nikkor 12-120mm zoom lens
Ilford Pan F ISO 50 black-and-white film set at ISO 40
Exposure unrecorded
Tripod
Natural light
Sepia tone added in Adobe Photoshop

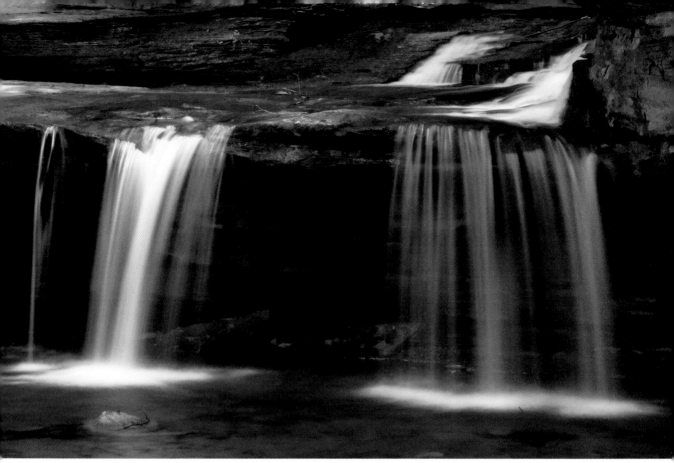

"Waterfalls at Old Man's Cave"
© Daniel Walczyk
Wrightsville, Pennsylvania
http://wystudios.photoworkshop.com

Moving water has a very soothing effect on people, so it's no wonder that rivers, streams and waterfalls are among the favorite subjects of landscape photographers. To get the effect of a silky, flowing veil that you see here, put your camera on a tripod and use a long time exposure. The amount of time it takes to blur the water varies, but generally, use exposures ranging from 1/4 second to four seconds.

Photographer's Comments

"After receiving word from the North American Nature Photographer's Association about the Friends of Hocking Hills State Park 'Shoot the Hills' photo competition, my partner and I decided to participate. Over 150 photographers competed in five categories in each division:

abstract, flora, human interest, landscape, and wildlife. I shot this image to see if I could satisfactorily achieve the wispy, ethereal look that's often seen in images of waterfalls. In the end, I didn't submit this photo to the competition, because I thought there would be as many waterfall images as photographers competing. As it turned out, there were only a handful of moving water images and two received honorable mentions."

Technical Data

Canon EOS 20D digital SLR
Canon EF-S 17-85mm IS zoom lens set at 85mm
3.2 seconds at f/32
Available light in forested area

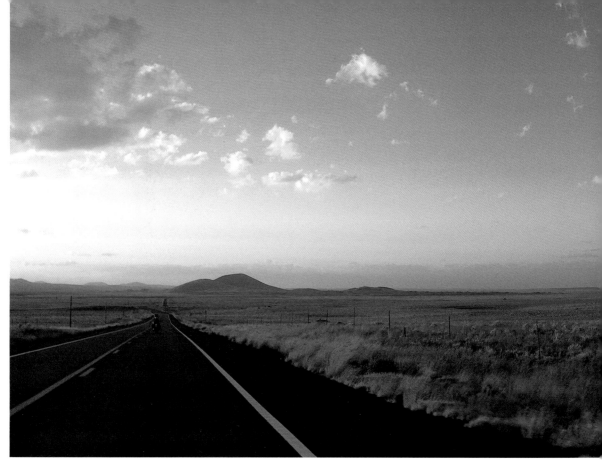

"THE ROAD #4"
© Susan Duckworth
Waverly, Pennsylvania
http://susan_duckworth.photoworkshop.com

There's nothing like an image of an open highway, which always inspires me to take a road trip. The leading lines of this road take our eye to the horizon line and the sun's last glow. The photographer has also wisely placed the horizon low in the frame, which adds emphasis to the beautiful sky and sunset-illuminated clouds. But no matter where you decide to place the horizon in a scene, be sure to keep it level. There are few things more distracting than an accidentally sloped horizon line in landscape photos.

Photographer's Comments

"I took this photo from the back of my husband's BMW K1200RS while we were on a cross-country trip from Pennsylvania to California. He was going to participate in an annual BMW-sponsored charity ride for St. Francis Children's Hospital's Footsteps program. We had just stopped in New Mexico to pick up a friend. Toward the end of the day, as we headed west through New Mexico toward Arizona, I saw this scene and snapped a photo. Our friend liked the image so much, he had it blown up into a mural and it's on the wall in one of his BMW dealerships in Albuquerque, New Mexico. I used the Casio because I knew it would be a long day with possible inclement weather, and I didn't want my Canon camera out in the open. But the little Casio point-and-shoot did a nice job!"

Technical Data

Casio EXZ750 compact digital camera
Speed priority setting

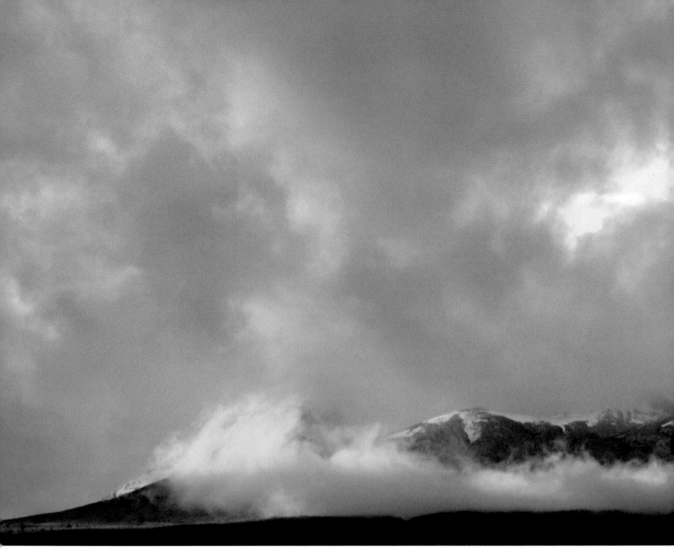

"Blue Sky"
© *Richard Roberts*
Mesa, Arizona

This photographer used a wide-angle lens to capture this beautiful panoramic view of the Andes Mountains. Stormy weather adds atmosphere to landscape scenes, and the early morning light on these clouds is very striking. If you're willing to brave the elements during inclement weather conditions, your efforts will be greatly rewarded, as was the case with this image. As a storm approaches or departs, cloud formations can be very dramatic. Whatever you do, however, make sure to protect your camera from the elements by keeping it under your raincoat or umbrella.

Photographer's Comments

"This is a very early morning view of the Andes Mountains. It was taken while I was on a fly-fishing trip to the Estancia El Palenque, which is at the southern end of what's known as Patagonia's

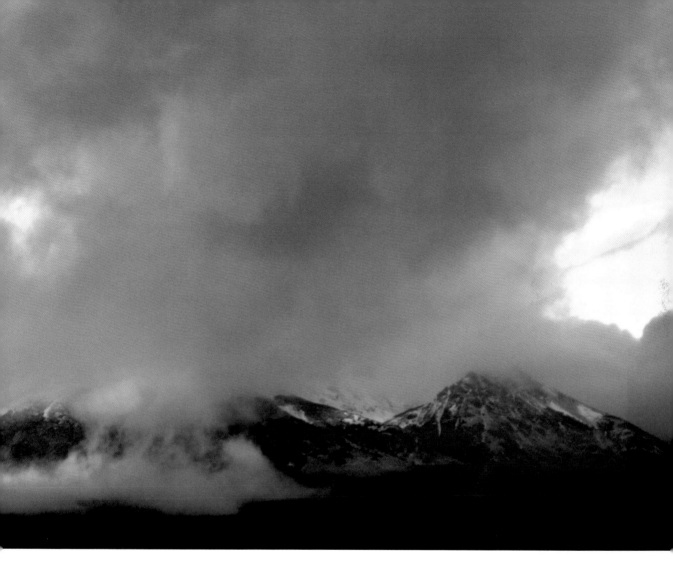

"lake and river district." The weather was stormy at intervals, and while the others were still sleeping, I got up and went outside to watch the clouds and the light on the mountains. It was my first trip to the Patagonia area of Argentina, and I was in awe being in the presence of the Andes. To say the least, it was a memorable morning."

Technical Data

Fujifilm FinePix S2 Pro digital SLR
Tamron 28-75mm f/2.8 zoom lens
1/180 of a second at f/2.8
Camera was handheld
Natural light

A prediction of rain doesn't always mean that you need to put your camera away — stormy skies often present dramatic photo opportunities. You'll get the best results by photographing storms as they approach or while they're clearing, as you'll have the opportunity to capture beautiful lighting conditions. The rays of sunlight piercing through the clouds are what make this image spectacular. The photographer also succeeded in accentuating the vastness of the sky in proportion to the land below.

Photographer's Comments

"This shot was taken during an early morning in October on the northern coast of Kri Island, Raja Ampat, Papua Barat, Indonesia. The Raja Ampat Islands are among the most fantastic and interesting skin diving locations in the world. When I wasn't diving in the ocean, I discovered that the Raja Ampat sky is the most beautiful one I've ever seen, with its dramatic light, nature's colors — and the clouds! I fell in love with them."

Technical Data

Canon EOS 1D Mark II N digital SLR
Canon EF 24-70mm f/2.8 L zoom lens
set at 32mm
1/6400 of a second at f/2.8
ISO 100
Natural light

"STORMY EARLY MORNING"
© *Carlo Ottaviano Casana*
Milano, Italy
www.photo.net/photos/cocasana

PART 2

ANIMAL AND WILDLIFE PHOTOGRAPHY

Photographing animals and wildlife — whether it's a domestic cat, a lion in the wilderness, or an iguana — requires patience, timing, and skill. It's difficult to pose them and they won't sit still for long. However, you can get some great shots by learning how to anticipate their behavior. The first thing that you want to decide is what you want to say about the animal you're photographing. Is it the lovable face of your puppy, the protective nature of a mother hen with her baby chicks, or the regal look of a mountain goat perched on a cliff? Whatever it is that you want to capture, look for the lighting and composition that enables you to emphasize this desired quality. And, you don't always have to travel to exotic locales like the Serengeti Plains of Africa to find good photo opportunities. Animal subjects can be found as close as your own backyard or the local zoo.

"LUCAS"
© Jennifer Chipperfield
Alberta, Canada
www.chipperfieldphotography.com

As mentioned earlier, getting down on the animal's level tells us something about their world. The photographer successfully portrayed innocence as well as a bit of "little lost puppy" in this photo. I also like the mood that's created by the sepia tone. Another element that makes this image strong is the use of selective focus, which creates a somewhat shallow depth of field and renders the railroad tracks out-of-focus behind the dog. This technique further focuses our attention on the appealing subject.

Photographer's Comments

"Lucas is my sister-in-law and nephew's dog, and he was absolutely adorable as a puppy. I always felt that there was a sadness in his face and in his eyes. For me, the train tracks in the rain summed up the melancholy "lost puppy" look that I saw in him. The deeper brown tone of the final image keeps the feeling warmer and friendlier, so as not to induce a sense of isolation. I've often come back to this image when I'm looking for inspiration for a current photo session, as it has so many elements that I am drawn to."

Technical Data

Fujifilm FinePix S2 Pro digital SLR
24-120mm VR Nikkor lens set at 39mm
1/25 of a second at f/4
ISO 160
Ambient light on a rainy day

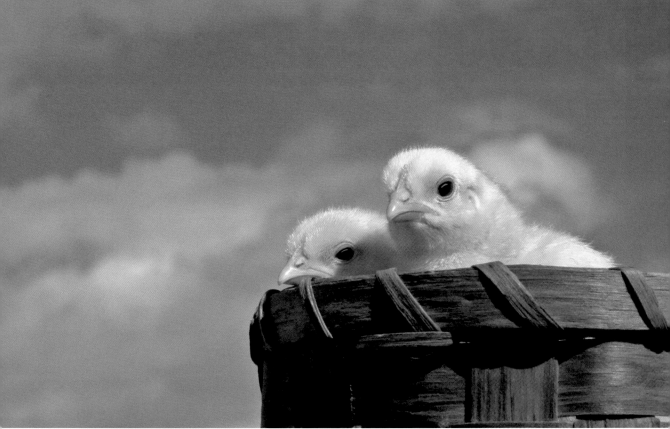

"COUPLE OF CHICKS"

© *Wendy Stevenson*
Ontario, Canada
www.intoitphotography.com

Be careful when dealing with such tiny, fragile sub-jects — the photographer was very sensitive to this issue. Small animals like this may be dwarfed if pho-tographed from above (unless you want to accentu-ate their tiny size in a big world). This photographer chose to photograph these adorable baby chicks from slightly below their level to reveal the blue sky behind them. This creates a beautiful background, in addition to providing a perfect complimentary color to the bright yellow subjects. They are framed in the right lower third of the image, which is a good example for the Rule of Thirds, in which sub-jects should be located off-center and in one of the thirds of a frame for added emphasis.

Photographer's Comments

"I was at a friend's house when she received a call from the local hatchery that her baby chicks were ready to pick up (she lives on a large family farm), so we set off to pick up her 150 chicks. On the way, I asked whether I could photograph them as they're so cute during their first week, and she said 'of course.' I immediately thought of a couple of scenarios in which we could photograph them, keeping in mind that it would have to be quick, as they are very frag-ile at a day old and can get cold without a warming lamp. As we drove home listening to the 'peep, peep' in the van, I discovered that I had a basket between the front seats, and decided that it would be in one of my shots. When we returned, we plopped three into the basket and I asked my friend to hold them up resting on her fence. This way, I had the beautiful sky as a background, which I thought would set off the yellow color of the chicks very nicely. One was just too sleepy to stand up, so I took a few pictures of the two chicks that you see here."

Technical Data

Canon EOS Digital Rebel
Canon EF 50mm f/1.8L lens
1/500 of a second at f/14
ISO 100
Natural light

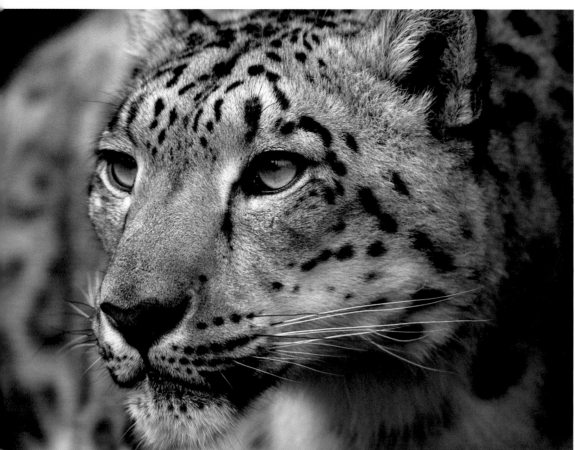

"Snow Leopard"
© Linda Wright
Wales, UK
www.lookingup.me.uk

Wildlife refuges offer great photo opportunities, such as the one where this beautiful leopard was photographed. At many of these areas, you can work fairly close to your subject, and you are rewarded with wonderful images. The photographer used a long telephoto lens and a shallow depth of field to get this very captivating, tight portrait. The use of black-and-white accentuates the patterns and texture of the leopard's fur. In a situation like this, you must be as still as possible and look through your viewfinder constantly to capture the right moments. The lighting was rather dim, so the photographer made the wise choice of shooting at a fairly fast ISO setting.

Photographer's Comments

"I had been inspired by a wildlife documentary program about snow leopards and wanted to photograph one. When a big cat sanctuary gave me the opportunity, I seized the moment. Most of the cats at the sanctuary are either endangered or part of a captive breeding program. It's not open to the general public, and photographers may work quite close to the animals as long as they are respectful and quiet. The time that I spent with this most beautiful cat was magical. The leopard was in the shade and it was a real challenge to get enough depth of field as well as a fast-enough shutter speed for such a long lens. In order to get this angle, I had to get very low to the ground and most of the time I was holding my breath. But it was worth the effort!"

Technical Data

Canon EOS 5D digital SLR
Sigma 50-500mm zoom lens set at 417mm
1/400 of a second at f/8
ISO 640
Available Light

This image of a turtle appears to have been taken while the photographer was deep sea diving, but it was actually photographed through the glass at an aquarium. You won't have to get wet or use underwater housing on your camera in this situation, but you do have to face the challenges of dim lighting conditions and thick glass. Whatever you do, avoid using on-camera flash through glass; you'll only get a picture of the reflection of your flash. This photographer used a fast ISO instead, and as a result, the light is much more natural looking than it would have been had she used flash. She also froze the motion of the turtle as it swam through the water. The colors in this photo are vivid, and her macro lens reveals the patterns of this turtle in sharp detail.

"Green Sea Turtle"
© Marilyn Hunt
Louisville, Colorado
www.marilynhunt.com

Photographer's Comments

"I shot this photo indoors at the Maui Ocean Center in Hawaii. We had been snorkeling in the ocean with green sea turtles, but the water there was fairly murky. I was delighted to get a clear, crisp look at this large and graceful creature. A little boy was as delighted as I was, and walked right in front of the camera as I pressed the shutter button. Thanks to Photoshop, I could remove the top of his head from the photograph!"

Technical Data

Canon EOS 5D digital SLR
Canon EF 100mm f/2.8 macro lens
1/125 of a second at f/3.5
ISO 1600
Minor contrast and saturation adjustments made in Adobe Photoshop

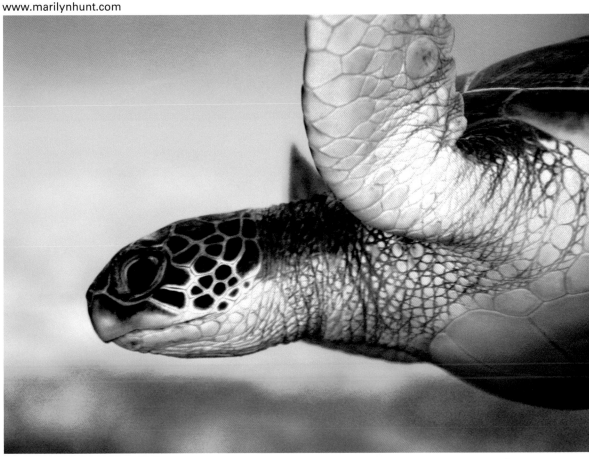

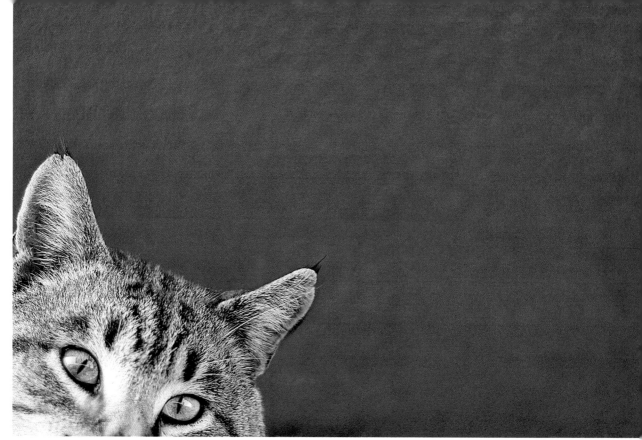

"BEGGAR"
© Susi Lawson
Wytheville, Virginia
http://susilawsonphotography.biz
http://susi-lawson.photoworkshop.com

When photographing a subject, photographers don't often consider placing it in the lower corner of the frame. This image offers an element of surprise by doing this. The photographer also got down on the animal's level, which is always advisable for photographing animals. She comments on the cat's amazing eyes, and her close position and red background sets the cat's blue eyes off beautifully. Graphically, this image is very satisfying, and the photographer was very successful in emphasizing what appealed to her about the animal in a dramatic way. The red background offers a large area of negative space, which can also be useful in an advertisement or magazine cover for titles and other blurbs.

Photographer's Comments

"My daughter and I went out for a drive to take pictures. We first stopped at a fast-food restaurant's drive-through window for a snack, and this large stray Tomcat came up to my window meowing quite loudly for food. I grabbed my camera and snapped this picture of him. He had the most amazing eyes!"

Technical Data

Canon EOS 20D digital SLR
Canon EF 50mm f/1.8 II lens
Aperture Priority mode 1/320 of a second at f/2.0
ISO 800
Natural Light

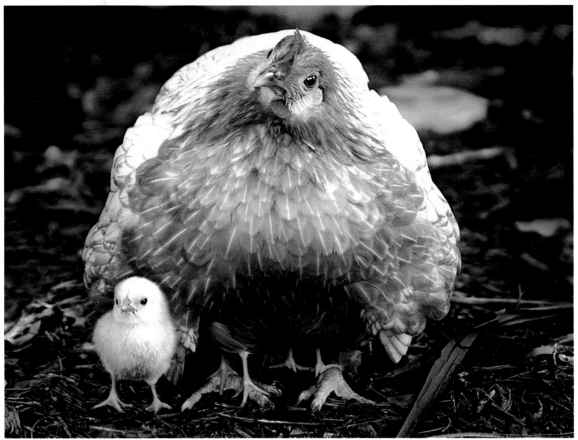

"Baby Drumsticks"
© C.J. Groth
Key West, Florida
www.keywestphotos.com

Some of the best photographs of animals are taken at their level, which sometimes means lying on the ground. If this photographer had photographed the mother hen from a standing position, she wouldn't have been able to capture the chicks' feet underneath, which is part of the charm of this image. One chick stands alongside her mother, which adds interest to the composition. Using a telephoto lens to photograph wildlife (particularly in the case where a mother is protecting her young) allows you to keep a more comfortable distance, and the subject is framed very nicely. The ground covering gives us a sense of place, but other visual distractions are kept at a minimum.

Photographer's Comments

"Key West is well known for its gypsy chickens that wander the streets. I spotted this mama hen with her brand-new brood of chicks while at my favorite coffee shop on Key West's main street.

The chicks had just hatched — they were still egg-shaped and very cute.

I was actually lying on the sidewalk to get this photo. Most of the pictures from this shoot are close-ups of the little chicks and mama, but after I'd already taken many photos, the mama gave some sort of signal to the little ones, fluffed herself up, and most of the chicks ran over and squeezed under her. If I had not already been lying on the ground, I would never have captured this unique image. I also love the pattern of mama's feathers and the look in her eye as she glared at me."

Technical Data

Canon EOS 10D digital SLR
Canon EF 28-135mm f/3.5-5.6 IS zoom lens
set to 135 mm
1/125 of a second at f/5.6
ISO 400
Ambient light in open shade

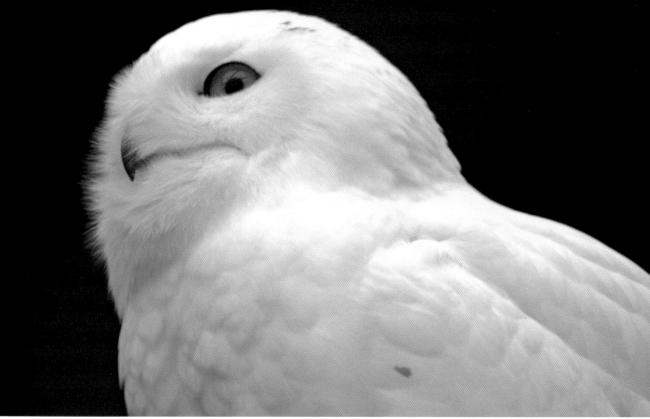

"SNOWY OWL"
© Cricket Krengel
Pendleton, Indiana

Because owls are nocturnal and reclusive, they pose a real challenge for those who want to photograph them. But knowing where to find them — in this case, a raptor preserve — greatly increases your chances. The photographer succeeded in zooming in for a noble portrait of this owl, in addition to paring the composition down to very simple elements. The softly lit white owl against a dark background is very dramatic, and as the photographer used a low vantage point, the owl appears even more regal. A long telephoto lens is imperative, even when shooting pictures at a game reserve where animals are somewhat more tolerant of human interaction.

Photographer's Comments

"I'm a fan of birds of prey; they are as mysterious as they are beautiful. And the likelihood of catching a snowy owl in its natural habitat isn't realistic for most photographers, but that doesn't mean that I can't get great shots of captive birds. It's really a matter of making unwanted elements disappear. I was visiting a favorite raptor center in Ontario, Canada, and this snowy owl was perched out in the open of its enclosure. However, there was a chain link fence between me and the bird. Rather than risk scaring the bird, I opted for stepping away from the fence, and adjusted the focus until the fence virtually vanished from my shot. I was still able to get a decent close-up, capturing the skeptical and watchful gaze of this magnificent bird."

Technical Data

Canon EOS Digital Rebel XT
Canon EF 75-300mm f/4-5.6 III telephoto
zoom lens
1/50 of a second at f/5.6
ISO 200
Natural light

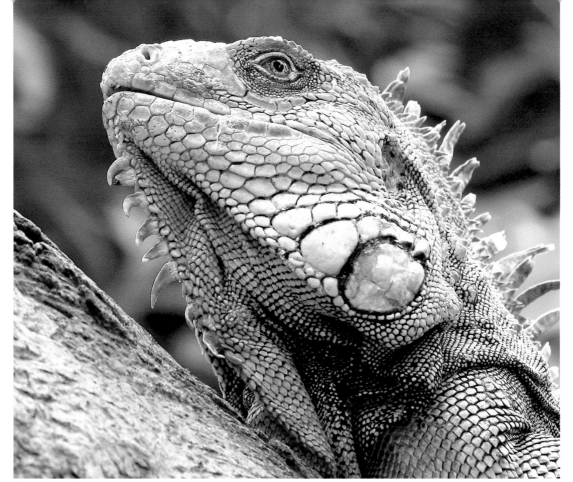

"IGUANA"
© *Marc Safran, MD*
Liverpool, New York

Generally, wild animals are skittish and flee if they sense you trying to encroach on their territory. But in some parts of the world — like the Galapagos Islands — the wildlife is accustomed to human interaction and is more approachable. This photographer also experienced this in a park in Ecuador, where the Iguanas seemed to not only be used to people, but downright friendly. In some cases, wild creatures accept your presence if you don't appear to be threatening. Just keep quick movements to a minimum and approach them very slowly. A good telephoto lens helps you keep a comfortable distance. And, like portraits of people, close-ups of animals are most flattering in the soft light of open shade or an overcast day.

Photographer's Comments

"I am an American ophthalmologist who had just finished a charitable mission in northern Ecuador to perform free eye surgery on children in that region of the country. We were returning to the U.S., and were in the city of Guayaquil prior to our departure. Just adjacent to our downtown hotel was a place called 'Iguana Park.' There, in and around the many lawns, were dozens and dozens of huge Iguanas. Kids in the park were playing with these creatures as if they were dogs and cats. This particular Iguana, probably four feet in length, was stretching languidly on a tree just feet from my lens."

Technical Data

Canon EOS 20D digital SLR
Canon EF 70-300mm f/4-5.6 zoom lens
1/80 of a second at f/8
ISO 200
Natural light

This appealing pet portrait displays some humor and captures a bit of the dog's personality. The photographer wanted to reveal the dog's behavior, based on his past hallway meanderings, and managed to capture an image of him with his signature vest and knowing expression, which is typical of this pooch. The photographer also got down on the dog's level, and composed an excellent head-and-shoulders portrait with a telephoto lens and studio lighting. At first glance this image appears to be sepia-toned, but the color palette is actually very subtle, almost monochromatic.

Photographer's Comments

"The reason that this subject intrigued me was because of his personality. Fred lived in a unit on the same floor as mine. His owner always let him wander the hall, which he did very secretly. Fred always wore this vest, and would stare at you as if he was trying to figure out what you were up to, almost as though he was the hallway monitor. My goal with this image was to capture the deadpan stare that Fred gave people on our floor. Not only does this image reveal his innocence but also shows his intelligence."

Technical Data

Canon EOS 1D Mark II N digital SLR
Canon EF 70-200mm f/2.8L IS telephoto zoom lens
1/200 of a second at f/8
Gitzo Tripod with a Kirk Ballhead

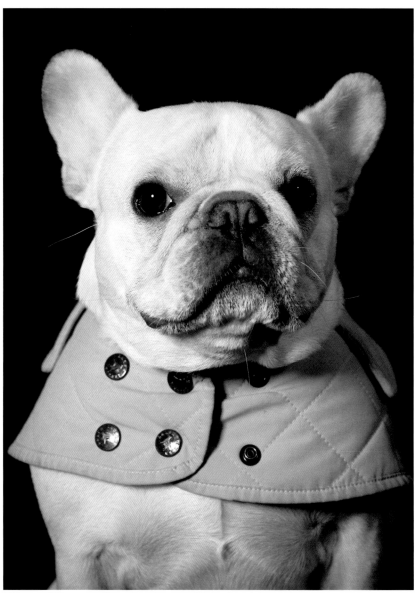

"FRED HOLMES"
© *Matthew Brush*
Portland, Oregon

Profoto 7B Light
22-inch Beauty Dish with Silk, positioned to left of the camera
Pocket Wizards for remote firing
Black seamless paper backdrop

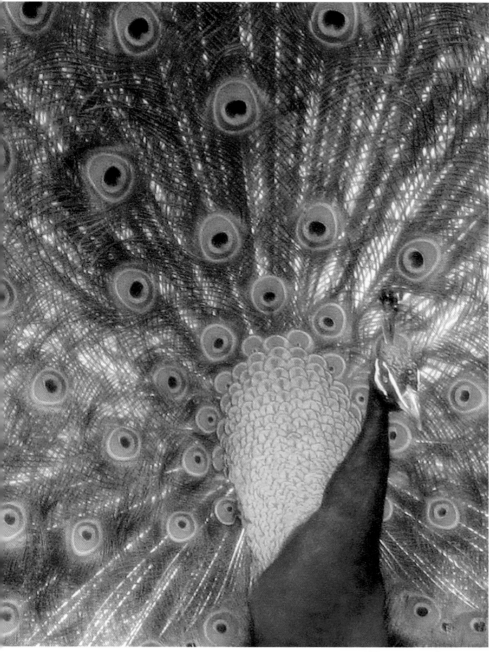

"DOTS OF COLOR"
© Yolanda Pucinski
New Britain, Connecticut

This photograph would not have been nearly as interesting if the photographer had positioned the peacock's head and body in the middle of the frame. The off-center composition of the subject and the three-quarter view of the head is much more dynamic. The colorfully fanned-out tail feathers create a wonderful abstract pattern in the background that fills the frame (it must have been mating season at the game farm). I also like the image's pleasing, cool blue-green color palette.

Photographer's Comments

"I took this shot when I visited Catskill Games Farm in New York during the summer of 2006. The peacocks were just walking around freely, and this particular one seemed to enjoy posing for my camera. I'm glad I had the opportunity to go to this game farm because it closed later in the year."

Technical Data

Canon PowerShot SD500
1/60 of a second at f/4.9
ISO 100
On-camera flash
Color saturated in Adobe Photoshop

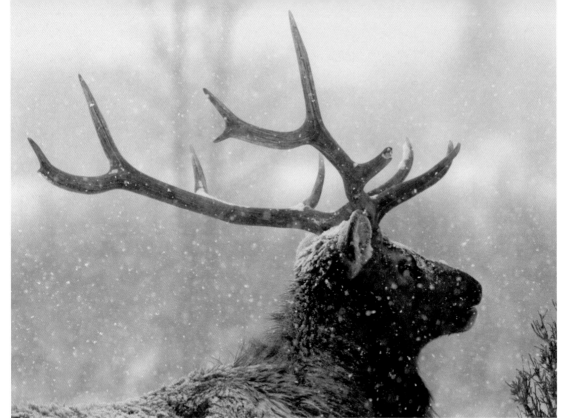

"First Storm"

© Keith Livingston
Longmont, Colorado
www.siennaphotography.com

A long telephoto lens, patience, and a little luck are all very important when photographing wildlife. Taking pictures of wild animals takes a lot of time, and you must be as unobtrusive as possible. The animals should be unaware or at least undisturbed by your presence so that you can photograph their natural behavior. Here, the photographer was fortunate enough to capture a fleeting profile view of this elk before it disappeared. As he apparently lives in the area nearby, he seems to be very aware of the behavior of these animals, and keeps a respectable distance. This image has the lovely, wintry quality of a holiday greeting card.

Photographer's Comments

"This picture was taken at Rocky Mountain National Park during the first big storm of the fall. Normally by this time, many of the bulls have abandoned the larger herds and grouped together in smaller herds of five to ten animals (bachelor bulls). In this particular group there were seven bull elk. All were very large animals with very good 'racks' that were well intact after the rigors of the fall mating season. It was around 3:30 p.m. and the animals were out feeding despite the heavy snow. They moved through my area of the woods, but one of the trailing elk stopped to gaze across the meadow. This is when I braced the camera on a close limb and clicked the shutter. He was gone in an instant but luckily, the snow helped with the exposure in the dim evening light, and this image was intact. I spend much of my free time photographing the majestic animals throughout the year, but to me, the snowfall is almost magical. The serenity of the park with the elk moving through in almost complete silence is beyond belief."

Technical Data

Canon EOS Digital Rebel
Canon EF 300mm f/2.8L telephoto lens
1/1000 of a second at f/5.0
ISO 100
Ambient light on a snowy afternoon

Farms and refuges with captive animals are wonderful places to photograph animals in a natural environment. This photographer shot a lot of images and was rewarded with this beautiful portrait of a Bengal Tiger. To capture a moment like this, you must be patient and keep watching through the viewfinder until the animal is positioned in a manner that you want to capture, and be prepared to shoot a lot. This photo presents a great case for keeping a camera handy, even if the camera is a point-and-shoot. You never know when the opportunity for wonderful images may present itself.

Photographer's Comments

"This was our last day in South Africa and we were leaving for the airport in a few hours. Before heading home, we decided to go to a farm where they had some captive animals. I only had my Nikon E8800 with me, as I didn't think we would see anything that we hadn't already photographed in the wild while on safari. They had some nice, smaller species of African animals but to my surprise, they also had a program with India to breed the Bengal Tiger in captivity for them. This pussycat was approximately nine months old and very calm. He was such a beautiful specimen, anyone would have been inspired to photograph this gorgeous animal. I just handheld my camera and shot until I had no more space left on the card. What a purrrfect ending to an already wonderful trip!"

Technical Data

Nikon E8800 compact digital SLR
Built-in 10X optical zoom lens set at 57.3mm
f/2.9 (shutter speed not recorded)
ISO 50
Natural light

"BENGAL TIGER"
© *Mary Ellen Kolsky*
Alajuela, Costa Rica

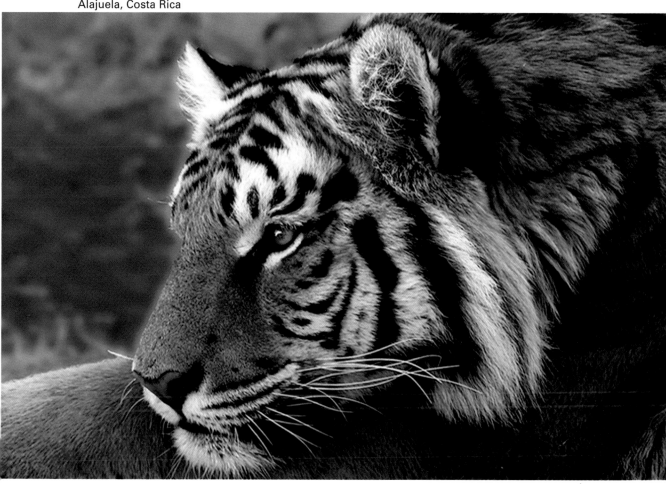

Photographing a domestic animal in its environment can give the viewer a sense of the animal's habits and places where it feels comfortable. This cat looks very complacent sitting on the arm of this Adirondack chair. This photographer wisely positioned himself at the cat's level and brought the subject in close with a telephoto lens. The cat's cinnamon color is a nice contrast to the white chair and dark background, and the composition of the image is very good, positioning the subject to the far left of the frame. The soft, natural light is also very pleasing.

"Sentinel"
© *Todd MacMillan*
Georgetown, Kentucky
www.macmillaninc.com

Photographer's Comments

"Shooting a series of barn cats at a local farm, I had selected nine cats and followed their lives. The original intention was to create a collection of images entitled, 'Nine Lives on the Farm.' This was the plan until the coyotes came along — a very unfortunate end to the project."

Technical Data

Canon EOS 10D digital SLR
Canon EF 100-400mm f/4.5-5.6L IS lens
set at 140mm
Manual Mode
Center Weight Average Metering
1/60 of a second at f/4.5
ISO 100
Available Light

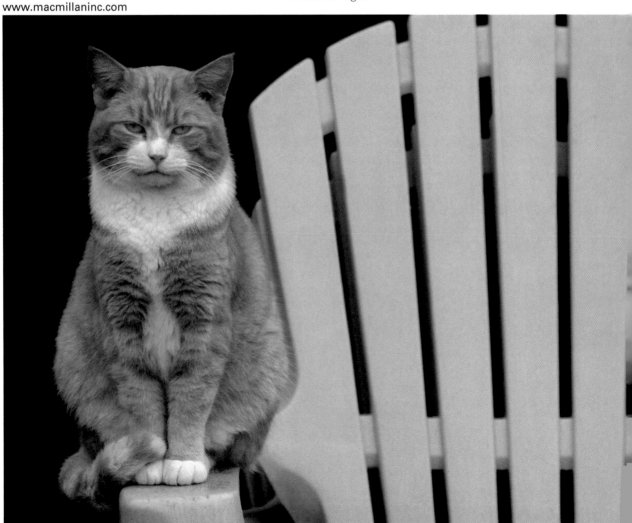

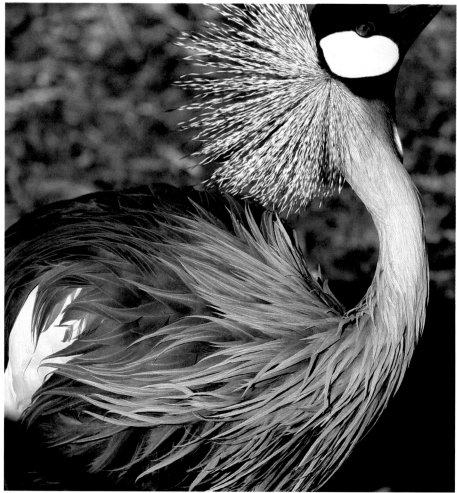

"CRESTED CRANE"
© Marilyn Hunt
Louisville, Colorado
www.marilynhunt.com

This great image of a Crowned Crane reveals a lot of texture in the bird's feathers. Instead of shooting a portrait or concentrating on colors, this photographer decided to focus on the details and textures of the body, and this is further accentuated by her use of black-and-white. And as this image attests, you can shoot some wonderful animal portraits at the local zoo. You'd never know that the photographer didn't capture this image in some far-away, exotic location. You can also find waterfowl and other birds at marshes, beaches and water preserves.

Photographer's Comments

"A couple of years ago, I had shoulder surgery and wasn't allowed to carry my heavy camera for about three months. When I was finally given permission, I went to the Denver Zoo and took pictures for about three hours. I love the beautiful gradations of gray in the feathers of this East African Crowned Crane. I cropped the photo at the top right portion because part of the tail was missing at the bottom left corner, and to really draw the viewer's eye to where it belongs — on the body."

Technical Data

Canon EOS 5D digital SLR
Canon EF 100mm f/2.8 macro lens
Camera set on Program/Auto
1/3200 of a second at f/3.5
ISO 200
Natural light

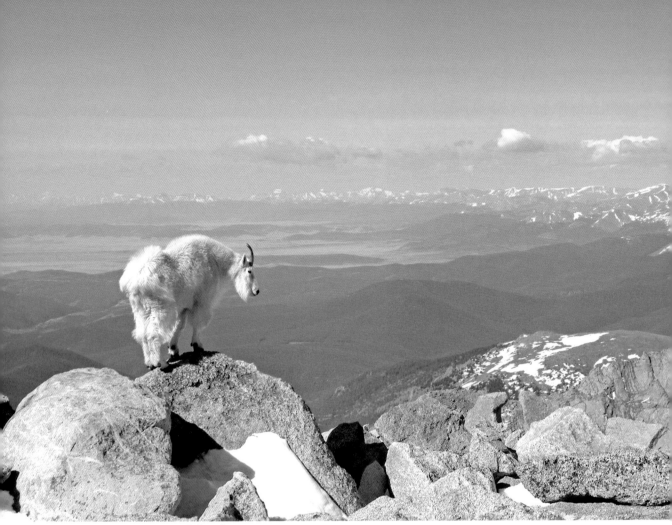

"King of All That I See"
© Allen Thornton
Castle Rock, Colorado
www.allenthornton.org

The ultimate challenge in animal photography is taking pictures of creatures on their own terms — in the wild. In many cases, you want to bring wildlife in closer by using a telephoto lens. However, there are times when you want to make a statement by stepping back and including the animal's environment in your frame. Here, the photographer chose to include the mountain goat's rocky terrain. And by encompassing a broad expanse of the scenery beyond, the photographer makes a statement about the animal's kingdom.

Photographer's Comments

"Mountain goats are among my favorite wildlife subjects. Each spring I travel to an area of thin air to photograph these fearless trekkers — Mount Evans, Colorado — at an elevation of 14,000+ feet above sea level. The mature adult goat in this image climbed on top of a large granite boulder to survey the mountainside as if he owned it."

Technical Data

Fujifilm FinePix S2 Pro digital SLR
Nikkor 24-120mm VR lens set at 35mm
1/350 of a second at f/10
ISO 200
Natural light

You should approach pet photography the same way you would photographing people — think about their character and try to capture it on memory card or film. What makes this picture particularly appealing is the fact that the photographer successfully portrayed the lovable nature of this dog — Arthur really reaches out to me. I also like the use of a moderately wide-angle lens and the angle that the photographer used to capture the image. Sometimes tilting the camera slightly lends excitement to a photograph. Try experimenting with this technique and remember that you don't *always* need to hold the camera totally upright in a vertical or horizontal position.

Photographer's Comments

"I've always loved animals. I was inspired to photograph animals from the Chautauqua County Humane Society to increase awareness of the many wonderful reasons to have a pet in your life, as well as the amazing companions people can adopt from the Humane Society. Arthur is part of an ongoing project called 'Tails of Love,' which is about the stories and photographs of animals and their guardians from my local community. Arthur spent weeks at the Humane Society before he was adopted, only because he was an older dog. The Horlachers, seniors who had recently lost their dog, took one look at Arthur and fell in love. I wanted to give back to all the pets I've loved, and who have loved me, by photographing animals like Arthur to highlight the need to find them loving homes."

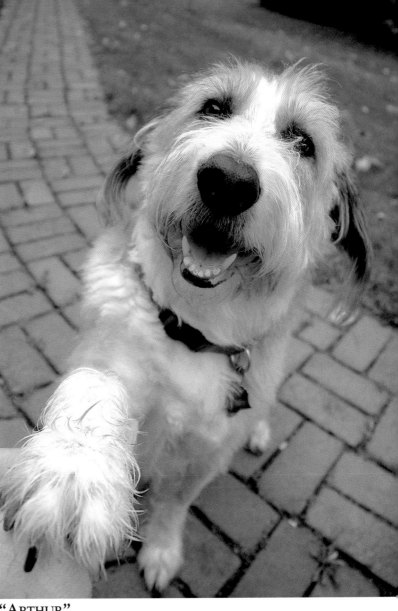

"ARTHUR"
© Catherine Panebianco
Jamestown, New York
www.panebiancophotography.com

Technical Data

Nikon D70 digital SLR
Nikkor 18-70mm f/3.5-4.5G ED-IF zoom lens
set at 28mm
Exposure Unrecorded
ISO 200
Natural light

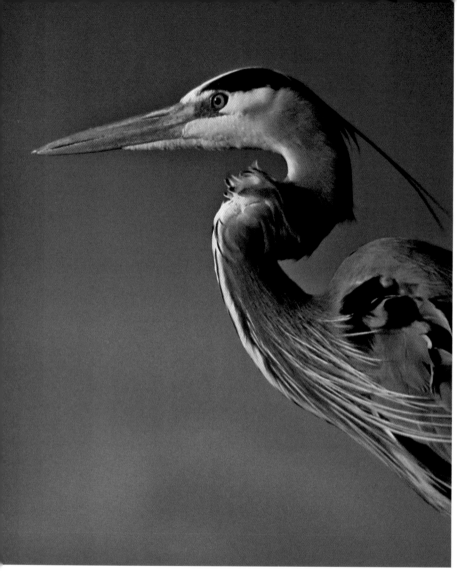

Besides being relatively tolerant of human company, many wading birds and other large shore birds make great subjects for nature photographers. They're often more accessible than smaller birds. The best time to photograph them is when they're hunting for food early or late in the day. Use a telephoto lens in the 100-500mm range or longer to bring your subject in closer. Make small, almost imperceptible movements so that you won't chase the bird away. All the elements such as great lighting, a gorgeous complimentary background color, and a handsome bird in profile all came together for this lucky photographer.

Photographer's Comments

"I was taking a sunrise walk on Stearns Wharf in Santa Barbara, California, when I spotted this Great Blue Heron standing on top of a container looking for breakfast. I slowly circled it looking for the best light. When I saw that beautiful blue background, I started snapping away. The golden light from the sun and a slight breeze fell upon the heron as I was photographing it, which completed the picture."

Technical Data

Nikon 35mm SLR
Nikkor 17-200mm zoom lens
Exposure unrecorded
Fujichrome Provia 100 transparency film
Natural early morning light

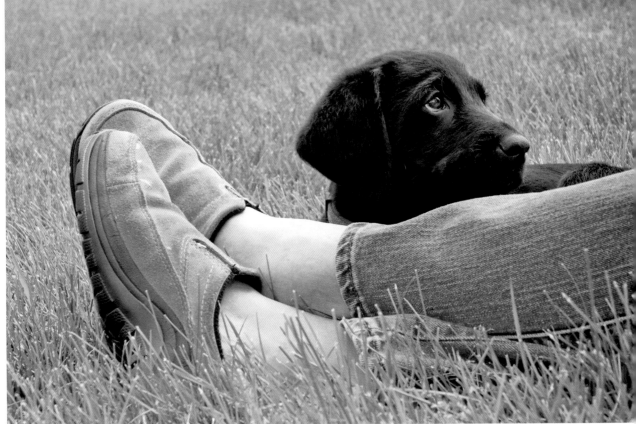

"LOVING LOOKS"
© Scott Slattery
Brockport, New York
www.sts-artworks.com

A successful pet and owner portrait often expresses attachment and companionship. In this simple image, you can sense a significant relationship between the dog and person. You don't need to see this person's face, as the focus is on the black dog and the devotion in his eyes when gazing at his owner. When composing your pictures, try to eliminate clutter and extraneous information, as the photographer has done here. Simple images are usually the most powerful ones. This photograph also presents a good case for watching through the viewfinder to capture just the right moment. If the photographer had waited any longer, he would have missed this special interaction altogether.

Photographer's Comments

"We already had a 120-pound Newfoundland and felt that he needed some canine companionship. So we found ourselves the proud new "parents" of two Labrador Retriever puppies. After an afternoon of racing around our yard chasing birds, butterflies and my daughter, Shannon, the pups finally settled down long enough for me to get some really nice shots of them. Murphy decided he wanted to be close to my wife and plopped down next to her feet. The bright green grass made a perfect background of texture that contrasted nicely with Murphy's red collar and Anne's blue jeans and brown shoes. I captured this image as he stared up at her with those beautiful eyes — and then he promptly fell asleep."

Technical Data

Nikon D200 digital SLR
Nikkor 18-70mm f/3.5-4.5 zoom lens set at 70mm
1/60 of a second at f/14
ISO 100
Natural light

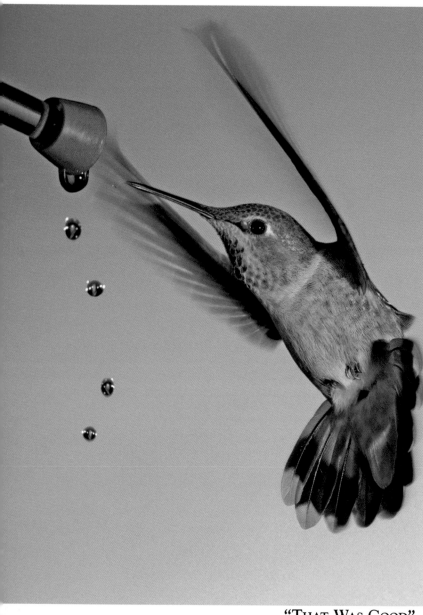

"That Was Good"
© Debbi Smirnoff
Chico, California
www.pbase.com/debbi/com/

Flash is a great tool for freezing action, especially when capturing the fluttering wings of a hummingbird, which appear to be just a blur to the human eye. This photo not only freezes the action of the bird, but also the droplets of water in midair. The flash also illuminated the hummingbird beautifully against the blue background. A telephoto lens framed the bird and just enough of the feeder perfectly. Great pictures like this are tough to achieve. You need to shoot several frames rapidly in succession to get one that works well. Depending on the type of camera you have, you can also try setting your camera on its Action mode.

Photographer's Comments

"We have a lot of hummingbirds in my area and I thought it would be fun to capture them in flight. The secret is the use of Speedlites set at 1/16 power to freeze the action without getting a lot of blur."

Technical Data

Canon EOS 20D digital SLR
Canon 100-400mm
f/4.5-5.6L IS telephoto zoom
set at 400mm
1/250 of a second at f/14
ISO 100
Two Canon 580EX Speedlites
for key light and fill flash
Background was blue
FomeCor board, lit with one
1600 White Lightning strobe

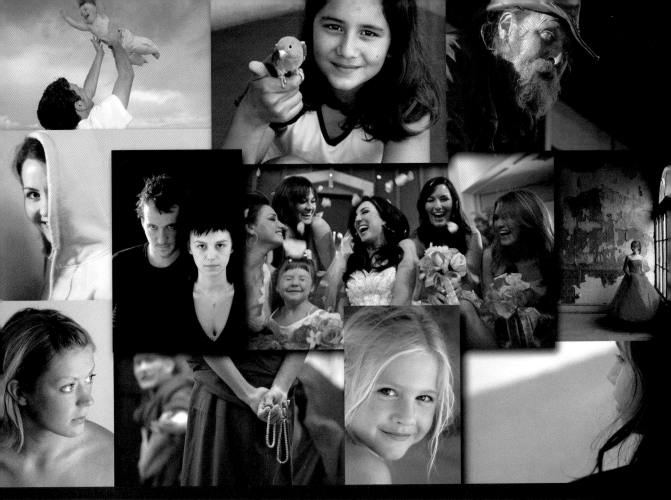

PART 3

PEOPLE AND PORTRAIT PHOTOGRAPHY

People are a continually fascinating source of subject matter. Photographers shoot pictures of people for a variety of reasons. Many of you likely want to document the changing scene of life around you — children growing up, family gatherings, or special moments with those you love. Others enjoy photographing people as a means of self-expression, while other individuals make their living by doing portraiture, weddings, or photographing people for advertising and editorial venues. When people are the subjects of photographs, it's usually their faces that hold our interest, as the human face is capable of an endless variety of expressions. Many of these expressions are fleeting, and photographers try to capture these moments before they disappear. Other times, people want to be memorialized in a formal portrait session. And, sometimes you don't even need to see the face to understand the power of the photograph. No matter what the motivation is for doing portraiture, photo-graphs of people tend to touch us more deeply than other subjects.

"AFRICAN SOUL"
© *Marie Preaud*
South Portland, Maine
www.mariepreaud.com

When you shoot a portrait of a child in an informal setting, try to find props or a background that reveals something about him/her. In this case, the photographer wanted to make a statement about hope by asking the little boy to look up at the sky. Kids can be very cooperative subjects if you explain what you want them to do, and if you make the photo session fun. Children's attention spans are brief, however, so plan your photo shoot accordingly.

Photographer's Comments

"A good friend of mine knew Louis' mother. He had told me how this little boy's soul was very deep and his green eyes were so beautiful. When I met Louis for the first time, I felt close to him. I asked him if he wanted to be photographed, and he allowed me to photograph him in such a calm, relaxed way. I knew he had been going through some emotional times, so I asked him to look up to symbolize hope. I will never forget the presence of this beautiful boy — he was wise for his age. A German record company (Blue Flame) later asked me to donate this photo for use on a cover of an album called 'Children Need Love.' They gave Louis 30% of the sales in order to give him savings for his education. This photograph means a lot to me."

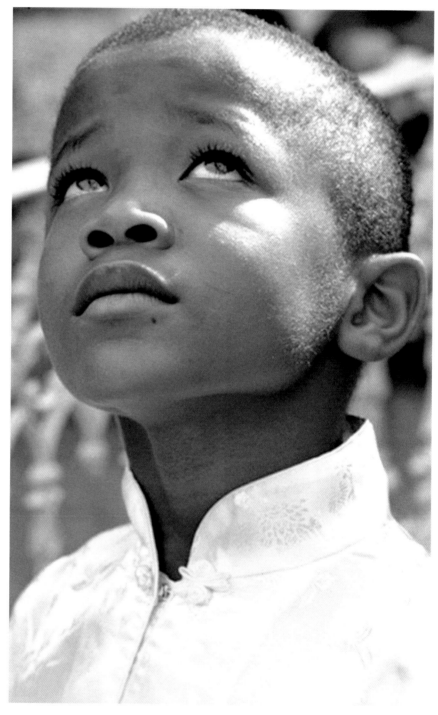

Technical Data

Nikon FM2 35mm SLR
Nikkor 50mm lens
ISO 100 film
1/125 of a second at f/11
Natural light with a reflector

As I've mentioned earlier, you often get the best images of a child when he or she is unaware of the camera. If you keep your camera handy and use it often, a child comes to consider it a normal part of life. This photographer captured this little girl's sweet, fleeting glance, and she doesn't appear to be aware that her photo was taken. Only a portion of her face is revealed, giving this image a very natural feeling. I also like the use of negative space that she's facing. By using a relatively fast ISO and shutter speed, as this photographer did, you can freeze action, which gives you great freedom in capturing brief moments and quickly moving children.

Photographer's Comments

"I was photographing a client who happened to be an old friend from childhood, and who I hadn't seen in many years. Her kids are mostly grown up, but this little girl is one of her daughters. The moment just struck me. Although it's pretty reminiscent of my shooting style, this image really penetrates. I took it at Huntington Beach, California, around 6:30 a.m. when the light is just so soft and beautiful. All the images taken during this sitting are gorgeous. It's amazing to me how we remember our children — for me, it's rarely a full frontal portrait, but rather a glimpse of a passing moment. I think this photo reflects this vision."

Technical Data

Canon EOS 20D digital SLR
Canon EF 50mm f/1.4 lens
1/1000 of a second at f/3.5
ISO 400
Early morning light

"SQUARE EYE PHOTOGRAPHY II"
© *Edna Eudave*
Anaheim, California
www.squareeyephoto.com

"NATALIA"
© *Christine McDonough*
Salt Lake City, Utah
www.ChristineMcD.com

Although she's looking right at the camera, the adorable little girl in this tightly framed portrait reveals an appealing shyness. Her hands hide most of her face, but her eyes show some excitement about being photographed. Children are often playful and clown around for the camera, but they are just as cute when they show a little bashfulness in front of the camera.

Photographer's Comments

"In the summer of 2006, I went with a group to Costa Rica on a Habitat for Humanity Global Village build. For a week, we worked daily with the families who were to live in the homes we helped build, and found some of the most congenial, hardworking, and beautiful people. While we worked, we also played with the neighborhood kids, who had a most special kind of beauty and joy. The first Spanish phrase I used was 'Puedo sacar una foto?' (May I take a photo?), and most people in the neighborhood would see my camera, run over excitedly, and pose themselves or their children for many pictures. Everyone was eager to see their image on the digital screen, and they would laugh and giggle, then insist on posing for more!"

Technical Data

Nikon D70 digital SLR
Nikkor 18-70mm f/3.5-4.5G ED-IF AF-S DX
zoom lens set at 52mm
1/160 of a second at f/6.3
ISO 800
Natural light

As subjects for informal portraits, children can often be more rewarding than adults. Grown-ups tend to approach the camera with a fixed set of behavioral patterns. In contrast, children are much more natural. They're at a stage in their lives when their individuality is just emerging, and they're imaginative and spontaneous. Kids can display complete innocence in some areas, along with great sophistication in others. This appealing little girl seems friendly and unafraid of the camera's presence. The photographer captured her personality beautifully. It's best to try to portray a child's natural charm than to ask them to grin and assume a stiff pose for the camera.

Photographer's Comments

"This shot was made during the holidays with my family at a farm in Jutland, Denmark. Heidi is my cousin's daughter and she joined the other kids in this Finnish wooden hot tub on Christmas Day. I didn't take a dip myself, but was outside with my camera because I thought that the cold air and steaming water might produce exciting soft lighting conditions under an overcast sky. I take a lot of pictures of the kids, so they're used to me behind the camera, poking the lens in their faces. I got about 15 really good shots of Heidi with different expressions. I chose this image because of her beautiful face and the confidence she revealed at that particular moment."

Technical Data

Canon EOS 5D digital SLR
Canon EF 24-70mm f/2.8 zoom lens set at 63mm
1/45 of a second at f/5.7
ISO 640
Overcast daylight

"Heidi"
© Steen Knarberg
Naestved, Denmark
www.shade-n-light.com

"SCOTT"
© Eric May
Nashville, Tennessee
www.ericmay.net

To many, a portrait is simply a head-and-shoulders shot of an individual. However, this interpretive portrait brings an outdoor environment into the image, in which the subject is a small part. The man in this photo is separated from the background by side lighting, which spotlights him in this dark, natural setting. If you want to include a person in their surroundings or one of your choosing, you should decide how to use this broader surrounding to make a statement about the subject. Make sure the background adds something to the photograph; otherwise it will detract from your true subject, the person. Look for strong design elements like shapes, lines and patterns. Be aware that every element in a photo, no matter how small, plays a part in the overall impact of the image. Here, the photographer appears to be making a statement about the subject in a natural world. This portrait represents a very intriguing, original idea — and one that's rife with mystery.

Photographer's Comments

"This image is a portrait of a friend of mine. I wanted to show him how I perceive him from my eyes. I asked him to pose for this photo as a personal image for my portfolio."

Technical Data

Canon EOS 5D digital SLR
Canon EF 24-105 L series zoom lens set at 28mm
1/125 of a second at f/11
ISO 100
Profoto Acute 1200R strobe

The young woman's eyes are the primary focus in this photo, and the photographer has rendered the rest of the photograph softly. Her face seems expressive and very natural. This photographer obviously puts a lot of thought into the way she wants to shoot her portrait subjects. To capture the essence of a person, you must try to show the qualities that make that person unique. It's also important to learn to assess a subject for the greatest visual impact. Your photos will be more satisfying for you because they'll reflect the image as you saw it when you clicked the shutter. It will also help you develop your photographic style. If you know how you want to portray a subject, and what qualities you want to show, your images will have far greater emotional impact for those who look at them.

Photographer's Comments

"Nicole is my younger sister, who is used to being photographed by me. I enjoy photographing her face and her big blue eyes. I used the natural daylight in the room, which allowed me to capture the eyes so clearly and the soft shadows in her face."

Technical Data

Canon 350D digital SLR
Canon EF 85mm lens
1/500 of a second at f/1.8
ISO 400

"NICOLE"
© Monika Manowska
Nacka, Sweden

Most formal family portraits show parents and children posed together, but few show much of people's personalities. By contrast, this family looks like they're having a great time in front of the photographer's camera. Whether you choose to portray a group of people in a formal or informal manner, however, you should try to arrange them in a dynamic way. Have some family members sitting, kneeling, or standing at a higher level for more pleasing visual variety. The positions of their heads should appear to be in a staggered pattern or in a triangular design, instead of heads lined up in a row, which can appear stiff and static.

Photographer's Comments

"This is Kari and her two children. The boy on her back is Jordan, who is in high school, and Brett is the one giving a helping hand. This family is so much fun and they interact so well. This was a moment that was completely candid, and I prefer to shoot unposed, candid portraits. Jordan unexpectedly jumped on Kari's back and Brett jumped right in there to give him a boost. People ask me where I want them to stand, and I tell them that I just want them to interact as a family so I can capture their true relationships as a family unit. I ask them to bring their favorite music CD and we just get into it. Those are the images they love best."

Technical Data

Canon EOS 10D digital SLR
Canon EF 17-40mm L zoom lens
1/60 of a second at f/10
ISO 100
Two Britek PS-300H studio strobes with softboxes and a Britek umbrella light to overexpose the background for high-key lighting

Window light
"FAMILY"
© *Eleanor Caputo*
Jackson, California
www.studio18gallery.com

"Devon"

© Patrick Lanham
St. Louis, Missouri
www.lanhamphotography.com

Photographs of people can convey a multitude of messages. You can look at the same photo over and over again and find some new meaning to it. For you as a photographer, an image can be a way of communicating a message to viewers. Whether your subjects are corporate executives or neighborhood children, the camera is a tool that allows you to express what you're feeling about the person you're photographing. This very tightly cropped image emphasizes the very direct gaze of a child, and from the photographer's point of view, a trip down memory lane.

Photographer's Comments

"Devon is a portrait of my nephew, which is part of my series of portraits entitled 'Faces.' I have always been fascinated by people's faces from my early years in figure drawing classes, and have turned to photography to capture that realism that I've always wanted to get with my drawings. This series of portraits features faces closely cropped to show eyes, nose and mouth, the three areas of the face that are the most relevant to one's own character. I chose Devon because of how simple and quiet he looked, and the beautiful pattern of freckles on his face. He looks so much like his father when he was 11 years old; I feel like I'm looking into the past."

Technical Data

Canon EOS 1D Mark II digital SLR
Canon 70-200mm EF zoom lens set at 200mm
1/125 of a second at f/8
ISO 50
Single Broncolor Softlight reflector directly overhead, about 45 degrees, with diffusion

"Subtle Melancholia"
© *Jonny Kahleyn*
Santa Monica, California
www.juhannusproductions.com/photo

To create a successful photo, you must make a few decisions beforehand about composition—where to position the subject within the frame, what other elements to include, and whether to frame the image horizontally or vertically. Traditional portraits are usually taken in a vertical format, whether they're full-length images or tight close-ups. However, this photographer chose to position his portrait subject on the far right of the frame in a wide, horizontal format. As opposed to positioning your subject dead-center, an image will have much more impact when the subject is off-center. Also, the use of fill-flash illuminates the man's face nicely. Without it, he would probably be rendered in silhouette.

Photographer's Comments

"Andy Anderson and I are part of the same theatre group in Los Angeles. Late last year, I offered to shoot some pictures that he could use as headshots. The only camera I had available on the day of our shoot was my first camera (and one of lucky charms), the very basic FujiFilm S5100. It was almost sunset with lots of warm light when I took this picture. His soulful eyes emanated a feeling of subtle melancholy that my little camera captured beautifully."

Technical Data

FujiFilm S5100 compact digital camera
Built-in Fujinon zoom lens set at 57mm
ND filter
1/80 of a second at f/3.1
ISO 100
Natural light combined with fill flash from the camera's built-in flash unit

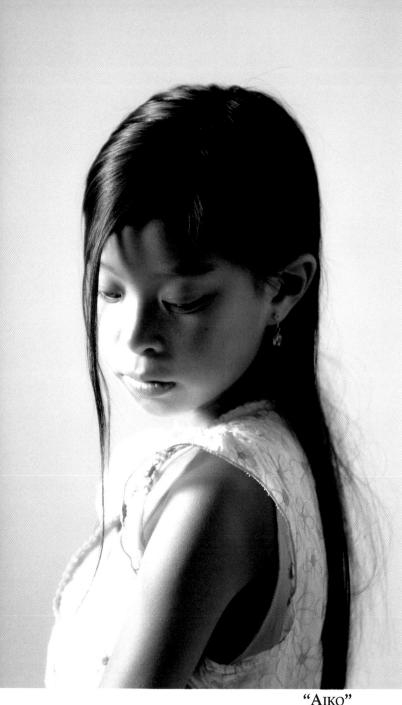

"Aiko"
© *Ronnie Benjamin*
Fairfield, California

You don't always have to portray people smiling and happy in your photographs. There may be times when you'll prefer to capture a mood, such as this photographer did by capturing this little girl's pensive, downcast look. To put mood in your photographs, you might begin by recognizing what visual elements best interpret how the subject is feeling, and how a viewer may feel when they look at the photograph. Perhaps it's a facial expression or body position. Remember that mood is a personal thing, and can be determined partly by a viewer's own interpretation of a picture. Whatever feelings a picture may evoke — perhaps sadness, joy or anger — they're usually enhanced by our own personal interpretations.

Photographer's Comments

"Aiko is half Japanese and half Filipino, and she is my niece. My wife was babysitting for her brother at our house where I also have a studio. When I saw Aiko looking a little bored, I asked her if she would pose for me while I experimented photographically without strobe lights. She agreed, and I shot around 10 images that day. The following day she came back wearing a nice dress, and I took more pictures. I gave my brother-in-law two 8 × 10 prints as a way of saying 'thank you.' This image hangs on their wall."

Technical Data

Canon EOS 20D digital SLR
Canon EF 70-200mm f/2.8L zoom lens set at 200mm
1/125 of a second at f/2.8
ISO 200
Window light with a reflector used to bounce light on the shadow side of the subject

"Snow Angel"
© *Lisa Butler*
Tulsa, Oklahoma
http://lisabutler.
photoworkshop.com

This studio portrait utilizes some very pleasing, soft light from a softbox and a tight close-up of a cute little girl. The high-key white of her hooded sweater surrounding her face draws the viewer's eye in to her face and appealing smile. There are many ways to light a subject, but to keep it simple, one main light is often all you'll need. When shooting a formal portrait, always remember that the best backdrop is a simple and uncluttered one. Most commonly used ones include a plain wall, fabric or seamless paper background. But whether you're indoors or outside, make sure that the background won't distract from your subject. It's always best to photograph children at their level, and a moderate telephoto lens (at least 50mm with a digital camera) is always a good choice for a portrait.

Photographer's Comments

"I captured this image during our children's Christmas portrait shoot. During any photo session, I am always drawn to the person's eyes — they are truly a window to the soul. While taking pictures of Courtney, all I could think of was how angelic her eyes were. To me, she looked like a snow angel, thus the title of this photo."

Technical Data

Canon EOS 30D digital SLR
Canon EF 50mm lens
1/100 of a second at f/9
ISO 100
3 × 5 Softbox with a B800 Strobe from AlienBees

Of all the photos taken on a couple's wedding day, candid moments often result in the most treasured images. If you're shooting a wedding, you can take a photojournalistic approach, which is a very popular style of wedding photography today. The couple and their families understandably want you to shoot events like the march down the aisle, bride and groom's first kiss, cutting of the cake, and so on. But you should also be ready to react quickly if a lovely candid opportunity arises, like this one. Wedding guests are usually very busy and preoccupied, which gives you a variety of candid scenes to shoot, and makes it easy to work unnoticed. A telephoto zoom brings people's faces in close so that you can take a fly-on-the-wall approach.

Photographer's Comments

"I book about five weddings per year and shoot photos for the Renfrew Soccer League. I still consider myself an amateur photographer, and my favorite saying when speaking to camera clubs is, 'Professionals built the Titanic, but amateurs built the Ark.' I took this picture at a wedding near Cobden, Ontario, after photographing the bride and her flower girl. I was just starting to pack up my equipment when I caught this special moment out of the corner of my eye, and quickly fired the shutter."

Technical Data

Canon EOS 620 35mm SLR
Canon EF 28-105mm f/3.4-4.5 zoom lens
1/250 of a second at f/5.6
Kodak Portra 400UC color film
Canon Speedlite 430EX with a LumiQuest ProMax Softbox

"SPECIAL MOMENT"
© J.J. Guy Longtin
Renfrew, Ontario, Canada
http://guy_longtin.
photoworkshop.com

"FAMILY PORTRAIT"
© Stacy Wasmuth
Indianapolis, Indiana
www.bluecandyphotography.com

Many family portrait sessions are carefully posed and don't tell the viewer much about the people in the picture. This one, however, shows us happy parents with an adorable child, people I'd probably enjoy meeting. It's a departure from the formal poses that most portrait studios shoot, in which the three people would form somewhat of a triangular composition. When photographing a family, you might first want to shoot some formal, posed portraits. You can instruct some family members to sit and others to stand to create an attractive arrangement. Then, ask the family to interact with each other for more spontaneous images. These will undoubtedly show something of the subjects' personalities and their relationship with one another, besides possibly being the best-loved photos you shoot of them all day.

Photographer's Comments

"I love family portraits with personality. When photographing families, I typically encourage them to interact playfully rather than pose for the camera. This mom and dad first played patty-cake with their daughter, which resulted in a few fun shots. But as often happens with babies of this age, she quickly squirmed to be put down on the ground. I asked her dad if she enjoyed being bounced or lifted into the air. My suggestion led to this capture — an adorably bewildered baby and natural joy on her parents' faces."

Technical Data

Canon EOS 5D digital SLR
Canon EF 50mm lens
1/250 at f/3.5
ISO 400
Window light

Not all portraits have to be created in completely controlled settings. After your more-formal portraits (or in place of them), when the model is relaxed and feeling comfortable in front of the lens, try shooting a few informal portraits. What you lose in a controlled lighting situation may result in fresher, more spontaneous images. You also can concentrate more on capturing natural expressions than when you're concerned with the details of lighting and posing a model. In this situation, try to utilize natural light as much as possible. By taking pictures on a lightly cloudy day or in the shade of a building, you'll get soft, diffuse light that will give your subject flattering illumination. Look for backgrounds where you can utilize light-colored walls to bounce a little light back onto the subject's face."

Photographer's Comments

"This image was taken during a portfolio development session, and it was one of the last photos taken that day. While the model was rearranging her hair, I noticed the effect and wanted to photograph it. Her piercing eyes make the image. What you can't see is her friend, who's holding her hair in place just outside the frame. I converted the image to black-and-white to accentuate her eye that's revealed here and used a fast lens to minimize the depth of field."

Technical info

Canon EOS 5D digital SLR
Canon EF 135mm f/2.0
L series lens
1/400 of a second at f/2.5
ISO 160
Natural light in open shade

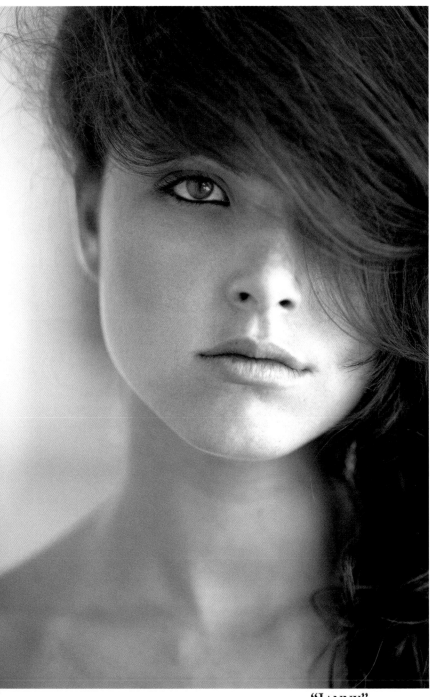

"Janny"
© Bryan Benoit
Miami, Florida
www.bryanbenoit.com

A lot of people enjoy shooting spontaneous pictures of people in busy urban areas. Candid — or street photography — as it's sometimes called, is usually done discreetly and photographers often take great care to avoid tipping off a subject. Others talk to their subjects and create a rapport before shooting pictures. To do street photography, you may want to find an interesting setting or event and look for interesting people to appear. Telephoto lenses help you keep your distance from wary subjects, but because of the inherent shallow depth of field that telephotos have, it's very important that your images are in focus. This photographer used an image-stabilizing lens to help alleviate that problem.

Photographer's Comments

"I shot this image at Eastern Market in Detroit, Michigan. I photograph a lot of people candidly on the streets of Detroit, and am very respectful of anyone I approach. Joe Jones was an exception — I saw that face, walked over to him and said something like, 'I have to take your picture. Look that way!' He did this and I got a couple of exposures, but this one was the killer. I had been going in and out of the market changing my camera settings, but as we all do sometimes, we forget to make the correct alterations until we shoot again and look at the results on the back of the camera. Fortunately, I was ready for this one."

Technical Data

Canon 20D digital SLR
Canon EF 28-135mm IS zoom lens
1/125 of a second at f/8
ISO 800
Natural light

"JOE JONES"
© *Bruce Giffin*
Dearborn Heights, Michigan
www.brucegiffin.com

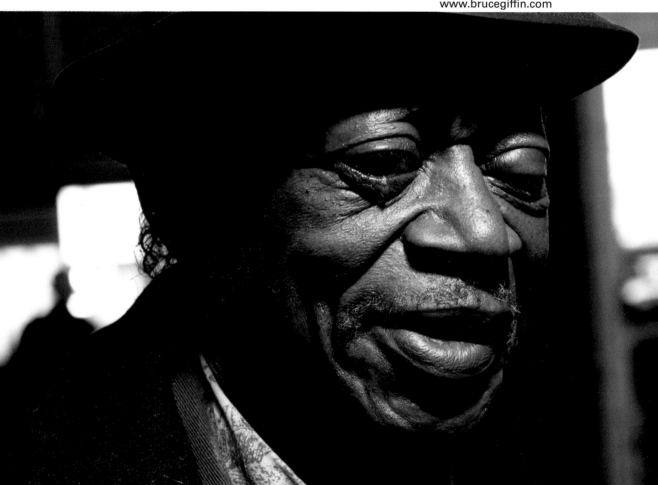

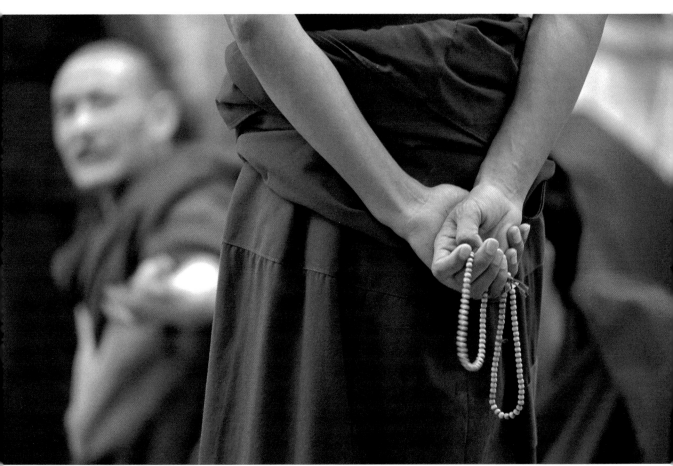

"Beads"
© Gerald Oar
Olympia, Washington
www.geraldoar.com

Although portraiture has been traditionally about people's faces, there's no rule that every photograph of a person must reveal one's face. This portrait speaks volumes about tradition in a Buddhist Monastery even without recognizable people. More importantly, this photographer captured a special moment, which is one of the greatest challenges of photographing people. In journalistic photography, timing is crucial to get a picture that best tells the story. You need to see the perfect moment before you can shoot it. Better yet, you must learn to anticipate it, to have your image planned and your camera ready when the elements of a scene come together.

Photographer's Comments

"One of my main destinations in Tibet was to visit the Sera Monastery. It's known for its Debating Courtyard where roughly 100 monks gather to test each other in their knowledge of the Buddhist scripture. This is done by pairing off into groups of two and then the questioner shouts his question at the other monk while loudly clapping his hands in his face and cajoling him while he attempts to reply. After approximately ten questions, they exchange positions. This photo is an example of a portrait without showing faces. I specifically used a shallow depth of field and tight framing to isolate the hands and the beads of the monk in the foreground, while keeping the blurred monk in the background to document the two characters' interaction."

Technical Data

Nikon F100 35mm SLR
Nikkor 80-200mm f/2.8 zoom lens
Fujichrome Provia film
Exposure unrecorded
ISO 100

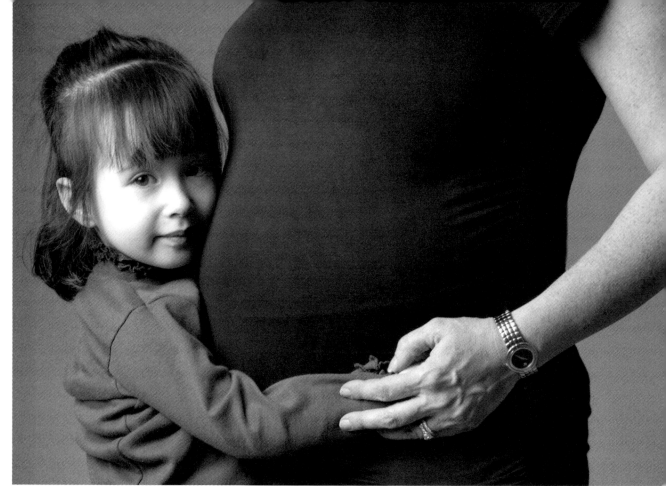

"Untitled"
© Lisa Klare
Northfield, Illinois

The relationship between parent and child is like no other, as beautifully portrayed in this child's face as she hugs her pregnant mother. Small children are usually naturally affectionate with a parent in a portrait sitting. This image shows a moment in time, a milestone in the life of this growing family. Also apparent is the love that this little girl has for her mother, whose affections she will soon have to share with a sibling. Family pictures are priceless —they show who we are and bring back memories of how we look at different times in our lives.

Photographer's Comments

"This session was initially planned as a maternity and mom and toddler photo shoot. The images I took were going to be part of a photo birth announcement. As we got into the session, however, I was struck by the innocence and vulnerability of two-year-old Samantha in the waning weeks of being her mom's only child. In just a couple of months she would no longer have her mom all to herself. I wanted to capture the mix of feelings inherent in this period of profound change. The remainder of the birth announcement held a happy group photo of Samantha with her mom, dad, stepbrother and stepsister, as well as a close-up picture of the new baby.

Technical Data

Nikon D200 digital SLR
Nikkor 24-120mm zoom lens set at 62mm
1/125 of a second at f/11
ISO 100
One Speedotron Brown Line D1204 M11 flash head set at 1/4 power with a Photoflex Lite Dome XTC softbox

"ALEX"
© Sally Haines
Cape Town, South Africa

Children seem to supply a never-ending supply of cute expressions, gestures and poses for the camera. Capturing a close-up of the face captures all the details around the eyes and a person's unique expression. And close-ups are especially fun with children because of their unguarded nature. If you're photographing a child outside on a sunny day, be sure to take pictures in an area where there's open shade, perhaps the side of a building or under a tree. Since children are small, be sure to move in close or use a moderate telephoto lens (about 50-105mm with a digital camera) so that their image fills the frame. This focal length range will allow you to keep enough of a distance to shoot candids, but won't be too long and awkward. Most importantly, keep your camera handy and be ready to click the shutter at an opportune moment, like this photographer did.

Photographer's Comments

"This picture was taken after Alex had been swimming and her hair had fallen so naturally around her face. The sunlight was falling perfectly on her, so I decided to sneak a picture, but without her knowing and posing for the camera. Once I pretended to be doing something else with the camera, I called her and she turned toward me and gave me a sweet smile."

Technical Data

Sigma SD10 digital SLR
Sigma 105mm macro lens
1/500 of a second at f/2.8
ISO 200
Sunlight

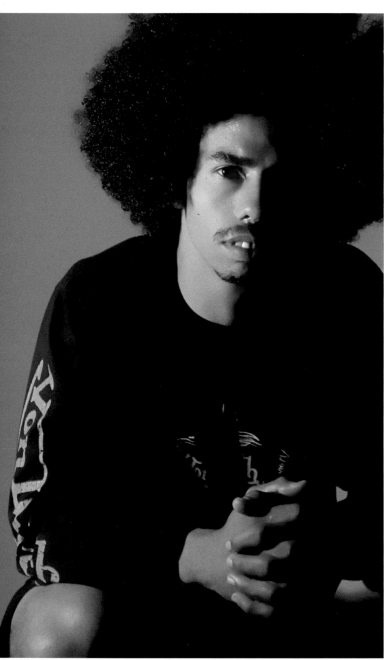

"MARK ANTHONY"
© *Susan L. DeLuca*
Valrico, Florida
www.bloomingdalephotography.com

Highly directional lighting that comes from the side gives a lot of drama to this studio portrait of a young man. There are a variety of ways to light a subject, and these variations will greatly alter the appearance of a subject. In addition to setting up the lights, you must pay attention to the subject's pose. It's best to photograph a person who's natural and relaxed in front of the lens. Keep in mind that a subject leaning slightly forward, like this one, seems more at ease. Someone leaning back can appear more reserved and distant. You'll want to click the shutter only when the posture, tilt of the head, and the expression appeal to you.

Photographer's Comments

"At 57, I was the oldest among all the young people starting a studio lighting class while working toward a photography certificate at University of Southern Florida. The professor brought a student into the studio area and started to show us how lighting works. Every time he did something different with the lights, I kept seeing a photo in my mind's eye to the point where I couldn't stand it anymore. I stood up and blurted in front of the whole class, 'Can I please take his picture right now?' Everyone laughed, including the professor. The result is this photo of Mark Anthony and a passing grade in studio lighting."

Technical Data

Canon EOS 20D digital SLR
Canon EF 28-80mm zoom lens
set at 52mm
1/125 of a second at f/11
ISO 100
Studio strobe lighting

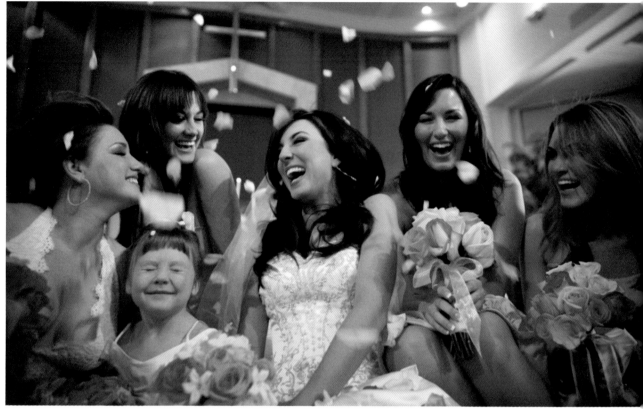

"Bridesmaids & Flowers"
© Scott Robert Lim
Monrovia, California
www.scottrobertgallery.com

Weddings offer a wealth of photo opportunities, both candid and planned. As you can see here, not every photo of the wedding party needs to be posed and formal. This joyful image of the girls being showered with flower petals was the photographer's idea. Even though it's a set-up shot, it has a very spontaneous feeling. When photographing a group of people, it's very important that they form an attractive composition so that everyone's face can be clearly seen, which is the case in this image. When taking pictures of the wedding attendants, you can gather all of them for a portrait, then narrow them down while you work, ending with just the bride and her maid of honor if you like. And because he utilized the ambient room light with no flash, the photographer captured this image with a high ISO of 800.

Photographer's Comments

"I had very little time to shoot some fun photos of the bridal party. I had just finished shooting all the formals and wanted to do something different, but I didn't have enough time to move the group to another location. I noticed the flower petals on the ground from the ceremony and thought it would be fun to shower the girls with flowers. I specifically instructed the girls to show extreme emotions of joy and laughter as the petals came down."

Technical Data

Canon EOS 5D digital SLR
Canon EF 24mm f/1.4L lens
1/200 at f/2.2
ISO 800
Ambient room light

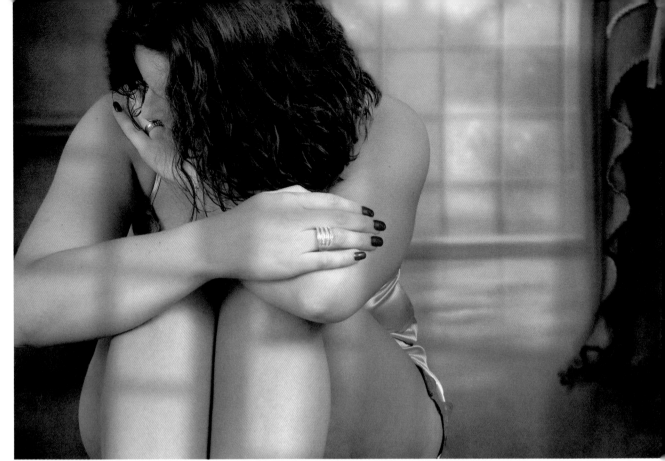

"PALACE PRISON"
© Steve Parrott
Jackson, Tennessee
www.parrottimaging.com

Mood is the way a picture feels. Moods can be changeable, and even subtle differences alter the feel of an image. There are a number of ways to convey mood, and it's partly determined by the viewer's own interpretation of a photograph. The woman in this photograph seems to want to avoid the camera's gaze, and although she's not really in a prison, as the image title implies, the photographer has utilized the lighting and shadows to make her appear as if she is behind bars — a prisoner of her emotions, perhaps. I also like the placement of the subject off to the left side of the frame, revealing a little of the environment she's in.

Photographer's Comments

"This woman wanted something different from the typical studio portrait. We shot many different poses, and while she was relaxing between shots, she took on this pose. I said, 'stay just like that!' I think the photo works well because the pose was just a natural state she was in at the time. I didn't have the finished product in mind when I shot this image, but I felt that the 'landscape' orientation would work better than the typical 'portrait' orientation."

Technical Data

Canon EOS 1Ds digital SLR
Canon EF 135mm f/2.0 L lens
1/100 of a second at f/5.6
ISO 100
One Adorama Flashpoint strobe with umbrella, positioned about 45 degrees left of the camera

This refreshing portrait is a contrast to those that are very posed and formal, and the photographer captured the subject's jovial spirit very well. She seems to be having such a good time that the audience also wants to hear the joke and join in the fun. Every photograph of a person conveys some sort of mood, whether it's happy or sad, and looking at other people can affect our emotions. Look at pictures of people and see what moods they evoke. Some may cause you to feel compassion, while others may conjure up anger. Some lighthearted images, like this one, draw you into the enthusiasm of the moment.

Photographer's Comments

"People have always been my favorite subjects to photograph. This was one of my first studio shoots, and I was nervous. I kept tangling myself up in my cords and messed up the settings on the camera. I probably made every mistake that one could in this situation. During my nervousness, I suddenly became very talkative and simply could not shut up. Eventually, my babbling made Natasha (the model) burst into laughter. As the photo session progressed, my silly remarks kept on coming — until I realized how great the way she laughed was. I waited for her next outburst of giggles and captured it."

Technical Data

Canon EOS Digital Rebel XT
Canon EFS 18-55mm zoom lens set at 55mm
1/250 of a second at f/8
ISO 200
Two Esprit Gemini GM500 lights; one aimed at the model, one with a blue gel aimed at the background.

"GIGGLES"
© Jean-Christophe Demers
Montreal, Quebec, Canada
http://jcdc.photoworkshop.com

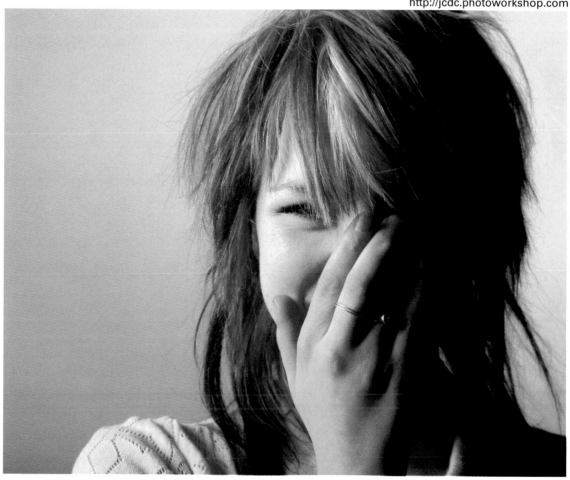

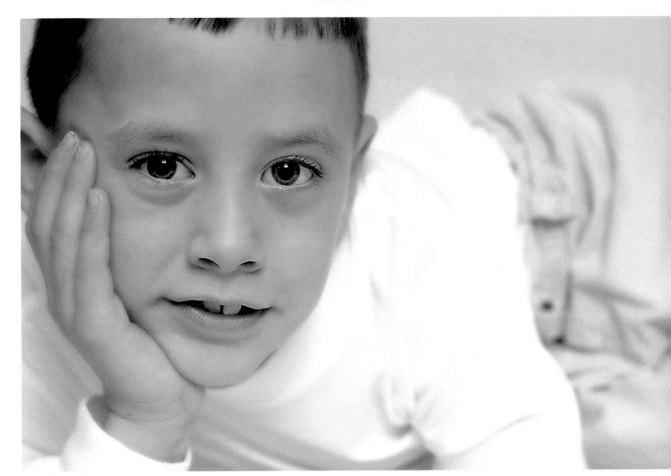

"BEN"
© Helen Miller
Adrian, Michigan

Without a doubt, the face is the most expressive part of the body. Thus, one of the easiest ways to capture a revealing portrait of a person is to concentrate on the face. A tight composition conveys a strong feeling of intimacy. This effect is accentuated when the subject looks directly at the camera, as we get the feeling of making eye contact with the person in the image. By concentrating solely on this little boy's face and throwing the rest of the image into a blur, we see something of his playful nature. Close-up portraits are very effective when photographing children, whose moods and expressions are often unguarded. It's also a good idea to get down on a child's level to photograph them, as this photographer did.

Photographer's Comments

"This is a photo of a friend's son. My friend wanted some family photographs that were a little different, something that would reveal his children's personalities. I wanted to show his expression more than anything, so I focused only on his face. But I chose not to photograph him in the typical way that one shoots headshots of a person—I chose a more fun and creative way. Ben's white shirt reminds me of the angel that he is. He's such a good boy, and you can see that in this portrait."

Technical Data

Nikon D2HS digital SLR
Nikkor 24-85mm zoom lens set at 75mm
1/125 of a second at f/5
ISO 200
Softbox light directly over the photographer's head.

Sometimes, a person's posture or body language can say a lot about him or her, even when the face isn't revealed. On-camera flash is very useful for portraits in low-light situations, as flash emits a powerful amount of light that approximates the color of sunlight. But if the subject's face were part of this image, the direct light might have flattened out her features. In this photo, the flash provides just enough fill light to illuminate the young lady's arms and legs. The background appears dark, so we don't see much in the way of shadows that often characterize on-camera flash. When photographing people with flash indoors, you can soften the light with a piece of tissue, cloth or acetate. Many flash units come with a diffusing panel specifically for this purpose.

Photographer's Comments

"This is a photograph of my daughter after she returned from a Homecoming Dance at school. She looked beautiful but very tired, and sat down in a chair to talk to me. I started taking pictures since my camera is never very far away. As I did so, she folded over to unfasten her shoes — and there was my shot. For me, a portrait is not honest unless it reveals something about the personality of the subject, and for me, this image conveys so much about her without even seeing her face."

Technical Data

Pentax MZ50 SLR
Pentax 35-80mm zoom lens
Fujichrome Provia transparency film
Exposure unrecorded
ISO 100
On-camera flash

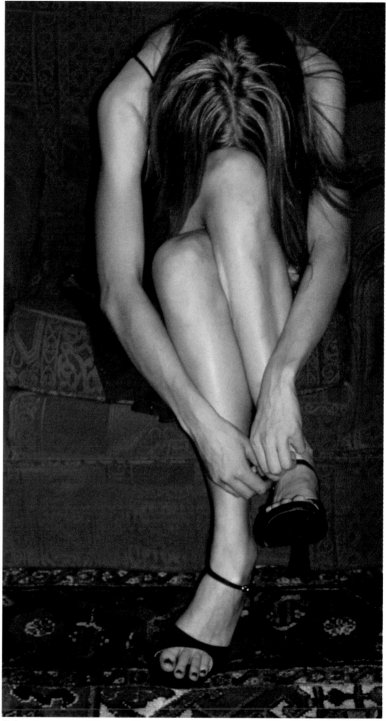

"AFTER THE DANCE"
© Heather Maslen
Anchorage, Alaska
http://heathermaslen_photography.photoworkshop.com

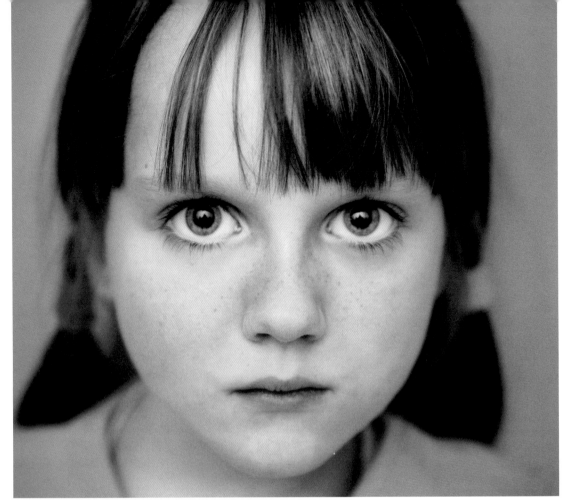

"Julia"
© Monika Manowska
Nacka, Sweden

Electronic flash can be a lifesaver in many photo situations, both indoors and outside. Compact and lightweight, dedicated flash emits a great amount of light that approximates the color of daylight. Rather than pointing your flash directly at a subject, try using a diffusing panel (many flash units come with this device), or bounce flash off a wall or ceiling to modify the light. When flash is bounced off a ceiling or wall, it spreads over a wide area and strikes the subject from many different angles, producing soft, even illumination. When light is bounced off a ceiling, it emulates room light from above. When it's bounced off a wall, it sometimes resembles soft window light. In this image, the photographer used flash indoors — as well as a very shallow depth of field — to emphasize this child's beautiful blue eyes. If you look closely at this (and other pictures taken with flash), you can see the flash in the subject's eyes, called a catch light.

Photographer's Comments
"Julia is seven years old and is my friend's daughter. She is accustomed to being photographed and is very relaxed in front of the camera. She opens her eyes wide when she's having her picture taken. My intention was always to show her beautiful big blue eyes."

Technical Data
Canon EOS 5D digital SLR
Tamron 25-75mm lens set at 68mm
1/64 of a second at f/2.8
ISO 400
Canon EX430 flash unit

This is a very appealing portrait of two young brothers, but even more so, a unique portrayal of an up-and-coming newborn as part of the family unit. This is a very inventive way of including an unborn family member in a family portrait. I like the camera level at the children's perspective, as well as the impish smile of the boy who's holding up the image of the ultrasound. Natural looking portraits like this one still take a lot of planning, and the photographer engaged the little boys in conversation to get some great expressions and draw out their reactions to the new sibling. The soft, yet directional light creates very effective separation between the children and the background.

Photographer's Comments

"Because I enjoy documenting family milestones, I hoped to capture the evolving family relationship for these two brothers by incorporating their new sibling's first ultrasound. I chose a simple background and clothing to bring the focus to the subjects and used directional lighting to give depth and mood to the photo. An antique table placed directly next to a window raised my little subjects to sit in the perfect light. As I asked the older brother to show me the image of his newest sibling, I talked to both of the boys about how they felt about the family's new addition. The resulting image of an exuberant older brother and a pensive younger brother was priceless."

Technical Data

Canon EOS 5D digital SLR
Canon EF 85mm lens
1/250 at f/3.2
ISO 500
Natural window light

"A New Addition"
© *Stacy Wasmuth*
Indianapolis, Indiana
www.bluecandyphotography.com

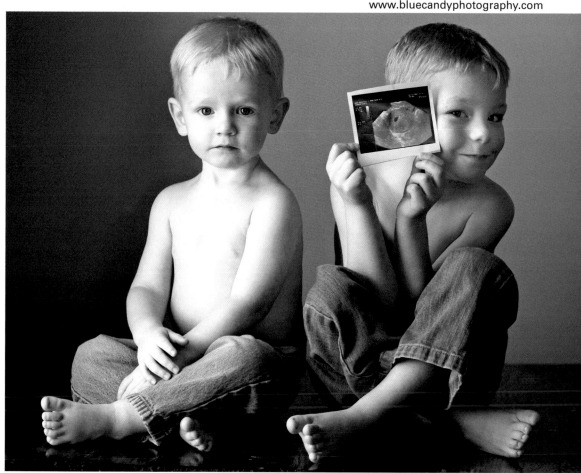

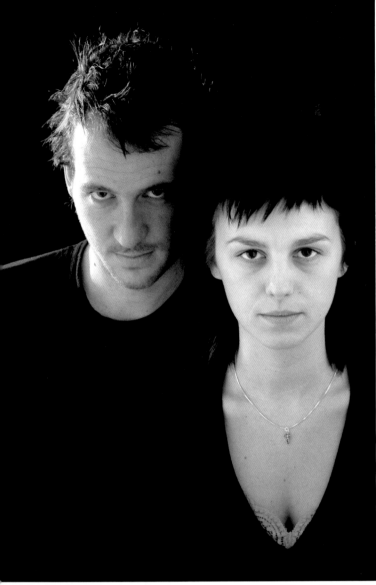

"Stef"
© *Ann Snoeck*
Bruges, Belgium

Although this couple is looking directly into the camera rather than at one another, there's still a sense of subtle intimacy between them because of the close proximity of their faces and the expression in their eyes. When photographing a couple, your goal should be to capture the feelings between them, whether it's in a posed portrait or candid shot. You don't want people to be standing stiffly in front of the camera. In a posed portrait, it's best to create a composition that's pleasing to the eye with one subject just slightly higher in the frame than the other. In this case, the man's mouth is aligned with the woman's eyes, which is generally a good way to portray two people together. You can also have the man stand on a step just behind the woman.

Photographer's Comments

"The picture was taken for this couple's wedding invitation. With few words, they gave me carte blanche to 'do whatever you feel!' Because these two people have something special and mysterious, I make them speak in this image with their eyes. I used a very small photo studio for this photo session. There was one softbox light behind the couple, and two reflection panels placed diagonally in front of them. I measured the reflected light off the panels on their faces."

Technical Data

Nikon D100 digital SLR
Nikkor 24-120mm f/3.5-4.5G ED-IF VR zoom lens set at 70mm
1/60 of a second at f/5.6
ISO 200
Studio lighting

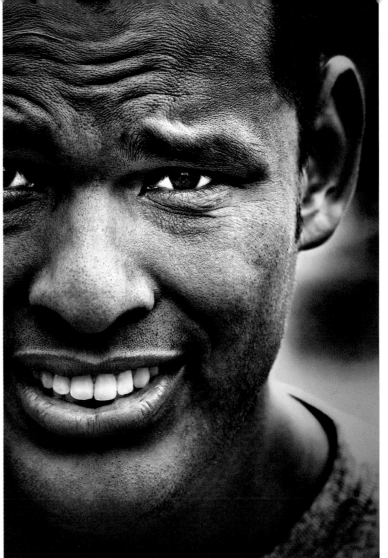

"Hockey Player"
© Yves Rubin
Los Angeles, California
www.rubinphoto.com

A person's facial expression can speak volumes about what they're feeling, and often reveals something about his or her personality. Faces are capable of a vast array of expression, much of it subtle and fleeting. So often, we don't study people's faces, especially those of people we already know, and we don't notice their changing expressions. To capture the essence of an individual, you must reveal the qualities that make that person distinct, as well as those qualities to which others can relate. This unique image is cropped in very close to emphasize the hockey player's intense expression after playing a rousing game on a hot day, and says far more about this young man's passion for the sport than would a portrait of him grinning at the camera.

Photographer's Comments

"The subject and I play rollerblade hockey together. After a hard-fought game on a rather hot Southern California morning, Edward's intense expression from the play was striking. Although I took this picture under a hazy midday sky, light happened to be well-suited for the intensity of his expression. I intended to render this picture in a monotone or black-and-white from the start."

Technical Data

Canon EOS 1Ds Mark II digital SLR
Canon EF 70-300mm f/4.5-5.6 DO IS USM
Zoom lens set at 260mm
ISO 200
1/40 of a second at f/11
Natural light

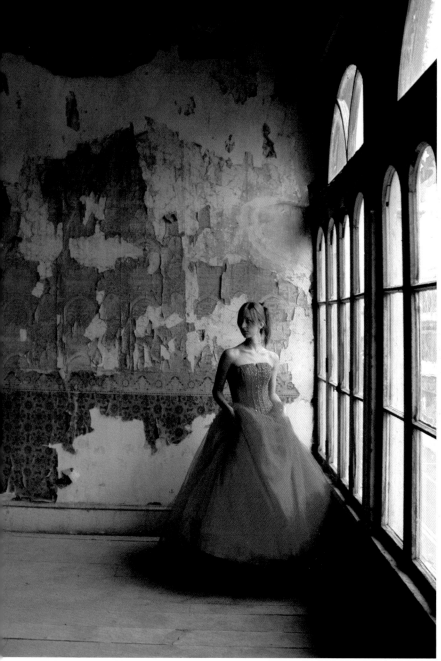

A portrait can tell a story when you put a subject in an interesting setting, such as this one, which blends new and old elements to make a statement about a former dance hall. When planning a portrait like this, keep it as simple as possible. Pictures that work best are those that convey their message quickly. Include only the elements that serve to make your intended statement. This photographer kept the composition simple and included just enough of the background to tell a story. The light coming in through the window serves as flattering illumination for the model, and her red dress is a welcome bright spot amid the drab interior.

Photographer's Comments

"It is believed that the abandoned loft on the third floor of our studio was once a beautiful dance hall for a lodge in the late 1880s. Now, the ornate wallpaper with its North African motif is tattered and torn, which was the perfect setting to create a photograph of a model in a prom gown, reminiscent of a bygone era. Although much has changed in the time since, the juxtaposition of past and present speaks of the transient nature of beauty and the profound choices that must be made in any age regarding the future that awaits."

"AWAITING"
© *Gordon R. Wenzel*
Danville, Pennsylvania
www.impressionsphoto.net

Technical Data

Nikon D100 digital SLR
Nikkor 18-70mm zoom lens
set at 18mm
1/60 of a second at f/4
ISO 640
Natural window light

"Counter Culture #17"

© *Robert Michael*
Hackettstown,
New Jersey

Some of the most revealing portraits are those that show what a person does for a living. Nearly every occupation has a distinctive tool, setting or clothing that can be used when photographing a person at work. As most workplaces are indoors, this may necessitate a flash or studio lighting, as this photographer used in his photo series about service personnel in a particular town. When you're making a statement about the person's surroundings at work, you may want to use a wide-angle lens. But in potentially hazardous places like construction sites, you need to keep your distance and use a long telephoto lens. Remember that at many workplaces, you probably need to get permission before you begin shooting.

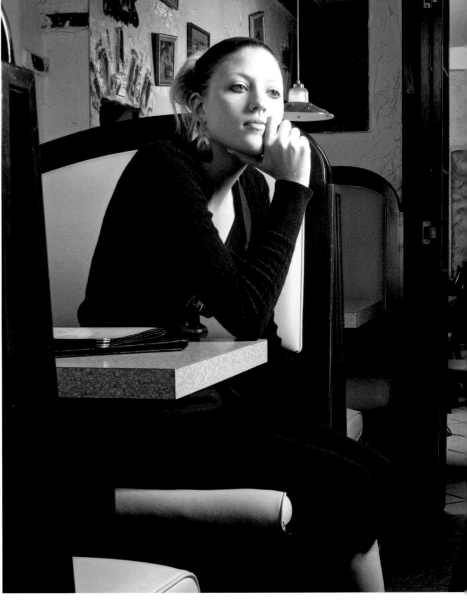

Photographer's Comments

"'Counter Culture' is an ever-evolving series of portraits. In the beginning, the goal was to represent people on the verge of their dreams, yet still doing what was necessary to survive. Counter Culture has emerged as a portrait of a town and a time, as a salute to those who make life better for us all. These subjects make our daily coffee, prepare our food, service our cars and build our kitchens. Some subjects are business owners, others work to get by until their dreams are realized. These are the people who make a town interesting and unique."

Technical Data

Canon EOS 1Ds Mark II digital SLR
Canon EF 50mm f/1.8 lens
1/60 of a second at f/8
ISO 100
Hensel softbox main light set at f/8, umbrella fill light set at f/2.8

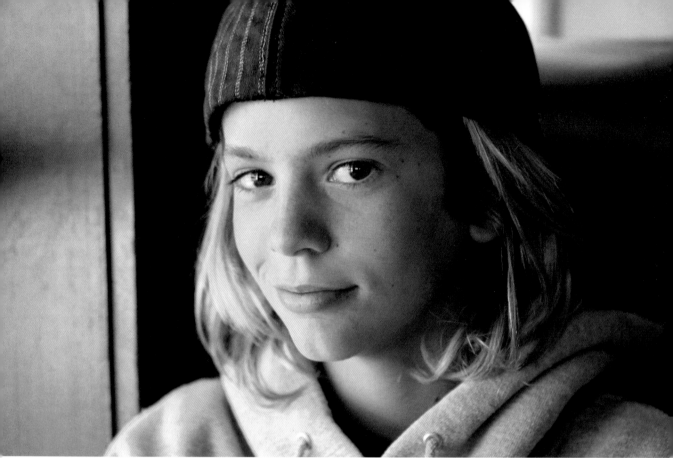

"MICHAEL"
© *Jody Gomez*
Murrieta, California
www.jodygomez.com

Taking indoor photos can be a challenge, particularly because of the relatively dim light. You can always use flash, but if the conditions are right, you can get great images of people using soft, indirect light coming in through a window. Sometimes light from a window can be very directional, and the shadow side of a subject's face may appear too dark. One solution for this is to use a reflector, or position your subject so that their face is turned towards the window. In this portrait, the soft light wraps around the boy's face nicely and renders soft shadows (sometimes called "modeling") on the shaded side. Harsh, on-camera flash would destroy this pleasing effect.

Photographer's Comments

"My 13-year-old son, Michael, and I were on our way home from a mountain bike race in Sonoma, California. We decided to stop in San Francisco and spend the day exploring the city. We stopped at a wonderful Italian restaurant on the pier. While waiting for our food, Michael and I amused ourselves by taking silly photos of each other and watching the fish in the harbor. It was then that I noticed the light from the window kissed Michael's face in a way that reminded me of all the sweetest moments I have ever experienced as a mother. I wanted to capture the essence of our perfect day and those sweet moments, and this image does just that."

Technical Data

Canon 20D digital SLR
Canon EF 24-70mm f/2.8L zoom lens set at 63mm
1/30 of a second at f/2.8
ISO 100
Window light

This portrait of an elderly woman is very successful because of the photographer's use of soft, diffuse light coming in through a window. The shadows in this photograph serve to create a frame around the subject's face, which is full of character. One of the primary ingredients in taking a good photo of an older person is the quality of light. Direct light brings out every line and wrinkle, so you may want to avoid this harsh type of illumination unless you want to emphasize the passage of time. Diffuse light, on the other hand, softens lines. This light is more flattering to a subject without concealing the effects of age that reveals an older person's character and experience. To flatter your subject even more, you might consider using a diffusion filter or adjust with image-editing software.

Photographer's Comments

"This is my Grandma. She is 85 years old and I think she's so beautiful. She's had a long and hard life, but nonetheless, she is still a strong person who travels and runs around like a 60-year-old woman. She never gets tired. I wanted to show her beauty and the good that you can see in her eyes. I took this photo in my living room with window light coming in from the right, and the sun outside created a nice shadow in the room. I also like the catch lights in her eyes."

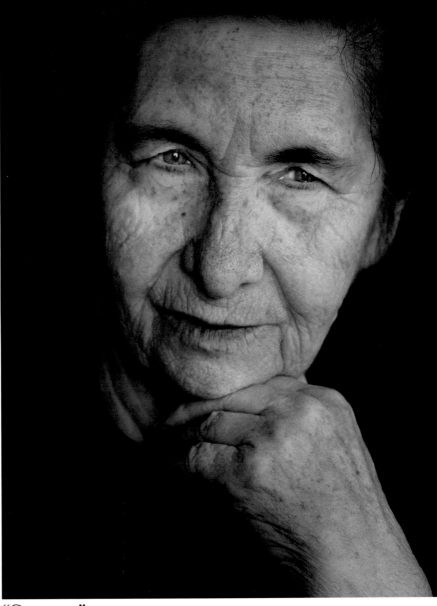

"GRANDMA"
© *Monika Manowska*
Nacka, Sweden

Technical Data

Canon EOS 350D digital SLR
Canon EF 60mm macro lens
1/250 of a second at f/2.8
ISO 800
Window light

As joyful occasions that bring family and friends together, weddings offer many opportunities to take pictures. In most cases, you shoot both candids and portraits. Because weddings progress in a predictable manner, you should plan what you're going to shoot and where to position yourself beforehand. Start with the bridal party getting ready and the nervous groom before the event, ending with the reception. Digital imaging offers the versatility of shooting at a high ISO indoors, where you may have to shoot without flash, to outdoor locations where you can use a slower ISO. But unless you are the photographer hired to shoot the wedding, always stay out of the professional photographer's way. Take your photos only when he or she is finished.

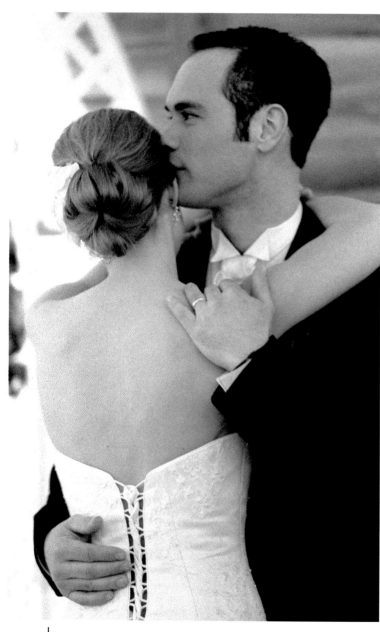

Photographer's Comments

"I was taking black-and-white candid images for a wedding that was being formally photographed by a friend of mine. He gave me the opportunity to take some pictures, as he knows the kind of portraiture I enjoy doing. The lighting for this shot was extremely harsh; a brightly colored room, fluorescent ceiling lights and a very small area for dancing. The bride and groom didn't dance for very long and I managed only three shots, the best of which is 'first dance.' At the time I took it, I felt that I had gotten the shot I wanted."

Technical Data

Pentax MZ50 SLR
Pentax 35-80mm Zoom lens
Kodak T-Max 3200 black-and-white film
Exposure unrecorded
Available light

"FIRST DANCE"
© *Heather Maslen*
Anchorage, Alaska
http://heathermaslen_photography.
photoworkshop.com

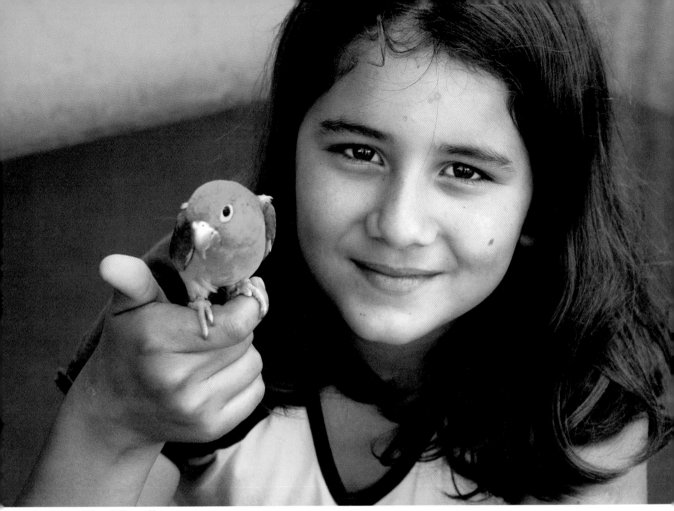

"LA NINA"
© Christine McDonough
Salt Lake City, Utah
www.ChristineMcD.com

You can capture an appealing, unself-conscious photo of a child when you choose an appropriate, uncluttered setting. Encourage him/her to get involved with an activity, or with a prop or pet, like the parrot that this little girl shows off proudly. All of the colors work well in this image too, from the blue hues in the background to the child's yellow top and green parrot, which is set off nicely against the red floor.

Photographer's Comments

"In the summer of 2006, I went with a group to Costa Rica on a Habitat for Humanity Global Village build. For a week, we worked daily with the families who were to live in the homes we helped build, and found some of the most congenial, hard-working, and beautiful people. While we worked, we also played with the neighborhood kids, who had a most special kind of beauty and joy. The first Spanish phrase I used was 'Puedo sacar una foto?' (May I take a photo?), and most people in the neighborhood would see my camera, run over excitedly, and pose themselves or their children for many pictures. Everyone was eager to see their image on the digital screen, and they would laugh and giggle, then insist on posing for more!"

Technical Data

Nikon D70 digital SLR
Nikkor 18-70mm f/3.5-4.5G ED-IF AF-S DX zoom lens set at 65mm
1/160 of a second at f/6.3
ISO 800
Natural light

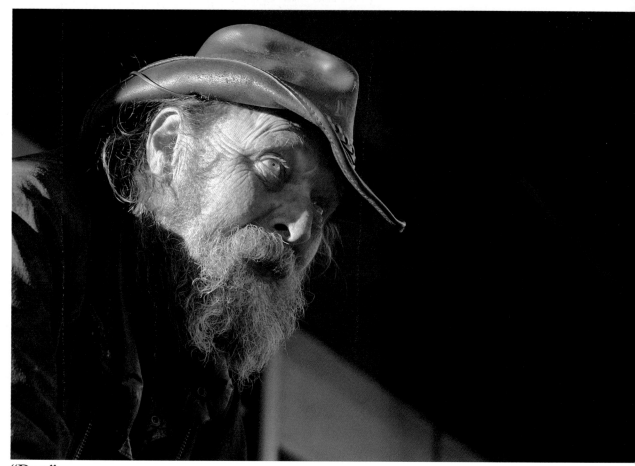

"Dan"

© Christian Goltz
Davis, California
www.kiss-of-light.com

One of the biggest considerations when photographing an older person is lighting, and how you want to depict the individual. Harsh lighting from the sun or a flash tends to bring out every wrinkle on a mature person's face. Soft, diffuse light gently fills in furrows, but the lines of a person's face can also reveal character. This photographer captured his elderly subject with areas of both light and shade on his weathered face. The sepia tone also makes a statement about a bygone era. Interesting subjects like this one don't come along that often, and the photographer quickly seized a great opportunity to capture a bit of history.

Photographer's Comments

"I usually shoot landscapes. That afternoon, however, I was roaming around in Old Sacramento, a recreation of the Sacramento of bygone days. The buildings were nice, but what were missing were the people of Old Sacramento. Then I saw Dan, leaning on a wooden barrel and smoking a cigarette. I asked permission to photograph him, set my camera on continuous mode, and fired away. This frame was the only one in which he opened his eyes wide for a brief moment. I was lucky that the sun illuminated his eyes this way. Another photographer showed up and drove Dan away. I was only able to speak to him again some weeks later at the same spot. If Dan's face isn't a landscape, then I don't know what is."

Technical Data

Canon EOS 5D digital SLR
Canon EF 24-70mm f/2.8 L zoom lens
set at 62mm
1/125 of a second at f/4.5
100 ISO
Natural lighting

"WARLORD"
© Roger G. Barry
El Sobrante, California

As the key ingredient in photography, light illuminates, shapes and defines subjects. The sidelighting from a studio softbox brings out shadow detail in this young man's face and body, while a tungsten light provides subtle lighting on his back. Straight-on light, like that of an on-camera flash, would have flattened the image. The photographer has chosen to light only the subject's skin, allowing his dark hair to fade gradually into the black background. Whether you choose to control light or to utilize the variations of natural illumination, you should learn to become sensitive to the emotional qualities of your photograph that derive from the way it was lit. Also, it's important to understand light and its effects well enough so that you know how the subject will look in the resulting image.

Photographer's Comments

"I first saw Eugene celebrating with a group of young Korean professionals in Oakland's Jack London Square. My immediate vision was of a young warlord and his retinue. In reality, he is a stylist and this was an office party. The lesson: Don't let reality interfere with vision."

Technical Data

Canon EOS 5D digital SLR
Canon EF 35-80mm zoom lens set at 53mm
1/30 of a second at f/9.0
ISO 200
500-watt Lowell Tota light with Photoflex softbox for main light
1000-watt Tungsten worklight behind a cotton muslin gobo for light on the subject's back

"ALANI"
© *Pei-Pei Ketron*
Fremont, California
www.penelopesloom.com

It's usually advisable to photograph children from their level, but in this case, the photographer purposely shot the image from above to emphasize the wide-eyed innocence of a small child. Shooting down from a high vantage point is a great way to show a child from an adult's perspective. She's used a wide-open aperture very effectively, which throws the rest of the image out of focus. As this appealing portrait reveals, it's a good idea to experiment with camera angles and levels when photographing children.

Photographer's Comments

"I was photographing Alain's four-week-old baby sister, Ava, while Alani and her older sister Aubrey played outside. Ava became cranky and needed to be fed, so I took a break from taking her picture and went outside to photograph the two older girls. The light in the shade of the house was ideal for portraits. I wanted to get a shot of Alani that played up her eyes, so I stood on a lawn chair and asked her to stand directly below me so that I could look down on her. Using my 50mm lens wide-open at f/1.8, I focused on her eyes and took advantage of the shallow depth of field, allowing everything else to fall out of focus. I was able to get the shot I wanted — one where she is staring intensely at the camera with the wide eyes of a child."

Technical Data

Nikon D200 digital SLR
Nikkor 50mm f/1.8 lens
1/500 of a second at f/1.8
ISO 200
Open shade

The vantage point from which we choose to shoot a picture is important, yet we typically shoot from our own eye level. Next time you photograph someone, try moving around your subject, shooting from different angles. Try shooting down from a high position (as this photographer did), or shooting upward from a low vantage point. Move close and farther away. You'll probably discover some interesting shifts between your subject and the background, allowing you to make different statements about the environment you're shooting in.

Photographer's Comments

"It's all in the face. I met Matt Pelliccia a few years ago during his graduate vocal studies at the University of Utah, while we were both cast in the Utah Opera chorus. We became friends, and often understood each other with a mere wink, crazy face, or pose. He now lives in New York, pursuing a singing career as a tenor, and I see him infrequently. He's one of those people with a liquid face, who can display or hide any emotion or thought. We were wandering through the Salt Lake City Main Library — an award-winning, architecturally stunning building — just taking pictures. Here, the library's fourth floor stairway leads up to the roof access level, and the lighting fell perfectly on his fantastic face as he looked up at me. The situation demanded I take a photo."

Technical Data

Nikon D70 digital SLR
Nikkor 18-70mm f/3.5-4.5G ED-IF AF-S DX zoom lens set at 48mm
1/30 of a second at f/4.5
ISO 1000
Natural window light

"MVP1"
© Christine McDonough
Salt Lake City, Utah
www.ChristineMcD.com

There are several ways to emphasize the small stature of a child in an adult's world, like shooting down on a child from above. The photographer chose to focus on the shy-looking toddler in this picture, who is holding the hands of her parents who appear much larger by comparison. By moving down to the little girl's level, you get a sense of what life is like from her perspective. Also, you don't need to see the parents' faces to know that there's a lot of affection in this family, and this image conveys a sense of trust. This is a more striking family portrait than had the photographer taken a traditional approach.

Photographer's Comments

"Sometimes bits and pieces of a portrait can tell a big story. I especially enjoy "feet" family portraits because they convey both a small child's size and view of the world. For this image, I chose a plain wall and floorboard as a simple backdrop and relied on a window behind and to my left as the light source. It was early in the photo shoot, and the toddler was still slightly apprehensive of me and my camera. I asked both parents to hold their daughter's hand as she stood. Once she found herself securely placed between mom and dad, she felt comfortable enough to flash a shy grin at me. The result was adorable!"

Technical Data

Nikon D200 digital SLR
Nikkor 50mm lens
1/250 of a second at f/3.2
ISO 640
Natural light

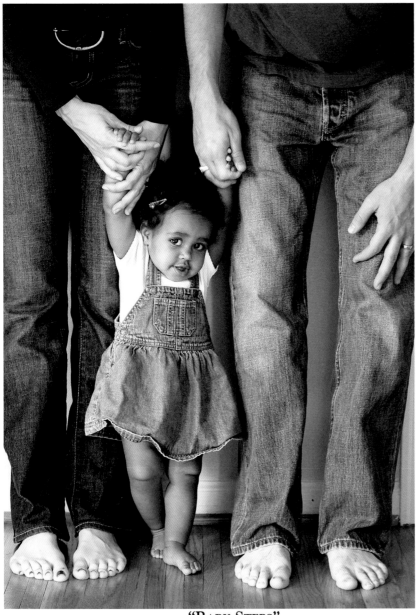

"Baby Steps"
© *Stacy Wasmuth*
Indianapolis, Indiana
www.bluecandyphotography.com

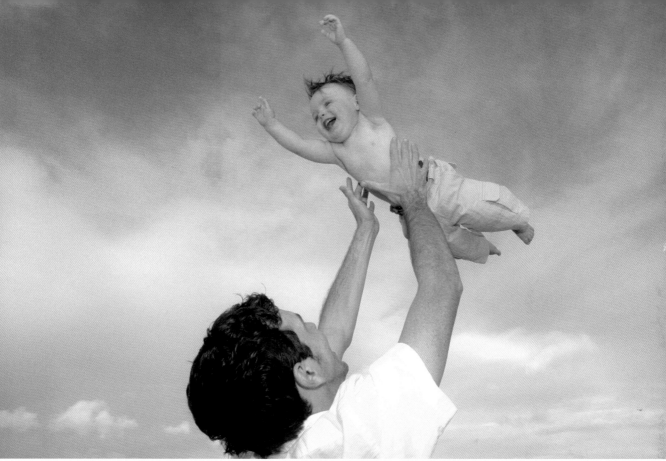

"Joy"
© Dan Barnett
West Palm Beach, Florida
http://danbarnettphoto.com

Photographing a parent and child together is always rewarding, as the relationship between them is unlike any other. In most cases, infants and toddlers can be easily photographed on their parents' laps or in their arms. However, try to avoid shooting a snapshot that looks too static. You can break out of this mold by exploring what's special about the parent-child relationship that you're photographing. Do they enjoy a particular activity? A father and son fishing together, for example, can yield some great candid moments. This delightful image expresses a toddler's gleefulness at being tossed up in the air by his father. And you can't help but smile at this wonderful photo, which takes family portraiture a step beyond by capturing a precious moment that can't easily be recreated.

Photographer's Comments

"While photographing a family portrait session at the beach, I suggested that the father toss their little son, Charlie, into the air. As a parent of four, I knew that kids at this age love to 'fly' like this. Whenever I work with families, my job is not simply to shoot nice pictures that the client will be happy with for a week after the photo session. Instead, I'm creating heirlooms that will be cherished for generations. My inspiration is to create an image that will be treasured long after I'm gone."

Technical Data

Canon EOS 1D Mark II digital SLR
Canon EF 17-40mm f/4.0 L zoom lens set at 17mm
1/800 of a second at f/8
ISO 200
Natural sunlight with fill-flash from a Canon 550 EX Speedlite

The tight composition of this woman's face and shoulders conveys a feeling of intimacy. And the studio flash creates a soft light that dissolves into just the right amount of soft shadow and "modeling" on the opposite side of her face. Revealing only a small part of the body and the mere suggestion of nudity can also be very sensuous, as this photographer indicates. To be effective, this type of image should be simple and uncluttered to convey a feeling about the subject's mood and individuality. The model should also feel relaxed and appear natural in front of the camera. The background you choose is important and can help to express the feeling you want to get across.

Photographer's Comments

"When I was working as a fashion photographer, I occasionally crossed over into glamour photography, and discovered that it didn't do much for me. I decided that instead, the allure of shooting nude photos has something to do with the anticipation. The most important part of a photograph can be the bits you fail to reveal. This image, for example, is a standard head-and-shoulders portrait that works particularly well because it looks as if the model might be naked (but she's not — her top starts a fraction of an inch below the frame of the photo), which adds an extra layer of complexity and titillation."

Technical Data

Canon EOS 30D digital SLR
Canon EF 28-135mm f/3.5-5.6 IS Zoom lens
1/60 of a second at f/9.5
ISO 100
3X Bowen 500W flashguns

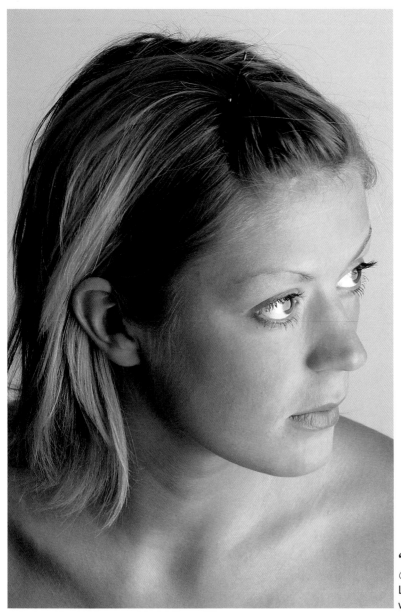

"Lucy"
© *Haje Jan Kamps*
London, England
www.photocritic.org

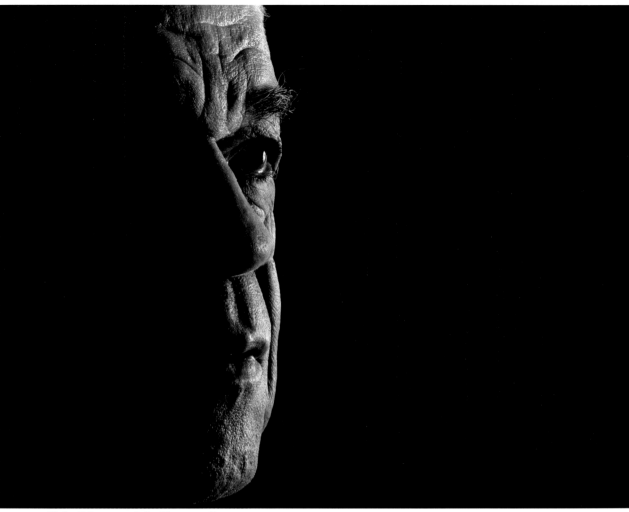

"My Uncle, My Friend"
© Jim Williams
Winston-Salem, North Carolina
www.creekridgestudio.com

Subtle differences in lighting and other elements can change the feel of an image altogether. In order to want to emphasize a particular mood, you must make certain creative adjustments. You need to learn to visualize what your picture will look like so that you can successfully manipulate its mood. One way to do this is by changing the light. This dramatically sidelit, shadowy portrait imparts somewhat of a melancholy feeling. Only a small portion of the subject's face is illuminated, just enough to reveal a little about his character. This is a very powerful image.

Photographer's Comments

"As the title suggests, he was more than my uncle, he was my very best friend. When I took this photo, he was 88 years old. Unfortunately he passed away less than a year later. I can see his wisdom and kindness in the photo, which brings to mind all of the special times we shared. I am a very lucky man to have grown up with not just one father, but two who loved me dearly."

Technical Data

Nikon D70 digital SLR
Sigma 70-300 D APO zoom lens set at 120mm
1/80 of a second at f/13
ISO 200

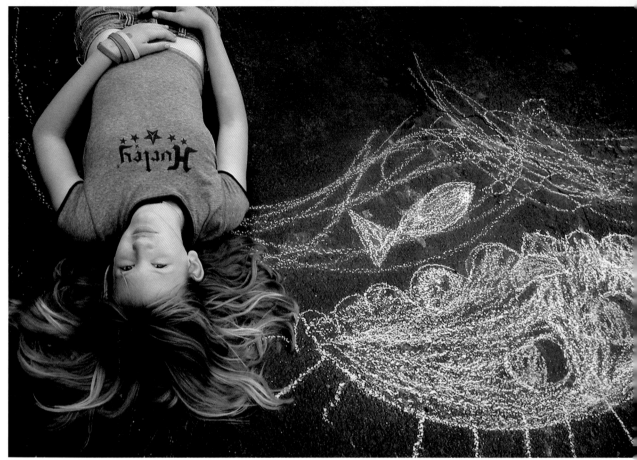

"Mermaid"
© *Debra Tomaszewski*
Kentfield, California
www.debratomaszewski.com

Including something of a child's environment or interests makes a statement about his or her individual personality. To capture a child's world, you must avoid imposing an adult's view of children. Instead, look for activities, toys or locations that offer interesting information about kids. As this photo demonstrates, shooting an image of the little girl with her artwork is very intriguing because her drawing tells us a lot about the talent and imagination of this youthful artist. This image is even more creative because the photographer chose to photograph the little girl from above, upside-down next to her colorful work. When you take pictures of a child and his or her environment, it's best to use a wide-angle lens to encompass all of the important elements of a scene.

Photographer's Comments
"My 11-year-old daughter was drawing with sidewalk chalk on our driveway when she created this sketch of a fish swimming in the ocean with a happy sun in the sky. I asked her to lie down next to it so that I could take a picture. Her hair spread out and she looked like a mermaid under the water. I loved the contrast of the child-like drawing next to the budding adolescent. It was the perfect metaphor: My 11-year-old daughter was growing up and swimming away as the world and I smiled down on her. I quickly clicked the shutter."

Technical Data
Olympus Camedia C-2000Z digital SLR
Built-in AF 6.5-19.5mm zoom lens
1/250 of a second at f/2
ISO 100
Natural light

Of course, the main focus of a wedding is the couple, particularly the bride. Many photographers photograph the bride alone in a portrait before the ceremony. In this lovely image of a bride on her special day, the photographer decided to utilize the architecture of the hotel and consequently, the city where the wedding was to be held. It provides a great backdrop besides showing the setting of the event, as well as the surrounding architecture. By using only the diffuse window light coming in through the window, the bride is rendered almost in silhouette, except for her beautiful white gown. This image probably serves as one of the couple's fondest memories in their wedding album.

Photographer's Comments

"As I started to do more destination weddings; I was hired to this one in Charleston, South Carolina. The wedding was held in a beautiful downtown hotel with great architecture. This image was taken in the room where the girls were getting ready. I saw this door and positioned the bride in front of it and shot several frames. The wedding was an elegant, yet simple event, and this image reflected the romantic feeling of the entire day. Laura was a gorgeous bride who worked very well in this spot — the image takes on a classic — almost fashion-like — pose and feeling."

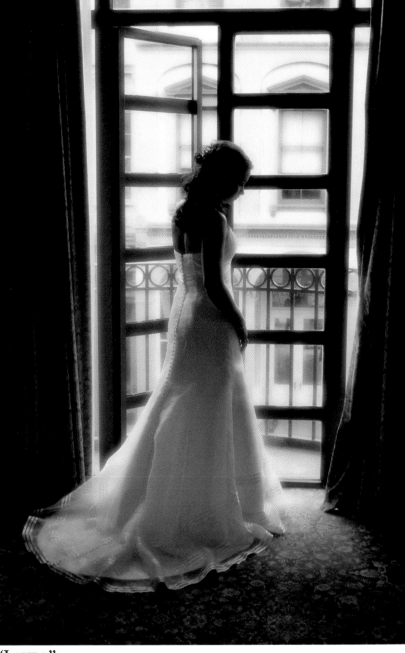

"LAURA"
© Todd Kuhns
Kettering, Ohio
www.studio12online.com

Technical Data

Canon EOS 20D digital SLR
Canon EF 17-40mm f/4 lens set at 29mm
1/60 of a second at f/4
Ambient light

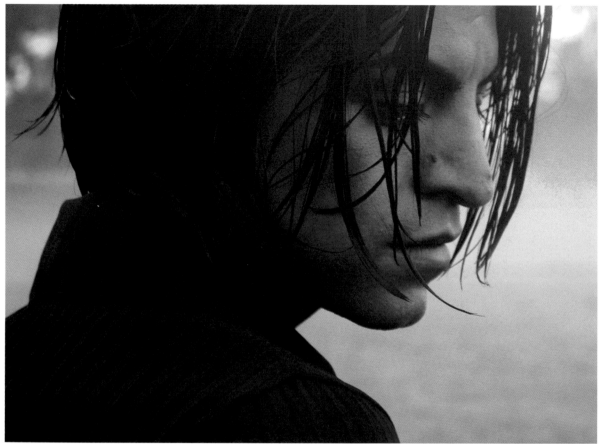

"Blue"
© Edna Eudave
Anaheim, California
www.squareeyephoto.com

When you want to accentuate emotion in a photograph, you can purposely enhance your subject's mood. Manipulating the mood of an image means making certain creative adjustments like changing the light, utilizing a particular point of view, or cropping your image to alter the spirit of a photo. In this example, the photographer successfully enhanced the "blue" mood of her subject by using the cool tones of a foggy day with lighting, cropping closely on her subject's face, and capturing him with downcast eyes.

Photographer's Comments

"My best friend is constantly asking me to take pictures of him — he's quite vain, but I love him. I didn't have any of my pro equipment with me at the time. All I had was my little Sony Cybershot, but I've always been able to make miracles happen with amateur equipment. I'm a huge Michael Kenna fan. I love the dark, foggy gardens that he has photographed, but because I don't like shooting landscapes, I try to translate this style into portraits. We were at Mile Square Park in Fountain Valley, California, and I knew that it would be foggy until shortly after dawn. I shot about 50 images of him that morning and liked many of the portraits, although this was definitely my favorite. I actually painted this in oil on a large canvas, and it sits on an easel in my living room."

Technical Data

Sony Cybershot compact digital SLR
Built-in lens set at 100mm
1/40 of a second at f/2.4
ISO 100
Ambient light on a foggy morning

Our families are usually our most frequently photographed subjects, and we treasure these photos more than others. We shoot pictures at weddings, of family gatherings, and of course, of our own children. We start taking pictures of them from the time they're born and document important milestones thereafter, on up to graduation and their own parenthood. As I mentioned earlier, it's important to have a camera with you at all times to document these precious times. And, because your family knows and trusts you, you'll have the opportunity to shoot lots of pictures of them and experiment with cameras, lenses, and various photo techniques. Close-up shots are always a great way to really capture a child's personality.

Photographer's Comments

"This photo was taken last fall when I was out with my two daughters at the park. I was trying to take some pictures for Christmas cards when my younger daughter, Grace, gave me this look. I think it really captures the mischief and innocence in the eyes of a seven-year-old having fun with her sister."

Technical Data

Canon EOS Digital Rebel XT
Canon EF 50mm lens
1/3200 of a second at f/2.2
ISO 800
Natural light

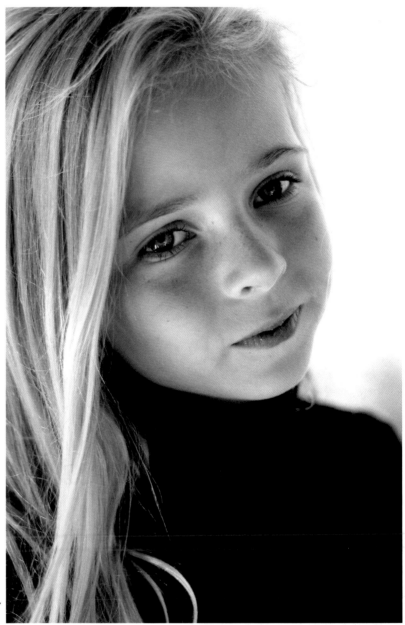

"GRACE"
© *Kristi McCluskey*
Lenexa, Kansas

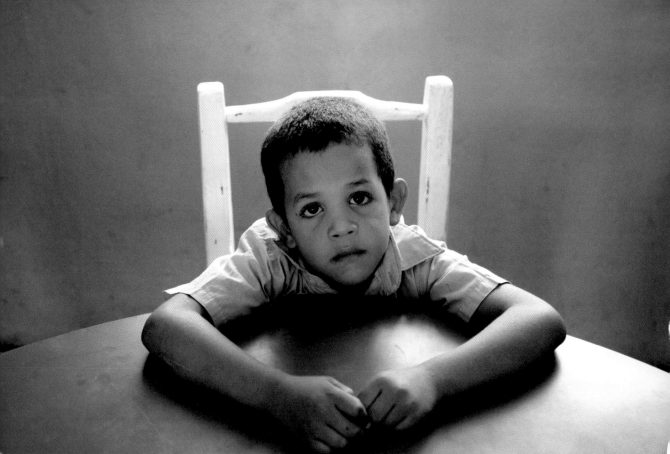

"SCHOOL KID IN DOMINICAN REPUBLIC"
©Timm Vladimir
Denmark
www.globaleye.dk

Children as photographic subjects can be endlessly fascinating. Unlike adults, they're non-pretentious, spontaneous, and curious. In this informal child's portrait, the photographer has included just enough of the simple setting of a classroom to form a pleasing, non-distracting visual composition. The boy also appears to be very small, sitting at a table made for adults. You can also use architectural details like doors and windows to emphasize the relatively small size of a child, as well as to provide framing elements. And, as you can see, you don't always have to ask a child to grin for the camera in order to get an appealing photograph. Remember that children's attention spans are brief, so be prepared to work quickly.

Photographer's Comments

"While traveling through the Dominican Republic, I visited a school sponsored by the fair trade system in a poor, banana farming community. Without the fair trade money, schools wouldn't exist in areas like this one. The first student I photographed was this little fellow. He looks a little apprehensive, but then again, the only white man that these children were used to seeing was the local doctor. So the boy thought I was there to give him a shot. And in a way, you could say I was."

Technical Data

Canon EOS 1Ds Mark II digital SLR
Canon EF 24-105mm L series IS zoom lens
set at 50mm
1/60 of a second at f/4.5
ISO 320
Ambient indoor light

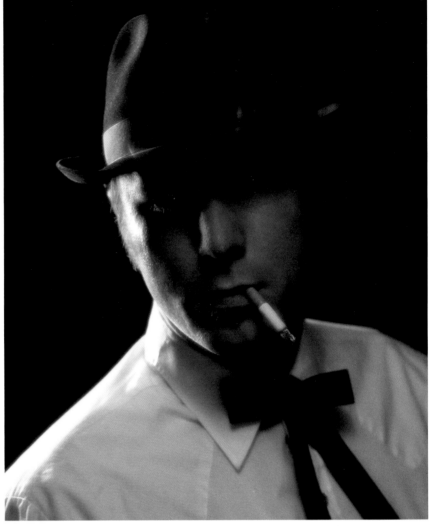

"Self Portrait"
© *Denny Mack*
Austin, Texas
http://deadsailor
productions.com

Many people who love shooting portraits create a self-portrait at some point in time. Usually, these images say something about the photographer's personality. But you can also make a statement by acting out a role, as this photographer did. In learning how to render his models as classic movie stars, he practiced the lighting and style by photographing himself in this manner.

Photographer's Comments

"At the time I took this photograph, I was deeply interested in the old Hollywood-type portraiture as done by photographer George Hurrell and the lighting of film noir motion picture directors, Robert Siodmak and John Huston. I was captivated by their use of dark backgrounds, directional lighting and the way the shadows and highlights gave the images an air of mystery. I planned to do this type of photo shoot, so in order to be prepared for the models, I set up my camera on the tripod and did some test shots of myself using the self-timer. In this shot, I used one flash set up at camera left, just behind my right shoulder. I also modified the light by using a small umbrella to soften the light just a bit while retaining a strong directional quality. On my right side, I clamped a reflector to a light stand to reflect some of the light onto my face."

Technical Data

Nikon D200 digital SLR
Nikkor 50mm f/1.8 lens
1/250 of a second at f/1.8
ISO 100
Spot Metering
Smith-Victor Flashlite 200i with shoot-through umbrella

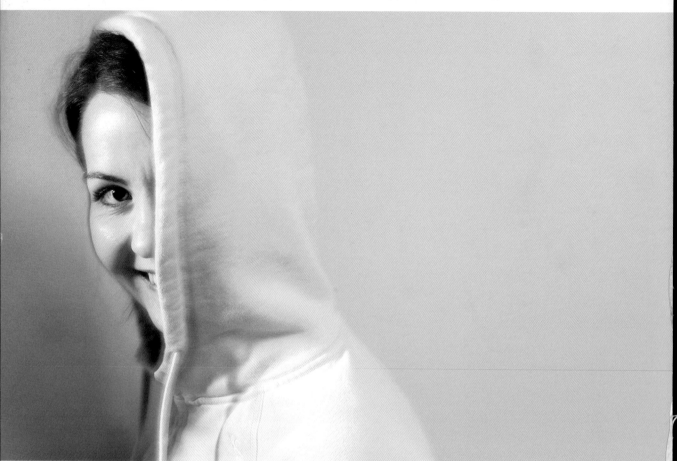

"The Eye"
© Atle Garmann
Bergen, Norway
http://atlegarmann.photoworkshop.com

A good photographer can snap an appealing portrait in a variety of situations. Although the photographer planned this image carefully and used an off-camera flash, this subject appears fresh, spontaneous, and unposed. When shooting informal portraits, you may want to try to use available light as effectively as possible. Indoors, you may want to utilize available light in addition to flash, as this photographer did because he was shooting at a slow shutter speed. Outdoors, you can use the ambient light of an overcast day or open shade to illuminate your subject's features evenly. Simple backgrounds always work well. Here the background is a natural reflector, adding to the cheerful nature of the portrait.

Photographer's Comments

"Last year I went to school in Bergen, Norway, to learn digital photography. One of our homework assignments was to use one of the rules of composition and to do one thing wrong. I used the Rule of Thirds and decided to put the eye you don't see straight into the upper left intersection of the first two lines. The composition works well despite breaking the rules. This beautiful lady is one of my classmates, Elin Anderson, who is a skilled photographer."

Technical Data

Canon EOS 30D digital SLR
Canon EF-S 17-85mm f/4-5.6 IS USM zoom lens set at 17mm
1/15 of a second at f/4
ISO 100
Canon Speedlight 550EX with a small LumiQuest softbox with a white reflector inside, handheld from the photographer's left point of view.

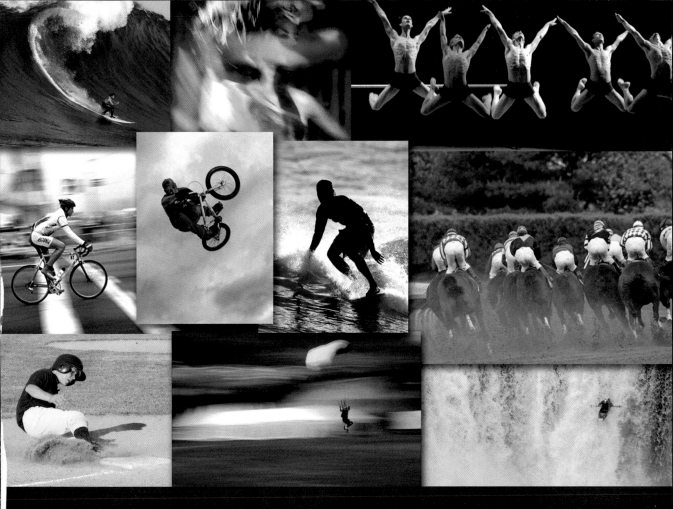

Part 4

Action, Sports, and Motion Photography

Action photos are some of the most exciting ones that we can create. However, portraying action and motion is challenging and requires timing and skill. The first thing you must decide is how you want to portray movement. Some kinds of action are best expressed by freezing their peak moments. You may want to use a fast shutter speed so that every detail is very sharp — a basketball player suspended in midair, or a skateboarder at the peak of his upward momentum. However, at other times you may choose to blur your subject intentionally with a slow shutter speed to emphasize the feeling of motion. For example, you can open your shutter and allow subjects like dancers to move across your frame in a blur of color. Whatever way you choose to portray action, it's fun to experiment with a variety of shutter speeds, vantage points, lenses and styles.

Besides shooting the typical sports action, sometimes it's nice to capture special moments as this photographer did during a Little League game. A fast shutter speed froze the mud spraying from the catcher's mitt, and a long telephoto lens brought the action in close. When using such a long telephoto, sharp focus is critical. For this reason, many sports photographers use a monopod to steady their cameras. A tripod often gets in the way at busy sporting events. When capturing split-second action like this, it's a good idea to use your camera's motor drive or sports mode to shoot several frames rapidly.

Photographer's Comments

"Shooting professional sports doesn't always allow you to be as creative as you would like to be. I

"PLAYING CATCH"
© *Jim Donnelly*
Coral Springs, Florida
www.ImageMastersPhotography.net

bought a Youth Sports Photography dealership, which enables me to be as creative as I like and my clients enjoy the results. The mother of this athlete asked me to get some shots of her son during the inning when he was catching. I set up right behind the pitcher's mound and used the available South Florida sunshine. I knew from being a catcher myself that the clay would explode off the glove when the ball hit it. This particular day, the clay was wet, and it stuck to his glove and popped just as I hoped it would."

Technical Data

Canon EOS 1D Mark II digital SLR
Canon EF 500mm f/4.5 telephoto lens
1/1000 of a second at f/4.5
ISO 400
Ambient daylight

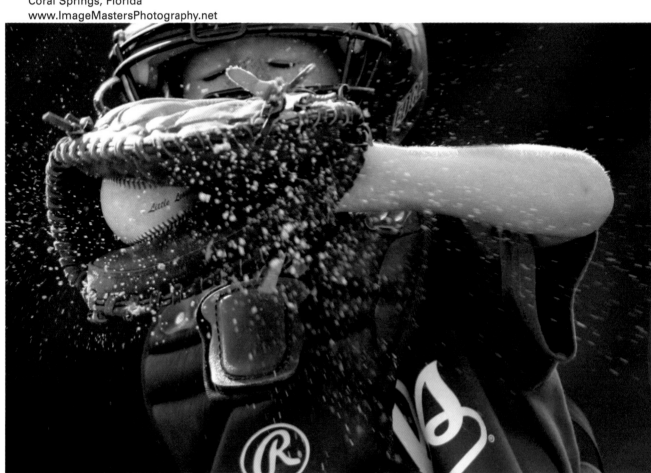

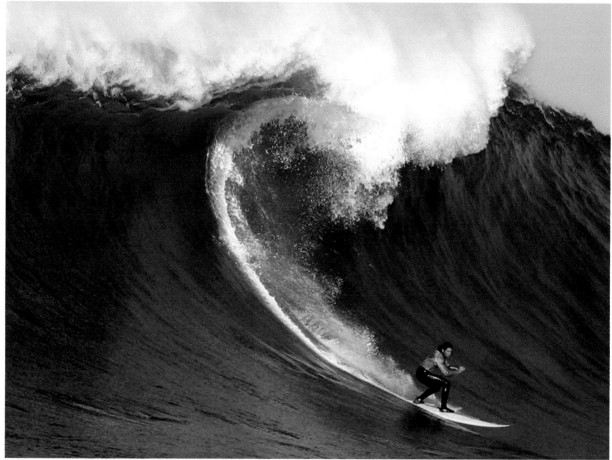

"MAVERICK SURF CONTEST"
© Michael Geib
San Ramon, California

Sports photographers usually rely on super-telephoto lenses to bring the action in close. But as this surfing photo attests, sometimes it's equally important to show an action subject in its environment. The photographer wisely included the wake of the surfboard, which leads the eye up to the froth of the wave above. He also froze the action with a moderately fast shutter speed. You can use a somewhat slower shutter speed (around 1/125) to stop action that's moving directly toward you than you need to stop action moving diagonally across the frame.

Photographer's Comments

"When I retired, I had a list of things I wanted to do, and seeing the Maverick Surf Contest was on that list. To my surprise and delight, I was able to be on a boat for the first runs of the contest off the coast of Pillar Point, about 25 miles south of San Francisco. The contest is held about a mile offshore, and the contestants wear different color wetsuit tops to distinguish who they are for each 'heat.' It's up to each contestant to get as many good runs as they can during the allotted time for each heat. The leaders move on to the finals in the afternoon. Photography topped off a great day of being at this competition."

Technical Data

Canon EOS 20D digital SLR
Canon EF 70-200mm f/2.8 zoom lens with
Canon 1.4X extender
1/200 of a second at f/3.5
Camera handheld
Ambient daylight

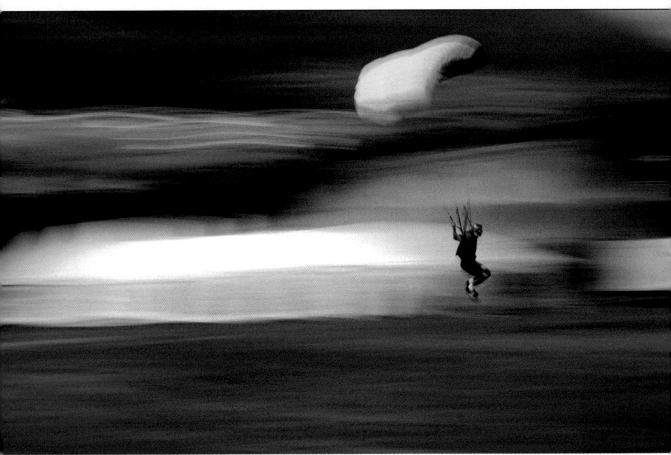

"Parapsychology"
© *Atle Garmann*
Bergen, Norway
http://atlegarmann.photoworkshop.com

One of the most effective ways to depict motion in an image is to follow a subject with your camera during a fairly long exposure. If the photograph is successful, you get a relatively sharp subject against a completely blurred background, as this photographer has achieved. You probably won't render your subject totally sharp, but a little blurring of the subject adds to the feeling of movement. When panning an image, try to choose subjects that are separated from the background, and look for bright backdrops that will produce an interesting color blur. Timing and smooth camera movement is critical when executing a panning technique.

Photographer's Comments
"This image was taken during the extreme sport week in Voss, Norway. I wanted to shoot a panning technique where the background was so blurred you couldn't recognize what it was. These paragliders were landing at 136 km/hour, and I knew that by using a telephoto lens and slow shutter speed, I could get what I was after. I also wanted to avoid positioning the paraglider in the middle of the frame, but rather on the right side, so I could get the most blur behind him. The purple color in the background is actually a tent with blue and red vertical stripes. I only had two opportunities to shoot this image, and this was the second take."

Technical INFO
Canon EOS 5 35mm SLR
Canon EF 75-300mm f/4-5.6 III zoom lens
set at 75mm
1/20 of a second at f/32
Kodak Ektachrome 100 VS film
Ambient light on overcast day

Good timing on the part of the photographer accounts for the success of this image, which is another wonderful depiction of motion. The people are rendered in sharp detail in contrast to the blurred hounds that are rushing forth in this race, a great way to use motion blur. This technique recreates the way that fast-moving subjects appear to us. Again, your shutter speed will depend on how fast your subjects are moving, and in what direction. In this case, a shutter speed of 1/125 was just slow enough to render these fast dogs as a blur while they passed through the photographer's field of view. Shutter speeds below 1/30 will blur motion even more dramatically, but it will be more difficult to render the rest of the image sharp. The closer you are to your moving subjects, the more likely they will be blurred in an image.

"TRAIL HOUNDS RELEASED"
© Alex Stephen
Ayrshire, United Kingdom

Photographer's Comments

"This photo was taken at the Grasmere Show, which takes place annually in the English Lake District. These hounds race each other over a course that begins at the show grounds, goes over several nearby fells (hills), and returns back to the show grounds. I chose this shutter speed to deliberately capture the forward motion of the dogs as they were suddenly released by their owners."

Technical Data

Canon EOS 20D digital SLR
Canon EF-S 17-85mm f/4-5.6 IS zoom lens set at 85mm
1/125 at f/5.6
ISO 200
Light overcast daylight

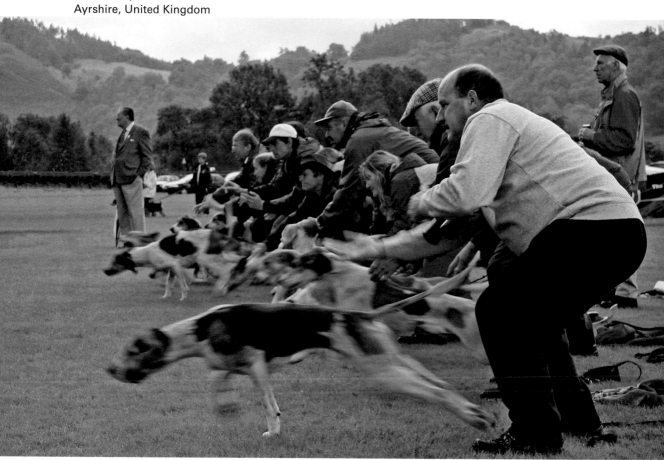

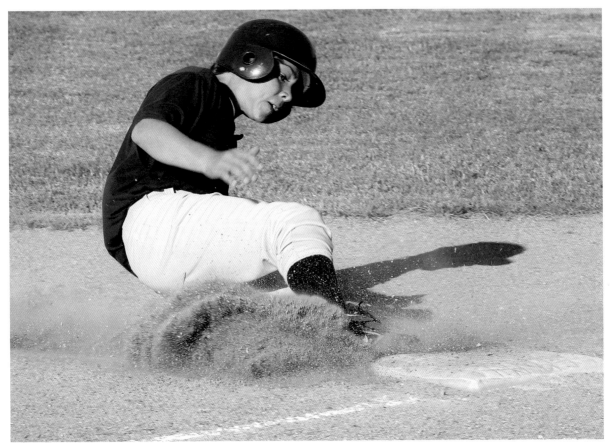

"Safe on Third"
© *Dennis Guillaume*
Elkhart, Indiana
www.guillaume.com

One consideration when shooting sports is getting close enough to the action (either physically or via a telephoto lens). This photographer positioned himself as close as possible to third base. He also fired at five frames per second to freeze the perfect moment of this young baseball player sliding into third base. To stop motion, you need to use a fast shutter speed, which depends on your directional relationship and your distance from the action. You can use a slower shutter speed to stop action that's moving directly toward or away from you than you can use to stop action moving across your field of view. You may be able to freeze the motion of a baseball player running toward you at 1/125, but an athlete who's moving from left to right in the frame may require a speed of 1/1000.

Photographer's Comments

"I was asked to shoot local little-league baseball action photos. This was a regular late-afternoon game with the sun over my shoulder, coming in at an angle. I positioned myself just outside a four-foot fence on the third base line just beyond the base bag. The advantage was being able to anticipate a steal or hit moving the runner from second to third and using a pre-set exposure. Following the runner from second base and firing at five frames per second yielded this shot."

Technical Data

Canon 20D digital SLR
Canon EF 28-300mm f/3.5-5 L IS zoom lens
1/400 of a second at f/11
ISO 400
Manfrotto 680B Monopod
Late afternoon sunlight

A very fast shutter speed and high ISO can enable you to freeze a moment of fast-moving action, like this wakeboarder suspended in midair. Even the spray from the wake below is rendered as frozen droplets. The necessary shutter speed to freeze action depends not only on the speed of your subjects, but also on their distance from the camera. Try a faster shutter speed for subjects that are large in the frame and relatively close such as a shutter speed of at least 1/1000. However you may be able to stop the action of a bicycler off in the distance with a shutter speed of 1/250. Try to anticipate the moment of peak action and click the shutter a split-second beforehand.

Photographer's Comments

"This image was taken from the back of a boat during the annual Southern Plains Festival wakeboarding competition, held in Eufaula, Oklahoma. I have seen some of the most spectacular tricks, as they use the wake from the boat to launch themselves into the air, forming the most beautiful forms of art. The strength and determination that each of them bring to this event is inspiring to all."

Technical Data

Canon EOS 30D digital SLR
Canon EF 70-200mm
L zoom lens set at 98mm
1/2000 at f/4.0
ISO 200
Daylight

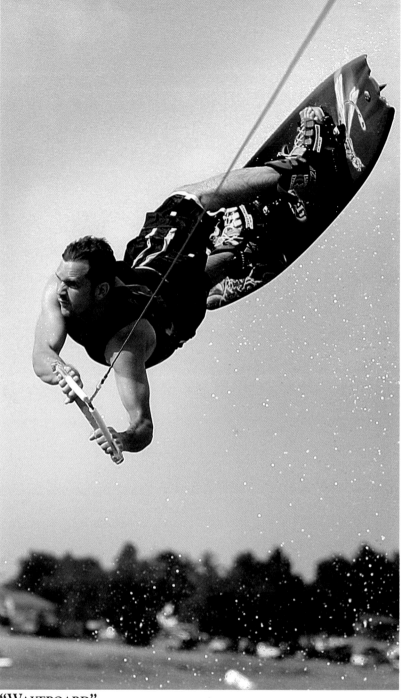

"WAKEBOARD"
© Lisa Butler
Tulsa, Oklahoma
http://lisabutler.photoworkshop.com

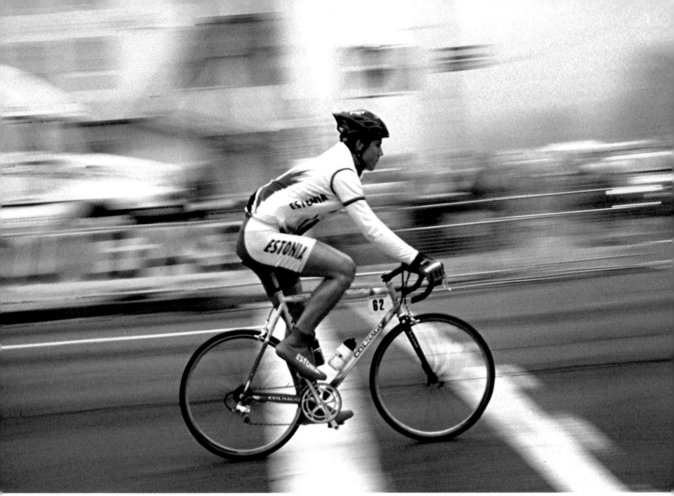

"RACER"
© *John Wallace*
Caledonia, Ontario, Canada

This image of a bicyclist is a good example of panning, which is a great way to infuse an image with a sense of motion. Follow the subject with your camera during a fairly long exposure. Choose a subject that's pretty well separated from its background, and try to find a background that will give you a pleasant blur of color. You've got to use a rather slow shutter speed — such as 1/15 or 1/30 — to pan a subject moving across your field of view. At shutter speeds slower than 1/15, use a tripod or monopod. For a successful panning technique, start following your subject before you click the shutter and continue to follow it after you hear the shutter click. And rather than moving only your head and shoulders, rotate your entire upper body in one smooth movement. Use a slow ISO of 100 or a neutral-density filter (which lets less light into the lens) to avoid overexposure on a sunny day.

Photographer's Comments

"I took this image of a single rider heading to the start line of the World Cycling Championships, a major cycling event in Hamilton, Ontario. I wanted this image to show a sense of motion. By using a slow shutter speed and a panning technique to blur the background, yet render the rider sharp, I was able to portray the sensation of speed.

Technical Data

Canon EOS 3 35mm SLR
1/30 of a second (aperture not recorded)
Fujichrome Provia 100 transparency film
Daylight

A fast shutter speed is the key element in stopping action. In this image, the subject is frozen midway down this waterfall. The water is depicted in sharp detail; you can almost hear the thundering sound of these falls. A good stop-action photo requires planning. This photographer could obviously foresee the path that the subject would take and anticipated this shot. It's a good idea to pre-determine your vantage point, lighting, background and exposure in advance so that you can concentrate on your subject. Use the motor drive or sports mode on your camera to shoot several frames in rapid succession, and learn to click the shutter a split-second before the peak action occurs.

Photographer's Comments

"This is a shot of my brother, Shaun Baker, who is the holder of four Guinness World Records for extreme kayaking. He's halfway down Godafoss (Waterfall of the Gods) in Iceland. We have spent a decade traveling the world to find kayaking challenges, but this remains one of our favorites. When shooting at these dangerous locations, I am very well aware that each shot may be the last one of my brother alive. This brings a lot of responsibility; I never want to be in a position where I put his life in additional danger by having to say, 'I missed the shot — any chance you can do that again?'"

Technical Data

Canon EOS-3 35mm SLR
Sigma 50-500mm f/4-6.3 zoom lens
set at 500mm
1/400 of a second at f/6.3
Fujichrome Provia 100 transparency film
Manfrotto monopod

"HALF WAY DOWN"
© *Darren Baker*
Reading, England
www.darrenbakerphotography.com

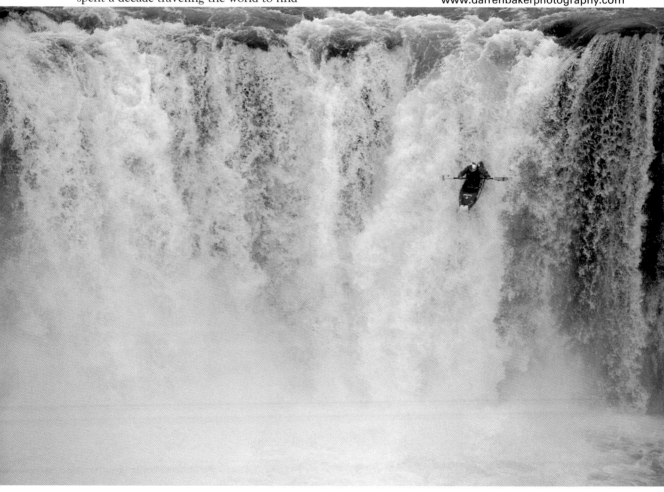

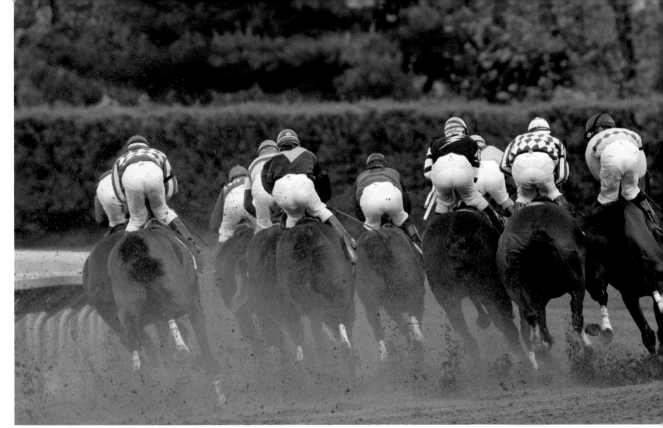

"TURN ONE"

© *Peter Marney*
Hoboken, New Jersey
http://peter-marney.smugmug.com

Shot from a rear view, this image captures all the excitement of a horse race soon after leaving the starting gate. And with the motion heading away from the photographer, instead of moving across his field of view, a shutter speed of 1/500 was perfect for freezing these thundering hoofs and flying dirt. Again, a good stop-action photo requires planning on your part. Venues such as racetracks provide a predictable path where the action takes place, making it easy for you to decide ahead of time where you want to shoot, and to adjust your camera settings. This photographer also used a polarizing filter to saturate colors. This filter also deepens the blue of the sky on a sunny day.

Photographer's Comments

"This image was taken at Monmouth Park Racetrack in New Jersey. I really enjoy photographing horses because of their natural beauty, whether it's racing, jumping, polo or any other event. Thoroughbreds are particularly competitive, so in this instance I really wanted to capture the charge for the lead heading into the first turn. The horses are bumping into each other in a mass as they approach the turn, as you can see with the three horses on the right. The flying dirt and cloud of dust helps to convey the action and high speed as each jockey tries to lead his horse into the winner's circle."

Technical Data

Canon EOS 20D digital SLR
Canon EF 400mm f/4 DO IS lens
1/500 of a second at f/5.6
ISO 400
Available light with a polarizing filter

Besides panning, another very effective way to depict motion in a photograph is by allowing the moving subject to become a blur. The best way to do this is to use a slow shutter speed, but just how slow depends on a number of factors, such as the speed and direction of your subject. A subject that passes across your field of view will blur more quickly than one headed directly toward you. And the slower the shutter speed you use, the more blurred the subject will become. In this case, the photographer used a slow shutter speed of 1/15, but added a little flash to bring out the colors of the rider and his bicycle (but not a strong enough flash to stop the action).

Photographer's Comments

"To me, mountain biking is all about the adrenaline rush of flying down, around, and through something, while maintaining some sort of control though your connection to the ground. I wanted to incorporate the science of photography in such a manner as to accurately portray this motion/emotion to the viewer. This shot was taken at the Mountain Bike Park, on a run called 'No Joke' on Whistler Mountain in summertime. It was taken at a slow shutter speed with a second-curtain synchronization on the flash in order to give the colors of the rider some punch. The image is intentionally blurred in order to portray a sense of movement."

Technical Data

Canon EOS 3 35mm SLR
Canon EF 20mm f/2.8
wide-angle lens
1/15 of a second (aperture not recorded)
Flash

"Bike Blur"
© *Greg Eymundson*
Whistler, British Columbia, Canada
www.insight-photography.com

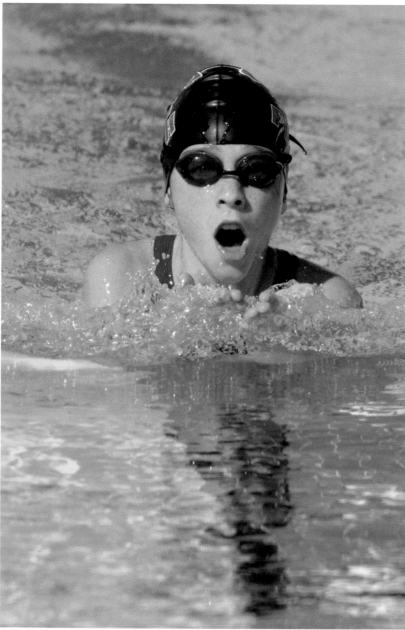

Sporting events held outdoors offer natural light that can give a photographer more flexibility in the aperture and shutter speed. And having this flexibility can free you up to capture fleeting moments like this one where the swimmer briefly came up for air. The subject fills the frame very nicely, and the photographer even managed to capture her reflection in the water below. Finding the right vantage point from which to shoot is important before the action takes place, and clicking the shutter a split-second before the moment occurs is also imperative.

Photographer's Comments

"My three kids are my favorite subjects, and I enjoy taking pictures at their events. On this gorgeous day in October, Maggie had a swim meet. The event was originally scheduled for indoors, but because the weather was so nice, they decided to move it to the outdoor pool. Taking pictures at a swim meet is very difficult because the kids spend most of their time underwater. I was determined to get a shot by timing her breast stroke and getting into the same rhythm. When she popped her head out of the water, I was able to grab the shot. The sun was at a perfect angle to give me a great reflection of Maggie in the water. It also made the water sparkle as her hands came out of the water."

"Cory 4"
© Bernie Cory
Chesapeake, Virginia

Technical Data

Canon EOS Digital Rebel
Quantaray AF 70-300mm zoom lens set at 300mm
1/2500 of a second at f/7.1
ISO 400
Daylight

"TROPICANA DREAMS"
© C.J. Groth
Key West, Florida
www.keywestphotos.com

This impressionistic image shows us the swirling excitement and color of a stage show. You can deliberately blur motion in your photographs by using a slow shutter speed, which enables you to convey a real sense of motion in your images. The slower the shutter speed, the greater the amount of blur, so try using shutter speeds of 1/30 or slower. You are likely to get a little camera movement when handholding your camera, which also contributes to a blurred image. And as you can see in this example, a brightly lit subject appears even more blurred because the highlights tend to spread. The bright colors are especially striking against the darkness.

Photographer's Comments

"'Tropicana Dreams' was taken at the floor show at the Hotel Nacional de Cuba in Havana. The dancers were glorious and I wanted to capture the energy of the scene before me. I was sitting at a table close to the stage, and I manually pre-focused on a bright area through which the dancers moved (most of the stage was quite dark). I planted my elbows firmly on the table to form a tripod with my body, and watched through the viewfinder, squeezing the shutter when a dancer whirled through my pre-focused area. I don't know the shutter speed, but it was obviously quite slow. This photo was the most abstract of the series and I think it's the most beautiful."

Technical Data

Canon EOS A2e 35mm SLR
Canon 28-105mm zoom lens set at 105mm
Fuji NGH 800 color negative film
Shot in program mode

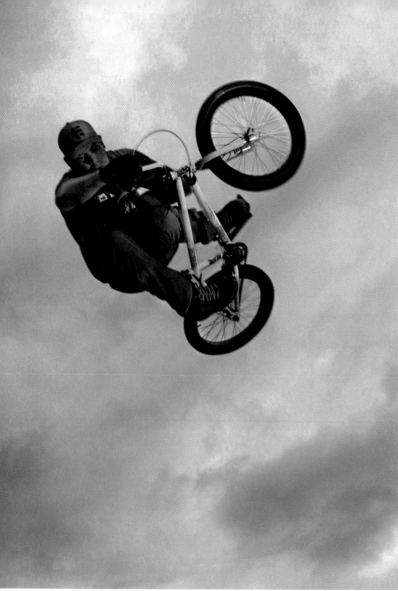

By using flash, this photographer was able to solve the problems of a slow shutter speed caused by the dull light of an overcast day and the dim light on the subject. Flash is a great tool for recording moving objects sharply, as long as they're within range of the flash. And in a case like this, where the photographer was working with the bicyclist one on one, using flash worked great. But don't use it at events where it would distract athletes or performers.

Photographer's Comments

"I was doing a photo shoot with professional BMX rider, Taj Mihelich, at the ramp behind his office. Because the day was overcast, I was having a problem keeping the shutter speed fast enough to freeze the action while still maintaining a small enough aperture to ensure that the entire bike was in focus. By boosting my ISO, I was able to get the exposure that I needed, but I was unhappy with the soft lighting from the overcast sky. To remedy the flat lighting, I placed a Canon 580EX flash on a stand to the right of the camera and aimed it in the general direction where Taj would be when doing the trick. I used a Canon ST-E2 remote commander to trigger the off-camera flash. The flash provided just enough light to separate Taj from the overcast sky behind him."

"TAJ MIHELICH–AUSTIN, TX"
© *J. Dennis Thomas*
Austin, Texas
http://deadsailorproductions.com

Technical Data

Canon EOS 30D digital SLR
Canon EF-S 18-55mm 1:3.5-5.6 zoom lens set at 18mm
1/200 of a second at f/7.1
ISO 400
Canon Speedlite 580EX flash and Canon Speedlite Transmitter ST-E2

This photographer caught the perfect moment of a cowboy suspended just above the ground after unfortunately being bucked off a bull. (The photo title is especially appropriate.) Although action often happens too quickly for the human eye to perceive the details clearly, you can capture the instant in a click of the shutter at the right time. This image also tells a story about the event and reveals its spirit. A good motor drive is handy for firing several frames per second in rapid succession. You might also try using the sports mode on your camera, which performs a similar function. A fast shutter speed is always essential for stopping action, and because the arena was poorly lit, the photographer used a very fast ISO of 3200. Although this photographer used a telephoto lens to bring the scene in close, the sense of the western atmosphere is still very apparent.

Photographer's Comments

"I had the chance to shoot at this rodeo, but had never photographed a rodeo before. This photo was taken in a *very* poorly lit arena, and because I had no access to strobes, I used a high ISO rating. I was amazed at the raw power of the bulls, and wanted to try to capture that violent power."

Technical Data

Canon EOS 1D Mark II digital SLR
Canon EF 300mm f/2.8 telephoto lens
1/500 of a second at f/2.8
ISO 3200
Ambient, interior light

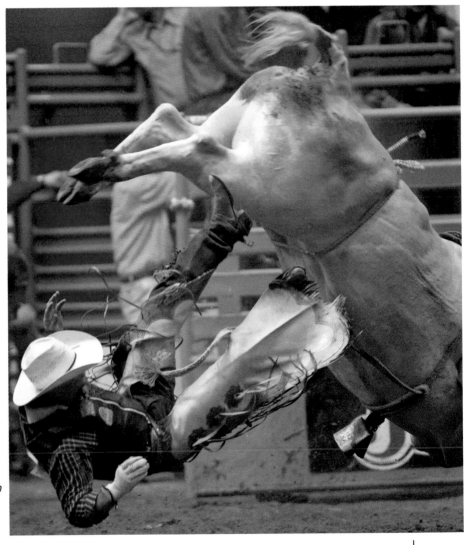

"OUCH"
© *Chris Anderson*
Waco, Texas
www.candc
photography.net

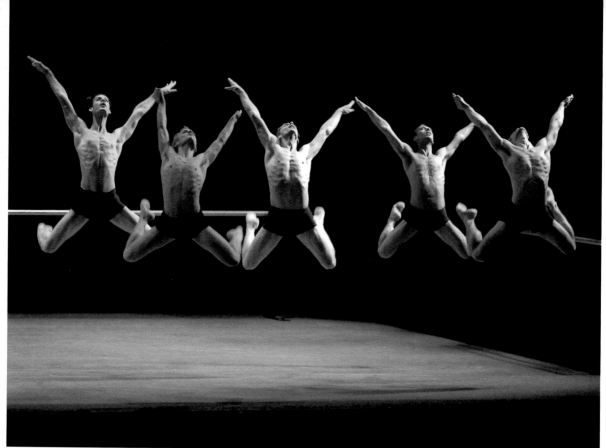

"JUMP"
© *Sharen Bradford*
Dallas, Texas
www.thedancingimage.com

This is a great example of a decisive moment frozen in time. Good indoor action photos demand a lot photographically. In most cases, you have to work with the ambient stage lights which means more wide-open apertures, a high ISO, and a fast telephoto lens. Your timing and technique is crucial to getting great images. Most cameras have a continuous-focusing feature that allows you to follow and focus on the action as it occurs. And, because there's such a discrepancy between the lights on the performers and the dimly lit background, use spot metering on your subjects.

Photographer's Comments

"This was taken during a live performance of 'Sextet' by Ballet Biarritz. The stage was framed by ballet barres to suggest a dance studio, and the photograph was made using available stage light. The dancers' incredible technique, combined with their long hours of rehearsal, provided the perfect moment in time. My past dance training has given me the ability to anticipate action, and I typically shoot with a shutter speed of at least 1/125 to capture the motion. Stage lighting for dance is unpredictable and often very dim. Depth of field, even at ISO 1600, usually ranges from f/2.8 to f/5.6. My personal preference is to shoot for stopped motion/peak action, rather than for great depth of field. Photographing dancers in performance is my passion."

Technical Data

Canon EOS 1D digital SLR
Canon EF 70-200mm f/2.8L zoom lens
set at 150mm
Shutter priority
1/125 of a second at f/2.8
ISO 1600
Ambient stage lighting

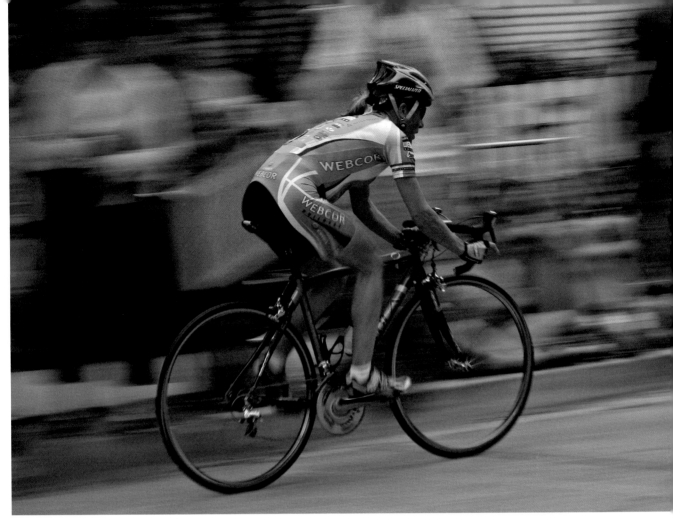

"Pro Rider"
© Kurt Harvey
Sunnyvale, California

A relatively sharp subject against a blurred background also conveys the feeling of speed. To produce this effect, you need to follow the subject with your camera in one smooth movement during the exposure. This technique is known as panning. As shown by the image of this bicyclist, panning focuses the viewer's attention on the subject and renders the background as a soft, colorful blur. It takes a lot of experimenting to do panning successfully and the results aren't always predictable. You must stand firmly and look through the viewfinder while twisting your upper body in the direction of the moving subject. It takes practice, but in time, you can release the shutter smoothly and avoid jarring the camera.

Photographer's Comments

"This was the first professional criterium bicycle race I've attended. I was amazed at the skill and tenacity of the riders as they powered around the hilly course for over an hour at maximum speed, charging toward me and then passing by in a whirl of air and a hum of tires — gone in a flash."

Technical Data

Canon EOS 20D digital SLR
Canon EF 70-200mm f/2.0 L IS zoom lens
set at 70mm
1/50 of a second at f/14
ISO 100
Ambient daylight

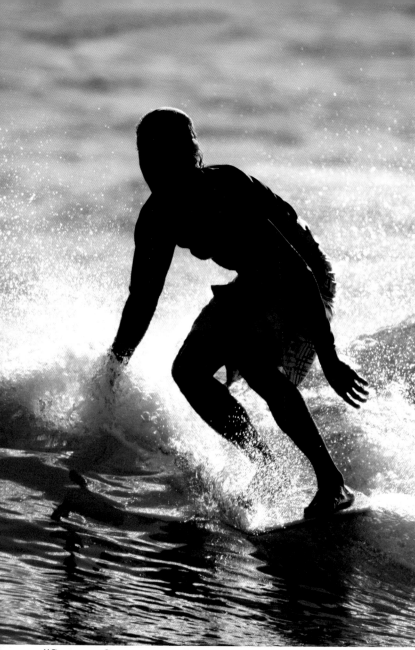

Great timing and excellent framing are two very successful elements in this surfing photo. And the backlighting has created a silhouette, a great technique when you want to emphasize a shape and obscure details. You can do this by exposing for the bright background, allowing the subject to become dark. By rendering his subject in silhouette, the photographer emphasizes the drama of surfing. To choose a suitable subject for a silhouette, you want to pick a simple, easily recognizable shape. Whenever you shoot into a light source, try not to include it in the picture because you get lens flare, which are the washed-out squares of light created when the sun's rays bounce off the lens's optical elements. Keep the light source outside the frame or use a lens hood, which guards against flare and offers some protection to the lens. The photographer also brought the action in close by using a telephoto lens coupled with a teleconverter.

Photographer's Comments

"I was attending the annual Jupiter International Surfing Contest here in Jupiter, Florida. It was early morning and the sun was behind the surfers, so it was ideal lighting conditions for a silhouette. I metered the water behind the surfer and fired away. This turned out to be a great shot; one that almost jumps off the page with energy."

"Surfer Silhouette"
© *Jerome Judge*
Jupiter, Florida

Technical Data
Nikon D2X digital SLR
Nikkor 400mm f/2.8 ED-IF AF-S II telephoto lens
2X Nikon AF-S teleconverter (for an effective focal length of 1200mm)
1/750 of a second at f/5.6
ISO 100
Early morning light

PART 5

NIGHT, LOW LIGHT, AND MAGIC HOUR PHOTOGRAPHY

Twilight, nighttime and low light offer some of the best opportunities to shoot dramatic images. You can photograph such diversity as clouds bathed in a blaze of color just after sunset, a city skyline at dusk, or the dark interior of a historical building. Many photographers purposely seek the light that occurs the first hour of dusk — there's no need to pack up your camera just because the sun has gone down. Whether you're shooting outdoors in the evening or indoors in a low-light situation, chances are that you'll make long exposures. This requires use of a tripod and a cable release to avoid shaking the camera when it's set for several seconds or on a bulb (B) setting. You also want to carefully meter your exposures, as there may be sources of light that appear in the frame that can fool your camera's meter. Bracket your exposures and shoot lots of images.

"RED STEAM"
© Bert Hustad
Gilbert, Arizona

Although many photographers may pass up an industrial scene in favor of more traditional subjects, these sites often have visual intrigue, especially when photographed at night. Like landscapes or city skylines, most industrial settings have a particular mood that's distinctly their own. Try to find a viewpoint or a special technique that helps capture the site's special atmosphere. For example, this photographer used a long time exposure at night to capture the red steam emitting from these towers, which provides a great contrast to the artificial blue light around the base of the compound. When photographing any industrial location, be sure to observe their rules and safety procedures. Working from a distance ensures your safety.

Photographer's Comments

"I drove by this refinery in Denver, Colorado, on my daily commute and visualized a possible shot. It presented itself on a cold (7 °F and falling) January night on the way home from work. I rushed home and grabbed my camera, returned to the refinery, waded through over two feet of snow for the best angle, and shot a series of timed exposures. I counted out the exposure times through chattering teeth to keep warm — well worth the effort!"

Technical Data

Canon F-1 35mm camera
Canon 50mm f/1.4 lens
Kodak Kodachrome 64 film
Approximately 10 seconds at f/8
Ambient light at night

Sunrise and sunsets can offer dramatic photo opportunities, far more so than if this scene had been shot during the middle of the day. To capture a sunrise scene like this, you must scout out your vantage point ahead of time and be an early riser. This photographer had the additional good fortune to capture a fog-free scene. San Francisco conjures up visions of the Golden Gate Bridge, trolley cars, or the city skyline. But this serene sunrise image renders San Francisco as a beautiful spot by the bay, with the hustle and bustle of the city at the horizon line far beyond.

Photographer's Comments

"There is no other city that I love more than San Francisco. I thought it would be fitting to give people a different perspective of the city and just how beautiful it can be. Every morning that the sky is clear, you may be treated to a breathtaking sunrise that silhouettes the city and casts it and the bay in different shades of magenta, orange, and blue. This was one of those mornings where all the colors came alive. One of the largest pastimes in the bay area is sailing, so I though it was fitting to photograph the sailboats using San Francisco as its backdrop."

Technical Data

Canon EOS 30D digital SLR
Canon EF 24-105mm f/4 L zoom lens
set at 24mm
22 seconds (f-stop not recorded)
ISO 100
Morning light at daybreak

"SAN FRANCISCO AT DAYBREAK"
© Jennifer Sawle
San Francisco, California
http://www.bjesf.org

"EIFFEL TOWER"

© Barry Pruett
Indianapolis, Indiana

Without a doubt, the Eiffel Tower is the most frequently photographed icon in Paris, and — as with many buildings — even more magical when illuminated at night. Buildings take on the color characteristics of the artificial light source being used. The incandescent sparkling light on this structure gives it a warm, bejeweled look. The streetlights below are rendered as bright stars because the photographer used a small aperture, and a long time exposure allowed the street traffic to be recorded as streaks of red and white. The long time exposures that night-time photography requires also necessitate use of a tripod.

Photographer's Comments

"This was the first time I had been to Paris, and I found myself taking numerous shots of the Eiffel Tower at different angles and from locations around the city. After just a few days, I decided that, in my opinion, the best time to see the Eiffel Tower is at night, when it has the various lights illuminating the steel structure. If you've been to Paris, you know that at night on the hour the Tower has hundreds of strobe lights flashing to make it sparkle. I wanted to capture that image. Just before midnight, I set up my tripod and waited for the moment the strobes started to sparkle. In the finished image, the Tower looks like a piece of jewelry — or as my kids say, the Eiffel with some 'bling.'"

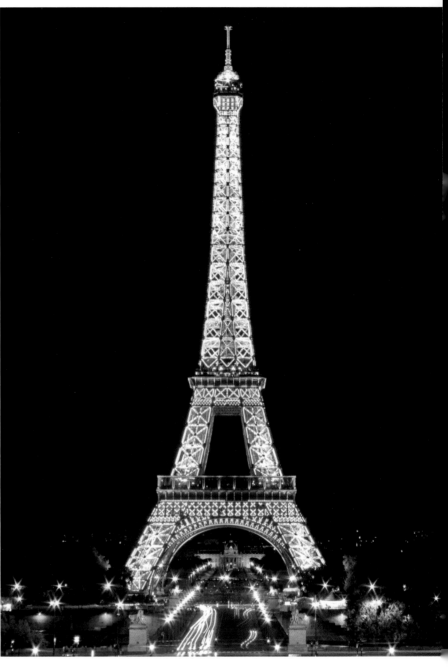

Technical Data

Canon EOS 30D digital SLR
Canon EF 28-135mm f/3.5-5.6 IS zoom lens
20 seconds at f/14
ISO 100
Tripod
Ambient night, city light

There are several ways to photograph a fireworks display. For handheld shots, try using a fast ISO (400 or greater), aim your lens in the direction of the fireworks, wait for the peak of a burst, and shoot. An exposure of 1/60 of a second at f/2.8 is a good exposure to start with when shooting bright, nearby displays. To encompass several bursts of light, set your camera on a tripod, set your camera on "B" and the aperture on f/8, and capture a series of bursts on one frame. Photos of fireworks are always more dramatic when you include foreground interest, as the photographer did here. The fireworks, Mount Rushmore, and the American flag add up to a strong patriotic statement.

Photographer's Comments

"I love fireworks, especially to celebrate Independence Day. The challenge was to create an image that captured the essence of the holiday, combining Mount Rushmore, the fireworks, and the American flag. Patience is a virtue when working with low light in a crowd of enthusiastic onlookers. My patience paid off at the last light of sunset."

"FIREWORKS AT
MOUNT RUSHMORE"
© Matt Guasco
Wantagh, New York

Technical Data

Canon EOS 20D digital SLR
Canon EF 75-300mm f/4-5.6 IS zoom lens set at 30mm
2 seconds at f/4.5, Shutter Priority mode
ISO 100
Manfrotto 724B Digi tripod

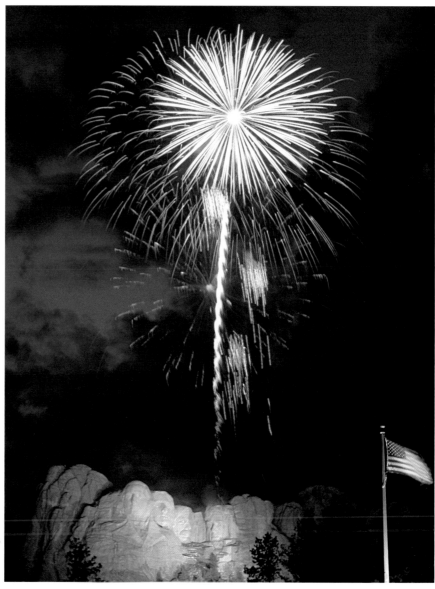

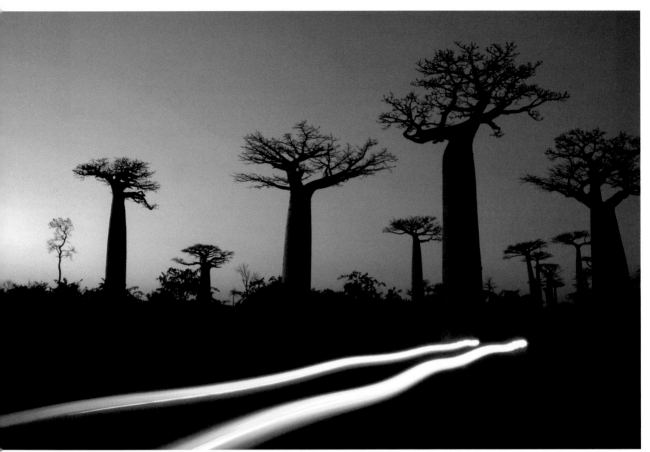

"MAGIC BAOBABS"
© *Yann Feron*
New York, New York
www.yannferon.com

Time exposures enable your camera to record patterns of moving lights that can't be seen by the eye after dark. Automobiles usually move too fast to be recorded on your memory card or film during a long time exposure, but their headlights and or taillights leave a mysterious illuminated streak across the scene. There are no hard and fast rules, but generally you want a long time exposure anywhere from five seconds up to a couple of minutes, along with a small f-stop to avoid overexposure. A tripod is also very important. This image portrays an otherworldly feeling, with the silhouettes of these unusual trees providing the background for the traffic streaks.

Photographer's Comments

"This is a traditional location in Madagascar where tourists shoot sunset photos. I shot some of these, but after the others left, I stayed alone with my camera and tripod (and fought off thousands of mosquitoes). I wanted to capture the last ray of light in the sky after the sun had set. To my eye, everything was dark, but with a long exposure and the right aperture I was able to capture the light that was invisible to the eye. When this taxi came by, I knew I got the perfect shot. Only its lights can be seen and you can't even see the car itself — just magic — and the 'Magic Baobabs,' these great trees in Africa."

Technical Data

Canon EOS Digital Rebel
Canon EF 18mm wide-angle lens
30 seconds at f/18
ISO 200
Ambient light at dusk

The best time to take pictures that include the moon is during the first couple of nights during a full moon. In this photo, the moon and other lights appear star-like because the photographer used a small aperture. The reflection of the light on the water is beautiful, and provides contrast against the dark hill on the left side of the frame. The illuminated color of the Golden Gate Bridge is also very striking. Be very careful when exposing for an image like this one, where several light sources could potentially fool your meter. Bracket exposures for best results.

Photographer's Comments

"I lived in Sausalito, California at the time I took this photo, so this location was very close to my home. At one of the first parking areas at the Marin Headlands, you can walk about a quarter mile to a great viewpoint of the bridge and the San Francisco coast. I chose a full moonlit night for this shot. I got several very nice images that evening shooting with a variety of cameras and lenses, and I was lucky enough to get several printable images. I especially liked the reflections of the moon and bridge in the water, and the 'golden' color of the bridge in the moonlight. I have this image framed in my home office, and it certainly reminds me that I left part of my heart in the City by the Bay."

Technical Data

Canon Powershot G2 compact digital SLR
Tripod mounted
10 seconds at f/8

"GOLDEN GATE MOONLIGHT"
© Ken Cohen
Anthem, Arizona

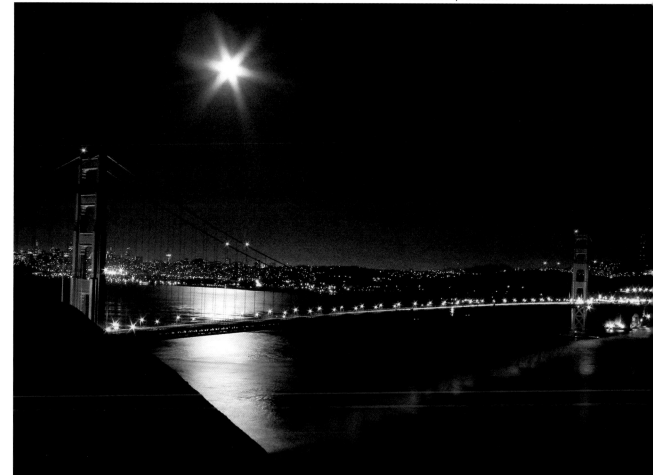

Sunset is one of nature's great spectacles, and always lends a sense of drama to a photograph. By experimenting with a variety of exposure settings, you can determine what works best for a particular scene. Whatever you do, however, take your meter reading from a portion of the sky away from the sun. This deepens the colors in the sky, as well as in the foreground. Because the sun is an extremely bright light source, it causes your meter to respond inaccurately when you take your meter reading directly from the sun. This image is also successful because of the detail in the grass in the foreground.

Photographer's Comments

"We were in Cape Cod for the weekend, and the wind and rain were fierce. This was in November, and a lot of the summer homes at the Cape are vacated at this time of year. We took shelter on someone's porch to check out the waves crashing onshore. Sand was pelting us from the right, but when we looked to the left, we all paused at how beautiful the sunset was. I snapped a few pictures — sometimes you just get lucky!"

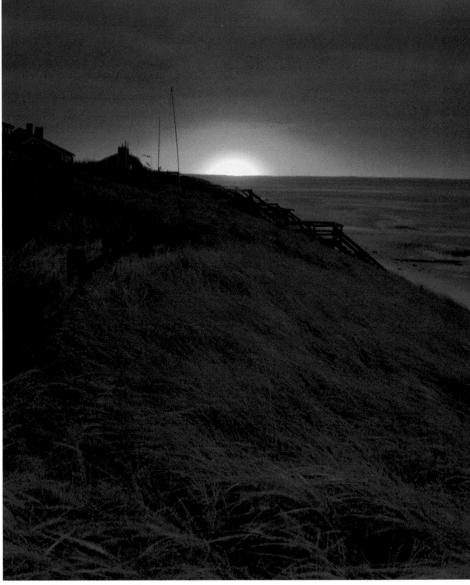

"CAPE COD SUNSET"
© Stephen Strutt
Seaford, New York
www.struttcreative.com

Technical Data

Canon EOS Digital Rebel
Canon EF 28-135mm IS lens
1/25 of a second at f/3.5
ISO 800
Ambient light at sunset

In photography, one of the most striking ways to reveal a shape is by creating a silhouette. Simply position an opaque object in front of a bright background and expose for the background. Any brightly lit backdrop will do. Look for simple, easily recognizable shapes to render in silhouette, like a sailboat crossing a glittering gold section of the sea, a person in front of a colorful wall, or a couple walking on a beach at sunset. More often than not, you have to orchestrate this setting; rarely does an interesting subject and bright background just happen to coincide. Experiment with a variety of exposures, as several of them can produce good silhouettes. And if you're shooting a silhouette against a sunset, consider using a sunset or enhancing filter to make the sky even more brilliant.

Photographer's Comments

"This image was shot at Saguaro National Park outside Tucson, Arizona, in early spring. It was evening in the desert. My wife and I were driving through the park and just watched a large, diamond-back rattlesnake slink across the road and down a cliff into the rocks. She was reluctant to get out of the car while I took this picture. There are many cacti inside the park, and evening is my favorite time to photograph them. Many bloom at night and their flowers are often gone by morning. This old saguaro was particularly dramatized by the evening sunset."

Technical Data

Canon EOS 5D
digital SLR
Canon EF 70-200mm
zoom lens set at 90mm
f/32
ISO 200
Evening light

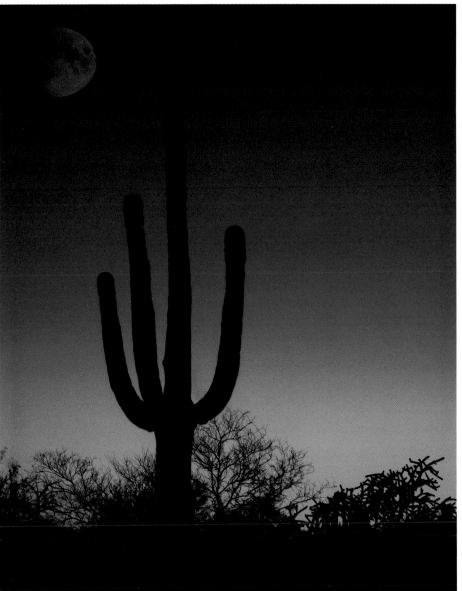

"SAGUARO NIGHT"
© *Keith Livingston*
Longmont, Colorado

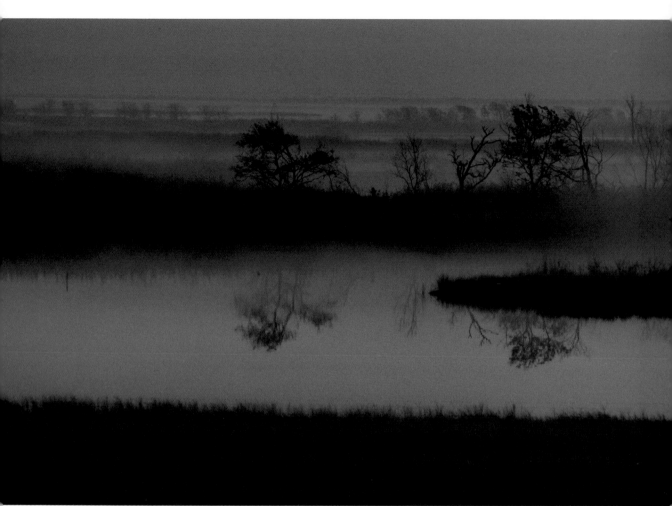

"MORNING MIST"
© Andrew Harris
Pensacola, Florida
http://www.photo.net/photos/lefthook51

The best place to find misty, ethereal conditions like this one is on or near bodies of water. And the best time of day to photograph it is near dawn, before the sun has had a chance to burn off the night's accumulation of mist. This moody, almost monochromatic image is a good example of atmospheric perspective — a feeling of distance that you see when haze is in the air, which makes objects look fainter in tone as they recede.

Photographer's Comments
"I work on a drilling barge on the marshes in Louisiana, and waited two months to shoot this scene because it was either too foggy or too bright. I really feel that this shot captures a winter mood. I took it from the helideck of the barge."

Technical Data
Nikon D2X digital SLR
Nikkor 120mm lens
1/40 of a second at f/6.3
ISO 200
Ambient light on a foggy morning

The city comes alive at night, giving you opportunities to capture some striking photos of cityscapes illuminated against the sky. Some buildings (particularly those of cities like Las Vegas) are illuminated brightly enough so that you can even shoot without a tripod. But for the most part, you are better off using one to ensure sharp images during long exposure times. You'll get even better results when you take pictures in the early evening, up to an hour after sunset, when the lingering light of dusk adds a little color to the sky, as opposed to shooting pictures of a brightly lit city when the sky is completely dark.

Photographer's Comments

"Holiday season at Grand Central Terminal in Manhattan is a special time, it seems. A multi-media 'light show' was being projected throughout the recently refurbished station — it stopped me dead in my tracks, and I frantically searched for a level surface to mount my little mini tripod. Grand Central always seems to have a distinct vibe, and somehow the space swallows a great deal of noise and lends an almost respectful hush despite the hubbub. This occasion was no exception; the only difference was that more people stopped to look and listen to the show. At the risk of 'gilding the lily,' I think they did a fine job of adding magic to an already awe-inspiring public venue."

Technical Data

Canon EOS Digital Rebel
Canon EF 18-55mm zoom lens set at 18mm
1/4 of a second at f/3.5
ISO 200
Ambient light at night

"GRAND LIGHT SHOW"
© Jim Lynch
Mount Sinai, New York
www.jimlynchphotography.com

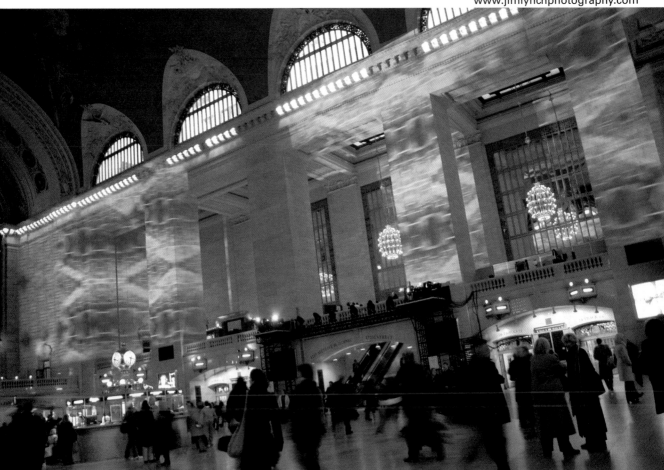

By adding a pier and some seagulls to the mix, this image of a pastel pink sunset scene is very intriguing. Sunsets and the magic hour are beautiful enough, but including a simple foreground element adds a center of interest and reveals something of your location. Much of the pier in this photograph is in silhouette, and the glimmering arcade lights add a festive feeling. One of the most challenging parts of photographing a scene like this is finding a good vantage point before it gets too dark.

Photographer's Comments

"I was taking a Photoshop class at Santa Monica College in December. When I left class around 4:30 p.m., the sun was starting to set, creating a potentially gorgeous sunset. I rushed to the beach at the Santa Monica Pier, which is only a five-minute drive from the college. I parked and ran across the sand with my camera and tripod. The tide was low and the sun was reflecting the clouds onto the wet sand. I couldn't believe how pink this sunset was. It was one of the most beautiful sunsets that I had seen in several years. Having the seagulls and arcade lights was an added bonus. I found the right point of view and set up my equipment. I had enough time to capture several images, but this one was my favorite."

Technical Data

Canon 1Ds Mark II digital SLR
Canon EF 100mm f/2 lens
1/2 second at f/5.6
Manual exposure setting
ISO 100
Bogen tripod
Natural light at sunset

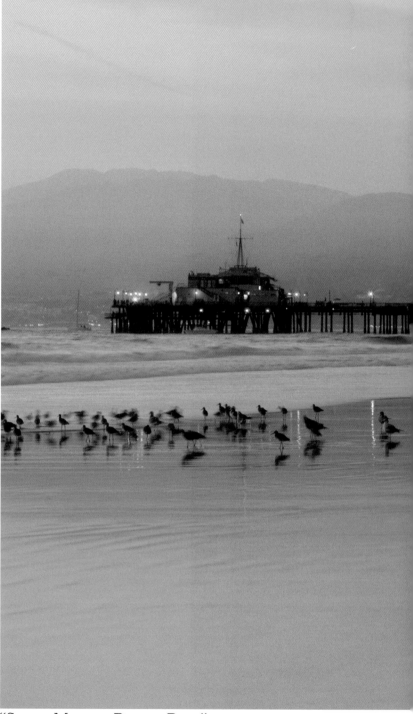

"SANTA MONICA PIER IN PINK"
© *Jim McKinniss*
Redondo Beach, California
http://jim_mckinniss.photoworkshop.com

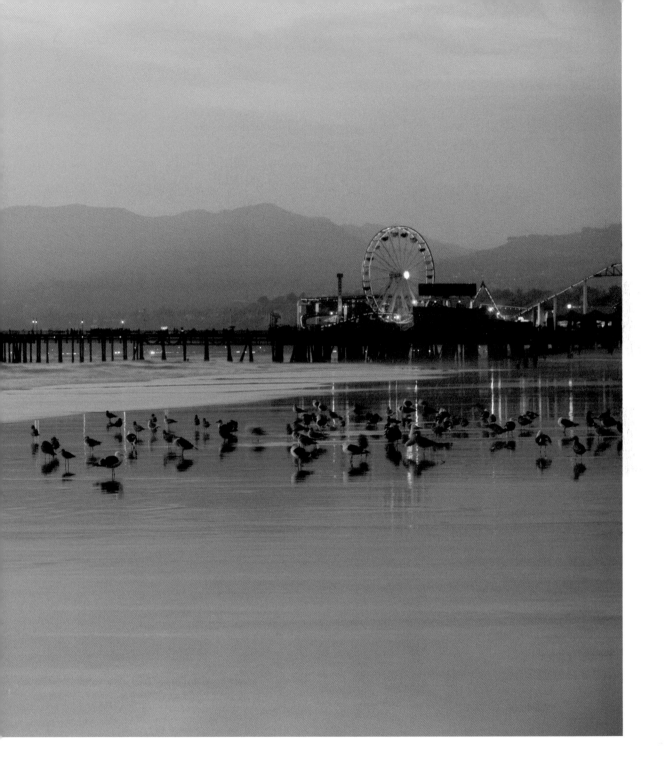

"TOUCH THE SUN"
© Brian K. Morrow
Porterville, California
www.allamericanimages.com

It's a good idea to use a telephoto lens when you want to include the setting sun in your images. This way, the sun will be rendered as a large orb. But when you meter your image, take your reading from a portion of the sky away from the sun, as the sun is a very bright object that will fool your camera's meter into underexposure. Bracket your exposures from one stop over to one stop under your camera's through-the-lens metering recommendations—you may wind up with several acceptable images. Including a simple foreground element adds interest to your sunset photos and may say something about your location. Try to scout out locations ahead of time so that you can silhouette an interesting object against the bright background, as this photographer has done with the needles of a pine tree. As the light becomes increasingly dimmer at sunset, you need to use a tripod or another means of steady camera support.

Photographer's Comments
"The location was Cambria, California, and I took this shot between our beach house and the neighbor's house. I was heading out to shoot some evening photos. As I headed past our mailbox, I looked over my right shoulder, composed this image in my head, and then captured the moment."

Technical Data
Canon EOS Digital Rebel
Canon EF 70-300mm zoom lens set at 300mm
1/160 of a second at f/5.6
ISO 100
Natural light at sunset
Tripod and cable release

"City by Night"

© Annette Chapman
New York, New York
http://annette_chapman.photoworkshop.com

The high-rise buildings of a city nearly always look more elegant from a distance, and photos of a skyline at night can be especially dramatic. All you need is a good spot from which to shoot it. Surrounding hills, bridges, and windows of other high-rise buildings often provide vantage points for expansive city views. A variety of exposures may be acceptable; you can experiment with time exposures ranging from less than a second to a minute. In this image of New York City, the photographer included the moon rising between two of the buildings, which is more interesting than if she had captured the cityscape alone. A tripod is recommended, but if the city lights are bright enough, sometimes a fast ISO in the 400-1600 range will do.

Photographer's Comments

"I have always loved the New York City skyline. I heard that there was going to be a full moon on this night. A friend and I went over to the New Jersey side to try to capture it. I used various exposures and experimented with the hope of getting a good photo. 'City by Night' was the result."

Technical Data

Nikon D200 digital SLR
Nikkor 70-200mm f/2.8 IF VR zoom lens
1/4 of a second at f/2.8
ISO 320
Manual exposure mode
Gitzo tripod with a cable release

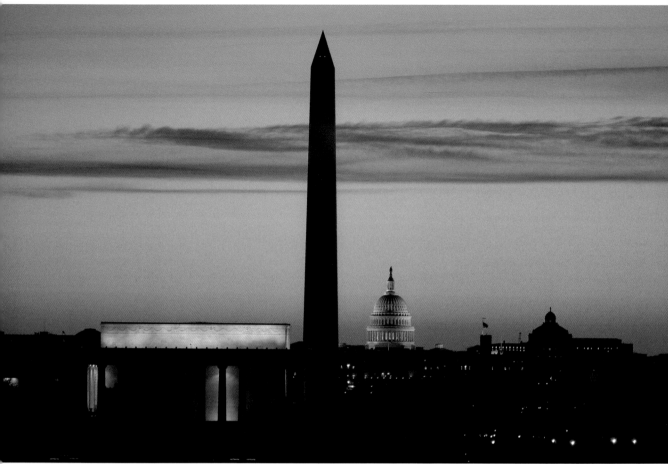

"Monuments"

© *Jim Stearns*
Woodbridge, Virginia
http://jimdstearns.photoworkshop.com

Dusk and dawn are magical times to photograph city skylines. Many monuments and statues are lit up when it's dark, giving you the opportunity to utilize these lights to get exciting photographs. These lights often record very warm on film and memory cards, but as you can see in this image, the results are very pleasing. The variety of lights and silhouettes offers some nice visual diversity. The photographer captured the illuminated Lincoln Monument and Capital building, and rendered the Washington Monument as a silhouette against the warm-hued sky, which works well with the warm glow of the illuminated buildings. Look for a time at sunrise or dusk when the light in the sky is in balance with the light on the buildings.

Photographer's Comments

"I had just finished shooting the Marine Corp Iwo Jima Memorial, which is on the high ground just outside of Rosslyn and overlooks the Washington D.C. mall area. I started walking back to my car when I looked up and saw this view of the Lincoln and Washington Monuments with the U.S. Capitol in the background. For me, it symbolized the dawn of a new day that democracy works for us all, and I captured this shot."

Technical Data

Canon EOS Digital Rebel
Canon EF 70-200mm f/2.8 L IS zoom lens
set at 200mm
1/6 of a second at f/2.8
ISO 100
Ambient light at sunrise

One of the biggest challenges when photographing a city skyline is finding the perfect vantage point from which to capture it. Many major cities have observation decks that offer great views, or there are various places at ground level (such as this one across the water) where you can find beautiful, unobstructed city vistas. You'll need to scout out your shooting spot well in advance to avoid scrambling around when light is quickly fading. Twilight is a magical time to shoot cityscapes, as a little light still lingers in the sky and buildings and streetlights glimmer.

Photographer's Comments

"I think one of my favorite activities after a good dinner out is to head down to the coastline along New York City, where you get a perfect view of the prettiest skyline anywhere. I shot this photo on a warm, damp, late-August night. As I carefully set up my tripod on a grassy slope in Long Island City, the mist lifted and the currents stirred the water. I believe that my love of night photography is connected to my love of color — only the night sky permits you to see these brilliant hues. Most of us live in the city but do not allow ourselves to enjoy the view. By the time we got back to the car, the skyline was shrouded in fog."

Technical Data

Canon EOS 1D Mark II digital SLR
Canon EF 17-40mm zoom lens set at 40mm
ISO 100
30 seconds at f/10
Bogen Manfrotto 3030 tripod
Evening light

"NYC"
© *Linda LaSala*
Floral Park, New York
www.lasalaphotos.com

The beautiful colors of sunrise and sunset ensure that you get an image with a dramatically heightened mood. By putting an opaque object in front of a bright background, you can render the foreground subject in silhouette, as this photographer has done. Whenever possible, try to scout out a good location ahead of time and look for simple, recognizable shapes, like this dock, to silhouette against the sky. It's important that the subject be surrounded by a bright background to be identifiable. The colors of a sunrise can vary greatly from place to place, and even from minute to minute in the same place. You'll want to shoot a lot of images and bracket exposures in the small window of time that's available. Here, the bright colors are reflected nicely in the water, and the sun, just beginning to peek above the horizon, shows the promise of a new day.

Photographer's Comments

"I love getting up early in the morning to take advantage of the light and color that a dramatic sunrise offers. While the same can be said for a setting sun, I feel that the light a morning sun provides is more dramatic, but also more fleeting. This shot was taken at 5:00 a.m. with the sun just peeking over the horizon. The lake reflected the morning colors, making the scene even more dramatic. This image was shot in RAW."

Technical Data

Canon EOS 20D digital SLR
Canon EF 16-35mm f/2.8L II zoom lens
set at 32mm
1/400 of a second at f/8
ISO 800
Ambient light
at daybreak

"MADISON SUNRISE"
©*Todd Klassy*
Belleville, Wisconsin
http://flickr.com/photos/latitudes

The photographer has heightened the excitement of this performance by deliberately not using flash, which would have minimized the impact of the fire this performer is using at night. She has also chosen to render it as blurred action, which accentuates the motion of this image. This photo presents a good reason to not limit your outdoor photography to daylight situations only. Pictures taken with existing light at night have an energy that isn't present during the daytime.

Photographer's Comments

"I travel to Grand Junction, Colorado every year to visit my parents. While I'm there, I always do as much photography as possible. A couple of nights before I left, I went to a local street fair, not expecting anything out of the ordinary. But I was pleased to see that a group of fire dancers was scheduled to perform later that evening. This was total experimentation for me; I aimed the camera at them and kept shooting, playing with the shutter speed and moving around for different angles. To my surprise, I had several very good images. The unexpected can be a blessing in disguise."

Technical Data

Canon EOS 20D digital SLR
Canon EF 28-135mm f/3.5-5.6 IS zoom lens set at 135mm
1/8 of a second at f/5.6
ISO 400
Ambient light at night

"Fire Dancer"
© Rhonda Mock
Walker, Louisiana

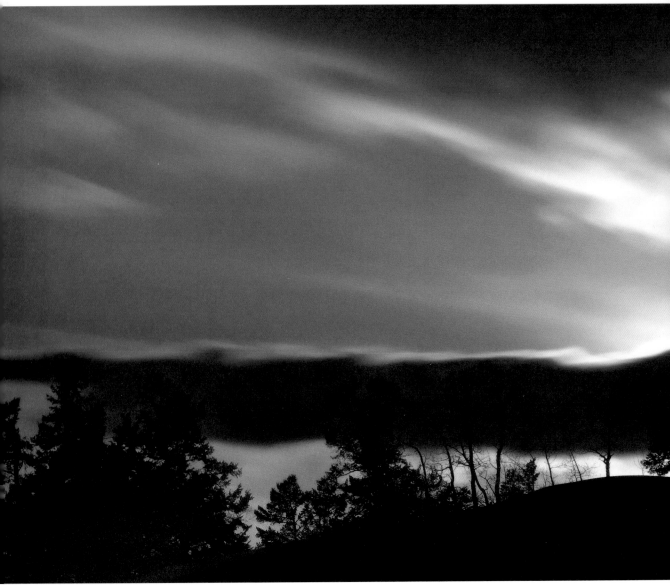

"MOONSET: UTE PASS, GRAND COUNTY, COLORADO"
© *Andrew Scott Fulton*
Centennial, Colorado
http://afpfa.photoworkshop.com/

We associate nighttime with feelings like peaceful-
ness and calm. This photo captures clouds illumi-
nated by moonlight, which creates an aura of
drama and mystery. A long exposure accentuates
this nocturnal glow and reveals details that aren't
apparent to the human eye at the time of shooting.
To take pictures at night, you need to use a tripod
to steady your camera during long exposure times.
It's also a good idea to plan your shoot when the
sky is relatively clear and the moon is full.

Photographer's Comments

"My intention was to make a mural-sized panora-
ma of the entire Gore Range, and I arrived at
this location atop Ute Pass about 45 minutes
before sunrise. After setting up my camera and
tripod, I sat on the lift gate of my truck sipping
coffee while trembling from the cold. I decided to
jog back and forth a few times to keep my blood
moving. As I did this, I looked over my shoulder
to the left and saw that a bank of clouds had

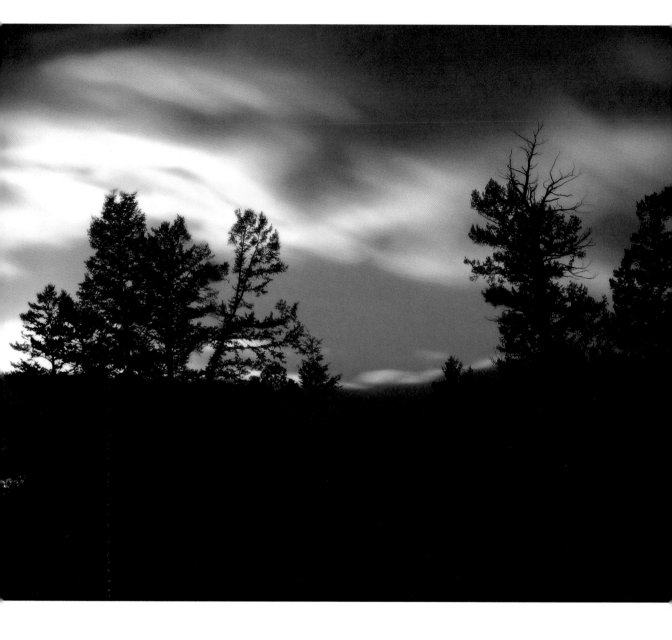

completely covered the moon, creating an incredibly surreal blue haze. I ran back to my camera and made three horizontal exposures. I wanted to ensure strong saturation in the sky, so I used my Pentax spot meter and metered its bluest part at 50 percent. I didn't realize what I had in this image until I got it into my computer."

Technical Data

Nikon D70s digital SLR
Nikkor 85mm f/1.4 lens
15 seconds at f/8
ISO 200
Moonlight

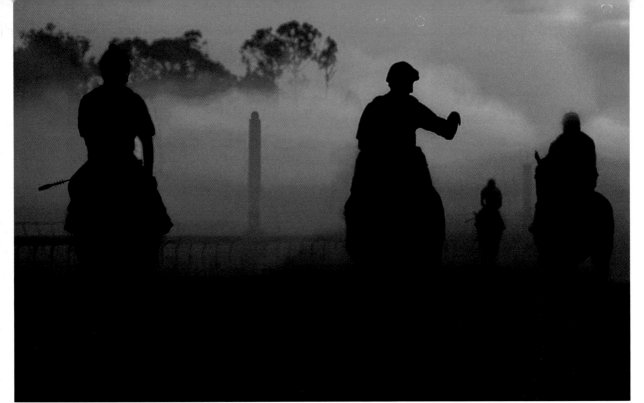

"Early Morning"
© Joel P. Black
Boynton Beach, Florida
www.photosbyblack.com

The colorful sky at sunrise is beautiful on its own, but your images will be that much more intriguing if you include a well-placed silhouette or two in the foreground. Your subjects can be trees, a couple strolling on the beach, or even trainers on horseback, as this photographer has done. The mist creates a dreamlike effect, and adds greatly to the atmosphere of this scene.

Photographer's Comments

"I shoot thoroughbred horse racing at Gulfstream Park in Hallandale Beach, Florida. As part of my assignments, I often shoot the training sessions of particular horses at Palm Meadows Thoroughbred Training Facility in Boynton Beach. I arrived prior to sunrise on this morning and waited while the first group of horses came out for their workout. It was still chilly, which created a mist on the grassy meadows that surround the track, while the sun was just coming up over the horizon and the sky was all aglow. I took a meter reading and determined the exposure of the bright sky because I wanted to silhouette the riders in the foreground. I wanted to shoot at a speed that would stop any action on the track, so I chose 1/800 and used the camera's tracking and burst capabilities to capture this image. I tried several different combinations of f-stops and shutter speeds to capture this scene, but in my opinion, this was the best one."

Technical Data

Canon EOS 1D Mark II
Canon EF 200mm f/2.8L telephoto lens
1/800 of a second at f/9
Misty light at daybreak

PART 6

ARCHITECTURE AND
URBAN SCENES

Architectural style and urban scenery are what gives a town or city its character, ranging from the high-rise buildings of Manhattan to the simple adobe structures in Santa Fe to city-specific scenes like subways. As with landscape photography, you must decide what it is about a building or an urban scene that appeals to you, and what makes you want to photograph it. With architecture, each building has its own character, whether it's a sleek, glass-and-chrome museum or a warm, homey residence. Think about what qualities you want to emphasize, and then look for the vantage points and light that help you portray these features. There may be times when you want to zoom in on small details that characterize a building's architectural style, or perhaps you want to step back and include a cityscape on a grander scale. Including people in your photos can help give scale to urban buildings, besides adding a little hustle and bustle to a scene.

After photographing an entire building, try isolating its unique and interesting architectural details — this may result in your strongest photos. In this image, the photographer has highlighted the complimentary colors of the building's blue windows against red bricks, as well as revealing some interesting patterns. To get great shots of architectural details, you must compose tightly. Fill the frame solely with your subject so that there's no question about what you were shooting.

Photographer's Comments

"It was two days into spring, with temperatures mild enough so that there was little danger of a finger being frozen solid to a shutter button, so a photo walk in the city streets seemed like a good idea. The sunlight was fantastic that day; a brightness that seemed to be in the right place and at the right angle every time I saw a shot I wanted to take. I came away with a healthy percentage of keepers, including this image of a bank building taken a few seconds past noon. I tried to take advantage of the diagonal lines of brick and window frame. Architectural subjects are a favorite of mine, and 'Blue Windows' proves my contention that you can always find something new in an old and familiar subject. This image is the result of finding the picture within a picture. There is still more hiding in this building that I hope to discover."

Technical Data

Canon EOS Digital Rebel
Canon EF 75-300mm zoom lens
1/160 of a second at f/5.6
ISO 100
Midday light

"Blue Windows"
© Al Morrison
Akron, Pennsylvania
http://amorrison.photoworkshop.com

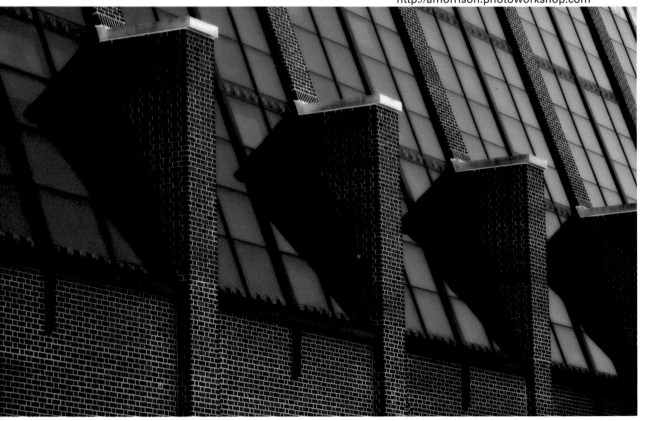

"Profiles"
© Colin Roberts
West Midlands, England

Very often, the style of a building is defined by its architectural details. Again, tight composing is key to emphasizing this detailing; it's important to fill the frame with your subject so that there's no question about what your subject is. In this case, it was these two heads on the wall of this British cathedral, which are dramatically illuminated from the sun coming in through windows at just the right time of day. The secret to getting great detail images is by being observant, and discovering the myriad parts of a structure that comprises the whole. Cathedrals like this one are ideal when you're looking for interesting details, but there are numerous other architectural subjects that have wonderful features such as houses, churches, hotels, and many historical structures. If you're shooting indoors in a public place where you're not allowed to use a tripod, using a fast ISO in the 400 to 3200 range should allow you to get sharp exposures. Today's digital cameras can easily handle these speeds with less noise than previous digital models.

Photographer's Comments
"This image was taken inside Lichfield Cathedral, Staffordshire, England. As the sun shone through the stained glass, it highlighted these two beautiful, crisp sculptured heads peering out from the stonework that was in an essentially dark corridor. This gave them a very dramatic appearance."

Technical Data
Canon EOS Digital Rebel
Canon EF-S 18-55mm lens set at 55mm
1/100 of a second at f/7.1
ISO 800
Ambient indoor light

This scene speaks of urban whirl, and provides a striking contrast between the still figure on the left and the subway in motion. Cities are wonderful places to photograph because of the variety of images you can capture, often just by turning another corner. In New York, for example, you can photograph a subway station, Times Square, and Central Park — all within blocks of one another. Traveling light with your camera gear is an advantage when shooting pictures in an urban environment. A digital compact camera or SLR frees you to concentrate on finding great compositions and to respond quickly to photo opportunities.

Photographer's Comments

"I was shooting from the hip when I took this photo. I saw the man standing near the subway tracks and thought it would be great to get the train as it pulled into the station. I hoped to get a feeling of motion by photographing the train while it was still moving."

Technical Data

Canon EOS-1D Mark II digital SLR
Canon EF 28-135mm zoom lens set at 28mm
1/50 of a second at f/4.5
ISO 800
Ambient indoor light

"New York Subway"
© Erik Graul
Tom's River, New Jersey

"UPSTAIRS TO THE MIXING CHAMBER"
© *Barry Cunningham*
Cleveland Heights, Ohio
www.zazzle.com/cunningba

One way to give your images drama and a new perspective is to shoot from an interesting vantage point. This photo takes our eye upwards with the leading lines of the railing, the stairway, and the bright area in the center of the frame. The arch above serves as a nice framing element. We're curious to know what lies beyond the top of the stairs. The ambient light coming in from above works very well also in this contemporary atmosphere, and the photographer used a fast ISO to accommodate it. Ambient light usually yields the most natural results, even in dimly lit interiors.

Photographer's Comments

"My wife and I visited her brother in Seattle, Washington, for a week in August. Because this was the first time we had visited him since he moved there from New York, he took the week off to show us the sights. I took this photo when we visited the Seattle Central Public Library building downtown. The architecture is spectacular, with eye-catching views every way you turn — sloping glass roofs, wonderful natural lighting, bold colors, sweeping stairways and escalators, stunning multistory interior vantage points, and artwork throughout. This image shows one of the most interesting stairways, leading from the bright red corridors of the Level 4 Meeting Room to the 19,500 square-foot Charles Simonyi Mixing Chamber on Level 5."

Technical Data

Canon EOS Digital Rebel XT
Canon EF 28-105mm f/4-5.6 zoom lens
set at 28mm
1/60 of a second at f/5.6
ISO 1600
Ambient indoor light

Fog and mist create atmosphere in photos, and often evoke emotion. So don't wait for a perfectly sunny day to get your camera out. Fog softens colors and shapes, so colors are muted and forms become more simplified. When shooting in the fog, it's best to choose simple scenes, rather than an entire cityscape. This photographer successfully captured the sharpness of the palm fronds in the foreground in contrast to the high-rise building that softly fades into the misty sky above. The palm leaves provide a pleasing frame around this architectural subject. The fog also causes the building to appear to recede into the background; an effect known as atmospheric perspective.

Photographer's Comments

"I was meeting Robert Kato, another Photoworkshop.com member, for coffee and conversation at the Ferry Building in San Francisco. I was a bit early and wandered along the Embarcadero (the street that lines the San Francisco waterfront). It was a typical foggy morning in the city. Sunlight filtering through the fog often yields an ethereal beauty to otherwise commonplace scenes. One of the high-rise structures across the Embarcadero is part of a complex known as Embarcadero Center. Looking up, I saw this scene of the tall building reaching up through the fog as though it was escaping the clutches of the shorter palm trees. I felt that rendering it in black-and-white was more dramatic."

Technical Data

Canon EOS Digital Rebel
Canon EF-S 18-55mm 1:3.5-5.6 zoom lens
set at 18mm
1/320 of a second at f/11
Early morning sunlight through San Francisco fog

"EMBARCADERO CENTER"
© Gerald Currier
San Francisco, California
http://cursmicon.photoworkshop.com

"GUGGENHEIM-BILBAO"
© Alan Berkson
Milford, Connecticut
www.omages.com

Oftentimes, your most powerful architectural images are those of details, rather than the "big picture." Looking for eye-catching details can challenge your compositional skills. Also, the architectural style of a building is often revealed in its details, such as the unique angles and patterns of this contemporary museum. Most of us tend to shoot subjects from an eye-level, straightforward point of view. But by exploring your subjects beyond first impressions, you can create striking new compositions — like the dramatic angles in this photograph.

Photographer's Comments

"Like many photographers who are mostly self-taught, I rely on the instincts of my vision, which is honed by experience and molded by the historical values I've studied in photography. Having been lucky to travel to many parts of the U.S.

and Europe, I try to capture the essence of the scenic wonders of these places. Be it nature or architecture, my eye is drawn to graphic shapes and perspectives. This museum is so powerful in the world of modern art that I spent three days photographing it. This image has elements of shadow and light that are unique to a time of day, and I have isolated a portion of the structure in a way that, for me, represents the colossal impact of the entire building."

Technical Data

Nikon D70 digital SLR
Nikkor 24-120mm f/3.5-5.6 VR zoom lens set at 120mm
1/500 of a second at f/5.6
ISO 800
Late afternoon light

Beautiful interiors almost beg to be photographed. The challenge is that if it's a public place where you may not be allowed to use a tripod, you need to find another way to brace your camera in order to get sharp photos in a low-light situation. This elegant image has a lot of appealing elements — the vertical lines on the right side, the skylight reflected on the left wall and on the floor, and the leading lines, which take the eye through the frame to the door in the distance. The silhouetted figure walking down the hall adds the perfect touch.

"Silhouette in the Hall"
© Tom Pipia
Milwaukee, Wisconsin
www.macrhinoimages.com

Photographer's Comments

"We were visiting the Milwaukee Art Museum and I was particularly interested in the gleaming marble hallways. I noticed a young art student walking and took a series of images as he walked down the brightly lit hallway. I had photographed silhouettes in the Quadracci Pavilion of the building before and was intrigued by the strong light that this beautiful building presents. The perspective of the hallway conjures up images of what I would imagine a futuristic time machine to look like."

Technical Data

Konica Minolta Dimage A2
10.1mm focal length
1/40 of a second at f/2.8
ISO 64
Ambient indoor light
Wall used to steady the camera (tripod usage was not allowed)

More than just a depiction of urban decay, this scene presents a striking contrast between the bleak concrete and the colorful, chaotic graffiti covering the walls and pillars. Industrial scenes are as individual as landscapes or city skylines, and range from futuristic looking nuclear power plants to the rubble of aging slaughter houses, as pictured here. Although these types of scenes don't represent your usual pretty picture, they are intriguing photo opportunities nonetheless — just as this photographer has successfully conveyed.

Photographer's Comments

"The Swift Processing Plant in Fort Worth, Texas closed in 1969 after 60 glorious years. The plant has a remarkable history in the Fort Worth Cowtown and produced the slaughter of millions of cattle for distribution throughout the United States. There are approximately 10 buildings still standing that are in very poor condition. It was only in the last building did I find the scene I had previously envisioned. I was immediately struck by the contrast of the floor and ceiling, producing almost a black-and-white photo effect while the center emitted a saturated color. To me, it represents the combination of the beauty of disciplined architecture with undisciplined restraint and the past meeting the present. The west wall had collapsed from a fire in the 1970s, which allowed the light to flow softly through the scene."

Technical Data

Canon EOS 5D digital SLR
Canon EF 24-105mm IS zoom lens set at 47mm
1/2 of a second at f/16
ISO 100
Bogen Monfrotto 3251 tripod with ArcaSwiss Moonball head
Ambient light

"Cowtown Graffitti"
© Kevin Moody
Richardson, Texas
www.kmoody.net

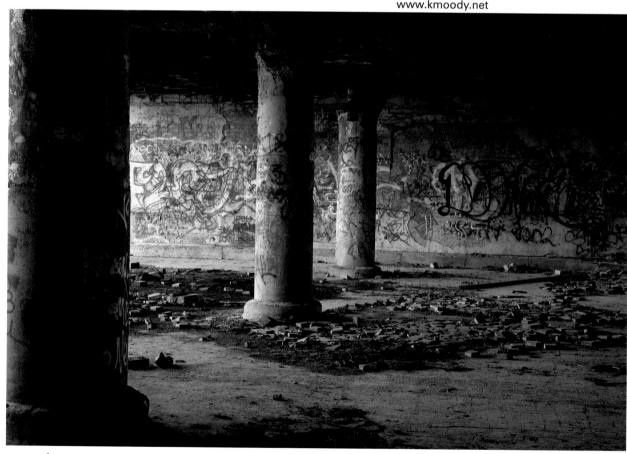

"METROPOLIS"
© *Silvia Ganora*
Messina, Italy
www.photo-sil.com

As with some of the other contemporary buildings depicted in this section on architecture, this image has a very futuristic look. The warm lighting suggests that this photo was taken early in the morning or late in the afternoon, and it emphasizes the cylinder shapes of this building, as well as the patterns of the small windows. Because much of this image is in shade, it also has a very abstract quality and is visually powerful; more so than if the light illuminated the entire building evenly. To make shapes and patterns prominent in an image, you need to zero in on them with your camera, and eliminate busy, extraneous background details. For maximum impact, it's important that there be a strong contrast between the shape that you want to emphasize, and the surroundings that help define them. This contrast can be between light and dark areas, as this photographer has done. And as this photographer also shows, images that show patterns are most successful not only when the pattern fills the picture, but when it's so tightly framed that the pattern seems to extend well beyond the confines of what you see.

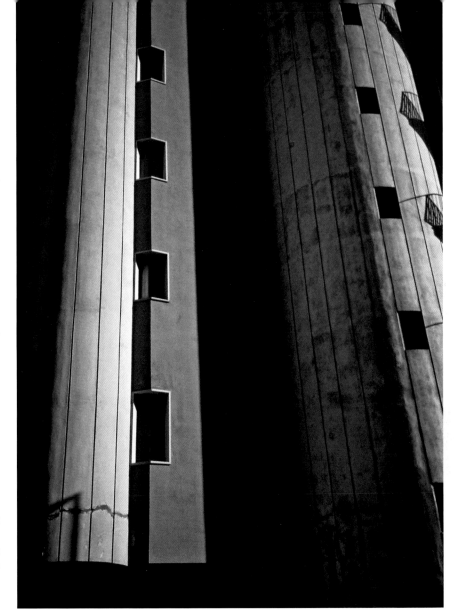

Photographer's Comments

"I was fascinated by the vertical lines of this building. Its rounded shape, the color of its walls — and the fact that it had such tiny, claustrophobic windows — made me think of some futuristic scenario. This is why I called it 'Metropolis,' like director Fritz Lang's movie."

Technical Data

Olympus XA compact digital SLR
Zuiko 35mm f/2.8 lens
ISO 100
Ambient light

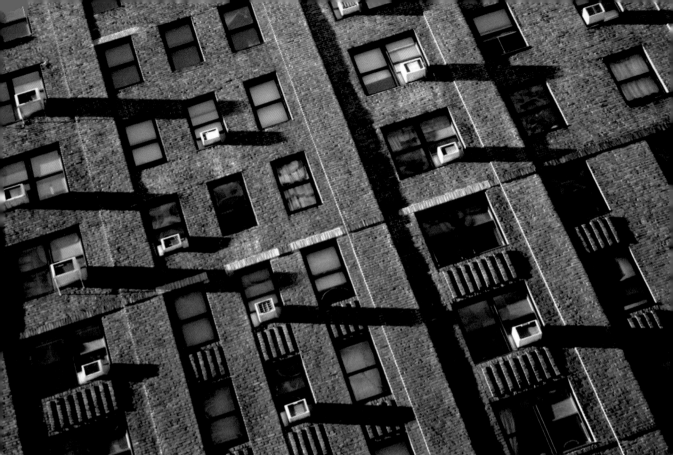

"7TH AVENUE FAÇADE"
© *Carlton Johnson*
New York, New York

The photographer of this image chose to empha-size the patterns created by the repetition of win-dows and air-conditioning units, as well as the vertical lines. They seem to continue into infini-ty beyond the frame. We usually don't think of tilting our camera at an angle, but this is a great (and very easy) technique to create a sense of the unexpected in a photo. You can tilt your camera when shooting, or do this in post-production on your computer. The photographer's use of the camera's black-and-white shooting mode empha-sizes the starkness of this building.

Photographer's Comments

"I was walking down 7th Avenue in New York on a sunny, but cold, day in mid-December without my camera. I happened to notice this building façade with strong elongated shadows emitting from the air-conditioning units. I thought this was visually interesting and appealing, but I didn't have my camera at the time. A week later, I returned to this site, making sure to arrive a little earlier than before. I wanted to take full advan-tage of the shadows' effects from the sun's angle, and my wishes to have a clear, sunny day came true even though it was very cold. I waited patiently to get the 'perfect' shadow lengths and angles of the air conditioners."

Technical Data

Canon EOS 20D digital SLR
Canon EF 28-135mm zoom lens set at 44mm
1/200 of a second at f/4
Black-and-white mode
ISO 100
Sunlight

This photographer has isolated the simple, elegant top of an adobe building in Mexico, and the reddish clay provides a beautiful complement to the deep blue sky. He was wise to include the wispy cloud above, which is a great design element as well. The way that you choose to emphasize the features of a particular building helps to determine the vantage point and camera angle you select. You can shoot straight on to show only the building's entry way, from an angle to show the front and the side, or maybe just the back of the building, if that view shows the most interesting architectural details.

Photographer's Comments

"I took this photograph while I was in San Miguel De Allende, Mexico, during the time I was taking a class from photographer Joyce Tenneson through the Santa Fe Photographic Workshops. Each morning I would get up and walk through the streets of town before class; sort of a way to wake up, or a bit of time to meditate visually. Rather than use the cameras that I was working with in class, I brought a small point-and-shoot camera, a Nikon 5700. It was small, lightweight, and capable of producing a RAW file. So each morning I'd shoot architectural images and street scenes. Then I'd head to class and make the transition to the figurative work that Joyce taught."

Technical Data

Nikon 5700 compact digital camera
Built-in zoom lens set at 15.7mm
f/7.2
ISO 100
Early morning light

"SAN MIGUEL 7"
© Jim Graham
Montchanin, Delaware
www.jimgrahamphotography.com

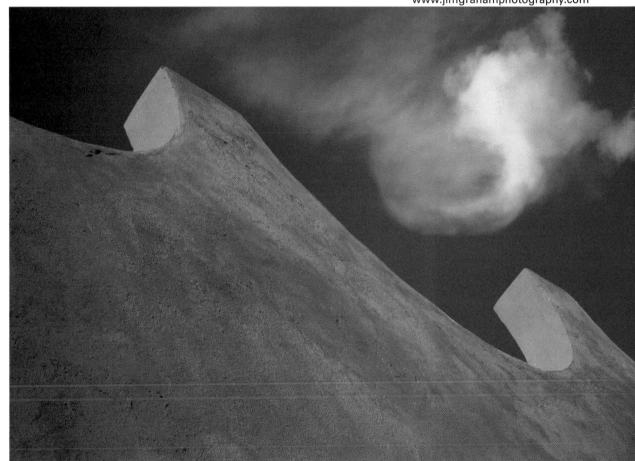

"In the Spotlight"
© Colin Roberts
West Midlands, England

This image of a stained glass window includes dappled light on the interior stone carvings below, which gives us more information about the beautiful cathedral in which this was photographed. When taking pictures of stained glass windows, you can shoot beams of light streaming through the window to capture mood. But if your goal is to capture the brilliant colors you see, you may wind up with washed-out photos if you shoot at a time when the sunlight hits them directly. Oftentimes, you get better results on overcast days when the light outside is soft and even. This gives you rich colors in the stained glass without getting glaring contrasts. In this case, the sunlight was coming in through a window behind the photographer. Thus, there's indirect illumination coming in through the stained glass window pictured here. The surrounding darkness dramatically sets off the window and the dappled light. A fast ISO enables you to handhold your camera indoors when you can't use a tripod.

Photographer's Comments

"This image was taken inside Lichfield Cathedral, Staffordshire, England. I wanted to capture the beautiful stained glass window as well as these beautiful carvings and stonework reliefs, that were highlighted by dappled sunlight coming in through the opposite window."

Technical Data

Canon EOS Digital Rebel
Canon EF-S 18-55mm lens set at 45mm
1/125 of a second at f/10
ISO 800
Ambient window light

Architecture is a melding of the art and science of design, thus providing a wealth of photographic opportunities. The key to revealing the best design compositions in architectural subjects lies in exploring them from different viewpoints. You may find different ways to interpret a particular element's design qualities, depending on your vantage point. Photographed from above with a wide-angle lens, this museum stairway reveals a series of graduating ovals, each compacted within one another. Our eye is drawn right into the center of the photo, which lies at the base of the stairway. This photographer chose to dramatize this architectural design by rendering it in black-and-white — color may have distracted from this graphic design.

Photographer's Comments

"I have been inspired by famous photographers who shoot spiral staircases all over the world, and I got the opportunity to do this when I visited downtown Chicago. While eating at a restaurant, I saw a poster of the MCA (Museum of Contemporary Arts) on Michigan Avenue, featuring its famous goldfish staircase. So I went to visit the museum, climbed the staircase, and took this picture from my own point of view."

Technical Data

Canon EOS 1D Mark II digital SLR
Sigma 12-24mm lens set at 12mm
1/13 of a second at f/13
ISO 1000
Ambient indoor light
Camera handheld

"MCA STAIRCASE"
© *Joaquin R. Felix*
San Jose, California
www.joaquinrfelix.com

"CHARCOAL MINE, BERINGEN, BELGIUM"
© *Richard Jungschlager*
Nieuwegein, Netherlands
www.richardsfotos.com

Although it's possible to use flash and light up the darkest places, the bright blast of light that flash often creates destroys the intimate mood of existing light. By using a fast ISO (400 or greater) and a tripod, you can shoot in the dimmest ambient light without flash. By utilizing the existing light, this photographer successfully captured the patterns, texture, and bleak ambiance of an abandoned European mine, and the composition leads the eye to the bright light in the center of the frame. When you're shooting indoors, you often work with a mixture of natural and existing light, and the results can be evocative.

Photographer's Comments

"During one of our expeditions at an abandoned charcoal mine in Beringen, Belgium, I walked into this hallway and noticed the patterns above and below me. I shot this image in the Program mode but shifted the aperture to f/5.6 to create more depth of field. I exposed for the first light patch of foreground, giving the brighter portions of the picture the correct exposure, and allowing the shadows to create patterns. I used a tripod to reduce camera shake and a six-second exposure, which can give you some interesting effects. I took three shots and didn't bracket exposures because my camera's histogram indicated that the scene had both the brightest white and darkest black."

Technical Data

Canon EOS 10D digital SLR
Tokina 28-70mm ATX-PRO f/2.6-2.8 zoom lens set at 32mm
6 seconds at f/5.6
ISO 400
Ambient indoor light
Tripod used

By exploring architectural subjects beyond the typical viewpoints, you can create some very original compositions. To do this, you need to move around your subject and discover where the most intriguing angles are, and decide how you want to render them to share what you saw with viewers. Shooting down from high vantage points can simplify busy scenes, while low angles exaggerate the height of tall subjects or reveal not-so-obvious features of lower ones. In this example, the photographer emphasizes the sharp angle of the converging lines in contrast to the softly rounded white sculpture in the center. This contemporary image, with its varying patterns and textures, is very pleasing graphically.

Photographer's Comments

"I was working on a project to feature various art museums in San Francisco. One of the major art institutions is the De Young Museum in Golden Gate Park. The building is a magnificent piece of modern architectural design. It is sheathed in a multi-textured copper sheeting and has many sharp angles that catch light and reflect it in fascinating ways. This sculpture is set in a sharp 'V' where two external walls of the building meet. The rounded shape of the sculpture set against the sharp edges of the walls and the colors of the paving stones cried out to me as a scene that had to be photographed."

"CONVERGENCE"
© *Gerald Currier*
San Francisco, California
http://cursmicon.photoworkshop.com

Technical Data

Canon EOS Digital Rebel
Canon EF-S 18-55mm 1:3.5-5.6 zoom lens
set at 18mm
1/200 of a second at f/9
ISO 400
Early morning light

"BOARDROOM"
© *Robyn Raggio*
Oxnard, California
www.raggiovisio.com

When you want to capture the essence of an interior space, decide what it is that you find appealing about it, and figure out ways that your image can accentuate those qualities. In this case, the photographer portrays contrasts: a window that offers a promise of a better tomorrow set against an aged interior. Lighting interiors can be challenging. You may want to shoot with ambient light from windows or lamps, or highlight a particular section with flash or strobes. Look at the architectural quality of a room and think about how you want to convey it photographically. To underscore the deteriorating aspects of this room, this photographer rendered it somewhat dark and moody.

Photographer's Comments

"This is the musty interior of an old, historical home in Sherman, Texas, that was undergoing restoration. The walls had been stripped down to the lathe construction with old fiber insulation that was deteriorating within the wall. The window was a complete white rectangle that provided a brightly illuminated promise of a new day, a counterpoint of contrast to the aged interior. The geometry and varieties of color and detail of the horizontal lathe lines and the texture of the fibrous insulation, along with the decorative moldings of the window provided a lot of graphic interest to the composition."

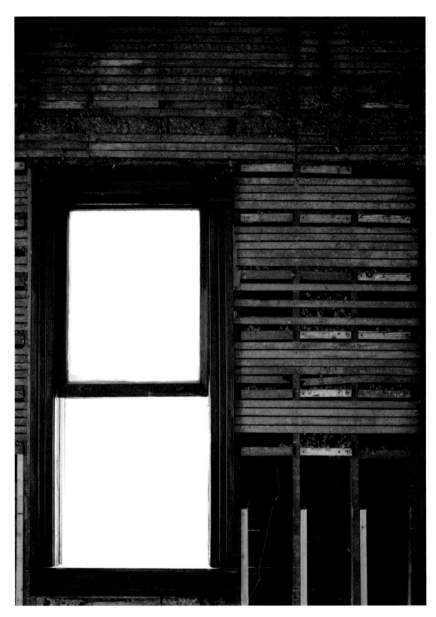

Technical Data

Canon EOS 5D digital SLR
Canon EF 24-70mm L Series zoom lens
set at 46mm
1/100 of a second at f/2.8
ISO 1250
Spot metered for both wall and window and averaged the exposure
Camera handheld

Both architecture and photography deal with similar elements — shape, line, texture, and pattern. When you photograph a building, try to emphasize what elements intrigue you about it. In this case, the photographer successfully captured the stark, massive shape of this famous adobe church in New Mexico, along with a dramatic sky and sidelighting. The vantage point you choose emphasizes different features too. A low angle enhances a building's height and massiveness, while a high angle may draw attention to the structure's relationship to its environment.

Photographer's Comments

"As a student of the history of photography, I have seen many images of this church, St. Francis of Assisi, in Rancho de Taos, New Mexico. Many artists and photographers have captured the simplicity of the structure in both form and materials. It is the merging of perspective and lighting that makes each vision of the church unique, and a single image only tries to define a momentary feeling, one that is likely to change in an hour or a day, or from a new vantage point. The joy of photography is that the moment is captured forever. My own vision is direct, uncluttered, and sharp most of the time and is reflected in this image."

Technical Data

Nikon N80 35mm SLR
Nikkor 20mm f/2 AF lens
Fujichrome Velvia ISO 50 transparency film
Auto setting for daylight
Nikon 5000 film scanner
Image adjusted slightly for exposure

"RANCHO DE TAOS"
© Alan Berkson
Milford, Connecticut
www.omages.com

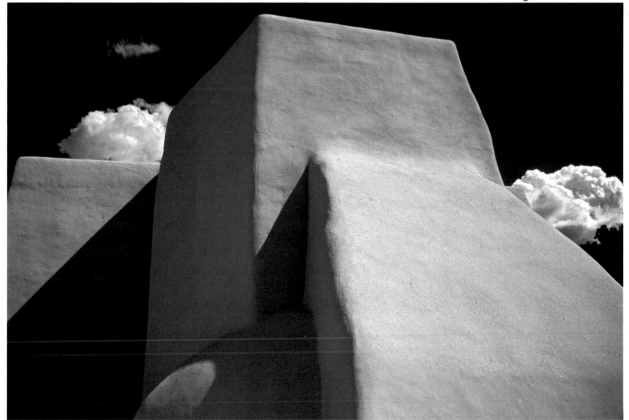

Buildings are often magically transformed after dusk by their beautiful lights. These lights take on the color characteristics of the artificial light being used. If your camera's white balance is set on Daylight or auto, incandescent light sources appear warm and golden. Fluorescent lights, such as those inside office buildings, give a scene a greenish cast. When shooting at night, remember that many exposures require a long shutter speed and a tripod or other steady camera support.

Photographer's Comments

"The CN Tower is a defining feature of the Toronto skyline, and most people who visit the city photograph this landmark. I've seen many nice images of the tower from a variety of locations, but they've always shown the tower among

"CN Tower at Twilight"

© Peter Strong
Ontario, Canada
http://strong_images.photoworkshop.com/

other buildings. I had just returned to the ground level after trying to take a few evening shots of the city. I took a walk along the base of the structure, something I'd never done before. Looking up, I was presented with a new perspective of the tower, a massive presence against the twilight blue sky, the warm glow of the transparent observation floor highlighting the scene. Without a tripod handy, I braced the camera against the railing of a stairwell and captured this image. Sometimes a change in perspective makes all the difference between a shot you've seen a dozen times and one that is truly unique."

Technical Data

Canon EOS Digital Rebel XT
Canon EF-S 17-85mm zoom lens set at 17mm
4 seconds at f/4
ISO 200
Ambient evening light

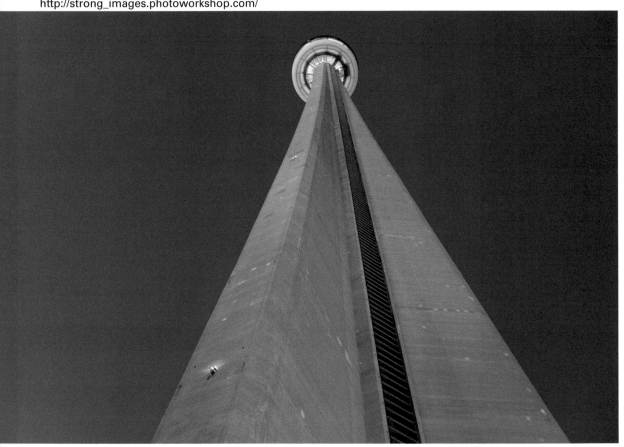

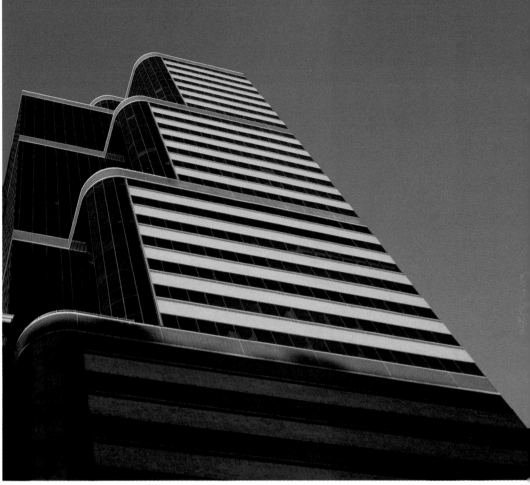

"Ladder to Infinity"
© *Vitali Gorobets*
Levittown, Pennsylvania
www.qwerty97.esmartweb.com

In cities, it's difficult to get an isolated view of a building unless you get very close to it, so use a wide-angle lens or the wide-angle setting on your zoom lens. This photographer has rendered this modern commercial high-rise building as an interesting study of lines and shapes soaring upward. The warm light illuminating the gold building also provides a nice complement to the blue sky. When you use a wide-angle lens to shoot up at a building, you're likely to get a slightly distorted perspective, in which all the lines seem to converge at the top of the structure and the building appears to be leaning. In many cases, like this one, this effect works to the photographer's advantage. But if you shoot architecture often and you need to get an accurate rendering of a building, you might try

getting a PC (Perspective Control) or shift lens. This allows you to tilt the lens so that you eliminate any distortion.

Photographer's Comments
"This picture was taken in December while I was visiting Philadelphia, Pennsylvania. I was inspired by the amazing combination of colors and shapes — the infinite blue sky as opposed to the bounded lines and curves of the building."

Technical Data
Canon EOS 20D digital SLR
Canon EF 17-40mm f/4 zoom lens set at 20mm
1/200 of a second at f/7.1
ISO 200
Daylight

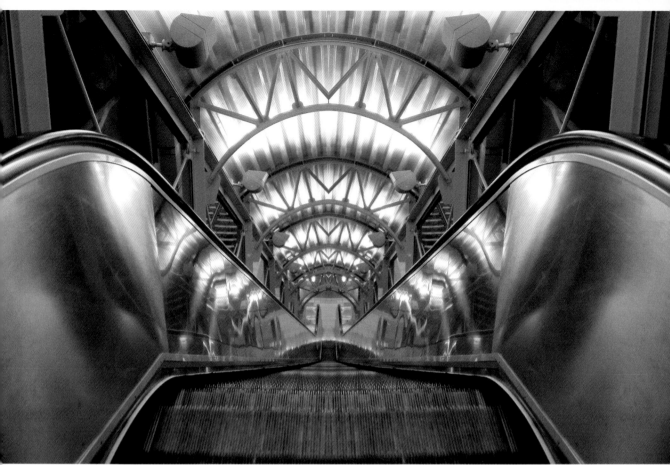

"ESCALATOR"
© Yusuf Hafiz
Arlington, Texas
www.hafizdesigns.photoreflect.com

This sophisticated photo of an escalator in a commercial building has a lot of interesting graphic elements. The existing overhead lighting fixture provides interesting design, as well as putting reflections on the sides of the escalator. The light was also sufficient to illuminate this scene at an ISO setting of 400. As the photographer wanted to encompass the entire escalator from top to bottom, flash wouldn't have worked well in this situation. However, there may be times when you photograph a room and want to utilize flash (preferably bounced or diffused) to supplement the ambient light.

Photographer's Comments

"My experience as a photographer runs the entire spectrum from fashion and portraiture to still life. One Saturday in April 2006, my wife, daughter and I were on our way to a movie in Dallas, Texas. It was my daughter, Amira, who first noticed the height and distance of this escalator and said, 'That would be an excellent shot for your collection.' Naturally I agreed and shot several photos from different angles. This view looking down from the top of the escalator gave me a sense of freedom and solitude — particularly because no one was taking a ride up at the time. I have to thank Amira for her inspiration and awareness on that beautiful Saturday evening."

Technical Data

Canon EOS 20D digital SLR
Canon EF 24-70mm f/2.8L zoom lens
Camera set on manual exposure mode
1/25 of a second at f/2.8
ISO 400
Existing interior light

This photographer could have portrayed this church any number of ways, but made a wise choice to emphasize the haunting qualities of the church by using black-and-white infrared film. The sky is dramatically darkened, while foliage and the sunny side of the building seem to glow as if illuminated by eerie moonlight. Infrared photography extends the vision of the camera beyond the limits of the human eye, giving images an ethereal, otherworldly look. Infrared imaging reveals what's beyond the red end of the visible spectrum. There are several digital cameras on the market today that have an infrared setting, if you are interested in this type of photography.

Photographer's Comments

"St. Theresa is the church that appeared in Alfred Hitchcock's movie, 'The Birds.' I've passed it many times on my way to Bodega Bay, and one day I decided to stop and take a closer look at it. I decided that there was a spirit about this place that would best be captured with infrared film, so I returned the next day and shot a dozen photos of it. When I scanned them into my computer, I discovered that my tripod had been at an odd angle. As I looked at the photo, the angle and light made the church appear to be a

"CHURCH, BODEGA, CALIFORNIA"
© Ron Breeze
Rohnert Park, California

spirit rising from the ground, and I knew this was the representation I was looking for."

Technical Data

Nikon F2 35mm SLR
Nikkor 24mm f/2.8 wide-angle lens
Kodak HIE infrared film
1/125 of a second at f/11
ISO 200
Hoya IR72 (a red filter designed for use with infrared film)
Tabletop tripod

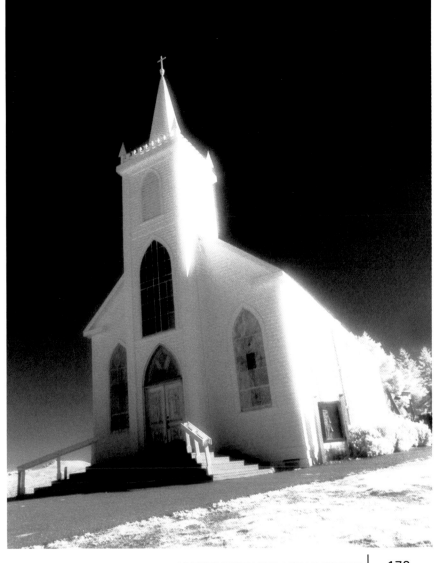

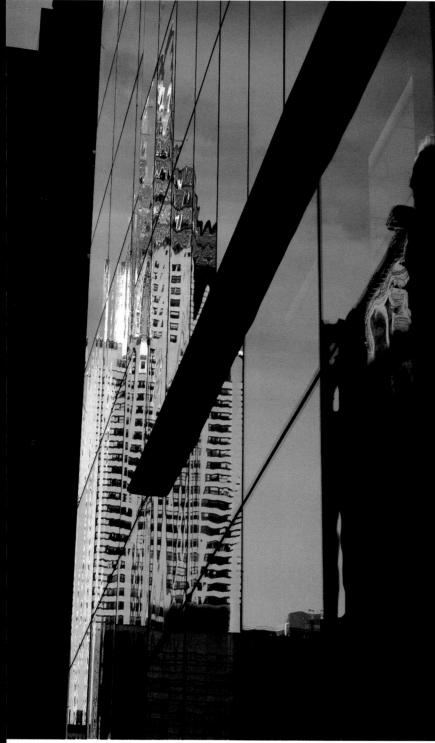

Reflections give you a great opportunity to give added dimension to a photo by showing two different aspects of the world at the same time. Since the reflected image is usually distorted, it may have a surreal quality, like this rather ornate building reflected in the glass of another urban high-rise. Because a reflection offers a second viewpoint in an image, it's a good idea to use a reflective surface that provides a natural frame.

Photographer's Comments

"A reflection of reality is what allows us to see additional angles in everyday life. This vision allows me to give my viewers the chance to see a different perspective; I just want to provide a new viewpoint to their experience."

Technical Data

Canon EOS 20D digital SLR
Canon EF 28-70mm lens set at 54mm
1/60 of a second at f/9.5
ISO 100
Daylight

"REFLEJOS"
© *Ivan Ceballos*
Caamano Quito, Ecuador
www.tallerdecasting.com

With rows of metal pillars framing a unique needle-like structure, this image imparts a futuristic, science-fiction look. This photographer successfully emphasizes the drama of these towers by shooting from a low angle and tilting the camera slightly. When photographing architecture, the lighting you choose should stress the building's unique features. If possible, study a structure at different times of the day to see how the sunlight affects it. The low angle of the sun creates shadows, adding further drama to this scene.

Photographer's Comments

"I took this photo while I was on a tour of Barcelona. I was impressed by the design and size of the tower and also liked the continuity of the yellow towers. I shot some photographs of the tower from different angles, including different elements in the foreground to give the image a sense of depth. I chose this one because it clearly shows the continuity of the yellow towers, giving the image depth, and shows the Calatrava Tower at the same time. The angle also helps make the image more dynamic."

Technical Data

Canon EOS Digital Rebel
Canon EF 18-55mm lens set at 18mm
1/80 of a second at f/16
ISO 100
Daylight

"CALATRAVA TOWER"
© *Julio Andres Arboleda Escobar*
Barcelona, Spain
http://julioarboleda.photoworkshop.com

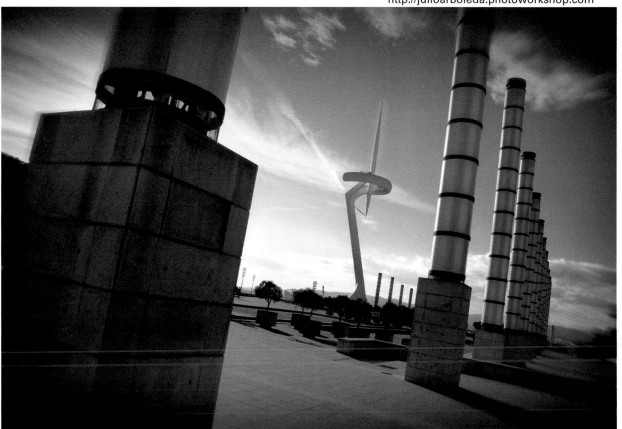

This photographer honed in on the beautiful simplicity of this unique structure in St. Louis, Missouri. Some of the most powerful images — of any subject — focus on a single idea with as little clutter as possible. One way to isolate subjects is to experiment with different vantage points. In this case, shooting from a low angle enabled the photographer to isolate the arch against the sky. This cool, blue-toned image has a strong graphic feeling, and the clouds serve to add a little texture.

Photographer's Comments

"Visiting an architectural wonder like the Gateway Arch is both a joy and an honor. As manmade wonders abound in this world, the opportunities to make images of them are plentiful. The eye is a lens for transferring images to the brain. Photographic lenses are either meant to mimic the eye or to create a completely different vision than what the eye alone can process. The lens is the intermediary in the inherent joy of photography, whatever one is used creates an image that is different than the eye, and then can be inspected by that same eye-brain connection. As a photographer and artist, I am inspired by my vision, both with and without the camera to my eye, but mostly I am thrilled in finding a way to capture the experience, and for the ability to share the image."

"GATEWAY ARCH, ST. LOUIS"
© Alan Berkson
Milford, Connecticut
www.omages.com

Technical Data

Nikon N80 35mm SLR
Nikkor 28-120mm f/3.5-4.5 AF zoom lens
Auto daylight setting
Fujichrome Provia 100 transparency film
Nikon 5000 film scanner

"ABOVE GROUND"
© *Sharon Perkins*
Lafayette, Louisiana

There are some people who are devoted to photographing cemeteries, and enjoy the design of the headstones and crosses, or the overall look of a graveyard. Particularly in the southern U.S., these final resting places are very interesting and historical, and can inspire those of us who don't normally seek out subjects like this. Look for intriguing vantage points for an overall view, and then seek out some interesting details. There are no rules that say your pictures have to show all of a particular landmark, or even to provide a completely literal interpretation.

Photographer's Comments

"I have always been fascinated with cemeteries. Here in southern Louisiana, they are very interesting photographically. There are many shapes and sizes of tombs, gravestones, and cemeteries themselves, if you can catch the light just right, all the stone reflects light beautifully."

Technical Data

Nikon D100 digital SLR
Nikkor 18-70mm zoom lens
1/160 of a second at f/3.8
Shutter priority
ISO 200
Daylight

"CITY BALCONIES"
© *Silvia Ganora*
Messina, Italy
www.photo-sil.com

Patterns appear wherever graphic elements like lines, colors, or shapes repeat themselves. Once you begin looking for patterns in the natural or manmade world, you can find them almost everywhere. Look at potential subjects from a variety of angles. When you want to emphasize a pattern, isolate it from its surroundings. If we saw a shot of this building in its entirety, we may not have been so struck by the interesting window patterns that this photographer reveals. By excluding everything but the design created by a pattern, you'll give a viewer the feeling that this repetition continues indefinitely. The blue window shades also contrast nicely against the more neutral shades of the structure.

Photographer's Comments

"On this particular day I was out looking for interesting buildings to photograph. Messina, Italy has architecture that ranges from very antique to very modern, and often odd buildings. I was interested in the ones that were unique, as they sometimes offer strange symmetries and eye-catching, clashing colors. When I saw this building, the blue tones of the rolling shutters and the yellow lines of the balconies instantly intrigued me. I also like the way the windows and balconies were oddly arranged on the building's façade."

Technical Data

Nikon D70 digital SLR
Nikkor AF-S DX 18-70mm f/3.5-4.5 G IF ED lens
1/1600 of a second at f/6.3
ISO 200
Daylight

As an art form, architecture includes many of the same elements that photography does — shape, line, texture, and pattern. This image of an adobe structure is a study of these elements, and the photographer has made it especially artistic by rendering it in black-and-white. In any case, decide what interests you about a particular structure and try to capture it. The way that you choose to interpret these features will determine your point of view and camera angle. You may want to emphasize the color of a building or decide to render it in black-and-white. The lighting makes a big difference too. Study the structure at different times of day to see how the sun hits it, and shoot your pictures at the most opportune time. Besides being interested in this building's history, the photographer wanted to portray the varying geometric shapes, texture, and patterns that captured his eye.

Photographer's Comments

"I was inspired to photograph this old adobe house for two reasons: for its historic value as the first theatre in California and its architecture. Built in 1846 and still open on a limited basis, its architecture features distinctive geometric shapes and strong texture and patterns on the walls."

Technical Data

Canon EOS 30D digital SLR
Canon EF 70-200mm f/2.8 L IS zoom lens set at 73mm
1/250 of a second at f/3.5
ISO 100
Daylight

"ADOBE HOUSE"
© Eduardo Fujii
Pebble Beach, California
http://eduardofujii.photoworkshop.com

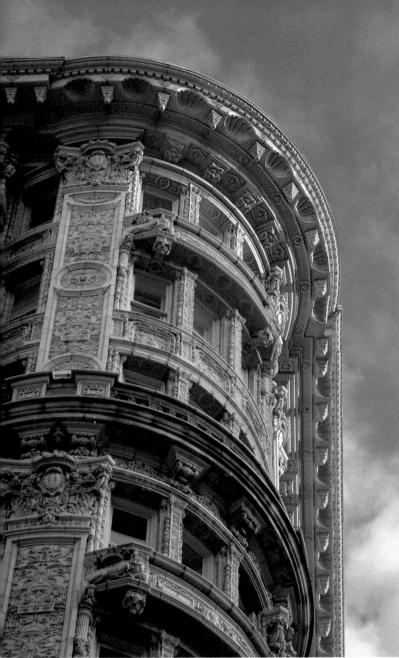

For those who love to shoot architecture, cities offer a wealth of photo opportunities. You can capture such diversity as historic buildings — often alongside modern high-rises — farmers' markets, monuments, and parks. Walking through a city will afford you more chances of finding places to shoot, but taking a tour can familiarize you with the area and you can come back later to photograph the places you find most photogenic. As with landscapes, early morning and late afternoon are the best times to photograph buildings. This photographer captured the ornate details of this New York City facade in the last glow of daylight, and used a moderate telephoto setting on his lens to isolate just a portion of the interesting architecture.

Photographer's Comments

"I took this shot during a walk around mid-town Manhattan. It was late afternoon and the setting sun was grazing the tops of the buildings along Broadway. The angled light profiled the details of this particular building. I liked the rich blue of the sky, the clouds, and the warmth of the light picking out the features on this façade. The structure is apparently the former U.S. Rubber Company building."

Technical Data

Canon EOS Digital Rebel XT
Canon EF-S 17-85mm zoom lens set at 85mm
1/250 of a second at f/5.6
ISO 200
Daylight

"NYC BUILDING DETAIL"
© Peter Strong
Ontario, Canada
http://strong_images.photoworkshop.com

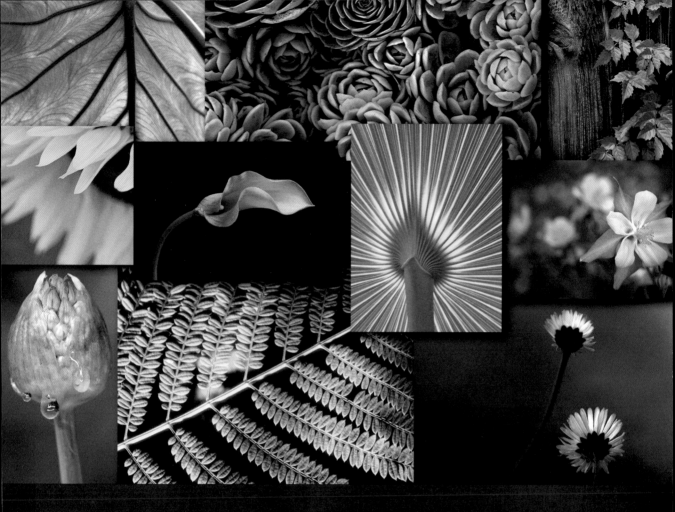

PART 7
BOTANICAL PHOTOGRAPHY

Nature always ranks among the most popular photo subjects. Much of this appeal comes from our sense of wonder at the beauty of plants and flowers. Through photography, we can express this fascination and share it with others. Whether you enjoy shooting close-ups of a bud unfolding, or an entire mountainside of spring flowers in bloom, there are a number of ways to approach this type of photography. It may mean a trip to a botanical garden, setting up an arrangement of cut flowers, or simply exploring your own backyard. Another plus is that flowers don't move around, nor are they sometimes uncooperative like other subjects. Again, good lighting and composition are key to getting great images. Possibly the best light is the soft, diffuse illumination of open shade or a cloudy day. Like gardening, photographing flora and fauna can provide a peaceful and enjoyable communion with nature.

Most people try to include too much information in their photographic compositions. By contrast, you can see that this photo is more than a simple floral close-up—it's an elegant rendition of bold colors and lines against a dramatic black backdrop. A good photograph of any subject should show a single idea with as little clutter as possible. The photographer chose to crop this composition very closely, reducing it to its simplest form, yet in a way that's highly effective. There's an old saying in photography that says if you want to improve your images 100%, then move closer, which is illustrated beautifully here. You can experiment with framing and cropping by shooting different compositions of a particular subject. Zoom in close and see how much you can eliminate from a photo. You may be surprised what powerful images you wind up with when you take risks and create a strong, graphic rendering of a scene. And when photographing bold colors like red and green, try using simple backdrops of black or white for added punch.

Photographer's Comments

"I was photographing this tulip and was looking for a simple, yet elegant, composition. After about 10 shots, I tried to use a different approach. As I looked through the viewfinder, I knew I finally had my shot."

Technical Data

Canon EOS Digital Rebel
Canon EF 60mm macro lens
10 seconds at f/32
ISO 100

"TULIP"

© Robert Slachta
Dunmore, Pennsylvania
http://bobslachta.photoworkshop.com

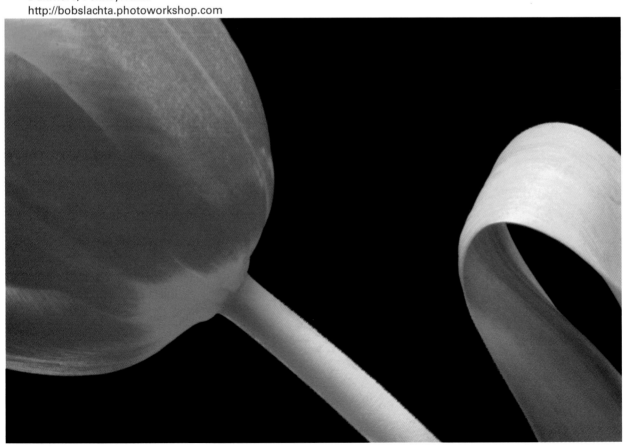

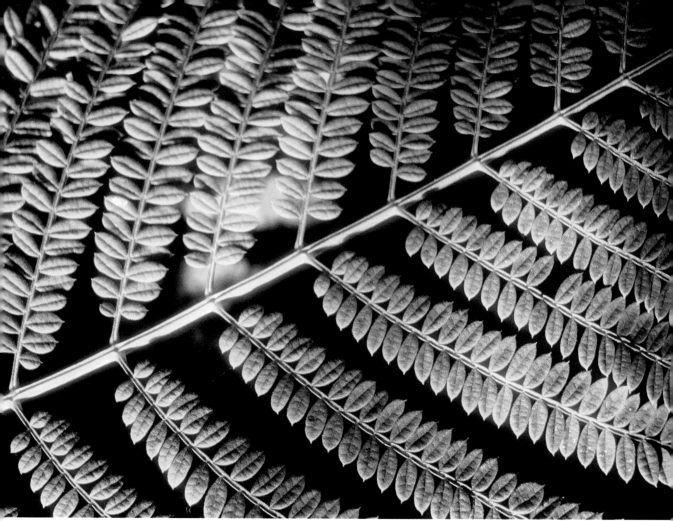

"BRANCH"
© *Eduardo Magana Vazquez*
Saltillo, Mexico
www.eyefetch.com/profile.aspx?user=edumagana

The low light of early morning and late afternoon accentuates features and qualities of plants and flowers that are rarely noticed in full frontal lighting. Side lighting explores the intricate details of this fern's leaves, and the soft warmth of its color is another plus of early and late light. Compositionally, the pattern of the leaves with the diagonal line of the branch moving across the frame is very pleasing, and the dark background sets the illuminated frond off nicely. Shooting close-ups of flora and fauna opens a new realm for those who choose to explore it — you'll never look at a petal or leaf the same way again. The simplicity of the composition and the beautiful lighting is what elevates this image beyond a simple botanical recording.

Photographer's Comments
"I like forms found in nature. One day I was pruning the trees in my garden, and I noticed how wonderful the light was on this particular branch. I immediately got out my camera and shot this scene."

Technical Data
Panasonic FZ20 compact digital camera
Auto exposure mode
Macro setting
Ambient daylight

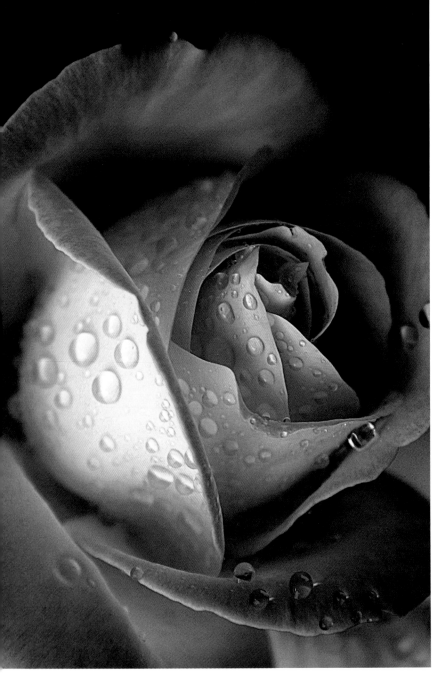

"YELLOW ROSE"
© *Al Morrison*
Akron, Pennsylvania
http://amorrison.
photoworkshop.com

Close-up images of flowers can be very striking, like this one, but also require some work on your part. Be aware that the closer your camera is to a subject, the shallower the depth of field becomes. Movement is also greatly exaggerated when shooting up close. A faint breeze can cause a flower to move around, so it's a good idea to try to block the wind from your subject whenever possible. You should use a tripod when photographing floral close-ups to reduce camera shake.

Photographer's Comments

"This rose bush is kind of a scraggly mutt among the rose bush genre, not an especially prominent feature of our landscaping efforts. It doesn't receive the care and attention that it should probably get, yet it perseveres year after year, stubbornly rubbing against a drab cinderblock wall at the side of our garage. Shortly after an early afternoon spring rain, however, it spoke loud, proud, and clear with an offering that *demanded* to be photographed. This is lightly called a "Kodak" moment, but for me, it's as important as eating or breathing. Was it just a rose heavy with raindrops sitting at the side of a garage and visible only to a select few for mere nanoseconds? Perhaps, but I was inspired enough by the sight to capture it and can now relive the sweet serendipity of that moment whenever I want."

Technical Data
Canon EOS 300D Digital Rebel
Canon EF-S 18-55mm zoom lens
1/125 of a second at f/5.6
ISO 100
Morning light

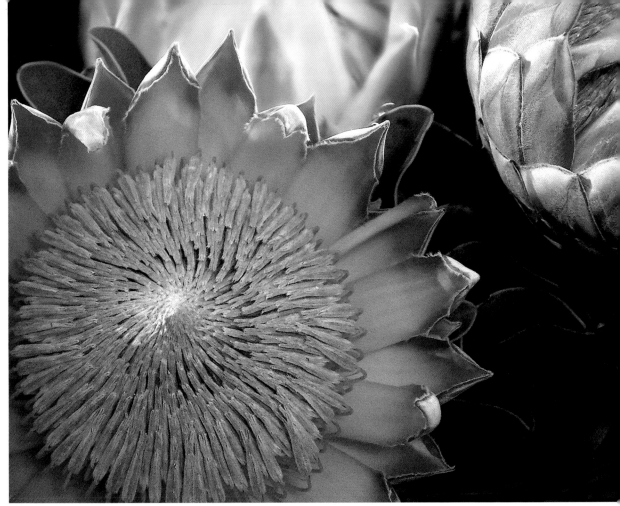

"Protea"

© *James Lowell*
Jacksonville, Florida

These close-ups of a Protea reveal the flower at a couple of different stages of bloom. Flowers provide enough diversity of color, shape, and patterns to keep nature photographers busy for a lifetime. In this shot, the photographer focused on the flower in full bloom in the foreground, and by using a large f-stop for shallow depth-of-field, the others are thrown slightly out of focus.

Photographer's Comments

"I photographed this Protea in May when my wife and I were on a cruise vacation that included the city of Funchal, capital of Madeira, Portugal, in the city's central market, Mercado de Labradores. To enter the Mercado, I had to pass through a long, arched entry that led to the two-story inner courtyard and the main markets. It was about 10:00 a.m. when I arrived, and I had just reached the end of the archway entrance when I noticed a number of baskets of uniquely gorgeous flowers — including two varieties of African Proteas. The market was crowded, so I had to grab my picture between passing shoppers. The light coming in through the arch was less than ideal, but it was soft and sufficient enough to allow me to shoot hand-held while kneeling. Because of the low-light conditions, I had to use the camera's manual-focusing mode (I give much of the credit for sharpness to the lens' image-stabilizer).

Technical Data

Minolta DiMAGE A200 digital SLR
Minolta 28-200mm zoom lens set at 31.2mm
1/40 of a second at f/3.2
ISO 200
Ambient indoor light filtered through an archway

Patterns bring a sense of visual rhythm to a photograph as with this grouping of succulents. You can find patterns in any number of subjects: a field of flowers, faces in a crowd, or the designs in architecture. Patterns can be revealed when you examine subjects from varying angles. Shooting down from a high perspective can reveal these patterns, as it does here. At other times, the low light of morning and afternoon may etch out patterns in nature. You can also emphasize pattern and design in nature by isolating them from their surroundings with a telephoto lens. Rendering this scene in black-and-white emphasizes its graphic aspects.

Photographer's Comments

"While I was traveling in San Francisco shooting images for my series, 'Botanica,' I came upon this scene and was immediately attracted to the concentric design of these plants (Echeverias). I liked the way the light and shadows brought out the form, which gave them a three-dimensional quality. These plants just had to be photographed. I chose black-and-white as a medium because of its abstract qualities."

Technical Data

Nikon D100 digital SLR
Nikkor 24-85mm lens set at 85mm
1/250 of a second at f/4.5
ISO 640
Daylight

"BOTANICA 4"
© Robert Cattan
White Plains, New York
http://cattan.typepad.com/photography

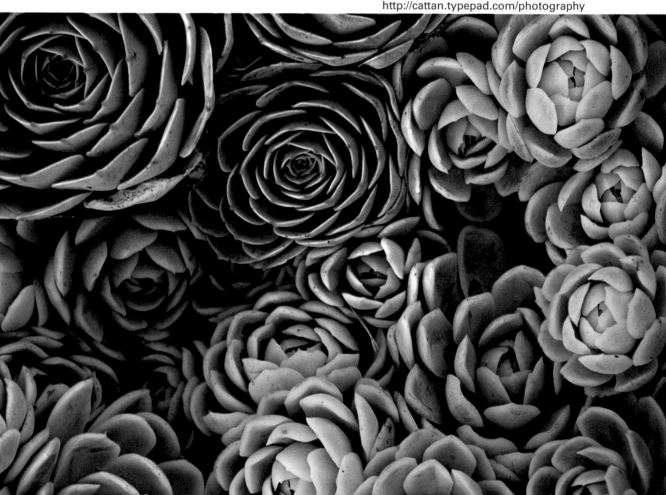

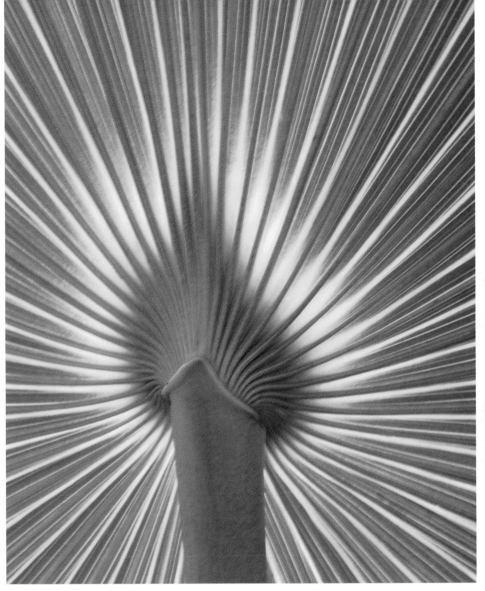

"THE PALM"
© *Gary Carter*
McLeansville,
North Carolina
www.garycarter
photos.com

Here is another image that shows us the beauty of nature's intricate design. Our eye is drawn to the center of the photo, from which the lines of this palm leaf radiate outward beyond the frame. Nature's allure comes from the fact that we have a shared sense of wonder and mystery at the complexity found in nature. We don't admire photographs of plant life when they're ordinary botanical records, but rather, when they celebrate nature's beauty. Some natural subjects are rather close to the ground, so when you're shooting close-ups and need to use a tripod, be sure to choose one that is adjustable so that you can shoot near ground level. The sun backlighting this leaf makes it appear especially radiant.

Photographer's Comments

"I shot this image in southern Georgia while I was staying at a motel. I walked around the motel grounds to see whether there was anything to photograph when I saw this palm frond and the sun behind it."

Technical Data

Canon EOS 1DS Mark II digital SLR
Canon EF 180mm macro lens
1/125 of a second at f/8
ISO 400
Gitzo tripod

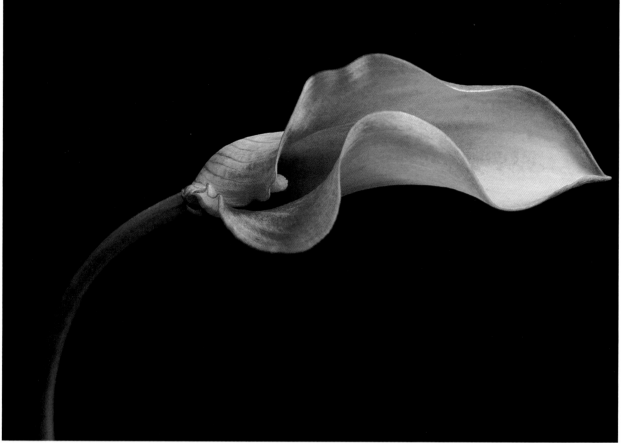

"CALLA LILY"
© *Susan Bokos*
Chappaqua, New York
www.susanbokos.com

A simple backdrop was used to accentuate the color and flowing shape of this beautiful flower. Her floral choice and composition are excellent also, with the flower bending gracefully to the right, rather than choosing a flower in a more static position. The choice of black in the background against the brilliant orange and pink of the lily adds drama, and the overall image appears very painterly. Her use of a small f-stop (f/13) enabled her to fully capture the texture details, and the soft lighting coming from the side works beautifully. Off-camera flash or a well-placed studio light works great when shooting indoors.

Photographer's Comments

"Most of my work has been portrait or documentary photography. As my love of nature, flowers, and gardening grew, I became interested in capturing that piece of my life in photos. I sought out flowers with beautiful, graceful lines and exquisite color — the simpler, the better. I was drawn to this calla lily first by its color, the rich orange with the blush of pink inside, and then by the graceful undulating lines of the flower and its stem. My aim was to capture this flower's strength and power, as well as its gentleness and flexibility."

Technical Data

Canon EOS 10D digital SLR
Canon EF 28-80mm zoom lens set at 63mm
6 seconds at f/13
ISO 100
Tripod
Smith Vector 10-inch 200-watt tungsten flood light, softened by hanging a plastic shower curtain in front of the light

You can really bring out the beauty of nature through the eye of a telephoto or close-up lens. And, as I've mentioned earlier, one of the pleasures of photographing flowers and plant life is that you may not have to look further than your own back yard, especially those of you who have a lovely garden. This photographer shot this colorful water lily in his pond at home with a telephoto zoom lens. And although there is an abundance of beauty in the natural world, you should focus on those subjects that hold particular interest for you. This photographer enjoys taking pictures of the flowers in his tropical garden, and even hopes to include these images in a book one day.

Photographer's Comments

"Basically, this image is from a series that I have taken in my garden. Every morning between 9:00 and 10:00 a.m. when the light is great and the sun is still low in the Hawaiian sky, I take a few images. If a great one stands out from the rest, I include it in my 'Hawaiian Garden Collection,' which I hope one day to publish as a coffee-table book. This pink lily was photographed in my 120 × 60-foot Koi pond (I have three large lily ponds), around 9:00 a.m. This lily was freshly sprinkled with water from a passing tropical shower."

Technical Data

Canon EOS 5D digital SLR
Canon EF 70-300mm IS lens
1/25 of a second at f/5.6
ISO 100
Daylight

"PINK LILY"
© Peter McLaren
Paauilo, Hawaii
www.woodshopgallery.com/Photography

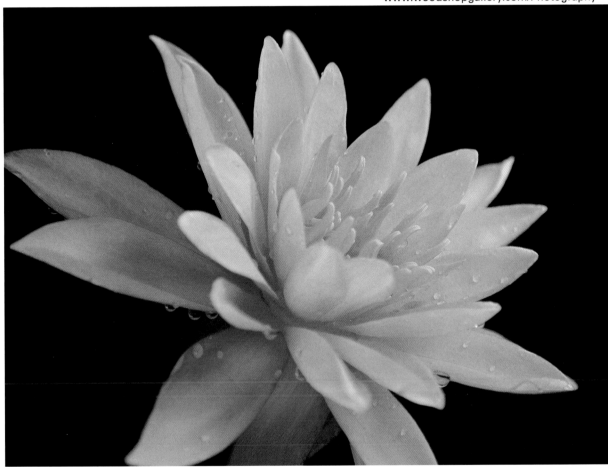

Many wonderful photo opportunities can be found in rural scenes, especially for those who can find interesting compositions. Rather than shooting the entire building, this photographer chose to isolate the green vine against the rusty brown veins of the cedar plank, resulting in a rich contrast of texture and color. This scene works especially well because of the soft, diffuse light, which is always a good choice when photographing plants. This flattering illumination wraps around the subject from many directions. Diffuse light also produces colors with greater saturation than with direct sunlight. Subtle tones and rich hues are beautifully reproduced, and primary colors are bold.

Photographer's Comments

"My family and I were spending the day at Gruene, Texas, which we enjoy visiting because of the historic sites. As we were about to return to San Antonio, I came across this scene. The green vine was highlighted as it clung to a cedar plank on an old building. The diffused light produced by the overcast skies provided a shimmering glow on the leaves and brought out the veins on the cedar board. I made just two frames of this scene, and we went on our way."

Technical Data

Fuji FinePix S5000 digital camera
Fujinon 5.7-57mm zoom lens set at 5.7mm
1/478 of a second at f/4.6
ISO 200
Diffuse light from an overcast day

"Vine 2"
© Ricardo Santos
Laredo, Texas

"MARGARITAS"
© *Jose Angel*
Diego Garcia
Asturias, Spain

Your images take on a new perspective when you change your vantage point. Most of us confine ourselves to the typical point of view that a standing position gives us because it's convenient and seems natural, but you can make an image far more intriguing by changing your point of view. There are times when you may want to shoot from a lower, upward-looking vantage point to make the subjects appear taller and more majestic. With subjects like these flowers, you may need to lie down on the ground to shoot up. These flowers have gained in stature, becoming a looming presence against a dark sky.

Photographer's Comments

"I have always appreciated images taken from an unusual point of view because I believe that our routines can prevent us from seeing the beauty around us. For this reason, I decided to view these humble daisies from the ground up — not from above shooting down as we would see them every day. After examining many of the daisies in this patch, I chose these two flowers because of their form, the way they reached toward the sky, and how their petals were illuminated. I had intended to make this a color photograph, but when reviewing it on the computer, it seemed as though the color worked against the flow and light on the flowers, so I chose to convert it to black-and-white with Capture NX software."

Technical Data

Nikon D70 digital SLR
Nikkor 105mm f/2.8 G VR lens
1/400 of a second at f/5.6
ISO 200
Sunlight

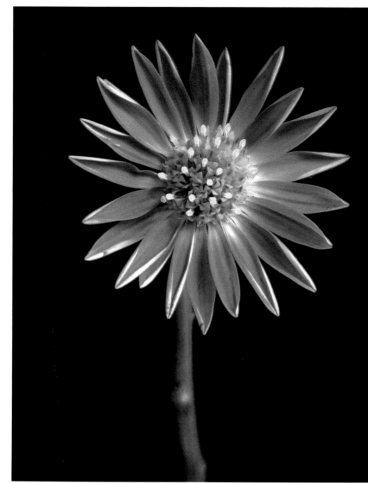

"LONESOME"
© *Andrew Dykeman*
New York, New York
http://adykeman.photoworkshop.com

This dark background emphasizes the color and shape of a lone flower, and brings some drama to the image. I also like the fact that the subject is off-center in the frame. When choosing a point of view to photograph a floral subject, you'll want to find a viewpoint that reveals one or more of the plant's outstanding characteristics. Nonetheless, it's a good idea to experiment by photographing a subject from varying points of view and from high and low vantage points to see which angle works best. As for lighting, you'll want to position your light so that it comes from one side or behind the flower to show surface texture and the translucence of the petals. You can hold an electronic flash a few feet off-camera, or, as this photographer has done, use window light with a reflector to bounce light back at the subject.

Photographer's Comments

"One of the great things about photography is its ability to reveal a subject in a manner we might not experience in our usual environment. With this in mind, I isolated this single flower against a black background so the viewer can enjoy its beauty with no distractions.

Technical Data

Canon Digital Rebel XT
Canon EF 28-135mm zoom lens set at 135mm
1/13 of a second at f/5.6
ISO 100
Window light and reflector with black fabric background

This view of a downcast sunflower is a departure from the typical floral rendition, in which we see flowers facing upwards toward the sun. Because she wanted to emphasize the solitary, downcast aspects of the flower, the photographer could have taken her pictures from further away, showing the flower in its environment. However, this close-up treatment provides a much more intimate view. Only a few petals close to the camera are in sharp focus, while the center of the flower and the petals on the far side are softly blurred. The light appears to be soft and diffuse, and the contrast of the bright yellow against the soft green of the background is pleasing. Colors often determine the emotional content of a photograph, and you can set the mood of an image by emphasizing particular colors. For example, blues and greens are peaceful and calm, whereas reds and oranges tend to be exciting and stimulating. The predominately yellow palette here imparts a feeling of warmth.

Photographer's Comments

"It was late afternoon and I was shooting lovely sunflowers in the shade in my front yard. I looked to my right to choose another flower to photograph, and then I glimpsed this solitary sunflower with its head slightly bent over. I immediately saw my next shot. I whipped my camera and tripod around to capture this rather moody floral image."

Technical Data

Canon 5D digital SLR
Canon EF 100mm f/2.8 macro lens
1/200 of a second at f/5.6
ISO 200
Tripod
Open shade outdoors

"SUNDOWN"
© Terry Ellis
Riverside, California
http://terryellis.photoworkshop.com

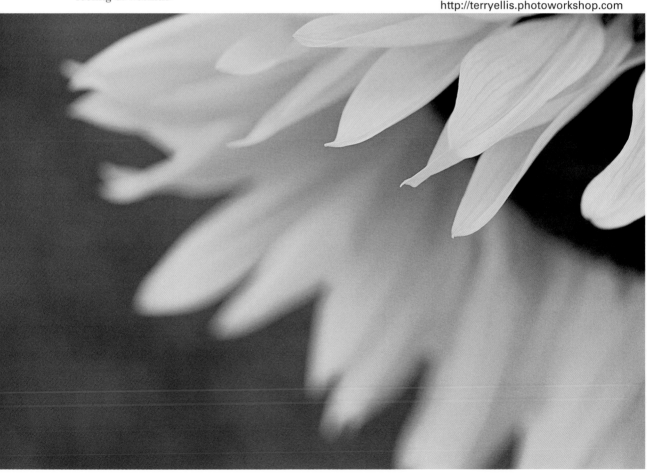

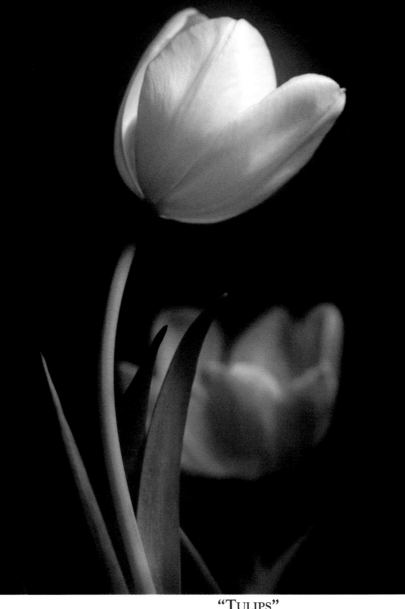

The graceful flower in the foreground would have been nice on its own, but the echo of the blurred tulip in the background creates added compositional interest. This image speaks to the importance of experimenting with different viewpoints and camera angles, which is very easy to do when working with inanimate objects like flowers. Curved lines in a photo are very effective as leading lines. Our eyes tend to follow a curved line into the picture and then stop at the end of the line. So these images are most effective when there's a subject at the end of the line worth looking at — in this case, the tulip. And, the photographer's low angle really makes the main subject appear stately and dynamic. Some tripods are adjustable so that you can get a very low viewpoint, but you can also try resting the camera on the ground or a tabletop. Use an off-camera flash to throw a little natural-looking light on the subject and a black background for a simple, yet dramatic, contrast.

"TULIPS"
© Ricardo de Masi
East Northport, New York
http://rdmphoto.photoworkshop.com

Photographer's Comments

"My wife had some wonderful tulips sitting in a vase for several days. I wanted to photograph them before they died, and see what kinds of images I could create. I took a series of photos, and experimented by shooting the flowers from all angles and a variety of flash positions."

Technical Data

Nikon D100 digital SLR
Nikkor 105mm f/2.8 lens
1/60 of a second at f/5.0
Hand-held flash with diffusion

This is one occasion when black-and-white just wouldn't have done justice to this beautiful flower that's bursting forth, making a bold, multi-colored statement. Although you can use off-camera flash to bring out colors, there are many times when natural light works very well, as in this case. This image was taken in early morning light. Try to avoid the harsh light of midday, as this illumination would wash out colors and create too much contrast. Drops from a recent rain (or even a sprinkler system) often add to the beauty of flowers. As with other close-up photography, be sure to fill the frame with your subject and use a shallow depth of field to blur the background, as this photographer has done. If you don't have a garden worthy of photographing, look for a local park or arboretum.

Photographer's Comments

"This image was taken in my own garden, the perfect place for macro photography. On a damp summer morning I was looking for some damselflies when I saw this emerging flower. What interested me was the way it was blossoming, the raindrops, and the intense colors. Looking through my viewfinder, I noticed the perfect background and I knew I had a great image. I love working with simple, colorful compositions and a blurred background. For me, this was the perfect scene."

Technical Data

Canon EOS 1D Mark II digital SLR
Canon EF 100mm f/2.8 macro lens
1/125 of a second at f/8
ISO 100
Morning light

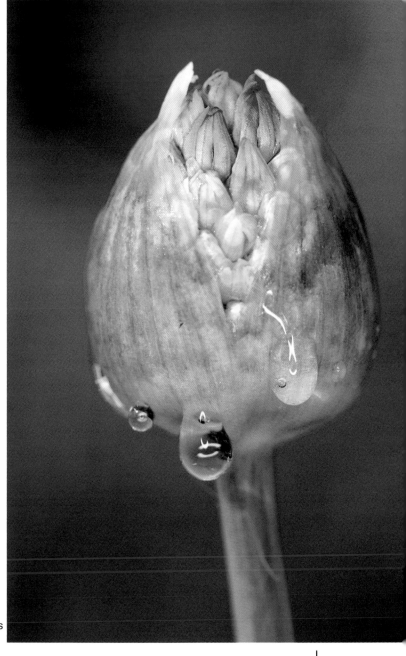

"Color"
© Bas Meelker
Groningen, The Netherlands
www.basmeelker.nl

This backlit scene renders the water very bright, setting the water lilies apart from the background. Backlighting occurs when the sun or other light source is positioned behind the subject and shines directly at the camera. This type of illumination can be a very effective way to light a scene, but it's also difficult to expose, mainly because both the camera and the human eye don't like looking into the sun. Take your exposure directly off your subject, even if it means that the background will be a little washed out, and don't allow your meter to be fooled by the bright light coming in. On the plus side, contrast tends to be greater in backlit scenes than in others, and colors appear vibrant when the sun is low in the sky. You can also use backlighting to create silhouettes, simply by exposing for the background and allowing your subject to be dark.

Photographer's Comments

"After shooting a variety of studio portraits, I wanted to do something different. I got a kick out of shooting flowers and trying backlighting. I took this image at the botanic garden at the University in Bergen. I still photograph flowers from time to time; it's so much fun to shoot them."

Technical Data

Canon EOS 10D digital SLR
Tamron 90mm f/2.8 macro 1:1 lens
1/800 of a second at f/8
ISO 100
Backlighting

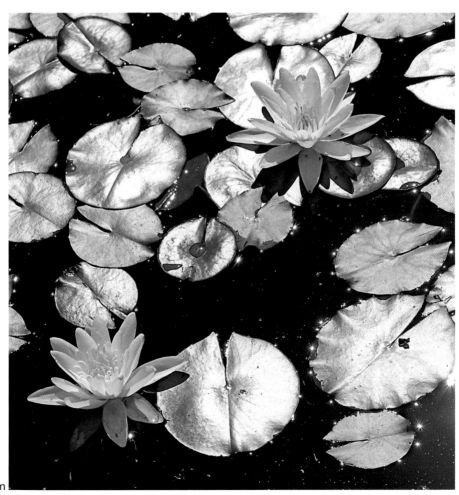

"WATER BABIES"
© *Atle Garmann*
Bergen, Norway
http://atlegarmann.
photoworkshop.com

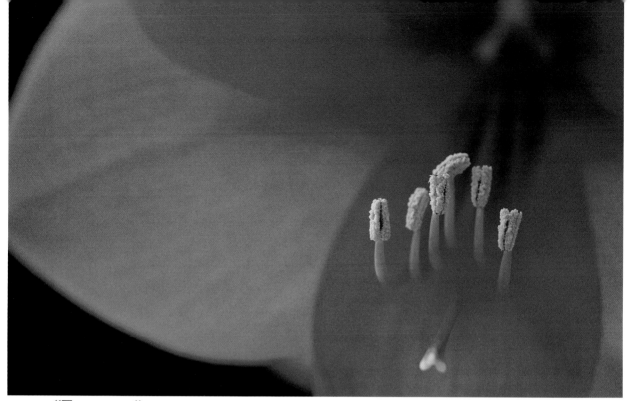

"Temptress"
© *Terry Ellis*
Riverside, California
http://terryellis.photoworkshop.com

Capturing images of the natural world in a way that satisfies the photographer's vision can often be a challenge. You can sometimes achieve this with minimal equipment, but there are occasions when you'll want to use specialized camera and lighting equipment, such as the macro lens and studio lighting that this photographer used. She chose to focus solely on the stamen, which seems to beckon to us, throwing the rest of the flower into a red blur. A very shallow depth of field is imperative to achieve this effect, as is a good tripod to ensure image sharpness.

Photographer's Comments

"This was a study of some lovely amaryllis bulbs that my husband grew for me to photograph. I wanted to capture the seductive, alluring quality of the stamens, leaving the rest of the flower soft and darkly mysterious. I do a lot of flower macro and still life photography, and have set up a mini-studio. I use a three-light soft photography lighting umbrella kit by Smith-Victor with a hair light and mini-boom. Two are 500-watt lights, and I position them on either side of my subject. Each light projects into a white umbrella. I moved the one on the right slightly forward and the one on the left slightly behind the subject for depth. The mini-boom is 250 watts and provides excellent backlighting. I also used a silver and gold mixed reflector to highlight the stamens."

Technical Data

Canon 5D digital SLR
Canon EF 100mm f/2.8 macro lens
1/4 of a second at f/5.6
ISO 100
Studio Lighting

This photographer was very successful in portraying the delicate details of the petals by using a small f-stop (in this case, f/16) and directional lighting. A simple white or black backdrop is often the best choice for accenting a flower's color or shape, and is less distracting than busy backgrounds. I like the way that she carefully chose a viewpoint and lighting to reveal the plant's outstanding characteristics — hence, "My Best Side." You can simulate sunlight by using an electronic flash held a few feet off-camera.

Photographer's Comments

"The dahlia in this image was photographed against a Digitflash 1000 flat panel light in its modeling mode. I wanted the delicacy of the translucent petals with streaming color to the very tips. As I explored different angles in composition, I discovered the image as I turned the flower to its profile. I found the back of the flower to be equally as interesting as the front. 'My Best Side' came to mind with a little chuckle. The exposure was made with a center-weighted meter and I used a large white poster board reflector curved slightly around the flower. I chose to avoid using a light on the front in order to avoid shadows within the flower petals."

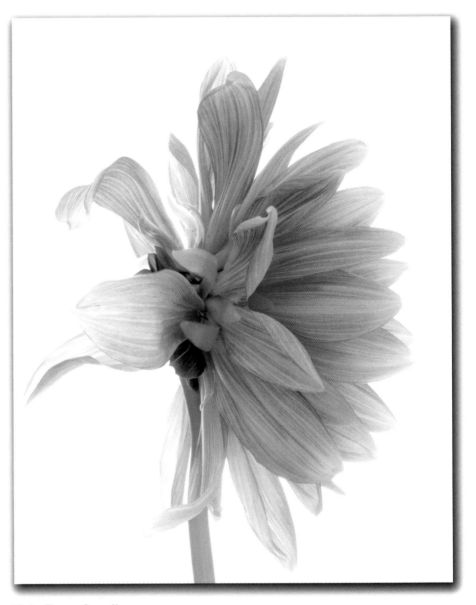

"MY BEST SIDE"
©Toni Martin
Lilburn, Georgia
http://toni-martin-photos.photoworkshop.com

Technical Data

Nikon D2X digital SLR
Nikkor 24-85mm zoom lens set at 38mm
1/2 second at f/16
Exposure compensation +1.33
ISO 100
Digitflash flat panel light

Flowers provide enough diversity of color, shape and pattern to keep even the most prolific of photographers busy for a lifetime. This bold photograph reveals every detail of an exotic orchid. The lighting is direct, specular, and very effective for the rich color rendition of this flower. Be careful when lighting a subject from the front, because glare reflecting from the subject can sometimes produce a washed-out appearance. A small aperture (f/11) aids in rendering this entire subject in sharp detail, and the photographer utilized an aperture of 1/60 because he was using flash. This photo stands in testimony that nature's designs can be truly amazing.

Photographer's Comments

"I attended a recent International Orchid Show in San Francisco, California. Of the 300,000 orchids there, I rapidly captured as many of the unusual and photogenic orchids as possible in a three-hour period. But this one, *Paphiopedilum*, a sub-specie, stood out among the madding crowd. This vibrant, almost pulsating specimen that seemed half-plant, half-animal — almost wet with its colorful sheen — was *the* orchid du jour. The background was not befitting of this magnificent creature, so I replaced it with a black background so as to showcase the marvelous coloring of this orchid."

Technical Data

Fujifilm FinePix S602 digital camera, built-in lens
1/60 of a second at f/11
ISO 160
On-camera flash
Camera hand-held

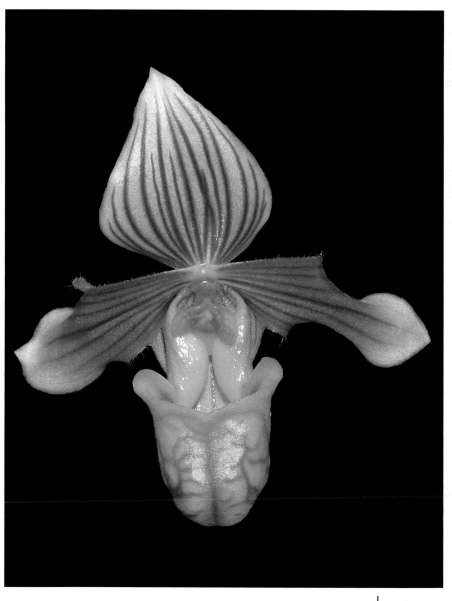

"Venous-Orchidosa"
© *Larry Reibstein*
Aptos, California
www.larryslens.com

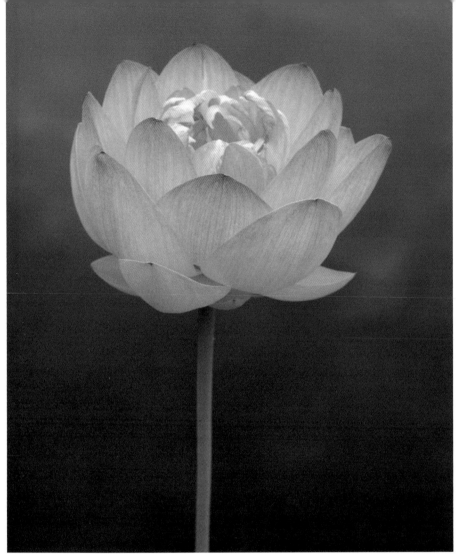

"FLOWER 4"

© *Kenn Jensen*
Tucson, Arizona
www.kennjensen.
com

This cheerful water lily seems as though it's illuminated from within, set against a dark backdrop. The contrast between light and dark makes this a very dramatic photograph. The lighting actually is the product of the soft and even illumination of an overcast day, which works well for floral and plant subjects. This photographer happened to find this scene when the light was right, but if you find a great subject and can't return to the scene later, there are still a few solutions you might try. For example, when shooting during the harsh light of midday, you can position some sailcloth, a white sheet, or other translucent material between your subject and the bright sun for diffusion. If you need more light, you can use an off-camera flash, positioned to either side of the flower or overhead.

Photographer's Comments

"I took this water lily photo in August a few years ago, in Madison, Wisconsin. It was a cloudy day and the gray background is a reflection of the sky in the water. As I turned a corner, the exotic water lily dazzled my eyes and would not be denied. I stopped and shot over 20 images from various angles."

Technical Data

Canon 20D digital SLR
Tamron 28-75mm lens
1/125 of a second at f/6.7
ISO 100
Diffused light of a cloudy day

Besides being a lovely floral close-up, this image is appealing because the other columbines dance across the background of the frame in a soft blur of color. And the fact that this photographer positioned her main subject off to the right side of the frame is much more pleasing to the eye than had she placed it dead-center. As a general rule, putting the main point of interest in the middle of the frame often creates a static composition that doesn't hold the viewers' attention for very long. When you're out shooting pictures of wildflowers, try varying your viewpoint by moving around your subject, or by zooming in and out with your lens for compositional variety.

Photographer's Comments

"Imagine being in the Rocky Mountains of Colorado. The mountaintops are covered with snow from the harsh winter. However, the warmth of the spring sun is renewing that hibernated, gray winter life. Bears are coming out of their dens while the chirping birds are nesting to form new life. While walking along the foothill paths, you stumble upon these beautiful flowers, the Colorado Columbines (also known as Rocky Mountain Columbines). This flower that is so delicate and soft with muted blue and yellow colors is the official state flower. Nature's little wonders are inspiration enough to stop and take this picture. Keep your eyes open to things we may take for granted."

Technical Data

Canon 5D digital SLR
Canon EF 24-105mm L f/2.8 zoom lens
set at 105mm
1/160 of a second at f/4
ISO 250
Spot metering
Natural daylight

"COLORADO COLUMBINES"
© Bea Friedli
Oyster Bay, New York
http://beafriedli.photoworkshop.com

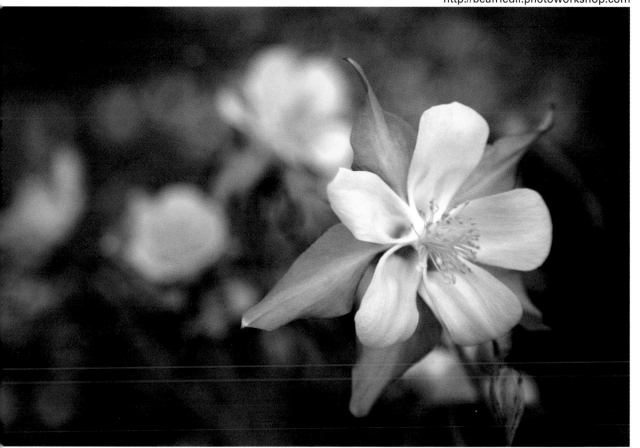

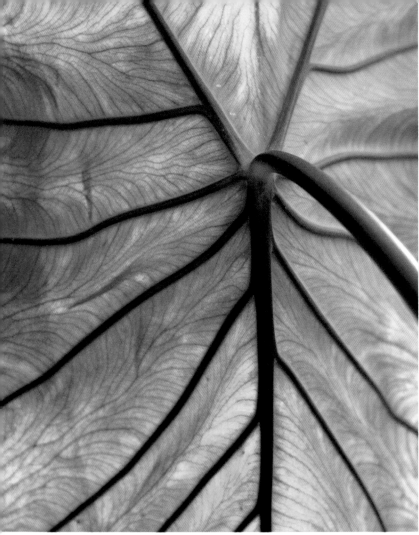

"ELEPHANT LEAF"
© *Paul Hippauf*
Napa, California

Remember that not every photograph you take must be a literal translation of the subject. After shooting pictures of a group of plants, get closer and concentrate on shooting the intriguing designs of a single leaf. Striking images can emerge from confluences of color, shape, texture, and form that comprise the larger scene. The secret to capturing powerful details is the ability to isolate them, extracting the components of your images from their surroundings in such a way that the design — and not the total object — becomes your subject. This photographer explored the designs of this Elephant Ear nicely, and the backlighting enhances its color and texture.

Photographer's Comments

"I often give myself assignments when I go out to shoot, like taking one picture every five minutes, or using just one lens. This time I set out to capture details. I had actually just finished shooting something else and then spun around and saw this leaf. It was backlit by the sun and just jumped out at me. I set up my tripod, steadied the leaf in the wind, and took a few shots. This is the one I liked best — I still find myself staring at all the detail that I captured in this image. You've probably heard this adage before; 'always turn around and look behind you.' Sometimes I'll take a trail, then return the same way and discover things I didn't see before."

Technical Data

Canon EOS Digital Rebel XT
Canon 28-105mm EF zoom lens set at 63mm
1/125 of a second at f/4.0
ISO 100
Ambient daylight

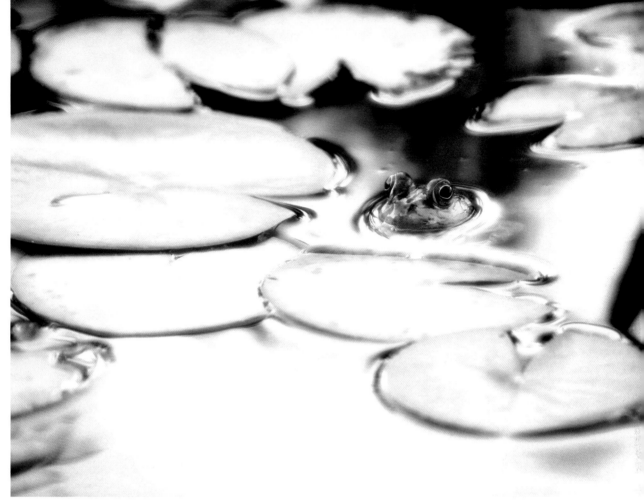

"Frog & Lily Pads"
© Eric Phillips
Camby, Indiana
http://picasaweb.google.com/ericandamos

The long end of a telephoto zoom focuses on a frog poking its head up in a lily pond. In addition to offering a shallow depth of field — thus throwing the background out of focus and accenting the subject — a telephoto lens enables you to keep your distance from skittish subjects in nature. One good zoom lens with a wide range of focal lengths can be a valuable addition to your camera gear, especially if you don't want to tote around a lot of lenses. On most digital cameras, the focal length of lenses is multiplied by a factor of 1.6, so the 200mm focal length used here effectively becomes 320mm. This photographer had to react quickly to capture the subject, and I like the way that the out-of-focus lily pads provide framing around the colorful frog's head, which in contrast, is in very sharp focus.

Photographer's Comments
"I was taking photos of water lilies in my small garden pond and the frogs would suddenly pop their heads up out of the water. There was no wind and the reflections from the flowers and the sky made the water appear to be a kaleidoscope. The frogs were so brilliantly green with the water glistening on them."

Technical Data
Canon EOS 20D digital SLR
Tamron 50-200mm zoom lens set at 200mm
1/100 of a second at f/5.6
ISO 100
Ambient outdoor light

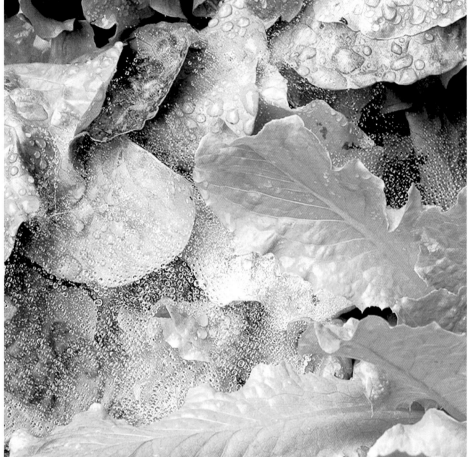

"Lettuce in the Rain"
© Ian Murray
Weymouth, Massachusetts

This image is a beautiful study of contrasting textures and color that create a beautiful design. And because it's photographed from above, it also appears to be a harmonious still life. Photographing a subject from a high angle also eliminates a cluttered background. In many cases when you're looking for a portable high-angle platform, a ladder will do nicely.

Photographer's Comments

"My dear wife is a landscape designer and avid gardener, so I get plenty of opportunities to photograph nature's handiwork. I steer clear of planting, but I've delivered presentations to garden clubs on 'Photographing Your Garden,' using a slideshow of my images. One key question that would-be garden photographers ask is, 'What is the best time to photograph the garden?' and my answer is always, 'any time.' To prove it, I've taken pictures at different times of day, in all seasons and weather conditions. This image of lettuce is one I have used to demonstrate the impact of water droplets on the plant you're photographing. It also doubles as an example of how to use rainfall to good effect. I took it early one rainy morning in July, but by holding the camera in one hand and an umbrella in the other, I was able to get the shot of the spider web and rain droplets."

Technical Data

Canon EOS 20D digital SLR
Canon EF 17-40mm zoom lens set at 40mm
1/100 of a second at f/9
Underexposed by 2/3 stop
Aperture Priority Mode
ISO 100
Ambient light on a rainy day

PART 8

MACRO AND CLOSE-UP PHOTOGRAPHY

You discover a whole new world when you take an "up close and personal" look at minute objects — colorful insects, the details of a leaf, or the stamen of a flower. This type of photography can be very gratifying, but macro photography takes time, patience, and the proper equipment. If you're photographing close-ups of still objects like plants and flowers, you have plenty of time to set up your shot. But if you want to shoot insects, you'll need to move quickly. You can shoot some images simply by using the close-up setting on your digital point-and-shoot or SLR. But there are other options for the serious close-up photographer: close-up lenses that screw onto the front of your lens like a filter, extension tubes, or macro lenses. You can examine macro and close-up subjects and techniques in this section; many floral and plant close-ups fall under both botanical and macro categories.

"BLUE LAVA"
© *Carolyn Jones*
Corte Madera, California

By extracting a small part of a larger object, you can create a beautiful abstract image. These pictures-within-pictures can emerge from interesting confluences of color, shape, texture or form. Whatever the design source that you're using, the secret to finding powerful abstracts is by isolating particular elements so that you arrive at a completely new subject. This highly original photo is the result of colored light filtered through cut glass. There are endless sources for great close-up abstracts, so have fun experimenting.

Photographer's Comments

"In November, I was preparing for a Christmas show and wanted to make up some really unique greeting cards. I noticed that when I shined colored lights through cut glass, the light was beautifully distorted and refracted, creating magical images. After constructing the environment to shoot the colored photos, I was inspired to shoot some in blue. A neighbor lent me a large, smooth cobalt blue bowl, and I set the cut-glass piece inside and provided backlighting. I was intrigued by what 'showed up' through the lens. Specifically I liked one corner of the larger image where the reflection of the glass produced a series of v-shaped characters on their side. I was also intrigued by the variations of blue hues, which reminded me of a lava lamp. 'Blue Lava' is a crop of that section from the cut-glass piece's larger image."

Technical Data

Nikon N80 35mm SLR
Nikkor 28-105mm 1:3.5-4.5D zoom lens
Fujicolor 100 film
1/60 of a second at f/5.6
Ambient room lighting and backlighting on subject

A shallow depth of field isolates this hood ornament in a very artistic manner. To achieve this effect, you must have a "fast" lens (one with a wide-open maximum aperture of f/1.4, or even f/2.8). When you focus a lens to form a sharp image, you create a zone of sharpness that extends in front of and behind the main subject. This zone is called depth of field, and the way you use it can really alter the mood of an image. With an extremely shallow depth of field, you can soften foreground and background details that could otherwise detract from your subject.

Photographer's Comments

"I like taking photos of automobiles because they can be one of the most challenging subjects to photograph well. Cars are essentially a huge reflective surface. As such, I like to go to car shows very early in the morning, just as the sun is rising. I took this photograph of a 1939 Buick in the wee hours of a spring morning. Adding to the drama of this image was the condensation that formed on the hood. I used a very fast lens and a very wide aperture to isolate the bullet-shaped hood ornament and some of the dew drops on the hood. Shooting vintage automobiles is a great way to learn how to photograph shapely objects, and inspires one to use creative composition techniques."

Technical Data

Canon EOS 5D digital SLR
Canon EF 85mm f/1.2L lens
1/6400 of a second at f/1.4
ISO 200
Ambient light

"ORNAMENT"
© *Todd Klassy*
Belleville, Wisconsin
http://flickr.com/photos/latitudes

"What Do You Want?"
© Richard Duffany
Pawley's Island, South Carolina
www.jewelrybyrichard.com

There are times when you can nudge nature along kindly to get a great photo opportunity, like this photographer did. But even with somewhat cooperative reptiles, you need to work quickly. You can increase your chances of taking a few sharp images by pre-focusing on a spot to which the subject is likely to move and wait for it to come into view. You might also try to use the sports mode on your shooting dial to keep a moving subject in focus. Here, the selective focusing on the head isolates this creature from its green environment and reveals the amazing markings of its face. The photographer was fortunate enough to be able to use natural light, but if you're in a situation where the lighting is less than ideal, you can augment the light with fill-flash.

Photographer's Comments
"For three weeks I would use a six-inch pair of tweezers to gather spiders around my home and set them on the bushes where this Green Anole traveled. He would come over and grab the meal after I backed away. By the fourth week, he got brave enough to take the spiders from the tweezers with my arm stretched out. On the fifth week, I held the spider just out of the camera's view and while he waited for his meal, I took the picture by holding the camera in my other hand."

Technical Data
Sony Mavica CD1000 digital camera
Built-in 6-60mm zoom lens set at 12.4mm
1/285 of a second at f/4
ISO 80
Sunlight

"GREEN APPLE"
© Andrew Dykeman
New York, New York
http://adykeman.photoworkshop.com

Flowers and insects often come to mind when we think about shooting close-up subjects. But you can also use macro lenses and close-up attachments to explore details, shapes and colors of more everyday subjects, like this green apple. By closing in on this portion of a tilted apple and its stem, this photographer has revealed something exciting in an otherwise everyday subject. And by singling out this apple from the fruit basket, the photographer has elevated this photo to something unique and more powerful than if he had chosen to shoot an entire grouping of fruit. The soft lighting reveals the apple skin's texture, and the black background accentuates the brilliant green in a bold, dramatic way. A long time exposure enabled the photographer to use a small aperture for great depth of field.

Photographer's Comments

"Images of fruit are pretty common, to say the least, so I wanted to try something different (although I'm sure it's been done many times before). I decided to isolate just a portion of the apple. I knew the beautiful green would really pop against the black backdrop, and getting in close created a larger-than-life scale. I think it looks like a planet in the glow of a rising sun."

Technical Data

Canon Rebel XT digital SLR
Canon EF 28-135mm f/3.5-5.6 IS zoom lens
6 seconds at f/32
ISO 100
Shot in a light tent with a black velvet background, using one 150-watt construction light

As with any insect, you've got to be quick to capture images of butterflies. They flee when they sense your presence close by. One photographer I know whose specialty was butterflies said that when they're perched on something, they flutter their wings slightly when feeling threatened, prior to taking off. For this reason, he recommended shooting from slightly below the butterfly to avoid having your shadow fall across it. This lovely black-and-white close-up reveals the contrast between this white-winged butterfly (aptly named Ghost) and its environment. The depth of field is just shallow enough to softly blur the background.

Photographer's Comments

"I shot 'Ghost Butterfly' in Florida. I've taken many nature photos of flowers, birds, lizards, leaves, and butterflies, but this particular butterfly caught my attention because her beauty lay in her lack of color. For me, it's a very special photo because when I took it, I knew very little about photography. My husband, who has been a pro for two decades, told me that I have a 'good eye.' It's been the cornerstone of a new and very rewarding career for me after years in the healthcare field. After that day, I couldn't stop taking pictures, and 14 months later, I'm working full-time with my husband in our photography business. I have dedicated a great deal of time to learning the art of photography and to developing creative skills and Photoshop techniques."

Technical Data
Canon EOS 20D digital SLR
Canon EF 85mm lens
1/250 of a second at f/5.6
ISO 400
Natural light

"GHOST BUTTERFLY"
© *Jackie Hitz*
Hollywood, Florida

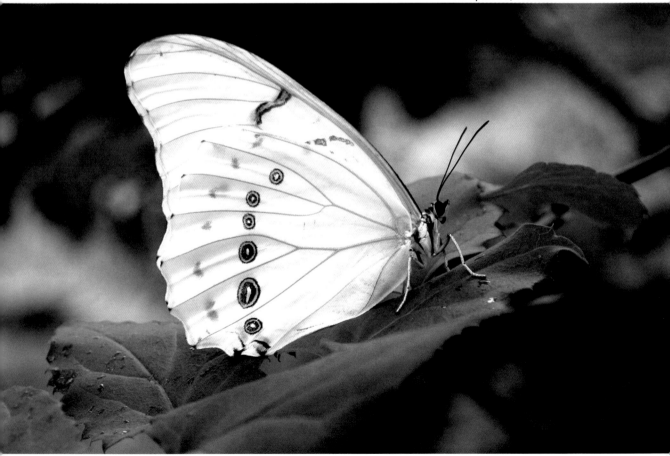

"Bell Pepper"
© *Mark Watt*
Santa Rosa, California
www.fotomark.net

Even common household items and food can become the source of interesting abstract designs when you shoot close-ups. So the next time you're preparing a meal, keep your camera handy. Sometimes, a photographer visualizes a close-up like this and arranges the props. Other times, the photographer happens upon a potentially interesting composition, as was the case here. The trick is to extract interesting compositions from a larger object. Lighting for this type of scene can be artificial or daylight. Window light is often a good source for diffuse or directional light. This arrangement of layered peppers was backlit by sunlight coming in through a window, resulting in a very colorful image. If window light is not available, try experimenting with off-camera flash for illumination or backlighting techniques.

Photographer's Comments
"I was simply in the kitchen cutting bell peppers for a salad and thought, 'I bet this would make a good close-up photo.' I experimented by taking the open half of red and yellow peppers, placed one behind the other in a window where the afternoon sun was shining in. Then I put my camera on a tripod and began to shoot some slide film I had on hand. What I didn't expect in the end result was the variety of colors that I recorded from putting the two halves of the peppers together."

Technical Data
Nikon N90 35mm SLR
Nikkor 105mm lens
Auto shutter setting at f/16
ISO 100 transparency film
Tripod
Subject backlit from window illumination

"Mocha Chai"
© Ronald Tibbs
Kungalv, Sweden
http://ronaldtibbs.photoworkshop.com

Every day we see close-up images in advertising that glamorize products we use on a daily basis. The professionals who shoot these photos spend hours and even days setting up these elaborate setups, but interesting objects to photograph exist all around us. The pros sometimes use simple compositions of food to get their point across. This image is successful because of the clean composition, and shows how you can create an great close-up with a subject as common as your morning cup of joe.

Photographer's Comments

"A few years ago, I bought my first digital SLR-style camera and was looking forward to putting it through its paces. I woke up early the next morning and headed down to a local coffee shop to get a start on my day of shooting. I was fortunate to get a nice table by the window and this image fell into place when I noticed the reflection of the spoon in the side of the cup. I slid the cup closer to the window. It was a typical cloudy San Francisco morning, and the diffused window light provided a nice glow to the spoon and the edges of the cup and saucer. It wasn't until I composed this shot that I felt all the curves, angles, and lines became very chaotic, while still having a feeling of calm."

Technical Data

Olympus E-20N digital SLR
Olympus f/2.0 9-36mm lens set at 26mm
1/100 of a second at f/2.2
ISO 80
Window light
Color adjustments in Adobe Photoshop

The amazing insect world is revealed through a macro lens. Many macros cover a range of magnifications from life-size (1X magnification or 1:1) to 10 times life-size (10X magnification or 10:1). The secret to shooting great close-up and macro images begins with seeing and being aware of small objects. This image of a mosquito (that is unfortunately stinging the photographer) shows just how intricate our microscopic world really is, and what details can be shown when we work to attain our vision. And because proper focusing on a macro subject is so critical, it's usually a good idea to manually focus your camera, rather than relying on auto-focus to give you completely sharp results. Also, you can use natural light to illuminate many subjects, but off-camera flash yields even better results.

Photographer's Comments

"I like to see things that I ordinarily cannot; this is the fun part of macro photography. The mosquito was actually biting my left wrist, and I shot this photo of it with my right hand. The details of these insects and their green eyes are very interesting."

Technical Data

Canon EOS 20D digital SLR
Canon MP-E 65mm f/2.8 1-5X macro lens
1/250 of a second at f/16
ISO 100
Canon Macro Twin Lite MT-24EX flash covered with an Omnibounce diffuser and a Sigma 500 DG super flash, covered with a Lumiquest Mini softbox, used as a slave light and positioned behind the subject

"OUCH!"
© Mark Plonsky, Ph.D.
Stevens Point, Wisconsin
www.mplonsky.com/photo

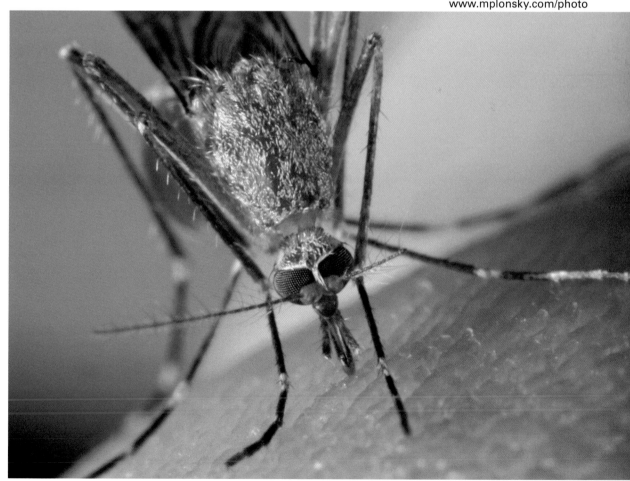

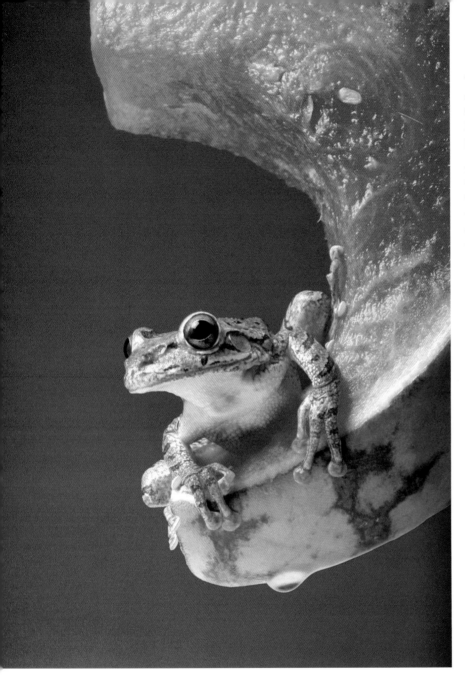

movement, so you must work quickly. Whatever you do, take great care to avoid harming small creatures when you're photographing them.

Photographer's Comments

"In Florida, the frogs seem to be everywhere after a good summer rain. One afternoon, while my 12-year-old daughter and I were having a slice of watermelon, I saw this frog in my screened patio. This was a spur-of-the-moment idea, and I was just trying to get my daughter to laugh. I took a bite out of the watermelon and we had fun trying to catch the frog every 10 seconds. Small animals like this are unpredictable, but if you have a lot of patience, you'll get your shot. In my book, this was a successful day. After this shoot, I put the frog safely outdoors."

This incredible close-up is not a product of Photoshop, but rather the result of a great sense of humor and some tenacity. Because the frog happened to be nearby, the photographer — who was eating watermelon in his patio — got the idea for this shot. Depending on the season and the part of the country you're from, subjects like this can be relatively easy to find. But small animals and insects are very wary and flee at your slightest

Technical Data

Canon EOS Digital Rebel XT
Sigma 24-70mm f/2.8 lens set at 64mm
1/320 of a second at f/16
ISO 100
Two White Lightning strobe lights, one with a red gel for the background.

When you're traveling, it's easy to find picture-postcard views and sweeping vistas to photograph. Although it's fun to capture these scenes, you shouldn't overlook the small details found in architecture or nature. These eye-catching details are fun to discover during your travels — or even in day-to-day living — and provide a contrast to the more broad expanses you shoot. This door-knocker is probably very indicative of the architectural style of the buildings in this Grecian town. When photographing close-ups like this, tight composition and good lighting is very important. Light coming in from the side works especially well because it provides the combination of shadow and highlight that gives your subjects three-dimensional form and texture.

Photographer's Comments

"While traveling through Greece on the island of Crete, my wife and I visited the town of Rethymnon on a day of shooting. As we were walking around town, this green door stood out from a distance. On closer examination, I saw the doorknocker and noticed the nice color combination of the layers of green paint and the rust that had been forming for who knows how many years. The natural light and shadows that were shining on the door made it perfect for photography. I set up my camera on a tripod and shot several images."

Technical Data

Canon EOS 20D
digital SLR
Canon EF-S 17-85mm
IS zoom lens
set at 20mm
1/5 of a second at f/22
ISO 100
Tripod
Daylight

"RETHYMNON DOOR"
© *Richard Prine*
Laredo, Texas
www.prineandco
photography.com

"RED ROSE MACRO"
© *Daniel Richards*
London, England

This tightly composed macro image reveals the lush layering of rose petals, and you can almost feel their velvety texture. Because this is an immobile object, the photographer was able to use a small aperture for great depth of field by shooting a long, 10-second exposure. Because any camera movement is magnified at extreme close-ups, the photographer wisely used a tripod. He also used a true macro lens to capture this image, which offers the best image quality of the close-up gear available today, but is also more costly. However, if you plan to do a lot of close-up work, a macro lens is well worth the investment.

Photographer's Comments

"I have always been captivated by roses — I love their clean lines and simplicity, the texture of the petals, and the saturated color. I have tried photographing roses and other flowers before, but have always been disappointed with the results. With this image, I believe I have achieved what I originally had in mind. Although this close macro shot only shows part of the flower, it is unmistakably a rose. The rose in this photograph was one of a dozen that I unexpectedly received on my 30th birthday from my fiancée. The roses had velvety petals and a uniformly rich crimson color. I wanted to capture their beauty and e-mail something to share with my fiancée."

Technical Data

Canon EOS 5D digital SLR
Canon EF 100mm f/2.8 macro lens
10 seconds at f/16
ISO 200
Tripod
Window light with hand-held reflector

Flash and a fairly fast shutter speed were used to freeze this liquid droplet in mid-splash, and a macro lens brings it in close for greater drama. This photographer obviously did a lot of advance planning to make this photograph successful, like calculating his camera angle, flash and exposure settings. When shooting a subject like this, you should also have a good motor drive on your camera that's capable of shooting numerous frames per second. Keep trying this technique and shooting lots of frames to get a few at the very peak of action. Tenacity pays off, as this photo attests, so keep plugging away to get successful images.

Photographer's Comments

"I have always been powerfully attracted to macro photography, and I'm particularly interested in insects, leaves, flowers, and other small objects. But for me, the most interesting subject is water. While trying to find a way to capture the movement of liquid, I tried different subjects, locations, lighting, shutter speeds, and a variety of techniques so that I could achieve what I had in mind — to freeze water in motion. Because I got many wonderful photos of water droplets in many spectacular forms, it was very difficult to select the image I thought was the best."

Technical Data

Canon EOS Digital Rebel XT
Canon EF 100mm f/2.8 macro lens
Circular Polarizing filter
1/200 of a second at f/2.8
Canon 580 EX flash

"Metamorphosis"
© Javier Preciado
Mexico City, Mexico
http://javierpreciado.photoworkshop.com

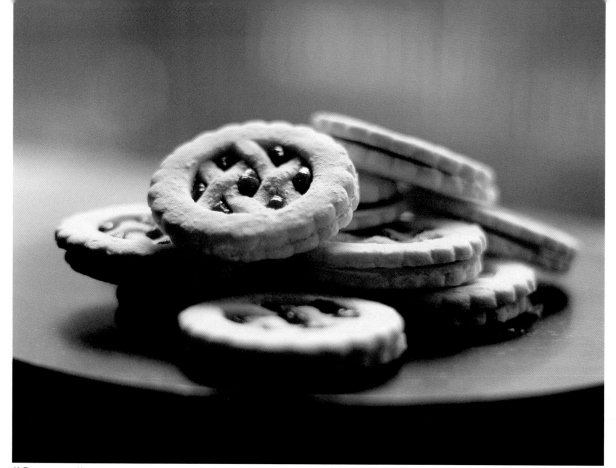

"COOKIES"

© *Natasha Reed*
Seattle, Washington
www.natashareedphotography.com

This is another illustration of selective focusing and a shallow depth of field, which accentuates one cookie in the batch. We only need to see one of these delicious-looking cookies in sharp focus; we know what the others look like. This is a much more interesting photo than if all the cookies were equally in focus, and this is a technique that's popular with many food photographers. The ability to control depth of field is one factor that separates the snapshooter from the more-advanced photographer. Generally, the closer you are to your subject, the less depth of field you will have. And large apertures, like the one this photographer used, will yield a shallow depth of field. If you're shooting an arrangement of food or other items at home, you can often use window light. This indirect lighting source throws some soft, natural illumination on your subject.

Photographer's Comments

"I love taking pictures of food. Cookies are one of my favorite subjects as they're colorful and fun, and there are so many ways to arrange them to create good compositions. Food photography is the ultimate revenge — playing with your food and not getting into trouble."

Technical Data

Canon 5D digital SLR
Canon EF 50mm f/1.8 II lens
1/6 of a second
ISO 100
Available indoor light

You know that they're are attached to a creature just on the other side of this leaf, and these disembodied, silhouetted feet of a gecko provided an opportunity for a very charming photo. This leaf, backlit by the sun, was just sheer enough to show this creature in silhouette. This photo is another great example of a tiny, mostly overlooked world revealed through the eye of a macro lens. The secret to great macro shots is to be observant of your surroundings — there are many small wonders to capture if we take the time to notice them.

Photographer's Comments

"Four little feet slide from leaf to leaf. They are so sticky that geckos can hang upside-down from a single toe thanks to the nanometer-sized hairy structure under their feet. I captured this day gecko among many others hanging out in front of a hotel in Kona, Hawaii in the midst of decorative tropical trees. Most passers-by do not even notice them. There are literally dozens of them on each tree if one looks carefully. Their beautiful green color blends superbly with the surrounding vegetation. I was struck by the silhouette of this gecko captured against the backlit leaf, which highlighted the amazing feet of the geckos."

Technical Data

Canon EOS 1Ds Mark II digital SLR
Canon EF 100mm f/2.8 macro lens
1/200 of a second at f/7.1
ISO 640
Sunlight backlighting foliage

"4 FEET ABOVE"
©Yves Rubin
Los Angeles, California
www.rubinphoto.com

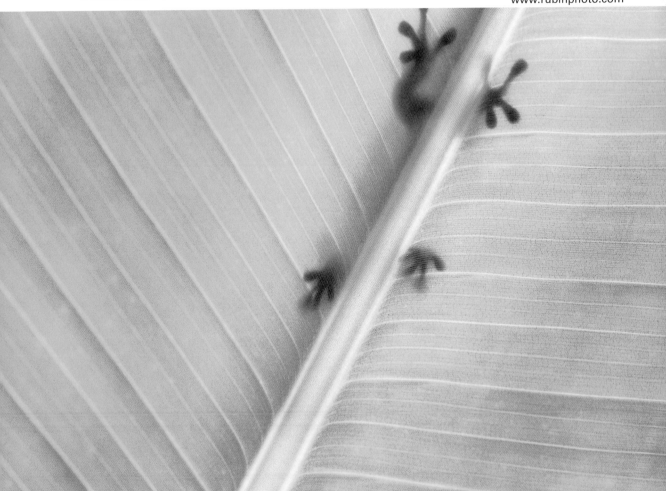

Macro images magnify tiny objects, revealing the amazing features of the microscopic world, as well as showing us the intricate details of not-so-small subjects. This photographer captured the very colorful markings of a reptile's head with a macro lens, which allows one to work closely to the subject. As mentioned earlier, lenses with macro capability are very expensive but well worth the money if you plan on shooting a lot of macro photos and want to get better quality than you would if you used the close-up setting on your camera. Macro lenses also have a very shallow depth of field, so decide what the most important part of your image is and make sure it's in sharp focus. If you're photographing a reptile, for example, you should focus on your subject's eyes and allow other portions of the photograph to be rendered softly. These lenses can be used to take pictures at normal distances as well, making them versatile tools for many photographers.

Photographer's Comments

"Two images were taken on one frame of film, and the backdrop was black velvet. My hardest job was estimating where to place the close-up of the chameleon. I have collected exotic reptiles for over 30 years and have photographed most of them in natural looking settings in a studio."

Technical Data

Canon A2E 35mm SLR
Canon 100mm macro lens
Fujichrome Velvia 100 transparency film
1/60 of a second at f/8
Canon Ring Light flash unit

"CHAMELEON"
© Kenneth Deitcher, M.D.
Albany, New York

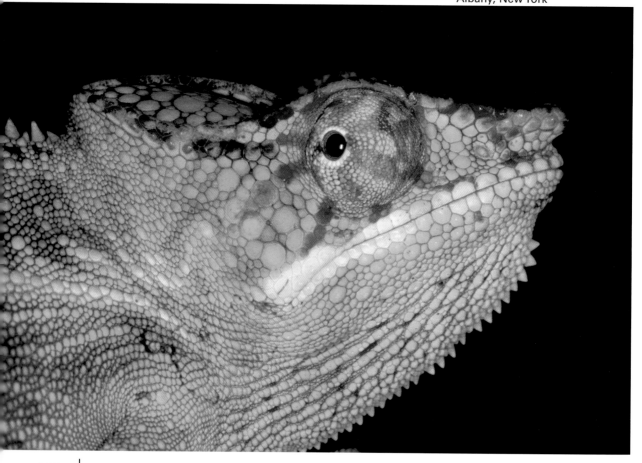

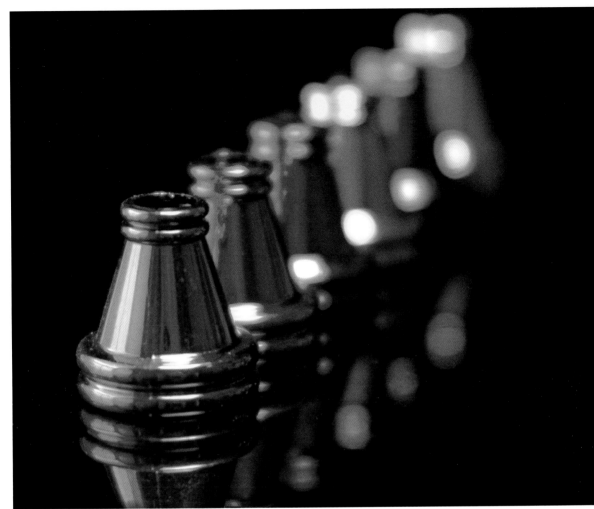

"IN FOCUS"
© Ed Konczal
Piscataway, New Jersey

This image is a classic illustration of shallow depth of field. The photographer used a wide-open aperture, f/2.2, to get this effect. To show the opposite effect — great depth of field — all that he would have to do is use a small aperture like f/11 or f/13 to render the row of colorful party toys in focus. Basically, three elements control how great the depth of field will be in a photo: lens focal length, aperture, and distance from the subject. Longer lenses, wider apertures, and a shorter distance to your subject reduce depth of field. Beyond this, I like the snappy colors in this photo, particularly against the black backdrop.

Photographer's Comments

"It was going to be a cold winter and I was look-ing for photographic inspiration. 'Aha! Still life and macro photography,' I thought. The first shots hooked me, as I found more control and endless possibilities. The only problem was that I found myself buying lots of props. I found the objects for this image in the party section of a department store. I saw this set of party toys that fit my style — minimalist, bold colors, and ele-gant simplicity. Then I decided to line up the toys at an angle, focus on the first one, and blow out the focus on the rest."

Technical Data
Nikon D200 digital SLR
Nikkor 105mm f/2D AF DC lens
1/50 of a second at f/2.2
DC (Defocus Control) setting for maximum background blur

This exquisite macro image of raindrops hanging precariously on a fragile spider web appears to actually be a photograph of fine jewelry. (I'd love to own a necklace like this one.) The reflections of surrounding greenery are captured beautifully in each droplet, and the whole image is set off by the pleasing green blur of the background. This is a good example of conditions that will disappear fast, so be prepared to work quickly once you discover a scene like this. It's very important to use a tripod and cable release to avoid camera shake and experiment with different angles to get reflections in the raindrops. The soft, diffuse lighting of an overcast day provides very flattering illumination. Flash isn't necessary, as the raindrops are highly reflective.

Photographer's Comments

"I took this photo in the early morning in my back yard. I noticed the spider web the day before, and then it rained during the night. I kept looking for the right angle to capture a good reflection on each water droplet."

Technical Data

Canon EOS Digital Rebel
Tamron 90mm f/2.8 Di macro lens
1/125 of a second at f/10
ISO 400
Natural light

"PEARLS"
© Harjono Djoyobisono
Victoria, Australia
www.djoyobisono.com

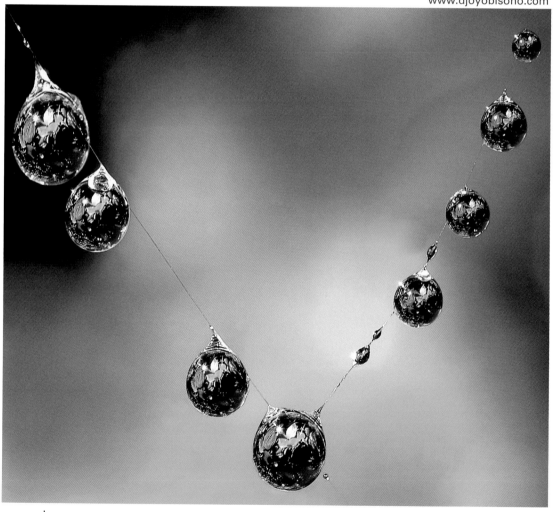

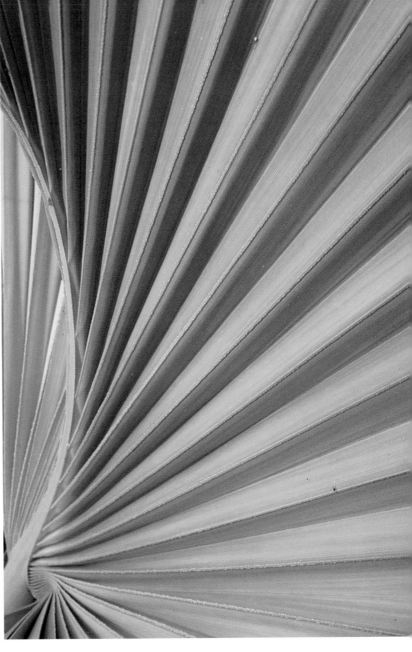

"EMERGING PALM"
© *Joe Crockett*
Corvallis, Oregon
www.joecrockett.com

As with the image of the Agave, this photographer also chose to explore nature's beautiful design in an abstract close-up. This unfurling palm frond sends graceful lines radiating out from the lower left side of the frame. You can create striking abstracts from confluences of color, shape, texture, and form that are part of larger scenes. Whatever the source of the design, the secret to capturing powerful abstracts is to isolate design elements and experiment with tight compositions. The natural world is rife with such designs, but there are multitudes of other sources if you just use your imagination. This is a much stronger image than if the photographer had backed off and included the entire palm tree. He also found this subject ahead of time and returned to the scene when the shooting conditions were better.

Photographer's Comments

"I had spotted this emerging palm frond the previous evening on a casual photo walk. The palm tree was young and about chest-high and the leaf's unique, emerging form caught my attention. I snapped a few pictures, but the lighting was poor and the wind wasn't cooperating, so I made a mental note to return the next morning. Luckily, the wind was calmer and the morning light highlighted the palm frond's natural beauty. I shot different compositions of this leaf, and chose this image as best displaying its natural beauty."

Technical Data
Canon EOS Digital Rebel
Canon EF-S 18-55mm zoom lens set at 55mm
1/100 of a second at f/9
ISO 400
Camera hand-held
Morning light

This photographer obviously has a gift of discovering great design potential in everyday household items, like these spoons. But this can be an inspiration for all of us. The secret to finding designs and patterns is to explore subjects from a variety of angles, and to arrange them in a manner that's pleasing to the eye. Lighting is also important when trying to emphasize the design aspects of a scene. In this example, positioning a light off to one side separates the sleek shape of the spoons and bowl from the dark background very effectively. This is also a great exercise in simplifying a scene — removing extraneous clutter and paring it down to only the essential elements. Experiment with framing to show only what's important in the image. A moderate telephoto zoom lens is a versatile tool for getting in close to isolate patterns and textures. When photographing a scene with such elegant simplicity, you also should use a simple, uncluttered background to show off the subject.

Photographer's Comments

"I love trying to create interesting images with mundane, everyday objects. So when I bought a new set of flatware, I knew I'd be photographing it. I like the smooth texture of the spoons and the way the edges catch the light."

Technical Data

Canon Rebel XT digital SLR
Canon EF 28-135mm f/3.5-5.6 IS zoom lens set at 85mm
4 seconds at f/32
ISO 100
Shot in a light tent with a black velvet background, using one 150-watt construction light

"SPOONS 1"
© Andrew Dykeman
New York, New York
http://adykeman.photoworkshop.com

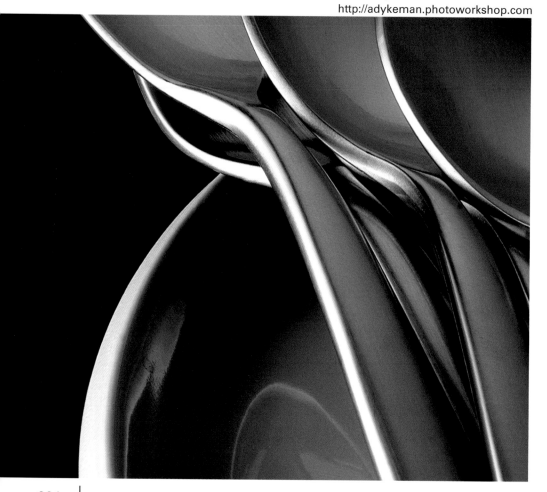

"CALLA LILLY"

© *Ricardo de Masi*
East Northport, New York
http://rdmphoto.
photoworkshop.com

This close-up study of a Calla Lilly accentuates the sensuous, flowing lines of its petals. The photographer took advantage of the very shallow depth of field in macro photography, as the delicate curve of the flower's line disappears into a soft blur near the top of the frame. As a general rule, the closer your camera gets to a subject, the shallower the depth of field becomes. The zone of sharpness can be as narrow as a fraction of an inch. When shooting a long exposure, which close-up photography often requires, a tripod is very important. Flowers are usually best captured in diffuse lighting conditions, and the illumination here is very soft and even.

Photographer's Comments

"I was waiting in a line at the supermarket and found these Calla Lilies for sale. I thought they were in great shape, considering that they were on the discount flower rack. I decided to photograph them and experiment with depth of field. I isolated the closer edge of the flower, keeping the small droplet of water in sharp focus, while allowing the curve of the petal to fall out of focus."

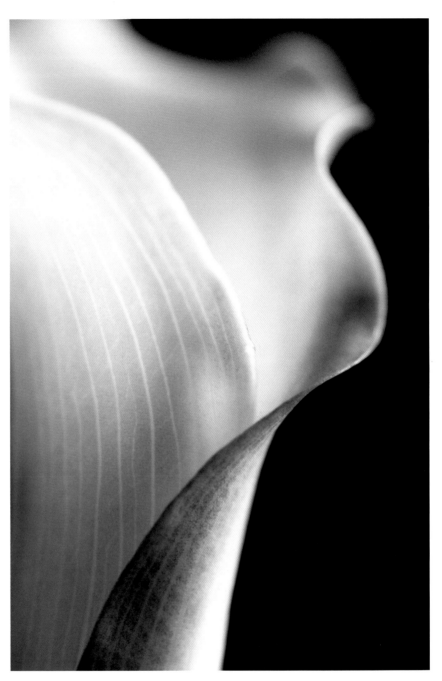

Technical Data

Nikon D100 digital SLR
Nikkor 105mm f/2.8 lens
1/60 of a second at f/3.8
ISO 100
Tripod

"Planet of the Eggs"
© Tami Isaac
Tucson, Arizona

Photography is considered a true-to-life art form; so many people have a difficult time breaking away from the conventions of what a photographic image is supposed to look like. A lot of us always make buildings look like buildings; people look like people, and so on. It may be difficult to imagine rendering a subject in a manner in which it isn't recognized instantly for what it is. But when it comes to shooting interesting shapes and designs, you can arrive at a creative solution by throwing caution (and reality) to the wind. Give yourself an assignment to photograph familiar subjects in a not-so-typical way. This photographer took advantage of the vibrant colors and shapes of these Easter eggs and rendered her idea in a very imaginative manner. The out-of-focus blue egg in the background looks like it could be planet earth,

the one in the foreground could very well be a colorful planet in our solar system, and the dark background suggests outer space.

Photographer's Comments
"I often pick up my macro lens when I'm in a creative slump. It seems to be just the right thing to jump-start me. I was inspired by the color of these Easter eggs and wanted to get in close using a shallow depth of field to create the feeling of a colorful planetary system of eggs."

Technical Data
Canon A2E 35mm SLR
Canon EF 100mm f/2.8 macro lens
ISO 200 color film
1 second at f/4.0
Two tungsten lights

Macro photography enables us to see the world in new ways, and gives us greater insights into commonplace objects. Not only do we get the opportunity to see something new, but we can also share our view of the miniature world with others. Many people shoot close-ups of flowers and insects, but how many of us would consider exploring objects like the head of a match with a macro lens? This photographer did, and the result is an interesting abstract and study of texture. Initially, we're not sure what we're looking at, and this photo could even be Mars or another far-off planet. The photographer also used a twin light flash to help reveal the surface texture of the match. This type of flash unit provides a directional quality of light (as opposed to the even illumination of a ring light) for close-up and macro enthusiasts.

Photographer's Comments

"People never quite believe me when I tell them how shallow the depth of field really is in macro photography, and this image is an excellent example. The object in the photograph is a standard match, and you can see how only a tiny donut of the match is in sharp focus — anything closer or further away is completely blurry. It also helps, of course, that it looks like a lunar landscape."

Technical Data

Canon EOS 30D digital SLR
Canon MP-E 65mm f/2.8 1-5X macro lens
1/500 of a second at f/2.8
ISO 100
Canon Macro Twin Lite MT-24EX flash

"MATCHHEAD"
© Haje Jan Kamps
London, England
www.photocritic.org

There are times when flash will be your best lighting source when photographing close-up and macro images. Besides providing illumination during low-light situations, flash enables you to freeze action. It will also render the background very dark, making your subject stand out. This photographer used a ring light, which provides even illumination for subjects very close to the lens. This light mounts on an adapter ring that's positioned on the front of your lens. When you use a dedicated flash unit, you can make full use of your camera's built-in flash automation to give you the correct exposure at macro magnifications. This grasshopper really does look as though he's greeting the camera, as the title implies. The bright, complementary colors are also dramatic.

Photographer's Comments

"I took this photograph at night, outdoors in my front garden. By using flash, it was possible to utilize a small aperture of f/16 to get an overall sharp image. Moreover, the flash helped me to shoot at 1/200 of a second."

Technical Data

Canon EOS 300D Digital Rebel
Tamron 90mm f/2.8 Di macro lens
1/200 of a second at f/16
ISO 200
Canon Macro Ring Lite MR-14EX

"HOW DO YOU DO?"
© *Harjono Djoyobisono*
Victoria, Australia
www.djoyobisono.com

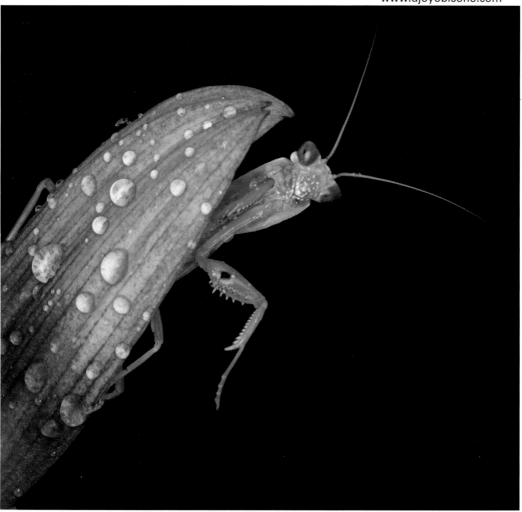

Part 9

Still Life Photography

Photographing still lifes enables you to practice your compositional skills, and to create your own original image. In many cases, photographers set up their own arrangements, but life is full of still-life scenes if you look for them. Just look for arrangements of objects that are visually pleasing. Whether you're setting up your own scene or happen to come across a great arrangement of objects, experiment with your camera angle until the elements appear to be in balance. You can also add or subtract objects to find the best composition. The arrangement of a still life should begin with one dominant object, and others can be added one at a time until you feel that you've created a composition that works well. Don't be afraid to experiment—there's no single answer. As with all photography, remember that simplicity always works best. An uncluttered scene is often the most dramatic one.

With just a few common household objects and a simple setting, you can create some interesting still life photos. Doing so will help you develop your compositional skills. You're in total control when you're shooting a still-life scene, as opposed to situations where you're at the mercy of bad lighting or uncooperative subjects. The subject(s), lighting, and backdrop are all entirely up to you. This photographer has a talent for turning the most ordinary objects into an artistic statement. In this image, he's positioned carrots so that the emphasis is on the complimentary colors between the carrot tops and green shoots, as well as the different textures. The warm window light works very well too. He presents this subject matter to us in a way that we're not accustomed to seeing. As an exercise in improving your photography, try picking out a few items around your house and create a still life with them. Experiment with zooming in tight and varying camera angles; you'll probably arrive at a uniquely different design.

Photographer's Comments

"One probably wouldn't normally look to carrots for photographic inspiration, but I love the complimentary colors and different textures in this arrangement. I also wanted to get in close to show a view that we don't often experience in everyday life."

Technical Data

Canon EOS Digital Rebel XT
Canon EF 28-135mm f/3.5-5.6
IS zoom lens
set at 120mm
1.6 second at f/5.6
ISO 100
Window light

"CARROTS"
© Andrew Dykeman
New York, New York
http://adykeman.photoworkshop.com

This photograph is a classic example of a still life, which painters and other artists have been captivated with for centuries. With just a few common objects and a simple setting, you can create some attractive and interesting still-life compositions of your own. Unlike many photo opportunities where you're at the mercy of existing conditions, still-life photography puts you in total command — the lighting, setting, and arrangement is all up to you. Still-life scenes can be any collection of visually interesting objects.

Photographer's Comments

"Built in 1890 as a facility for wayward boys, the Preston School of Industry Castle was left to rot in 1960. I have always been intrigued by it and have wanted to go inside from the first time I saw it. I was armed with my camera gear and props such as a red rocking chair, a model (my mom) to use as a ghost, and the vase of flowers, which I used in this image. I shot this photograph in the kitchen pantry, and the light was dramatic and perfect for the atmosphere I wanted to achieve. The castle inspired me to create this contradictory image of the beautiful flowers against the peeling paint on the wall — I wanted to portray renewed hope and restoration."

Technical Data

Canon EOS 10D digital SLR
Canon 100mm EF macro lens
1.6 seconds at f/7.1
ISO 200
Manfrotto tripod and quick-release ball head
Natural lighting from window on the right

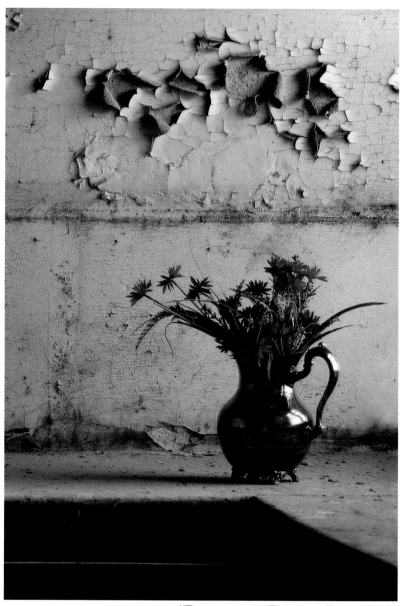

"Petals and Peeling Paint"
© Eleanor Caputo
Jackson, California
www.studio18gallery.com

"ON THE ROCKS"

© *Bob Garas*
Clermont, Florida
www.bobgarasimages.com

Professional photographers often utilize elaborate setups — lights, reflectors, backdrops, and more — for their studio still-life shoots, which they produce for magazine ads. But you can still take some great still-life or product shots without all this equipment. A single subject illuminated by a single light source against a plain background will enable you to experiment with the effects of different camera and lighting angles. Just remember that simplicity usually yields your best results. To shoot an image indoors, all you need is a yard or two of seamless backdrop paper (found at many photography stores), or even a yard of fabric to use as an uncluttered background. A piece of white cardboard can serve as a reflector, and a flash unit or window light can supply your main light on the subject. When shooting indoors, you also want to steady your camera with a good tripod.

Photographer's Comments

"As an airline employee, I have a limited time to shoot pictures. But photography is my therapy. When I was at the grocery store one day, I had the idea for this photo and bought some olives and 7-Up. Out of the 200 frames I took during the photo shoot, I only liked around two or three images. It took longer to soak up the carpet and clean up afterward than it took to capture these 200 frames."

Technical Data

Canon EOS Digital Rebel XT
Sigma 24-70mm f/2.8 lens set at 39mm
1/250 of a second at f/19
ISO 100
Three White Lightning studio strobes

Not every still-life scene has to be carefully set up, they can also be arrangements of objects that the photographer happens upon, like this one. These scenes can be found wherever you go. Still life photos give you the opportunity to work at your own pace and explore lighting, camera angles, and compositions. This image conveys the story of a restaurant closed down for the evening, and the photographer has captured the warm gold lighting in contrast to the rich green color of the stacked chairs. The low vantage point and tilted camera angle also adds a lot of interest to a composition that otherwise may have appeared too static and commonplace.

Photographer's Comments

"This picture was taken at the Ye Old Orchard Pub in Montreal, Canada, in the wee hours of the morning. Being the local pub, it has become my local haunt for the past few years, as well as the backdrop for countless pictures that I've taken. On that particular night, or morning, I was looking for new subjects to photograph. I headed toward the back room, which was closed. Noticing for the first time that the chairs were green, I decided to snap a quick photo, without taking the time to gage my camera settings. I am still amazed at how well the photo came out; and how well it represents this place to me."

"Last Call"
© *Jean-Christophe Demers*
Quebec, Canada
http:/jcdc.photoworkshop.com

Technical Data

Canon EOS Digital Rebel XT
Canon EF-S 18-55mm zoom lens set at 18mm
1/6 of a second at f/4.0
ISO 1600
Ambient indoor light

Any object or groups of objects can be subjects of a still-life photo. But because of their shape and beauty, flowers, fruits, and vegetables have served as favorite objects in still life paintings and photography throughout the years. These items are easy to obtain and offer numerous possibilities for arrangements and color combinations. Even if you don't have a studio, you can easily set up lighting and a backdrop suitable for still life scenes in your own home. Window light can provide a soft, even source of light, although you can utilize other lights, including off-camera flash and household lamps. You can utilize fabric or paper as a background. This photographer used photo lamps to illuminate the onions, and black muslin for a simple, dark backdrop.

"Onions 2"
© *Gerald Currier*
San Francisco, California
http://cursmicon.photoworkshop.com

Photographer's Comments
"I arranged the onions on a piece of black muslin on a card table. The lighting was two track-lighting flood lamps mounted in clamp-on units. I put my camera on a tripod, and used an aperture of f/6.3 to produce a relatively shallow depth of field. This image is the result of an ongoing project I'm working on that will combine images of various fruits and vegetables with dahlias. I'll put them into a book that I will self-publish and use as gifts for family and friends. I might use Japanese Haiku for the text, or may write some text myself."

Technical Data
Canon EOS Digital Rebel
Canon EF-S 18-55mm 1:3.5-5.6 zoom lens
set at 55mm
1/100 of a second at f/6.3
ISO 100
Lighting provided by flood lamps

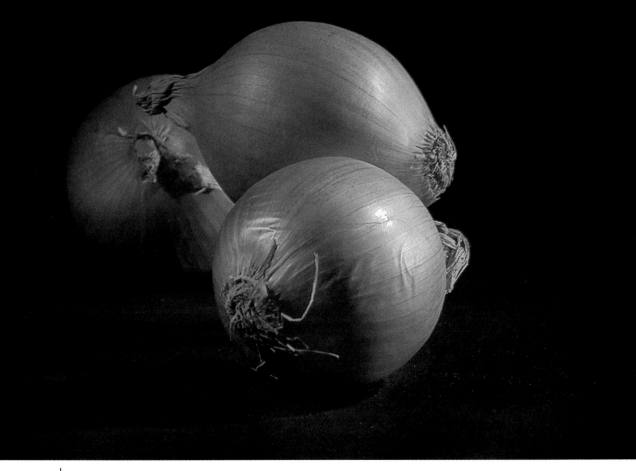

A great photograph should reveal a single subject or idea with as little clutter as possible. It's up to you to take charge of selecting the subject matter, as well as the background, camera angle, and lighting. For still-life subjects, simplicity is key — you often get better results than if you try to include too many objects. This simple composition comes from the photographer's ideas about color, shape, and form. The secret to discovering and capturing simple, yet striking images is the ability to extract a composition from a larger scene. In this image, the photographer chose to emphasize the sleek lines of the green vase against a subtle background. The result is a beautiful, graphically powerful image.

Photographer's Comments

"The *Double Exposure* assignment, 'Green,' inspired me to take this photograph; I enjoy these 'challenge' assignments. I also like to use natural and available light in my photography. The different colors and intensities are fun to work with and manipulate. The vivid green color of this vase and translucent glass had inspired me to use it as a subject. I wanted to try to alter the feeling of the softly shaped curves of the vase by rendering them as crisp lines. I also wanted a muted background in contrast, and used a spare floor tile to accomplish this."

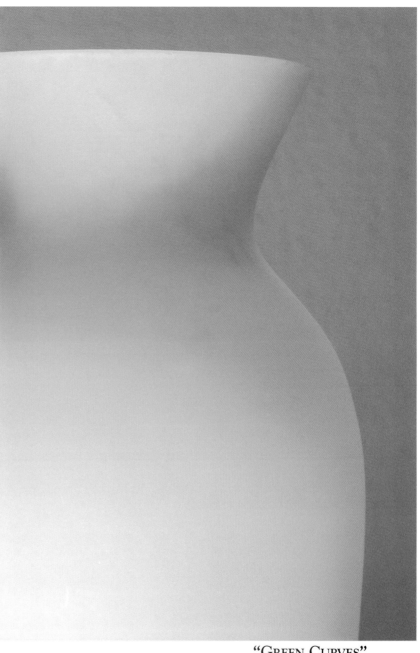

"Green Curves"
© Tom Pipia
Milwaukee, Wisconsin
www.macrhinoimages.com

Technical Data

Konica Minolta
Dimage A2, built-in lens
Focal length 44mm
6 seconds at f/11
Tripod and ambient window light
Single floor tile as background

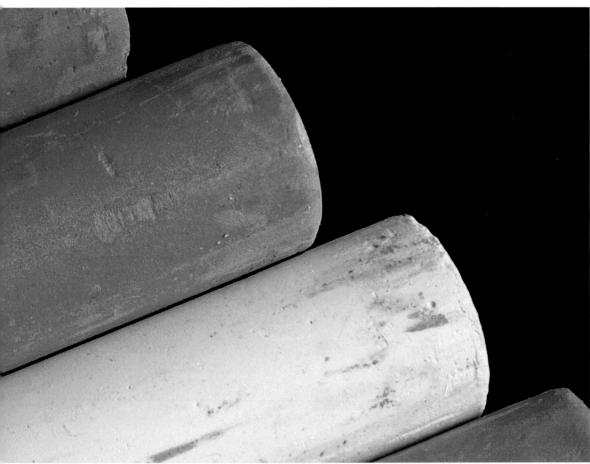

"CHALK"

© *Andrew Dykeman*
New York, New York
http://adykeman.photoworkshop.com

Several sticks of chalk were combined to create a study of color and shape against a black backdrop. This simple composition is proof that you can assemble very ordinary household objects to create an original design. When making a colorful statement like this in a still-life image, it's a good idea to experiment with framing and your camera angle to get the best results. The photographer also lined up the chalk in different color combinations to see how they played off one another. You can also frame your image to feature some colors and not others. This image also makes a strong argument for simplifying compositions. The best way to do this is to decide exactly what idea you want to get across in a photograph, be it bold colors, lines and patterns, or perhaps some great light. Then eliminate everything in the frame except for the most essential elements.

Photographer's Comments

"I'm always looking around the house (especially on rainy days) for interesting objects to photograph. This colorful chalk caught my eye. It was fun arranging them in different ways to see how different colors complement each other."

Technical Data

Canon EOS Rebel XT digital SLR
Canon EF 28-135mm f/3.5-5.6 IS zoom lens set at 100mm
4 seconds at f/32
ISO 100
Shot in a light tent using construction lights and a black velvet background

These beautiful flowers almost appear to be delicate items of apparel hanging on a clothesline. The photographer has chosen to photograph a simple, yet original, idea, and used a black backdrop for dramatic effect. She hung the twine between her studio lights to provide even lighting from both sides. If you're just learning how to shoot still lifes, you can learn a lot by studying images that you find striking taken by other photographers. Notice how they arrange still-life scenes, the compositions that they use, and the colors that they choose to offset one another. Any object or group of objects can be used to create an imaginative still life. And in a well-executed image, the photographer decides just how these objects will work together and how to compose the photograph for effective results. Don't forget that the strongest still-life scenes are simple ones — always eliminate extraneous clutter from the image and take a final look around the frame before shooting.

Photographer's Comments

"This was an image that I created as I finished a shoot of standard still-life photos of various flowers. I strung some twine between my two side lights and hung the flowers up with these clothespins. The setup was precarious, but I like the results. I wish I had photographed a string twice as long!"

Technical Data

Canon EOS 20D digital SLR
Canon EF 24-70mm f/2.8L zoom lens set at 42mm
20 seconds at f/22
ISO 100
Studio lighting

"Hung Out to Dry"
© Denise Ritchie
Vero Beach, Florida
www.deniseritchie.com

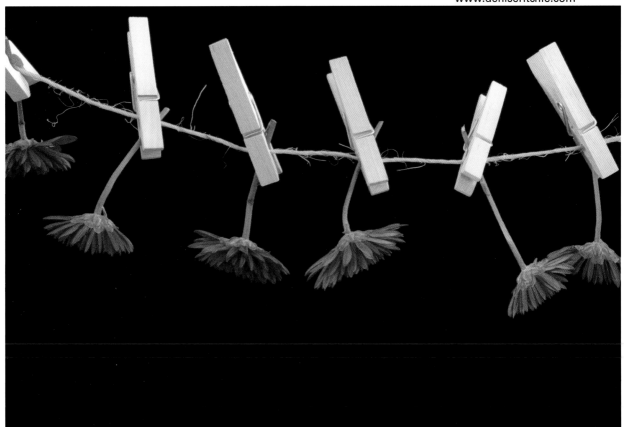

Food remains one of the most popular subjects for artists and photographers who create still lifes. This image of radishes is simple and to the point, and simplicity is usually the best rule of thumb when shooting still lifes and other scenes. You don't need a wide range of objects to create an interesting image. Besides food, you can arrange any number of inanimate objects to create a good still life. Shooting still lifes can be a form of self-expression, so you should photograph objects that have special meaning or appeal to your artistic senses.

Photographer's Comments

"Pike Place Market in Seattle, Washington, is a food photographer's dream. You can get prime produce from just about anywhere in the market. I prefer getting local and seasonal produce, however, like these organic radishes, one of the first spring crops available in the northwest. To me, they spell out spring, and mark the beginning of all the fresh produce to come. This bunch of radishes struck me as particularly beautiful, looking almost straight out of the ground with smudges of dirt still intact. I used filtered natural light to give just a hint of shadow, and to let the colors in the radishes pop, but still have softness to them. I loved the crumbled, dingy tag that says "Don't panic, it's organic!" as an invitation to grab one and pop it into your mouth."

Technical Data

Canon EOS 20D digital SLR
Canon TS-E 45mm f/2.8
Tilt-Shift lens
1/10 at f/4
ISO 100
Natural light indoors

"RADISHES"

© Lara Ferroni
Sooke, British Columbia, Canada
www.platesandpacks.com

"JUST PEACHY, BABY"
© *Toni Martin*
Lilburn, Georgia
http://toni-martin-photos.photoworkshop.com

One way to bring mood to an image is to emphasize its lightness or darkness. In high-key pictures, like this one, light and medium tones dominate. The mood this image conveys is one of delicacy, airiness, and cheer. When creating a high-key photo, the light should be diffuse and even, producing a minimum of shadowy areas. You can heighten this effect with strong backlighting. You'll also want to overexpose your image slightly to get a high-key effect. Experiment by shooting several exposures with different settings.

Photographer's Comments

"I chose to capture the delicate peachy color and character of these Gerbera daisies. When I photograph flowers, I think in terms of living, moving subjects with personality, which comes to life with emotion, and sometimes even humor. On occasion, I've thought, 'what is it you want to show me?' A 30-39 inch softbox mounted onto a 1000-watt strobe light supplied the background and source of light for this image. I placed the softbox approximately 4-5 feet behind the subject. I used a large white poster paper curved under the camera at the base of the potted flowers to reflect light onto the stems and front of the scene. Poster paper was also positioned on either side of the camera to bounce light back onto the flowers. I pushed the exposure to reveal the beautiful rim light on the edges of the stems."

Technical Data

Nikon D2X digital SLR
Nikkor 24-85mm f/2.8-4D IF AF zoom lens
set at 62mm
1/30 of a second at f/16
ISO 100
Lighting from a single softbox

The variety of subject matter available to a photographer who wants to shoot a still life is limited only by one's imagination. Most people might overlook objects like this, but the photographer who shot the image of these locks and chains recognized an interesting composition as well as the importance of tight framing. The diagonal lines and texture of the wood against the metal is also intriguing. Another advantage of still lifes is that you can work at a leisurely pace, and can pay attention to how all the elements will work together in a composition. When you're looking for objects to use in a still life, look for ones that tell a story, reveal contrasts, or are visually interesting in other ways, like the interplay of shape and texture that this photographer has shown us. Experiment by rearranging the elements in a still-life scene if you think that it will improve the composition.

Photographer's Comments

"This was taken while I was on a trip to visit my wife's family in North Dakota. Her cousin has a small barn and some horses. After horseback riding for a few hours, I wandered about the stalls, looking for objects that caught my eye. Hanging on one wall were these great old locks and chains that appeared to be about 100 years old. And the light coming in from the main stable door on my right was just perfect."

"LOCKS AND CHAINS"
© Brian Tremblay
Ontario, Canada
www.tremblayphoto.com

Technical Data

Nikon F90x 35mm SLR
Nikkor 35-105mm f/4.0 zoom lens
Exposure unrecorded
Ambient indoor light

"Study in Rust & Glass"
© *J. Dennis Thomas*
Austin, Texas
www.deadsailorproductions.com

Still life photos are often groupings of objects that a photographer carefully sets up, while others may be scenes that you just happen upon, like this one. This image explores the contrasts of textures between the rusted automobile and broken glass. This is also a study of complementary colors, as the photographer has drawn attention to the fading red paint of the car and the blue sky. Our eye is led to the small piece of broken glass in the foreground that still remains in the window.

Photographer's Comments

"As I was returning to Texas from photographing a sports car race at Pike's Peak International Raceway in Colorado, there was a terrible accident on the highway. When it became clear that we were going to be trapped on the road for quite a few hours, I decided to venture out onto the

highway with my camera to see if there were any interesting photo opportunities. While wandering around, I noticed off in the distance among the foothills of Pike's Peak was the abandoned wreck of an automobile. I hiked over to the car and started snapping pictures. When I got near this door I noticed the contrast between the red of the paint and the blue of the Colorado sky. I was also intrigued by the overlapping of the broken glass remaining in the door and the fractures in the rear window."

Technical Data

Nikon D70 digital SLR
Tamron 70-300mm f/4-5.6 zoom lens
set at 100mm
1/180 of a second at f/11
ISO 200
Early evening light

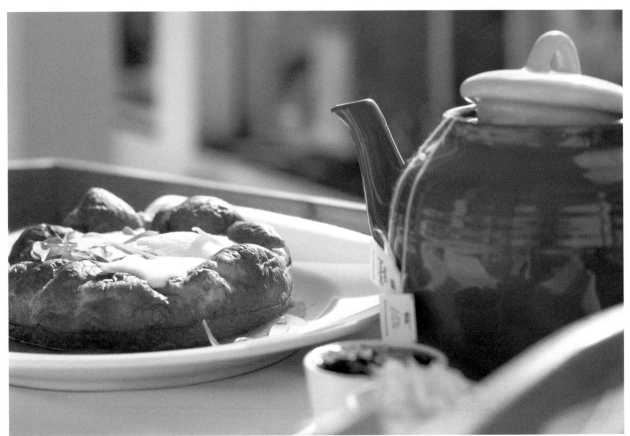

"Breakfast"

© Lara Ferroni
Sooke, British Columbia, Canada
www.platesandpacks.com

In this image, appetizing breakfast fare becomes the subject of a still life, illuminated by the warm light of early morning. Sometimes scenes like this present themselves in an attractive manner and all you have to do is isolate the elements you want to photograph. Other times, a little rearranging on your part can result in eye-catching compositions. Challenge yourself by looking for still lifes wherever you go, from ordinary objects in your own home to city streets and rural areas. Natural light may be the only illumination you'll need, but if it's too harsh and contrasty, consider using white poster board or a reflector to bounce a little light back into the shadowed areas.

Photographer's Comments

"The Sooke Harbor House sits on a beautiful inlet of water teaming with wildlife — eagles, seals, deer, and, in the distance, pods of whales. Each room at this resort has a glorious water view, the perfect spot to enjoy a leisurely breakfast. This inn hosts one of the finest restaurants in Canada, and specializes in seasonal cuisine, flavored almost exclusively with herbs and edible flowers from their organic garden. The light on this particular morning was quite strong side lighting, with a nice, golden touch. A little creative positioning allowed me to get the pancake in a nice ray of light without creating overly harsh shadows. This is one of the few shots I've taken in a landscape (horizontal) orientation."

Technical Data

Canon EOS 20D digital SLR
Canon EF 50mm f/1.4 lens
1/1000 at f/4
ISO 100
Natural light

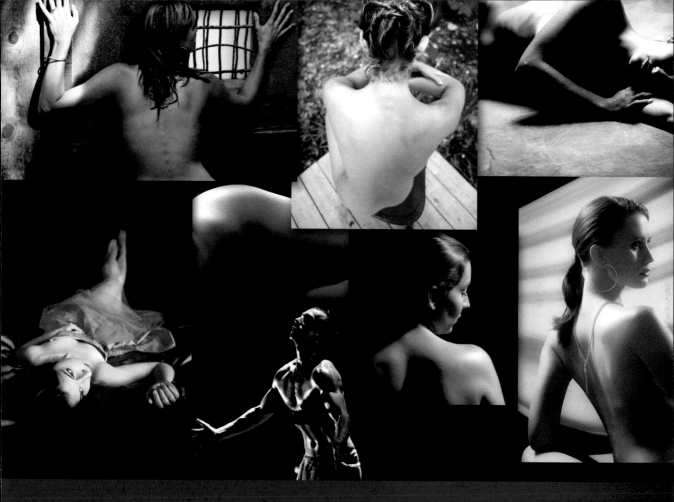

PART 10

SKIN

The art world has long celebrated the human body in countless paintings and sculpture, and creating a great nude study poses a challenge to most artists. It's important for a photographer to develop a style and the technical expertise to portray an artistic nude successfully. A number of variables should be considered, such as posing, camera angle, lighting, and composition. In a studio setting, a simple backdrop paper works well, while outdoor backgrounds should complement the subject without distracting from it. Shooting an image of a person that reveals the body takes much planning and practice to arrive at the artistic statement you want to make. Successful nudes and semi-nudes are often a blend of the aesthetic and sensuous. Some are rendered as bold, blatant statements, leaving little to the imagination, while others are more sophisticated and subtle. In this section of the book, we will focus on the latter.

One aspect of photographing people successfully is the ability to think visually, to recognize photographic possibilities in any given situation. Sometimes this means being aware of design elements like colors, shapes and lines, and utilizing them with your choice of camera angle, point of view, or composition. Ask yourself whether a scene you want to shoot needs explanation, or stands on its own. Learning to assess a situation visually enables you to get more aesthetically pleasing images, and can help you develop your own personal photographic style. The outdoor setting contributes to the natural feeling that this image portrays. Also, the photographer wanted to show the subtle colors, as well as the contrast of the red chair on the blue porch, and shot down on his subject to include these elements. With her back to the camera, this model remains an anonymous figure.

Photographer's Comments

"'Red Chair' was taken during a break in shooting. The light was soft but diminished due to a number of trees, so a tripod was necessary. Although I rarely shoot in color, the contrast of the red chair on the blue porch called for a change in my preferences and I asked the model to have a seat. Because it was the muted colors I was after more than the details, I went for a relatively shallow depth-of-field to obscure the background and lose focus midway down the model's back."

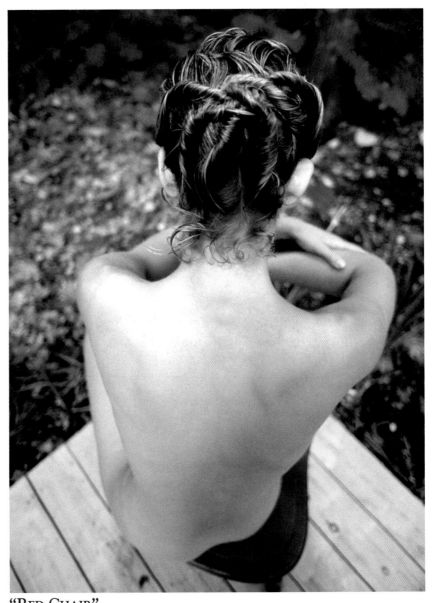

"Red Chair"
© Daniel Leighton
Davenport, Iowa
http://daniel.photoworkshop.com

Technical Data

Nikon F3 35mm SLR
Nikkor 50mm lens
1/60 of a second at f/5.6
ISO 100
Natural light
Tripod

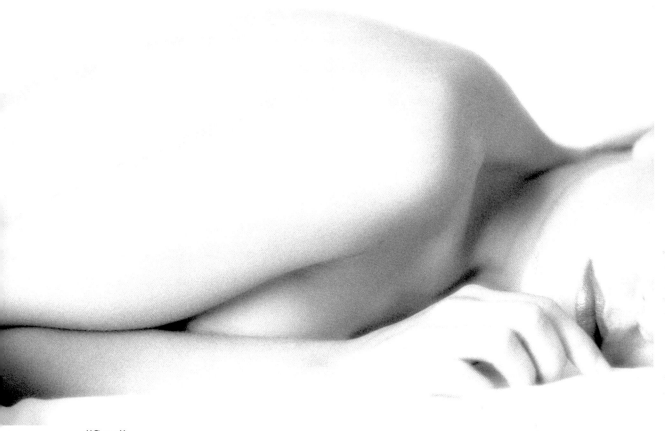

"Shy"
© *Ricardo de Masi*
East Northport, New York
http://rdmphoto.photoworkshop.com

By cropping closely, this photographer has placed the emphasis on shape and form, and has thereby created an abstract nude. When moving in close for a tightly framed close-up of part of the body, it's best to pose the model against a very simple, non-distracting background. He has also played up the delicate qualities of this feminine shape by using a high-key technique, in which the light tones of the image predominate. The model's skin and background are very light, and shadows are almost nonexistent. To create a high-key image, your lighting should be soft and diffuse. It's also a good idea to overexpose your image slightly, but do it with care. The light meter in your camera was designed to read a scene with an average range of tones. A subject with only light tones will cause the camera to select a smaller aperture or faster shutter speed than you actually need, resulting in underexposed images. Experiment by bracketing your exposures for the best results.

Photographer's Comments

"Here, my goal was to try and show this model's beauty, yet maintain a certain degree of mystery. I shot a few frames that included her face, but they lacked the mystery I was looking for. So I took a few more shots where I cropped her face at certain points, and ended up with this image. I used window light with some flash for fill."

Technical Data

Nikon N70 35mm SLR
Nikkor 85mm f/1.8 lens
Ilford Pan F Plus ISO 50 black-and-white film
Exposure unrecorded
Ambient light and fill flash

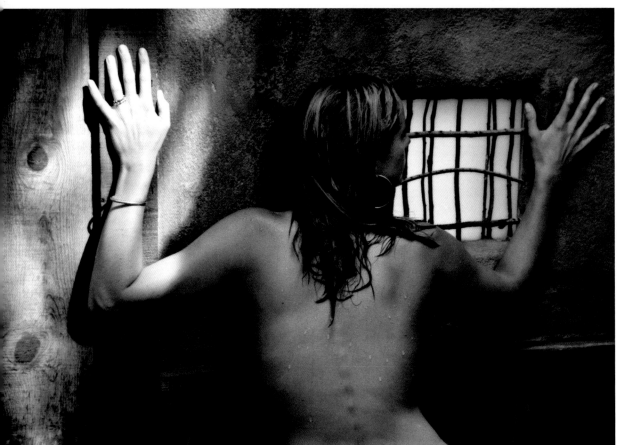

"Seeking"
© *Ken Jackson*
Fayetteville, North Carolina
http://kenjacksonphoto.photoworkshop.com

When photographing people, particularly nudes, it's imperative that you give a lot of thought to your background. In this dramatic photo, the photographer utilized the backdrop of a rustic building and dappled light to provide contrast to the model's skin. Because her back is toward us, this image becomes a most interesting interplay of tone and texture, rather than a portrait in which we can identify with the subject. The photographer captured his subject in an area with interesting highlights and shadows on her body, particularly on the left side. In this portion of the frame, our eye is drawn to the illuminated area, which spotlights her smooth arm contrasting with the rougher texture of the wood.

Photographer's Comments

"I made this photograph at a Japanese-style spa outside of Santa Fe, New Mexico, while I was there to attend the Santa Fe Photographic Workshops. I prefer to work intuitively rather than to pre-visualize shots, and this picture came about as a result of collaboration with the model, giving minimal direction while maintaining a mindful connection, and responding to her movements and poses. I wanted to express the sensual experience of being in the place, and the contrast of the model's wet skin with the texture of the wood and stucco, the dappled shade, her form and pose all combine to make this image work for me."

Technical Data

Canon EOS Elan 7 35mm SLR
Canon EF 24-70mm f/2.8L zoom lens set approximately at 35mm
Kodak Tri-X ISO 400 black-and-white film
Exposure unrecorded
Natural light, open dappled shade

The lighting in this image is very directional, and appears to be coming in through a window located right behind the model on his left side. It highlights the shoulders and the man's muscular arms, while the rest of his torso and face are thrown into shadow. The closer the model is to a window, the greater the contrast between highlighted and shadowed areas of the body. And, as opposed to the soft lighting that flatters the female form, it's acceptable to use a somewhat harsher light to illuminate a man's body. When photographing indoors, a window provides the easiest-to-use source of light. But many photographers use softboxes or umbrella lights when photographing nudes in a studio setting.

Photographer's Comments

"Today's world is obsessed with youth and beauty. We see it in all aspects of advertising and marketing. This obsession leaves many people over the age of 40 with the feeling that they're no longer valued by society. After my fortieth birthday, I decided to focus my ongoing project of nude photography on those men and women who were in the same frame of mind as I was. I placed an ad in a local paper requesting volunteers age 40 and over. Everyone who responded to the ad was photographed in one day at a friend's studio in Manyunk, Pennsylvania. The image you see is one of the amazing people who I photographed that day."

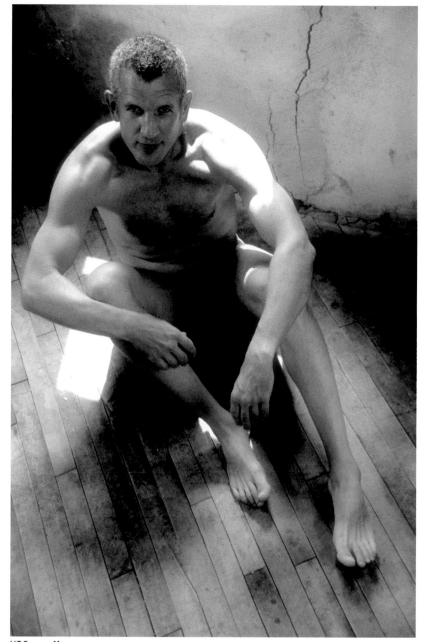

"KARL"
© Kevin E. McPherson
Philadelphia, Pennsylvania
http://kevinmcpherson.photoworkshop.com

Technical Data
Nikon N90s 35mm SLR
Nikkor24-85mm zoom lens
Kodak Portra B/W film
ISO 160
Exposure unrecorded

"UNTITLED"
© *Todd Kuhns*
Dayton, Ohio
www.studio12online.com

This elegant nude harkens back to the days of glamour photography. The lighting is a wonderful interplay between highlight and shadow. What's not obvious from this image is the fact that the photographer rendered the model as a mermaid for this portrait session. The backdrop's sweeping lines work well, adding to the sophisticated ambience of this photograph. As opposed to images where the model's head is turned away from the camera — which tends to draw the eye to her body — our attention is drawn to this woman's lovely profile. But because she's not looking directly at the camera, this image retains a more impersonal look.

Photographer's Comments

"This was an extra image for the model and make-up artist, and was part of a photo shoot I did as a self-promotion where I portrayed the model as a mermaid. I shot some tighter compositions to show off the model as well as her hair and makeup. I really intended for the images to be only for the others involved with the photo session but liked the image enough that I've used it myself."

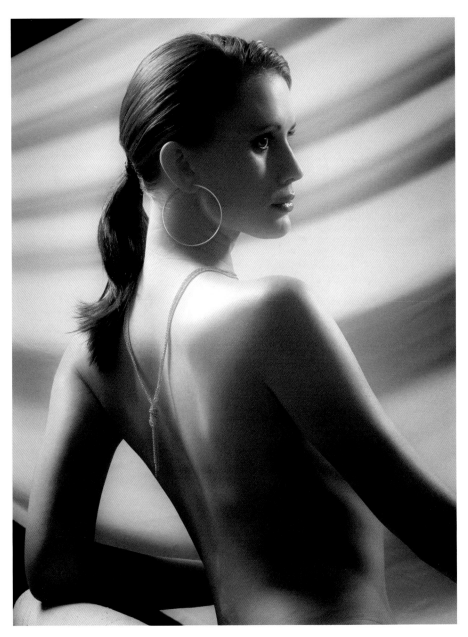

Technical Data

Canon EOS 20D digital SLR
Canon EF 85mm f/1.8 lens
1/160 of a second at f/13
ISO 100
16-inch parabolic as the main light, with a soft-box as an accent light

This is another beautifully rendered high-key image that emphasizes the shape and form of the model. But rather than zooming in on soft curves, this photograph focuses our attention on the angles created by her arms and legs. As you can see in this image, an expressive portrait doesn't even need to include a person's face, and it becomes that much more anonymous because of this omission. To create this type of image, ask a model to assume a pose that creates an eye-catching shape, and then move in close to isolate this shape or design. Abstract studies like this one often work well with directional lighting. In this case, the photographer took his meter reading off the woman's skin tones so that the frontal light coming in through a window would render the background into overexposure, further accentuating her body. Again, it's always a good idea to make two or three exposures with different settings.

Photographer's Comments

"This image is the result of another experiment with window light. The model was positioned on a windowsill. I took my meter reading in front of her so that the light coming into the window would blow out and give her a nice outline. I didn't know if this technique would work out, but it was successful."

Technical Data

Nikon N70 35mm SLR
Nikkor 85mm f/1.8 lens
Ilford Pan F Plus ISO 50 black-and-white film
Window light

"Flower"
© *Ricardo de Masi*
East Northport, New York
http://rdmphoto.photoworkshop.com

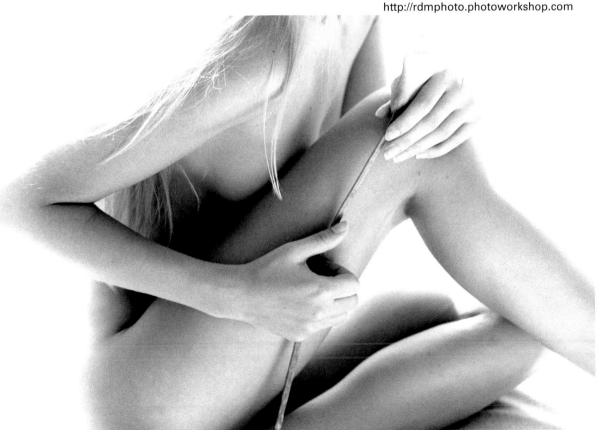

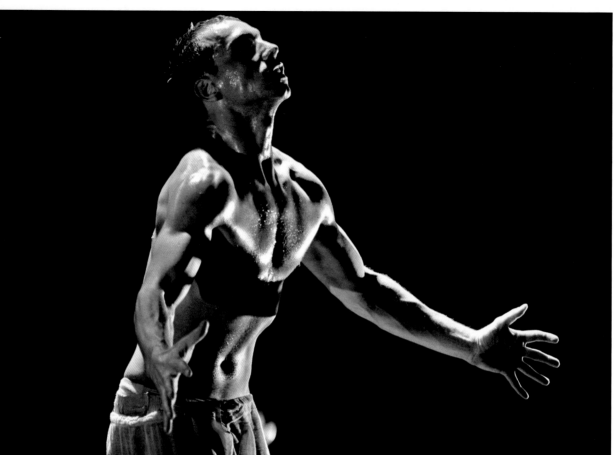

"SHADOW & LIGHT"
© *Haje Jan Kamps*
London, England
www.photocritic.org

Dancers offer some intriguing photo opportunities (remember to check if photography is allowed at a venue and be considerate of the audience). Plan to stand to the side or back of the theater when shooting. Flash probably isn't permitted, but you can capture some powerful images with the existing stage lighting. One of your greatest challenges in photographing live performances is the lighting, which can be very contrasty because performers are often spotlighted against darkness. For this reason, it's a good idea to take a spot reading on the subject alone whenever possible. If you can't do this, one guideline of shooting stage performances is to use a setting of 1/60 of a second at f/2.8 with ISO 400. Here, the photographer successfully captured the dramatic play of shadow and light created by a spotlight, which accentuates this performer's muscular body.

Photographer's Comments
"There's something unique about seeing live theater — everything is constantly in motion, and the lighting ensures that nothing is left to coincidence. This photo of Yorgos, a performer with the renowned United Kingdom performance arts group, Momentum, strikes me as particularly powerful because of the incredible contrast of light and dark, and the juxtaposition of both."

Technical Data
Canon EOS 30D digital SLR
Sigma 70-200mm f/2.8 zoom lens set at 200mm
1/125 at f/2.8
ISO 400
Ambient stage lighting

Perhaps the best lighting for nude studies is soft and directional. Many photographers use just one light positioned above the model, as this photographer has done, or the soft light coming in from a north-facing window. When light comes from one direction, it highlights one side of the body and puts shadows on the other, giving the body a three-dimensional form. Also, soft light makes more of a subtle transition from dark to light areas, and the contrast is not as pronounced as it would be with harsh, direct illumination. This beautiful black-and-white image has a painterly feel and is reminiscent of classic nude art throughout the centuries.

Photographer's Comments

"This was one of my very early figure studies. I was influenced by the likes of Helmut Newton, Kim Weston, and Greg Gorman. This is a good example of what I was trying to accomplish with a single light. I think sometimes that photographers get caught up in their equipment, and — what I believe — over lighting their images. In this photo, the light is coming from a softbox directly above the model. I've always illuminated my work with one light, a reflector, and possibly a background light. Remember that it's not the violin, it's the violinist."

Technical Data

Nikon F90x 35mm SLR
Nikkor 35-105mm f/4 lens
Exposure unrecorded
Studio strobe light in a 20- × 24-inch softbox

"NUDE STUDY 13"
© Brian Tremblay
Ontario, Canada
http://briantremblay.photoworkshop.com

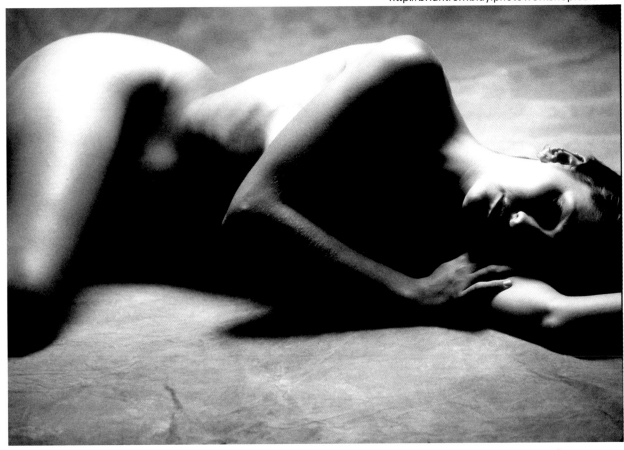

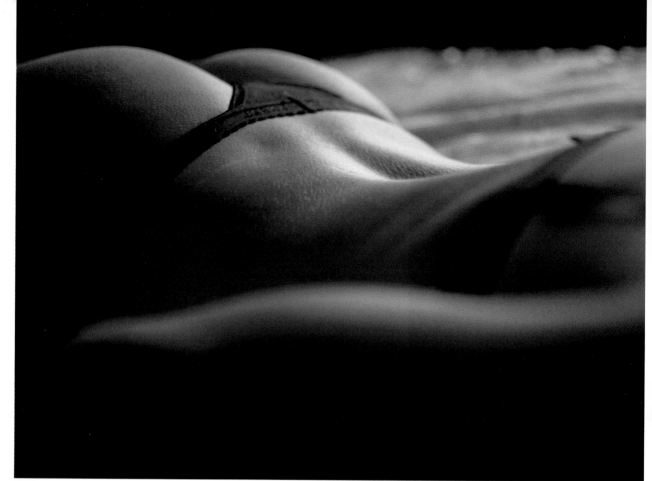

"Untitled"
© *Tyler Keeler*
Aldie, Virginia
http://tjkphotography.photoworkshop.com

In this image, the soft curves of a woman's back are rendered as a sleek body landscape. The human body is very appropriate for studies in which part of the form can be isolated and abstracted, and has an array of curves and angles that can interact with the light in subtle or dramatic ways. To create an abstract, you can move in for a tightly framed close-up of part of the body, as this photographer has done.

Photographer's Comments

"I took this image when I attended my first group photo shoot, which was staged by another photographer in northern Virginia. About 10 photographers and 14 models attended this two-day event. As our time and space was limited, I could only set up one softbox for lighting. I wanted to capture some of the serenity that I usually feel on my 'normal shoots,' so after taking some portraits, I asked the model to lie down on the bed and relax. I like to make the most of highlights and shadows in my images, which really came into play with the low camera angle and the light coming in from behind her. I used a very shallow depth of field to bring a feeling of softness to the curves of her back and arm. I used the camera's built-in spot meter to get the exposure on her skin."

Technical Data

Canon EOS 1DS Mark II digital SLR
Canon EF 28-80mm II zoom lens set at 48mm
1/200 of a second at f/2.8
ISO 400
Single softbox positioned above and behind the subject

This portrait is very subtle in its sensuality, in many ways more so than had it been a nude. The image appears to be lit by window light, which is very soft on the young woman's face and shoulders and drops off softly towards her legs. The use of a shallow depth of field is very effective here too. One important aspect of photographing people is learning how to think creatively, to consider the photographic possibilities of a situation. This includes planning the visual design elements of lines, shapes, and colors, as well as the lighting and the vantage point from which you want to photograph your subject. Once you learn to assess a scene for its visual impact, you can create photos that reveal your own personal style. This photographer's intention was to shoot a glamour photo, and the result is an intriguing, sophisticated image. The dark background provides a dramatic contrast to the woman's skin and red dress, and her gaze toward the window suggests that she's deep in thought.

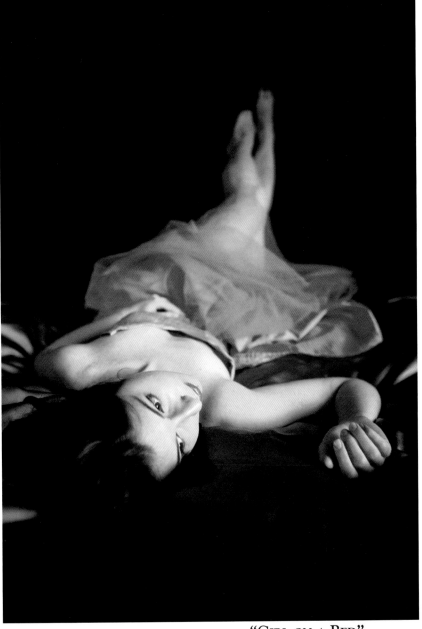

"GIRL ON A BED"
© *Scott Robert Lim*
Monrovia, California
www.scottrobertgallery.com

Photographer's Comments

"I wanted to shoot a more glamorous photo of my subject. I asked her to lie on this bed and to look toward the main source of light to eliminate shadows on her face. I told her to raise her legs and rest them on the headboard of the bed in order to create a more graceful line."

Technical Data

Canon EOS 5D digital SLR
Canon EF 24mm f/1.4L lens
1/200 of a second at f/2.0
ISO 800
Ambient indoor light

Photographing a nude means that you need to consider the background and lighting you want to use, as well as the poses you want your model to assume. Depending on the pose and your lighting, you can create an abstract by photographing a subject from an unusual angle. You may want the model to strike a pose that creates an interesting shape. In this example, the model's curled-up posture, as well as the subtle lighting, results in an intriguing abstract.

Photographer's Comments

"My inspiration was to find the abnormal in a normal scene through effective management of the light source. By eliminating a high percentage of distinguishing physical features, the viewer is formed to concentrate on the data presented, to form in their own mind a fuller, more detailed image. No single feature dictated the direction of the viewers' thoughts — rather, all features presented must be considered. In this way, my images can be seen as a whole, yet differently, by various people which, when discussed with others, opens another view for consideration. Kim has a well-defined body that screams 'abstract' when the light is played upon her. Rather than soften the lines between highlight and shadow, the harshness pushes the image to an abstraction as opposed to glamour or soft eroticism — shapes and contours take on a whole new meaning."

Technical Data

Pentax Z70 SLR
Sigma 28-80mm lens set at 55mm
Ilford HP5 400 film
1/15 of a second at f/4.5
One tungsten light overhead and 1 foot behind the subject's back.

"ABSTRACT 11"
© Darryl Matters
Exmouth, Western Australia
http://darrylmatters.photoworkshop.com

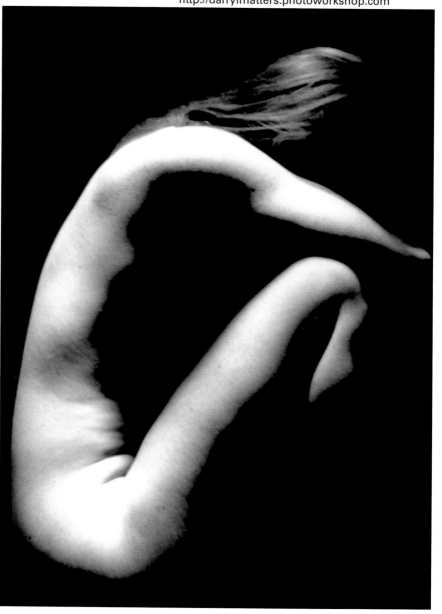

This photographer has succeeded in conveying the strong relationship between these dance partners in this sensual portrait. When photographing couples candidly, you can do this when the couple is most involved with each other, allowing you to capture a moment when a loving gesture or glance passes between them. Their rapport may make it possible for you to photograph them at close range, relatively unaware of the camera's presence. (And, because these two people are professional dancers, they're probably already more comfortable around lights and cameras.) As with many candids, you want to be ready to fire your shutter button quickly. A relatively slow shutter speed (1/30) shows the motion in this photo.

Photographer's Comments

"I recently went to a great party in Portland, Maine, where all the best disk jockeys from New England were meeting at the Space Gallery. This dancer, Keph, was performing at the party, doing break-dancing on stage in front of a very young crowd. His show was fantastic. I approached him and invited him to come to my studio with his girlfriend, Karinate. They came over a week later, and I set up my studio lighting and photographed them for three hours. They were both very gracious and obviously in love — it was such an amazing photo shoot. This series of images is for my project called, 'Love in Motion.'"

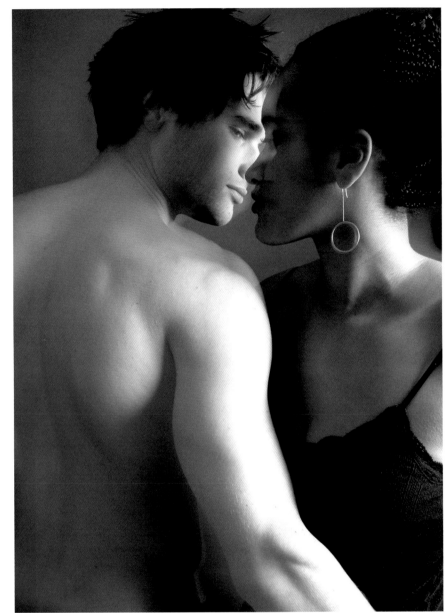

"LOVE IN MOTION"
© *Marie Preaud*
South Portland, Maine
www.mariepreaud.com

Technical Data

Nikon D50 digital SLR
Nikkor 24-120mm f/3.5-5.6G ED-IF AF-S VR zoom lens
1/30 of a second at f/16
ISO 100
Strobe lighting positioned on the left and right of the subjects

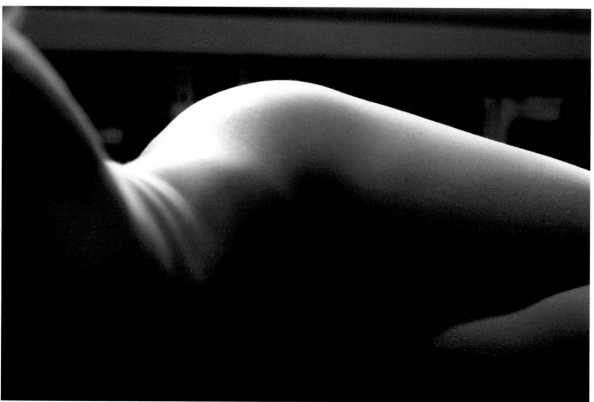

"CURVE OF LIGHT"
© *Ricardo de Masi*
East Northport, New York
http://rdmphoto.photoworkshop.com

The curves of a human form lend themselves well to abstract studies. Some of the most beautiful nudes are those that reveal only a portion of the body, and like this one, are strategically lit to highlight a beautiful line or shape. In photographs like this, the body is often posed against a very simple backdrop, but you can also frame an image like this so tightly that it's all form with no visible background. Here, the black background provides a dramatic contrast to the rim light that defines this woman's side. The shadows are every bit as important as the light in this artistic image. Although outdoor scenes can be effective, you may be able to achieve better control of light in a studio or other indoor setting.

Photographer's Comments

"I took this image during a workshop with other Photoworkshop.com photographers. The model was backlit from sunlight coming in through a New York City apartment window. It was one of those lucky shots where the model was in the right place at the right time, with the right lighting."

Technical Data

Nikon N70 35mm SLR
Nikkor 85mm f/1.8 lens
Ilford Pan F black-and-white film
Exposure unrecorded
Window light

In an interpretive portrait, the model conveys a mood or feeling. The photographer must draw on their skills of working with people, as he/she is responsible for bringing out the personality of the subject, as well as creating a relaxing atmosphere for the model. In this sensuous image, the subject is not an overtly nude study, but an individual that is expressing subtle emotion. Posing and camera angle are important in these portraits. To convey a sense of the model's personality, it's very important to show her face. For effect, the face can be somewhat obscured, but the overall image should still reveal something of the subject's personality or mood. This photographer made an artistic statement by cropping tightly, and putting the emphasis on her lips with a shallow depth of field, allowing the rest of the image to become a soft blur.

Photographer's Comments

"I was working with Lisa, a model from London, England, who was traveling in the northern Virginia area. I liked the way her lip gloss shone in the light coming in through the window, and I used a narrow depth of field to isolate the focal point of the image on her lips. I also pushed the exposure up a half-stop. This is one of my images where I feel that I have captured a quiet, intimate moment with the model."

Technical Data

Canon EOS 1Ds Mark II digital SLR
Canon EF 50mm f/2.5 macro lens
1/500 of a second at f/3.2
ISO 400
Afternoon sunlight coming through an east-facing window

"NUDE 2"
© Tyler Keeler
Aldie, Virginia
http://tjkphotography.photoworkshop.com

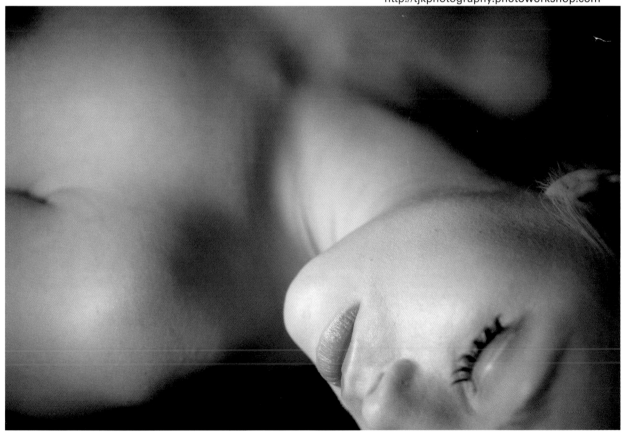

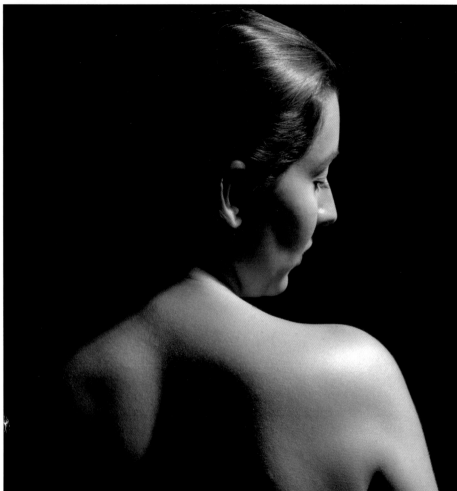

"LUZANDA"
© *Eddy McDonald*
Naguabo, Puerto Rico
http://eddy.photo
workshop.com

When it comes from one direction, illumination highlights one side of the body and creates shadows on the other, emphasizing its three-dimensional form. The best lighting to use when photographing a nude is soft and directional. And because it's somewhat soft and diffuse, the light makes a transition from bright to dark areas in a subtle manner. This photographer utilized a single studio light to make an artistic statement about the curve of this model's neck and shoulder. If you don't have studio lighting, however, window light can provide a lovely source of soft illumination. You can utilize a reflector to bounce a little light back into shadowy areas if the contrast between light and dark areas is too great.

Photographer's Comments

"This was taken during a nude portrait session with a model. The inspiration for this specific pose comes from the art of the Pre-Rafaelite Brotherhood such as that of Dante Gabriel Rossetti. Most of his paintings — especially those of Jane Morris — emphasize this aspect of the female body. More than anyone else, Rossetti recognized the sensuous beauty of the curve of a woman's neck and shoulder, and that is what I tried to capture in this photograph of my model. I positioned the softbox at camera right, above and behind the model, and the light skimmed over her shoulder."

Technical Data

Fujifilm FinePix S2 Pro digital SLR
Nikkor 28-105mm f/3.5-4.5D AF zoom lens
1/125 of a second at f/5.6
ISO 200
One Calumet Travelite 750 with a 24 × 36 softbox